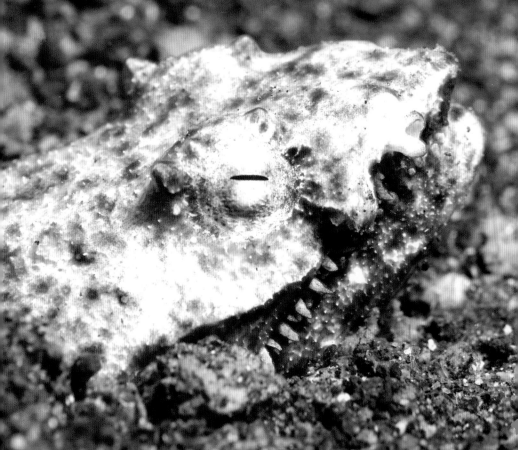

MUCK DIVING

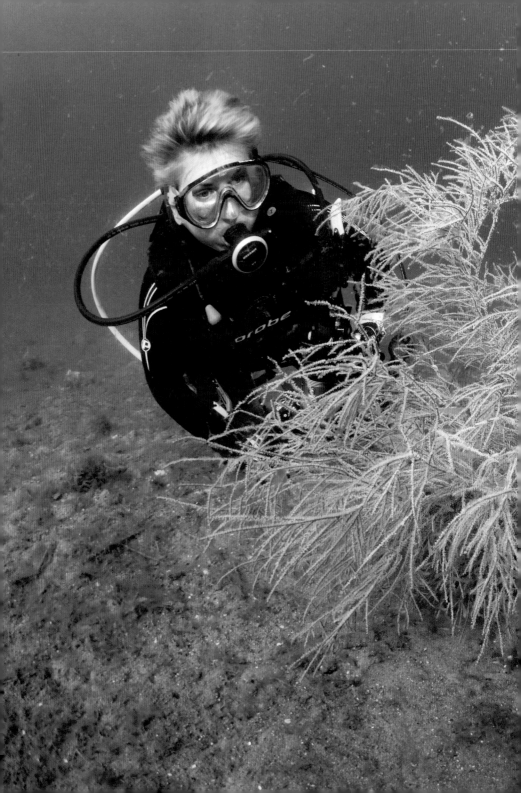

MUCK DIVING

A DIVER'S GUIDE TO THE WONDERFUL WORLD OF CRITTERS

NIGEL MARSH

First published in 2017 by Reed New Holland Publishers Pty Ltd

London • Sydney • Auckland

The Chandlery, Unit 704, 50 Westminster Bridge Road, London SE1 7QY, UK

1/66 Gibbes Street, Chatswood, NSW 2067, Australia

5/39 Woodside Avenue, Northcote, Auckland 0627, New Zealand

www.newhollandpublishers.com

ISBN 978 1 92151 781 5

Group Managing Director: Fiona Schultz
Publisher and Project Editor: Simon Papps
Designer: Andrew Davies
Production Director: James Mills-Hicks
Printer: Hang tai Printing Company

10 9 8 7 6 5 4 3 2 1

Keep up with New Holland Publishers on Facebook
www.facebook.com/NewHollandPublishers

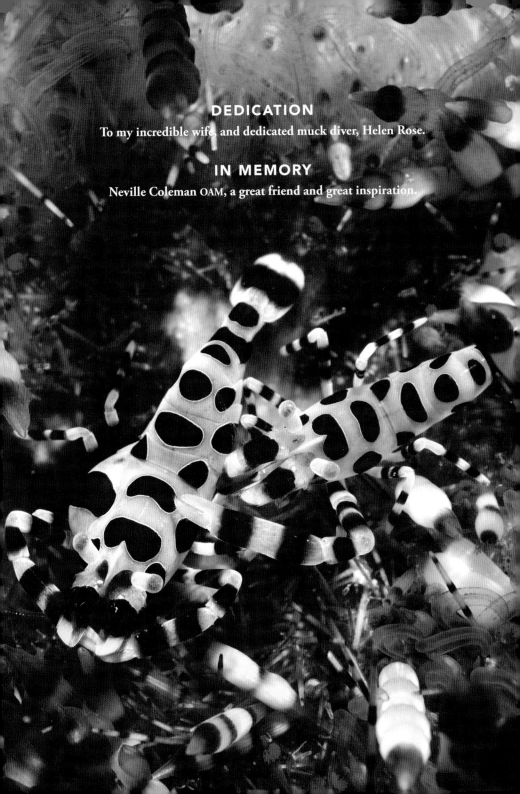

DEDICATION

To my incredible wife, and dedicated muck diver, Helen Rose.

IN MEMORY

Neville Coleman OAM, a great friend and great inspiration.

CONTENTS

INTRODUCTION 11

MUCK
ENVIRONMENTS 15

HISTORY OF
MUCK DIVING 19

MUCK DIVING GUIDES 24

MUCK DIVING
TECHNIQUES 27

MUCK DIVING
PHOTOGRAPHY 31

INVERTEBRATE
MUCK CRITTERS 44
CNIDARIANS 46
MARINE WORMS 51
SHRIMPS 58
PRAWNS 71
MANTIS SHRIMPS 73
TRUE CRABS 76
PORCELAIN CRABS 86
HERMIT CRABS 87
SQUAT LOBSTERS 89
MOLLUSCS 91
NUDIBRANCHS 97
OCTOPUS 102
CUTTLEFISH 113
SQUID 120
ECHINODERMS 122

MUCK FISH 134
MORAY EELS 136
SNAKE EELS 141
CONGER EELS 145
GARDEN EELS 146
CATFISH 147
LIZARDFISH 148
TOADFISH 151
FROGFISH 153

HANDFISH	159	FLOUNDERS	225
CLINGFISH	160	SOLES	227
PINEAPPLEFISH	163	FILEFISH	229
SHRIMPFISH	164	BOXFISH	232
SEAMOTHS	165	PUFFERFISH	236
GHOSTPIPEFISH	166	SHARKS	238
SEAHORSES	169	RAYS	240
PIPEHORSES	173		
SEADRAGONS	176	**MUCK REPTILES**	242
PIPEFISH	178	SEA SNAKES	244
SCORPIONFISH	182		
GURNARDS	192	**MUCK DIVING**	
RED INDIAN FISH	196	**DESTINATIONS**	246
CROCODILEFISH	197	INDONESIA	249
CARDINALFISH	198	PHILIPPINES	279
GOATFISH	200	MALAYSIA	299
ANEMONEFISH	202	TIMOR-LESTE	307
HAWKFISH	205	PAPUA NEW GUINEA	313
RAZORFISH	206	AUSTRALIA	319
JAWFISH	208		
STARGAZERS	210	**MUCK DIVE**	
SAND DIVERS	212	**OPERATORS**	336
GRUBFISH	213		
BLENNIES	214	REFERENCES AND FUTHER	
DRAGONETS	216	READING	350
GOBIES	218	INDEX	351
DARTFISH	223		

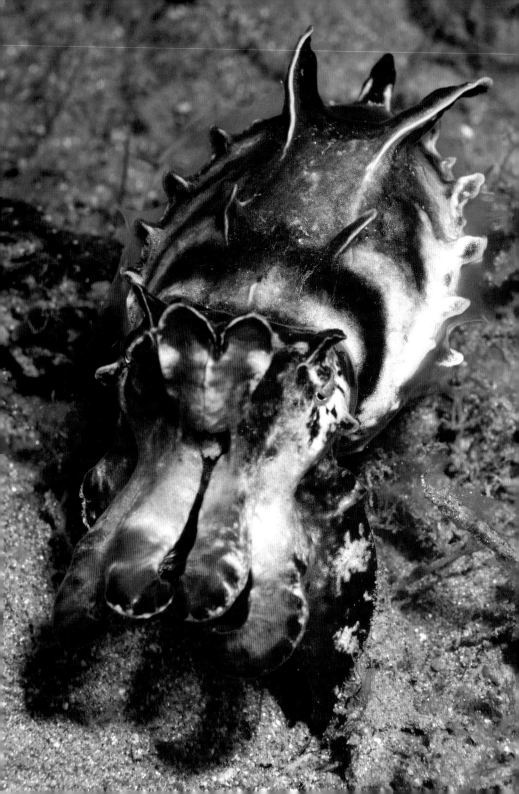

ACKNOWLEDGEMENTS

This book would not be possible with the support of many wonderful divers, dive guides and dive operators spread throughout the Indo-Pacific region. In **Papua New Guinea** – Dik Knight (Loloata Island Resort), Linda Honey (Tufi Resort) and Bob Halstead. In **Indonesia** – Martinus Wawanda, Syainal Hamid, Iwan Muhani, Fian, Ronni and Mamang (Cocotinos Resort and Odyssea Divers, at Lembeh, Manado and Sekotong), Richard Janiszewshi (Seaworld Club Hotel, Flores), Ah Gan and Syam (Blue Dragon, Komodo), Wayan and Komang Lejing (Liberty Dive Resort, Tulamben, Bali), Annabel Thomas and Parman Joseph (Aquamarine Diving Bali) and Jeff Mullins. In the **Philippines** – Phil McGuire and Pedro Batestil (Sogod Bay Scuba Resort), Michael Donaldson, Frank Doyle and Ogin (La Laguna Beach Club and Dive Centre, Puerto Galera), Andrea Agarwal and Wilbert (Thresher Shark Divers, Malapascua Island), Martin Nussbaumer, Dave Santos, Nelberto 'June' Ilagan and Elmar Mendoza (Buceo Anilao Beach and Dive Resort, Anilao), Karl Epp and Cayo (Cebu Fun Divers and Love's Beach and Dive Centre, Moalboal), Rocky, Tim and Zoe Latimer and Jim Thompson (Liquid Dumaguete). In **Malaysia** – Ah Gan and Ronnie Ng (Bubbles Dive Resort, Palau Perhentian) and Keirsten Clark (Seaventures Dive Rig, Mabul). In **Timor-Leste** – Susie Erbe (World Wide Dive and Sail). And finally in **Australia** – Stuart Ireland, Carey Harmer, Dave Harasti, Ian Palmer (The Dive Shop, Hobart), Selina and Clinton McMaster, Hans and Ling Van de Ven, Susan and Cameron McKinnon, Mary Malloy, Alan Beckhurst, Margaret Flierman and Geoffrey Whitehorn. I would also like to thank Jeff Johnson and Rudie Kuiter for assistance with critter identification, any misidentifications are purely my own.

OPPOSITE: The wonderful Flamboyant Cuttlefish is only found when muck diving.

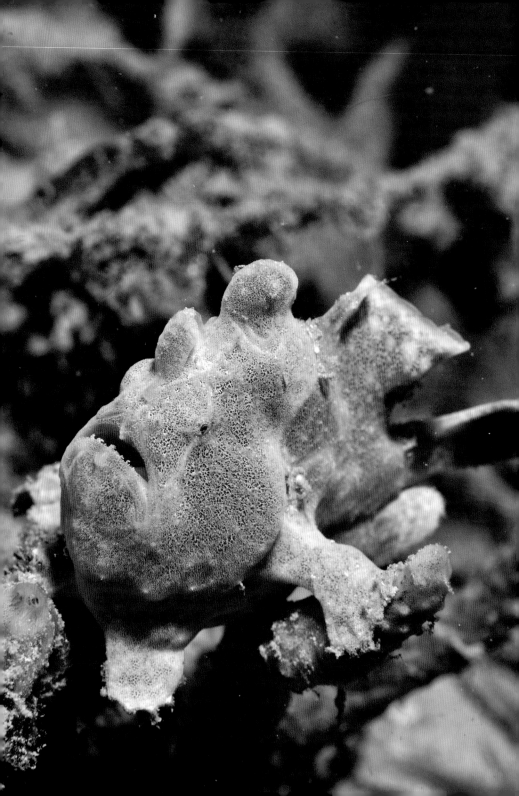

INTRODUCTION

Twenty years ago divers never would have dreamt of booking an expensive dive holiday to explore sandy or silty bottom environments, or as it is commonly known today – muck! Back then if you ventured away from a coral reef or shipwreck to explore the sand you were considered slightly strange or lost. But twenty years ago divers didn't know that diving on muck opened up a whole new world – the realm of weird and wonderful critters.

Muck diving today is a global phenomenon, with divers travelling around the world to marvel at exotic critters like Mimic Octopus, Flamboyant Cuttlefish, mantis shrimps, Bobbit Worms, stargazers, frogfish, snake eels, Demon Ghouls and blue-ringed octopus. While muck diving can be enjoyed in any country that has sandy and silty bottom environments, the best area to see the most diverse range of critters is the Indo-Pacific region. This area encompasses the hot-spots for muck diving – Indonesia, Philippines and Malaysia – but also includes other great muck diving destinations like Australia, Papua New Guinea and Timor-Leste.

In your hands is the first complete guide to muck diving. This book has been designed to introduce the new diver to the wonderful world of muck and entice the experienced muck diver to explore more of this amazing marine ecosystem. This book looks at different muck environments and explains why they attract these amazing critters. It also details the history of muck diving, muck diving techniques, photography tips and how indispensable a great muck dive guide can be.

The second part of the book provides information about the most popular muck critters that divers will see in this environment. The book concludes with a guide to the best muck diving destinations of the Indo-Pacific region. So dive in and experience the magic of muck, and be prepared to encounter the bizarre and beautiful critters that live in this fascinating marine environment.

OPPOSITE: The magic of muck diving is seeing wonderful critters like Painted Frogfish.

NOMENCLATURE

In the text species names have been capitalised, for example 'Ornate Wobbegong', while the names of families have been left in lower case, for example 'the wobbegong family'. The names of fish species and families broadly follow those used in *Standard Names of Australian Fishes*, edited by G.K. Yearsley, P.R. Last and D.F. Hoese. The names of other creatures broadly follow those used in *Australian Marine Life: The Plants and Animals of Temperate Waters* and *Australian Tropical Marine Wildlife* by Graham Edgar.

BELOW: Imperial Shrimps are often found living on nudibranchs.

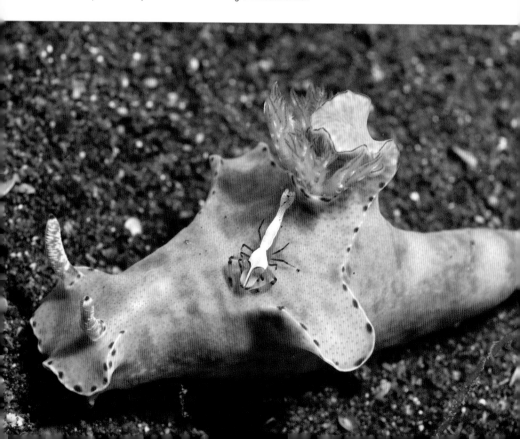

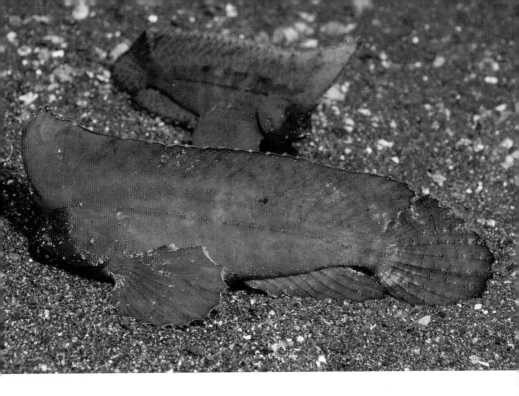

ABOVE: Cockatoo Waspfish are only found at muck sites.

IDENTIFICATION OF MARINE LIFE

For the identification marine wildlife the following Reed New Holland titles are recommended:

Australian Marine Life: The Plants and Animals of Temperate Waters (Second Edition) by Graham Edgar (ISBN 978 1 87706 948 2)

Australian Tropical Marine Wildlife by Graham Edgar (ISBN 978 1 92151 758 7)

Field Guide to the Crustaceans of Australian Waters by Diana Jones and Gary Morgan (ISBN 978 1 87633 482 6)

Fishes of Australia's Southern Coast by Martin Gomon, Diane Bray and Rudie H. Kuiter (ISBN 978 1 87706 918 5)

Guide to Sea Fishes of Australia by Rudie H. Kuiter (ISBN 978 1 86436 091 2)

Tropical Marine Fishes of Australia by Rick Stuart-Smith, Graham Edgar, Andrew Green and Ian Shaw (ISBN 978 1 92151 761 7)

MUCK ENVIRONMENTS

Muck is a term that describes a wide range of marine environments, however they all have one thing in common – they are a perfect habitat for weird and wonderful critters. Mucky seafloors can be made up of fine sand, coarse sand, coral rubble, small pebbles, powdery silt, volcanic black sand and even mud! But it is this sediment, combined with a number of other factors, that makes for a good muck habitat for critters.

In general, muck sites are sheltered from rough seas, so are usually found in bays, inlets and even estuaries. Muck sites also require a good source of nutrients, so are washed by gentle currents or tidal flows. Many good muck sites are also located close to river mouths, which are another rich source of nutrients. Furthermore, most critters like somewhere to hide, so muck sites are not just plain sand, but dotted with rocks, seagrass, coral outcrops (both live and dead), branches, logs, coconut shells or manmade additions like rubbish, jetty pylons and even shipwrecks. All these ingredients go together to make the perfect habitat for muck critters.

THE CORAL TRIANGLE

Indonesia and the Philippines are without doubt the best muck diving destinations in the world. Many would argue that the reason for this is volcanic black sand, with these island nations dotted with hundreds of active volcanos that regularly rain volcanic ash onto the land and surrounding waters. But it wouldn't matter if these muck sites had white, grey, brown, yellow or even green sand – the real reason that these countries have such great muck critters is that they sit smack-bang in the middle of the Coral Triangle.

The Coral Triangle is the name given to the richest marine ecosystem in the world. This area of 5.7 million square kilometres is located in the Indo-West Pacific and encapsulates parts of Indonesia, Malaysia, the Philippines, Timor-

OPPOSITE: Muck is not all about sand, as many corals also grow in this environment.

ABOVE: Some of the best temperate water muck sites are the jetties and piers in southern Australia.

Leste, Papua New Guinea and the Solomon Islands. This area has a staggering amount of biodiversity, with over 3,000 species of fish, 500 species of coral and an incredible number of invertebrate species. The seas within the Coral Triangle are known as the 'Amazon of the Ocean' with an abundance of marine life not seen elsewhere on the planet, and the further one moves away from this area the less species, and less diversity, can be found.

The richness of the muck sites within the Coral Triangle soon becomes apparent once you have dived into this realm. A typical hour-long dive at any muck site in the area will expose the diver to an overwhelming number of species, with critter after critter after critter. It is not uncommon to see several hundred different muck critters at sites within the Coral Triangle. Muck sites outside this area still contain some great species, but they are nowhere near as abundant as in the Coral Triangle.

TEMPERATE TREATS

While tropical waters abound with muck critters, temperate waters should not be ignored as a host of very different species call this cooler zone home. Muck diving in temperate waters can be enjoyed in several countries, however, the waters of southern Australia are particularly blessed with a wealth of endemic species. The great southern land is renowned for its unique animal life, but this uniqueness continues underwater. The muck sites in the southern waters of Australia can be just as good as the best muck sites in Indonesia, as this area is rich with octopus, cuttlefish, squid, crustaceans, seahorses, pipefish and especially frogfish. The diversity of these prized muck critters in this area cannot be understated, as a diver can see more octopus species on a single night dive in Melbourne than can be seen in a week of night dives at many tropical muck sites. Plus Australia has a few critters found nowhere else in the world, such as seadragons, Goblinfish and handfish. The water may be a lot cooler than the tropics, but wearing a thicker

BELOW: Wonderful nudibranchs are found when muck diving, including the Long-cirri Phyllodesmium (*Phyllodesmium longicirrum*).

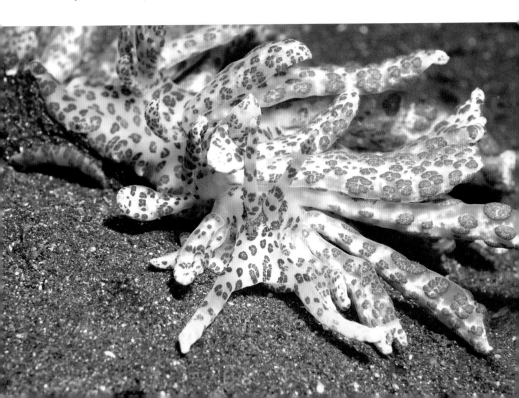

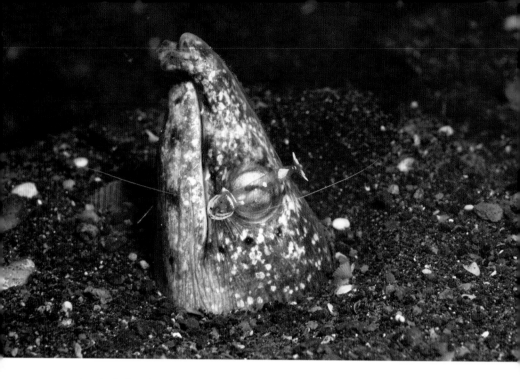

ABOVE: Longfin Snake Eels are sometimes found with commensal shrimps sitting on their head.

wetsuit or a drysuit is a small price to pay to see some incredible temperate muck critters.

NIGHT LIFE

A great range of muck species can be seen during the day, but many muck sites really don't come to life until the sun sets. It is amazing how many muck critters live under the sand and emerge after dark to feed. Night time is the best time to see shrimps, crabs, octopus, squid, stargazers, snake eels, moray eels and many other species. While some of these critters emerge on twilight or just after darkness falls, others are only active a few hours after the sun has set. So doing a night dive at sunset can be completely different to doing one a few hours later. Some very keen underwater photographers have been known to do several night dives overnight and then sleep during the day. So make sure you experience the muck environment after dark, otherwise you will miss seeing some amazing muck critters.

HISTORY OF MUCK DIVING

The term 'muck' was first coined by the legendary Bob Halstead, a pioneer of diving in Papua New Guinea. Bob arrived in Papua New Guinea in 1973, and quickly discovered that the local coral reefs were incredibly rich and beautiful. He then got hooked on shell collecting, but soon found that shell numbers were limited on coral reefs. Around this time Bob met another diving legend, Australian marine naturalist Neville Coleman, who had produced one of the first books illustrating living shells. Neville informed him that he needed to look beyond the reefs and explore sandy, silty and even muddy environments to find unusual shells. Bob

BELOW: Seahorses are more commonly seen in muck environments than coral reefs.

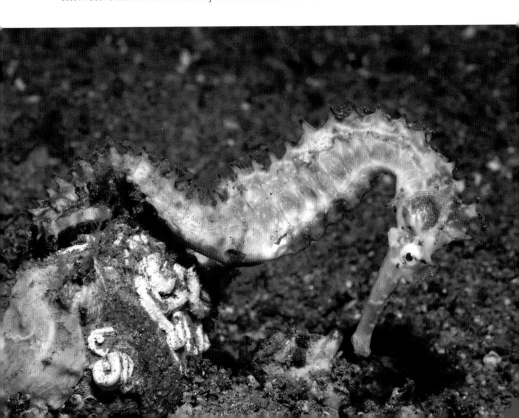

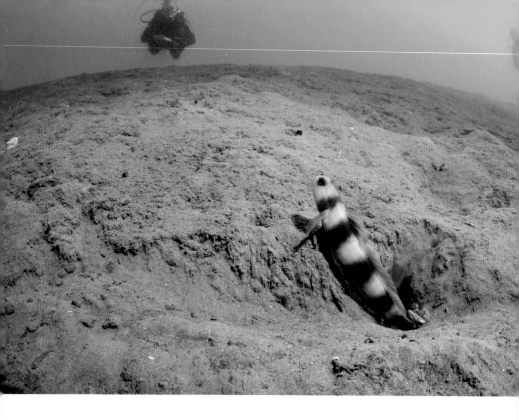

ABOVE: At first glance many muck sites appear to be barren, but this sandy habitat is home to shrimpgobies and many other species.

started to explore these different habitats and found plenty of shells, but also some amazing critters – species he had never seen before.

While Bob and a few friends were diving this muck and marvelling at the critters, he didn't take paying customers to these sites as everyone at the time wanted to dive colourful coral reefs. But in 1986 Bob started the liveaboard charter boat *Telita*, and proceeded to get hordes of zealous underwater photographers looking for something new and different to photograph. Bob decided to introduce them to a new environment, explaining that: "I just thought other divers would be interested and muck described the environment well!"

Bob discovered that at first divers were very reluctant to explore these muck sites. "Our agent Carl Roessler wanted me to call it 'exotic critter diving', as we had people initially unwilling to dive the sites. They thought we were trying to

save fuel. I always told them the truth about the site, it's not glamorous, and said if they did not like it I would move to another site. Mostly they loved it; easy diving conditions and the opportunity to photograph lots of weird and wonderful critters."

While Bob Halstead may have come up with the name, he and his dive groups were certainly not the first to enjoy muck diving. When recreational diving first started in the 1950s most divers were either hunters or gatherers, entering the water to spear fish or collect shells. A few of these pioneering divers would have been the first to explore muck sites, especially in their quest for exotic shells. But as scuba diving grew as a sport in the 1960s many divers started to take pictures, capturing the beauty of coral reefs and colourful reef fish. To these divers exploring sand would have seemed like a waste of time and film, but one of them did, the late Australian underwater photographer and marine naturalist Neville Coleman OAM, who had inspired Bob Halstead to muck dive in the first place.

BELOW: The Mimic Octopus is a star attraction at many muck sites.

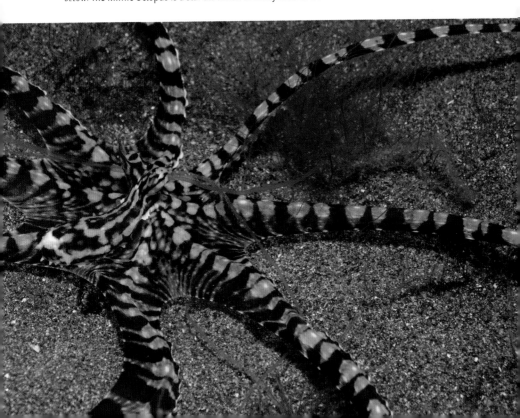

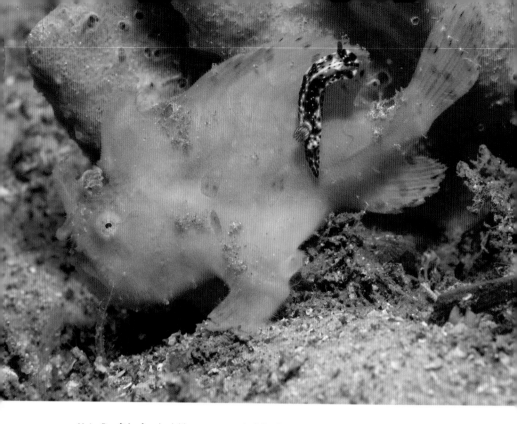

ABOVE: Hairy Frogfish often look like a sponge, which leads to nudibranchs crawling over them.

Neville learnt to dive in Sydney in 1963 and, with a curious nature and a desire to discover, he documented all the species he encountered. No marine life guide books were available at the time, and scientists could only identify dead animals, so Neville did something never attempted before anywhere in the world. He photographed every species he encountered alive and also collected the animal, so scientists could cross-reference a photo of the living creature with the dead animal. This pioneering work lead to Neville discovering over 450 new species, producing over 50 books on marine life, and conducting marine fauna surveys around the world. He was also one of the first divers to spend a great deal of time muck diving.

Neville, in this quest to catalogue all species, explored all marine environments, including muck. Neville called this 'soft bottom diving' well before the term muck came into use. Over the years Neville found some very interesting critters while

exploring this environment. He found new shells, flatworms, nudibranchs, crabs and even a pygmy seahorse, but one of his first discoveries was a commensal shrimp, now known as the Coleman's Shrimp. Neville sadly passed away in 2012, but not before exploring muck sites in Australia and throughout the Coral Triangle.

While Neville was interested in exploring muck sites, the average diver was only interested in diving on coral reefs, especially when they travelled to countries in the Coral Triangle. Looking back at dive magazines in the 1980s, when dive tourism first took off, there are many articles on Indonesia, Malaysia, the Philippines and Papua New Guinea, but the focus was always on the wonderful coral reefs. Many of these articles featured destinations such as Manado, Bali and Flores – all locations with wonderful muck – but at the time the local muck sites were either unknown or not popular attractions.

Some muck sites did start to get a mention in the early 1990s, such as Dinah's Beach at Milne Bay and The Twilight Zone at Ambon, but the authors never used the term muck. One author, writing about The Twilight Zone, referred to its substrate as 'sludge', and while praising the variety of unusual species, was concerned that some of these critters were possibly a direct result of pollution, stating that: 'we strongly believe [they] are mutants, unique to the area'.

In 1994, even after the first dive resort opened in Lembeh – the world's premier muck diving destination – the area only received a side bar in articles, mentioning it as a place to go and see exotic critters when visiting the coral reefs off Manado. One author even described the area as a place to see 'mud-bottom animals', which is not the best way to sell it to most readers.

By the late 1990s things started to change, and articles appeared in dive magazines that focused on muck diving sites as dedicated dive destinations. These articles featured weird and wonderful critters, species that had never been seen before in dive magazines. Divers suddenly learnt that there was more to diving than coral reefs and shipwrecks, with feature articles focused on the wonderful critters at muck diving sites like Lembeh, Mabul and Ambon.

The term 'muck' may have first been used by Bob Halstead in the 1980s, but it didn't catch on as popular term in the dive community until the new millennium. Today it is commonly used by most divers to describe any soft bottom site with remarkable critters.

MUCK DIVING GUIDES

Most experienced divers hate being guided on a dive, much preferring to do their own thing at their own pace. But muck diving is one underwater activity that is improved by the services of a knowledgeable and eagle-eyed dive guide, or perhaps a better term would be a 'critter spotter'.

Some muck critters are very easy to find, but many others are small, well camouflaged and often difficult to locate. To find these critters a local dive guide is invaluable, as they not only know the local dive sites, but also the places where many of the best critters like to hide.

Most of the dive shops and dive resorts in South-East Asia employ local dive guides, but a few also have expat guides. These guides work very hard, sometimes for very low wages, but they are worth their weight in gold.

Finding a good dive guide at the top muck diving sites like Lembeh, Ambon, Bali and Anilao is not difficult, as most of their diving is on muck, and all they do, day in, day out, is search for critters. At most major muck sites the guides will generally ask you what critters you want to see, and then select the dive site to deliver those species. Good guides not only know where to find the critters, but seem to have their own secret society. When a rare or unusual critter is found by one guide, everyone in the area seems to know about it the next day. This sharing of information is generous and extremely helpful if you have your heart set on seeing a particular species.

One thing that always amazes me is how knowledgeable the good guides are about muck critters. This really shouldn't be a big surprise, as the guides spend more time with these animals than the research scientists that study them. So ask the guides questions, most of them love to share their knowledge and observations, and you will definitely learn something new and fascinating about muck critters, which isn't in a book or on the internet.

Dive guides have not only expanded our knowledge about muck critters, but have also found new species in this habitat. Pontoh's Pygmy Seahorse (*Hippocampus pontohi*) was discovered by Indonesian dive guide Hence Pontoh,

ABOVE: Great dive guides are invaluable when searching for critters.

but other guides have discovered new species of nudibranchs and other critters.

One thing you should also work out is a system of communication with your guide. Most tap on their tank when they have found a critter, but if there are several dive groups at the one dive site this can get very confusing with tapping going off in all directions. Ask them to tap the same pattern each time, like two taps, or if they have a torch get them to flick it on and off at you. Anything that distinguishes your guide from the crowd is helpful, especially if the visibility is poor.

Finally, appreciate your guide. They work very hard at finding critters to make your dive holiday a rewarding experience, so reward them in return. Tipping is popular and appreciated, but also get to know your guide, and ask them about their family and what other activities they enjoy. Your friendship can also be a reward.

MUCK DIVING TECHNIQUES

Muck diving is usually done in locations with easy diving conditions that anyone can enjoy. Most muck diving sites are in shallow warm water, with no currents or rough surface conditions, and are either done as boat dives or shore dives. But diving on sandy silty bottoms looking for critters still presents a few challenges, and requires a few special techniques.

BUOYANCY CONTROL

Every diver is taught basic buoyancy control on their open water course, but it is amazing how many so-called experienced divers still lack this basic skill. Good buoyancy control is critical while muck diving. Too heavy and you will constantly crash into the bottom, either kicking up silt or even worse, squashing some poor critter. Too light and you will be high off the bottom and missing half of the critters that you came to enjoy.

While muck diving you need to be neutrally buoyant and able to hover only a metre at most above the sand. Some critters in this environment are tiny, only millimetres long, so you have to be able to settle on the bottom and get your mask up close to see them. With good buoyancy control you should be able to do this with ease, and then gently rise off the bottom without stirring up the silt. If you have just learnt to dive, practise good buoyancy control in a pool or on reef dives before hitting the muck, and the experience will not only be better for you, but also for the divers sharing this environment with you.

FIN CONTROL

Everyone kicks up silt now and then while muck diving – it is hard to avoid in this type of environment – but there is a big difference between an accidently

OPPOSITE: When muck diving, good finning techniques are critical.

misplaced fin and someone that kicks up silt on every fin stroke. Commonly known as 'sandstorms', divers who can't control their fin kicks are not very popular with other muck divers, and especially with underwater photographers. There are a number of finning techniques that can be used to ensure that you don't make a sandstorm, and don't find your air turned off by some irate photographer.

Don't use powerful kick strokes – you are looking for small critters so the slower you go the better. Don't kick down in your fin stroke, as this stirs up the silt – kick back (like pedalling a bicycle) or kick to the side (like a frog). This may sound a bit strange if you have never tried it before, but it does work. Also keep your fins up off the bottom – don't swim horizontally, but instead angle your body with your head slightly down. When you stop to look at a critter, either keep your fins off the bottom or rest them on the sand, don't keep kicking them to stay in position. And finally use your hands if you have to – they can help you to manoeuvre, turn and settle on the bottom with the aid of a scuba pointer.

SCUBA POINTERS

It is rare these days to see a dive guide who doesn't carry a scuba pointer or 'muck stick' of some type. These metal rods are very handy to point out small critters, or to tap on tanks to get attention, and they can also be stuck in the sand to give you an anchor point when looking at critters. Divers used to make their own scuba pointers from tent pegs, but today you can buy them with a lanyard attached. Scuba pointers are very handy when muck diving as they allow you to stop and observe the critters without having to settle any part of your body on the sand. However, these rods shouldn't be used to harass or poke the critters.

GLOVES

Some irresponsible dive resorts ban divers from wearing gloves, as they think divers will be less likely to touch things with their bare hands. This is a silly rule and very unwise. If dive resorts don't want divers to touch things they should

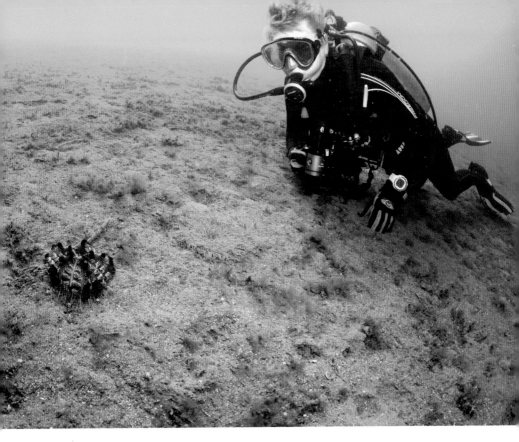

OPPOSITE: The scuba pointer is an invaluable tool for muck diving.

ABOVE: Good buoyancy control is essential when muck diving.

just tell them, but instead they expose divers to potential harm from having bare hands. All divers exploring muck environments should wear gloves as there are many potentially dangerous critters in this habitat. Blue-ringed octopus, cone shells, lionfish, scorpionfish and stonefish are just a few of the venomous critters that divers see muck diving, especially at night. While these critters aren't out to get you, some of them are very well camouflaged and difficult to see, and others can also be hidden under the sand. As much as we like to think we are careful where we place our hands while diving, divers are forever putting their hands on the sand while looking at critters. It only takes one jab from a stonefish or a bite from a blue-ringed octopus to not only end your dive trip, but possibly your life. So always wear gloves and always take care when settling on the bottom.

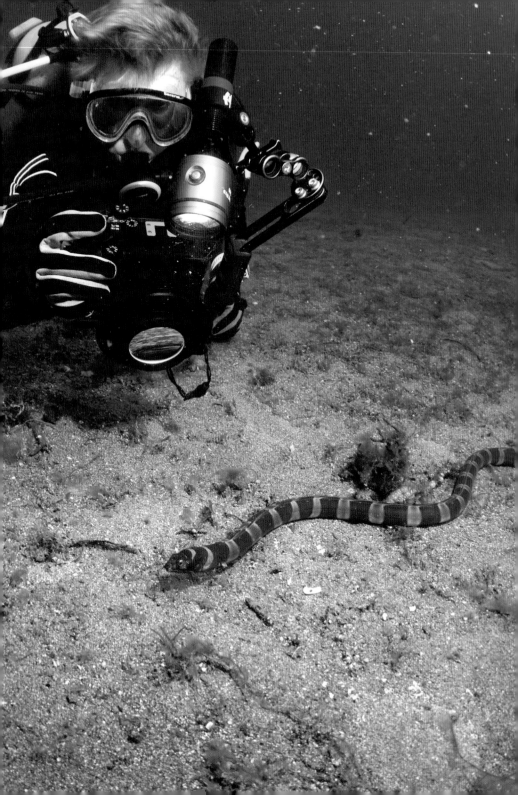

MUCK DIVING PHOTOGRAPHY

Muck diving is an activity that can be enjoyed by all divers, but this environment is perfect for underwater photography, with a horde of weird and wonderful subjects awaiting the diver with a camera. However, underwater photography can be quite challenging in muck environments as one has to deal with silty water, small subjects, well camouflaged subjects and even finding subjects.

Before digital photography it seemed that underwater photography was only attempted by the rich, dedicated and foolhardy. Stunning images could be captured on film, but you didn't see your results until the film was developed and you were limited to 36 images on a dive. The digital age has changed all that and now almost every diver enters the water with a camera to record their experiences. But before you enter the water with camera in hand here are a few tips to ensure that you get the best images possible while muck diving.

BACKSCATTER

Muck diving involves diving on sandy or silty bottoms, with sediment that can be easily disturbed by a diver's fins or hands, or by currents. This means that there are often suspended particles in the water column which can cause backscatter in your images. This can be a major problem for compact camera users who rely on the built-in flash for their lighting, as this set-up is more prone to picking up backscatter. The solution to this is to always work close to your subject and to use a diffuser over your flash, to spread the light. But the only way to really eliminate backscatter is to use an external strobe that allows you to light your subject from an angle, ensuring that lit particles are reflected away from your lens and not directly into it. The other option is to use an external video light, which will allow you to take images and shoot video.

OPPOSITE: A diver photographs a rare sight, a Napoleon Snake Eel out of its hole. Note the particles in the water, which are hard to avoid when using a wide angle lens.

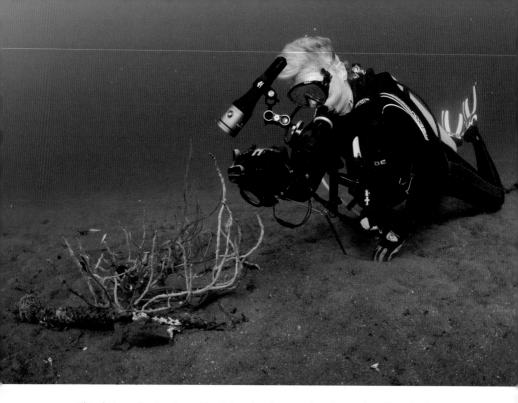

ABOVE: This photographer is using a video light rather than a strobe, allowing for stills and video with her compact camera.

STROBE PLACEMENT

Your strobe should never be stuck in a fixed position, but should always be adjusted depending on the subject, the distance to the subject, how the subject is positioned and your camera angle. In muck environments the best position is to start with your strobe above the camera and angled down. As most particles in the water are going to be close to the bottom, this minimises your chances of backscatter.

With instant feedback in your LCD screen it is easy to see how effective your strobe lighting is on the subject. But it is worth playing around with different angles, as lighting from the side will be different from light from the front or above. Snoot lighting has also become popular when photographing muck critters, allowing photographers to spotlight only certain parts of the animal for dramatic effect.

LENS CHOICE

Muck diving and macro photography go hand-in-hand, with 90 per cent of the critters in the muck environment being in the macro range of 1–15cm long. For the photographer with a DSLR system the lens of choice would be either the 60mm or 105mm (or 100mm) micro lens. Some prefer the 60mm micro lens as it allows 1:1 reproduction, but still allows you to shoot slightly larger subjects. Others prefer the 105mm micro lens; it also gives 1:1 reproduction but allows the photographer to shoot from a little further back, which is great with nervous or skittish subjects. It comes down to which lens you are most comfortable using.

Compact camera users have a little advantage here as their standard lens allows them to photograph both small and large critters just by zooming. However, with plenty of tiny critters that are beyond the macro ability of many compact cameras, you may also need to add an external macro lens, which has the advantage of being removable underwater.

BELOW: A wide angle lens is required to capture a feeding school of Striped Catfish.

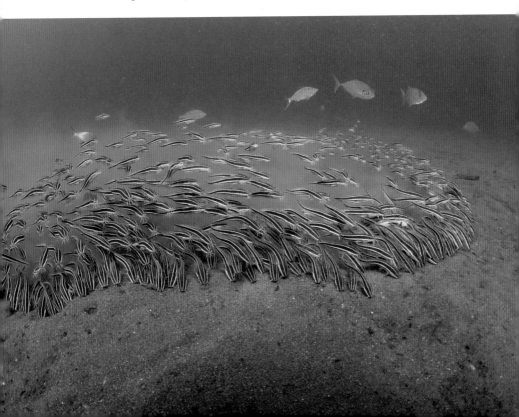

Wide angle photography in muck environments can also be very rewarding, especially with larger subjects such as sharks and rays, but this technique will be limited by the available visibility. Close focus wide angle photography can be interesting with many muck critters, with this technique used to show the subject in the context of its habitat. With this type of photography you will need to get very close to the subject and positon your strobe or strobes so the subject is well lit.

NIGHT PHOTOGRAPHY

Many muck critters only emerge after dark, but photographing these subjects in the dark presents its own challenges. A torch or strobe modelling light with a red filter is a good idea when photographing muck critters at night. Many of these animals are sensitive to the light and will dig in the sand or scuttle into a hole if you point a bright white light at them, but they seem to tolerate the dimmer red

BELOW: At night critters like Bigfin Reef Squid are easier to photograph.

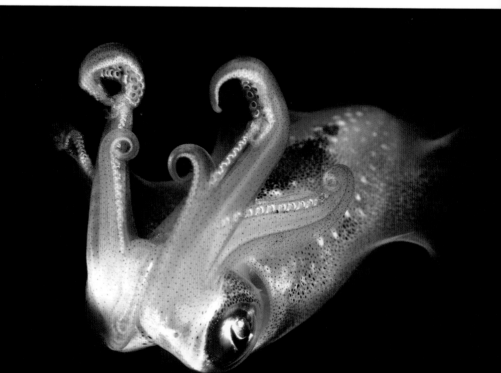

ABOVE: Many muck critters are tiny, this Donut Doto nudibranch (*Doto* sp.) is less than 1cm long.

light. I often look for critters with the bright white light and then flick on a red light to photograph them.

In the last few years fluoro photography has become popular on night dives, with photographers finding a number of muck critters having fluorescence colouration. Frogfish, mantis shrimps, flatworms, nudibranchs and even seahorses have been found to have fluorescent colours. You don't need a special camera to see these fluorescent colours, just a blue excitation filter on your torch or strobe and a special yellow barrier filter for your mask and camera. The results can be amazing.

FINDING SUBJECTS

The biggest challenge for the underwater photographer working in the muck environment is often simply finding subjects; this is where a good guide becomes

ABOVE: Photographing behaviour, like a yawning Painted Frogfish, takes time and patience.

invaluable. Good guides know where their local subjects are and how to find them. But before your dive tell the guide what subjects you would like to photograph, as this information can often determine the dive site or which way to head at a certain dive site. Guides will often swim off to find other subjects while you are busy photographing a critter, just ask them to stay within visibility range and maybe flash a torch at you when they have found something exciting.

If you are diving a new muck location without a guide, a little research beforehand can often save time finding subjects. First, know what critters are common to the area and what sort of habitat they prefer. Do they live on or under the sand; do they live in burrows, under rocks, or in the seagrass; and are they more active by day or night. All this information can help you find the best critters to photograph. Also, luck plays a big part in muck diving, as you just never know what critters you will stumble across.

CAPTURING BEHAVIOUR

The critters that divers encounter while muck diving are very photogenic and will have your camera working overtime to record their antics. While photos of a colourful critter sitting motionless are great, they are even better if you capture the subject actually doing something, so always try to photograph behaviour when you have the opportunity.

Behaviour photos are generally not easy, but they tell more of a story of the life history of the critter. Typical behaviours to look for are motion (of the animal swimming, crawling or walking), yawning, stretching, eating, building a home, mating, displaying, fighting or interacting with another species.

Some behaviour is witnessed on every dive, such as shrimpgobies and snapping shrimps sharing a home, nudibranchs eating and porcelain crabs feeding by waving their feather-like claws. But other behaviours require a bit of patience to capture, such as the yawn of a frogfish, the mating dance of a pair of mandarinfish, or finding a cardinalfish with a mouthful of eggs. Sometimes you can plan to

BELOW: Some behaviour images are sheer luck, like finding a mating pair of Greater Blue-ringed Octopus.

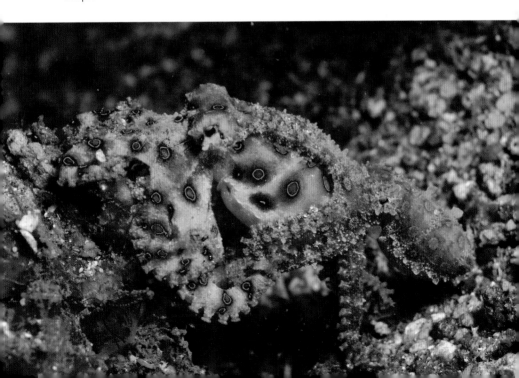

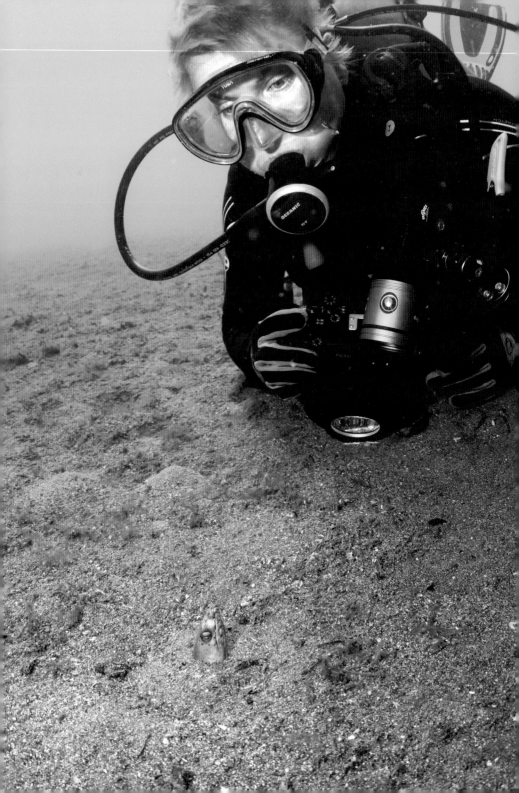

capture behaviour, but many of the best behaviour photos are simply a matter of being in the right place at the right time with the right camera set-up.

CRITTER CARE

Please don't destroy what you came to enjoy. Many muck critters rely on camouflage for survival, and underwater photographers blasting them with their strobe can alert predators to their location. So be mindful of this at all times, as you don't want to see that little commensal shrimp you are photographing get snapped up by a passing fish.

Don't harass the critters. Don't touch them, poke them, move them or pick them up. Good guides might gently manoeuvre a critter for the photographer, but bad guides will break coral and poke the critters into submission. Please tell them not to do this, and don't do it yourself. If you can't get the photo you want because the critter is not co-operating, then too bad, you will just have to hope that you get another chance in the future. It's not the end of the world for you, but it might be for the critter that you are harassing!

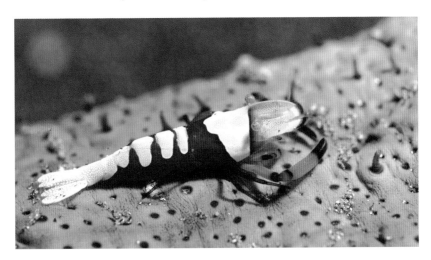

OPPOSITE: Always take care when settling on the bottom as many critters, like snake eels, live in the sand.

ABOVE: Imperial Shrimps often live on sea cucumbers, sometimes riding on top, but also on the underside of the animal.

Also be aware of sensitive animals. Most critters are unaware and unaffected by strobes blasting them, but creatures such as seahorses are greatly affected by the light and attention. So be considerate, turn down the strobe power and only shoot a limited number of images. A little critter care will ensure that all involved in the encounter will come out healthy at the end.

COMPOSITION

The difference between most good and bad images is not directly related to the cost of the camera system, but the composition by the photographer. Some basic rules of composition can help anyone get good images in the muck environment.

Firstly, get close to your subject and fill the frame. By reducing the distance between the subject and camera you reduce the chances of backscatter, your strobe will be more effective, meaning more colourful images, and the subject will have far more impact.

Shoot at eye-level and ensure that the eye is in focus. Avoid photographing subjects from above or behind. Eye contact with the subject will engage the viewer. Of course not all muck critters have eyes, so in that case find what looks like a head and work with that.

Use the rule of thirds. This is a basic rule of composition, but it works well. Divide your image into thirds and always try to align an eye, or fin, or claw, on these third points. Also try and photograph the subject coming into the image, rather than exiting, as it will engage the viewer more.

One thing you should also consider when taking photos in a muck environment is the background behind or around the subject. Many camouflaged critters blend in with the background, so can be difficult to see, but also the background can be distracting if it is more prominent than the main subject. Reducing background clutter can be done in a number of ways. Fill the frame with the subject, so reducing the amount of background in the image, play around with your f-stops and shutter speed to reduce your depth of field or darken the background, or use a snoot to only light the subject.

OPPOSITE: A black background is always a pleasing composition and makes the subject, like this Xeno Crab, more prominent.

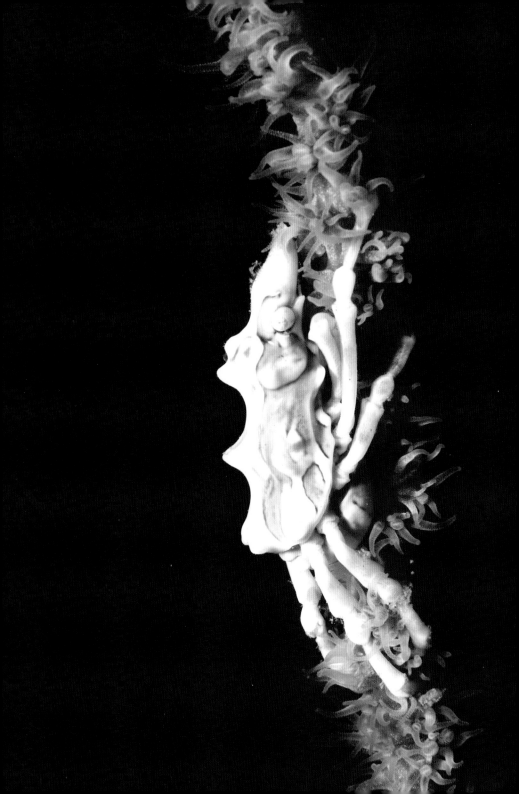

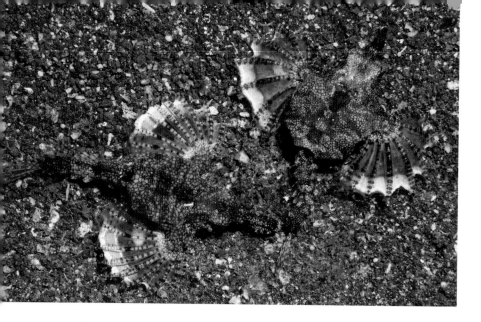

ABOVE: Some critters call for unconventional compositions, like this aerial view of a pair of Pegasus Seamoths.

And be warned, your muck dive site may be a garbage dump. Litter is a major problem in many Asian countries, and muck sites are often strewn with plastic bags, tins, cans, fishing line and other rubbish. Some of this litter becomes a home for critters, but it doesn't look the best in the background of your images, so pick up what you can and remove it from this unique environment.

CAMERA ETIQUETTE

It is great when you get a muck site all to yourself and you can photograph the critters at your own pace. But at the more popular muck diving locations you will often have to share the site with other divers wanting to photograph the same species. This is when a little camera etiquette comes into play. Here are a few simple suggestions to ensure that everyone gets great critter images.

First in, best dressed. The first photographer on a subject has right of way. Don't push in and start taking photos. In the past I have had photographers elbow me out of the way and stick their camera right in front of me. This is rude and unwarranted. Muck critters are slow-moving, so there is no need to hurry – just be patient and wait your turn. Most photographers will take a dozen or so images

and then wave you in when they have finished. Of course some people are critter hogs and will spend the entire dive photographing one animal. If you come across one of these, just move on, there are plenty of other critters to photograph.

If diving with a group of photographers, take turns in photographing a critter, or with prior agreement position yourself so two or three photographers can photograph the same subject from different angles without getting in each others' way. It can be quite easy to share a critter with other photographers so everyone comes away happy.

Photographers should also be mindful of their fins and hands stirring up the silt. When you have finished photographing a subject, gently lift off the bottom so the next photographer doesn't find the critter swallowed up in a cloud of silt. Good buoyancy control is essential for underwater photography while muck diving, so ensure you have mastered it.

Finally, don't get stuck behind your camera and miss the experience – occasionally lower the camera and enjoy observing the incredible critters that reside in the world of muck.

BELOW: While it is great to get close-up images of critters, also look at their setting, as a good background can make for a better composition, like this Zebra Crab on a Variable Fire Urchin.

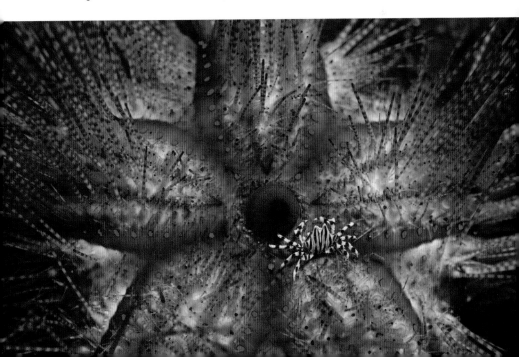

INVERTEBRATE MUCK CRITTERS

Feather Star Shrimps are just one of the critters that reside on feather stars.

The big attraction of muck diving is without question the weird, wonderful and sometimes bizarre critters that inhabit this realm. Without these fantastic critters, muck diving would be pretty dull.

An amazing variety of marine creatures can be found in the world of muck. Where else can you see an octopus that mimics other marine life, or a shrimp with claws that snap so hard and fast that they can crack glass, or a worm with a jaw like a rabbit trap? Since muck diving came into vogue, many new species have been discovered in this soft bottom environment, and many more are just waiting to be found.

While some species that inhabit coral reefs also reside in muck, this environment has many critters that are found nowhere else. In the follow pages is a guide to the main invertebrate muck critters that divers will encounter in both tropical and temperate seas.

CNIDARIANS

The cnidarians are a group of invertebrate animals that all have one thing in common – they all possess stinging cells that are used to capture prey. These simple creatures all have a basic structure consisting of a flower-like polyp. This massive family contains over 10,000 species and includes the corals, sea jellies, sea anemones and sea pens.

CORALS

Many divers on their first muck experience are surprised to discover how much coral grows in this soft bottom habitat. Many coral species thrive in the muck environment, attaching to rocks, rubbish or just emerging from the sand. Beautiful soft corals and black corals particularly flourish in this habitat, and can cover the sandy seafloor at some sites. These corals may look pretty, but they also provide a home and food to many muck critters, including commensal shrimps, coral shrimps, decorator crabs, spindle cowries, brittle stars, nudibranchs, coral crabs, gobies, seahorses, pipefish, shrimpfish and many other species. So always have a close look at the corals when muck diving.

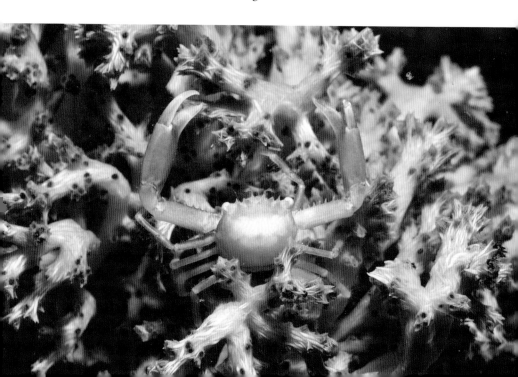

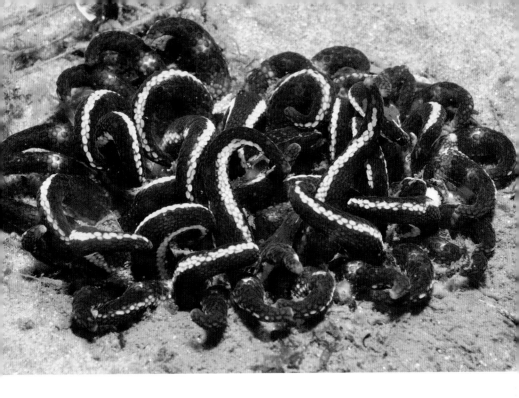

SEA ANEMONES

A wide variety of sea anemones are found in muck environments. These vary in size from over a metre wide to only a few centimetres. The most obvious sea anemones are the larger species that provide a home for those cheeky clowns of the sea, anemonefish. Numerous anemonefish species can be found in muck environments, living in a symbiotic relationship with their sea anemone. They both benefit from this relationship, the anemonefish getting a sheltered home safe from predators, but they also fiercely protect the sea anemone from its own potential predators, such as turtles. But anemonefish are not the only animals that seek shelter amongst the tentacles, as many other fish species, shrimps and crabs also use this trick.

While the sea anemones occupied by anemonefish are found on rock, coral and sand, the soft seafloor also provides a habitat for many other sea anemone

OPPOSITE: Always check the corals when muck diving, as many small crabs use corals for shelter.

ABOVE: Armed sea anemones are only found in sandy environments.

47

species. Tube anemones emerge from a tube-like tunnel, stinging anemones look like giant flowers, and the armed anemones wouldn't look out of place in the film *Avatar*. Many of these anemones also attract lodgers such as commensal shrimps and commensal crabs.

While most sea anemones are fixed to the bottom, some are detached by muck critters to be used for personal defence. The Anemone Hermit Crab (*Dardanus pedunculatus*) likes to attach sea anemones to its mobile home to deter predators. Even more bizarre is the Boxer Crab (*Lybia tessellata*), which attaches sea anemones to its claws, making them look like boxing gloves.

SEA JELLIES

Sea jellies (or jellyfish) are not common in muck environments, but one genus that does regularly appear in this habitat is *Cassiopea*, the upside-down jellies. These bizarre members of the sea jelly family seem to think they are sea anemones, as they like to spend their time upside-down with the bell on the bottom and the tentacles waving about. At least eight species of upside-down jellies are found in tropical waters around the world, and they all seem to prefer habitats of mangrove, seagrass and muck.

OPPOSITE: Tiger anemones are sometimes found in muck environments growing on sea whips.
ABOVE: Upside-down jellies often get commandeered by Carrying Crabs.

ABOVE: Sea pens come in a wonderful variety of shapes and colours.

If you find one of these strange sea jellies gently flapping on the bottom, but not moving much, take a closer look as it may be held by a carrying crab (*Dorippe* sp.). These crabs like to carry sponges, sea urchins, sticks, leaves and also upside-down jellies on their back as a form of protection. A number of small crabs and shrimps also reside on upside-down jellies, so don't swim by without having a closer look at these unusual critters.

SEA PENS

Sea pens are the only cnidarians that are found exclusively in muck environments, as they only live in sand and silt. Sea pens are colonial animals, made up of multiple polyps. These pretty creatures are found around the globe in deep and

shallow water. Sea pens come in a variety of colours, shapes and sizes. The largest are 2m tall, but most seen in the muck environment are less than 40cm high.

Sea pens anchor themselves in the sand with a root-like foot called a penduncle. The feather-like portion above the sand filter-feeds on passing plankton. These unusual creatures pump themselves full of water to remain erect, and can expel water and retract into the sand when not feeding. Sea pens, like all cnidarians in the muck environment, play host to a wide range of critters. Little porcelain crabs often pack onto them, turning the sea pen into a crab apartment block. Other common critters found on sea pens are spider crabs, commensal shrimps, gobies and marine worms.

MARINE WORMS

On land most people don't give earth worms a second look if they stumble across one in the garden, however their marine cousins are incredibly diverse and colourful, and always worth a closer look.

FLATWORMS

Flatworms are a very diverse group of marine worms with over 20,000 species found on land and water. The marine flatworms that divers see on coral reefs and muck environments are a colourful bunch, and it is hard to reconcile that they are in the same family as tapeworms, liver flukes and other parasitic worms.

Marine flatworms belong to a group called the polyclads and are found in oceans around the world in all marine environments. Several hundred species of these colourful worms have been described, and new ones are being found all the time. Most are less than 10cm in length. These flat-bodied creatures have no internal organs, their bodies are made up of tissue only. They use a diffusion process to convey nutrients and waste between cells, and have no circulatory system.

All flatworms are hermaphrodites, and sex between these critters can be very bizarre, with some species having a sharp penis which they spear into the body of their mate to inject sperm. The diets of flatworms are varied – some are predators,

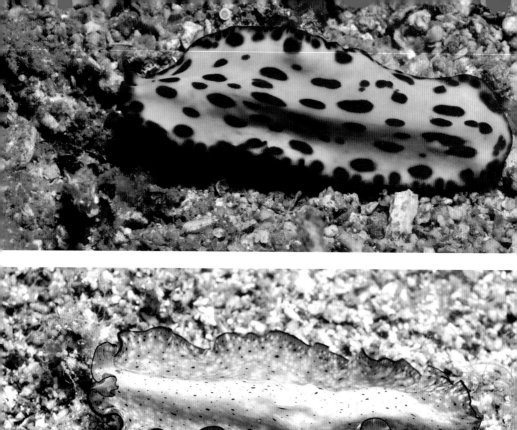
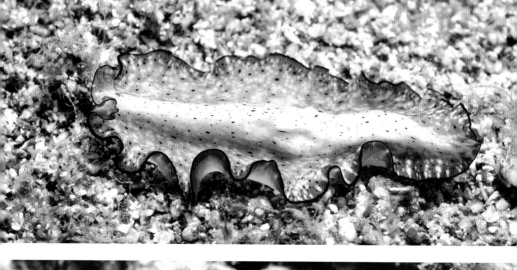
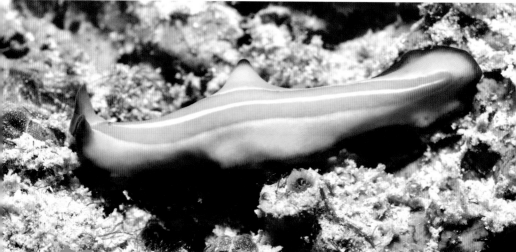

Flatworms are very colourful critters, with the three illustrated just a sample of the species. At the TOP is a Purple-spotted Flatworm (*Pseudoceros* sp.), in the MIDDLE is a Damawan Flatworm (*Pseudobiceros damawan*), while the BOTTOM one is a Susan's Flatworm (*Pseudoceros susanae*). BELOW: Colourful Christmas tree worms often cover coral heads.

others are scavengers, while some are vegetarian and feed only on algae. Many flatworms are toxic and have bright colours to warn fish not to eat them. Other species have taken to mimicking the colours and patterns of toxic nudibranchs in order to make sure they are not consumed.

While flatworms come in just about as many colours as nudibranchs (a family of creatures they are often confused with), they are far more cryptic and harder to find. Some species of flatworms are found out in the open during the day, while others only emerge at night, but some are never seen unless you lift up rocks or dead corals to find where they live. In muck environments flatworms can make an unexpected appearance at any time.

TUBEWORMS

Tubeworms are a common sight in muck environments, with their bushy fan-like heads seen sprouting out of coral, rocks and the sediment. These unusual worms live their entire life in a tube or tunnel, with only their bizarrely shaped head exposed. Most tubeworms feed on plankton that lands on their head, and being

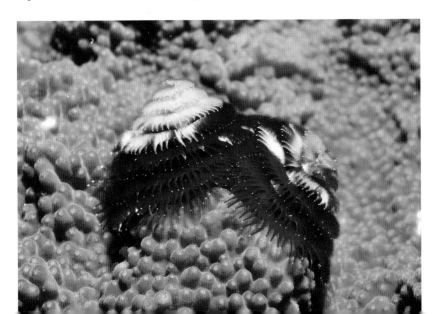

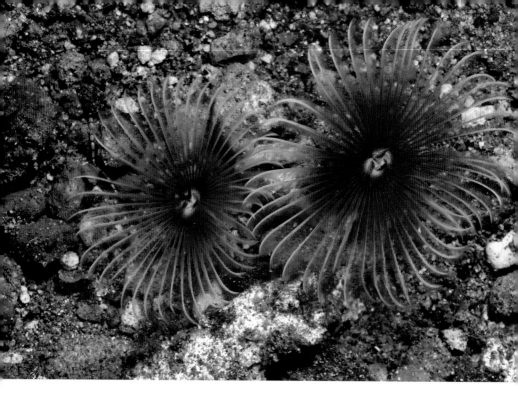

ABOVE: Red Tubeworms are best found at muck sites.

a popular meal for many fish, they rapidly withdraw into their tube whenever a shadow passes overhead. Tubeworms belong to a group known as polychaetes – a family that contains over 10,000 species.

The best-known tubeworms are the fan worms or feather duster worms, which come in a range of colours and sizes. The very colourful Christmas tree worms (*Spirobranchus* sp.) are often found in large colonies covering coral heads. Other fan worm species are more common in muck habitats, such as the Red Tubeworm (*Serpula vermicularis*). One very striking tubeworm seen in muck is the Honeycomb Worm (*Lygdamis splendidus*), which has two claw-like fans for catching food.

While muck diving in Australia always check the sand as you may find a Giant Beach Worm (*Australonuphis teres*). These impressive creatures grow to a metre in length and have claw-like arms that they use to feed on dead fish and other carrion.

BOBBIT WORM

Most tubeworms are colourful, but a little dull, but there is one member of this family that is quite fearsome and spectacular – the mighty Bobbit Worm (*Eunice aphroditois*). Reaching a length of 3m, these predatory polychaete worms live in the sediment in burrows, with only their head, antennae and massive jaw exposed.

Found in tropical seas around the globe, Bobbit Worms are ambush predators and have powerful jaws that open like a rabbit trap, waiting to snap closed on unsuspecting prey. They feed on fish and worms that come within striking distance, and have been known to cut prey in half with one snap of their jaw. They are also known to scavenge food, and will even consume seaweeds and algae if hungry.

Little is known about the biology and behaviour of these spectacular worms. They are broadcast spawners, releasing eggs and sperm into the water, and it is suspected that they breed at an early age, when only 10cm in length. They have

BELOW: The Honeycomb Worm has two claw-like fans to capture food.

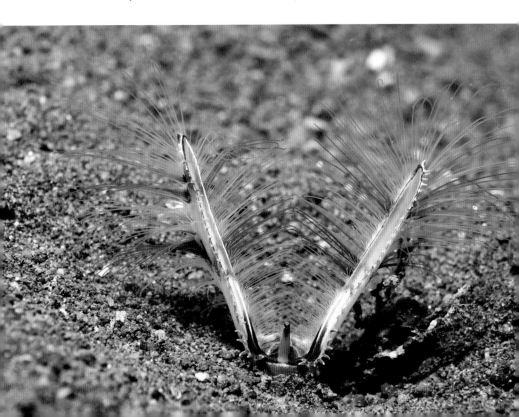

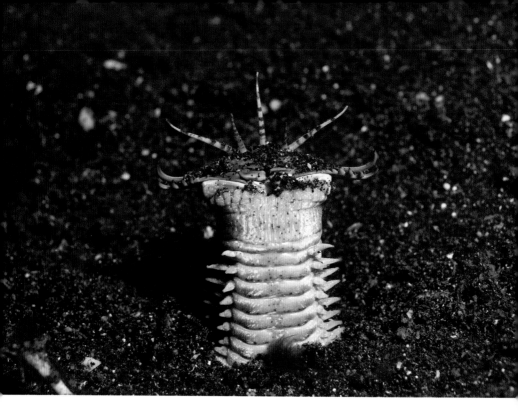

ABOVE: The Bobbit Worm emerges at night to grab fish and other prey.

a yellowish-brown base colour, with a shear skin that is iridescent and shimmers with a rainbow of colours.

Bobbit Worms are very popular photographic subjects and are best observed at night. At some muck diving destinations the local guides feed these worms, giving divers a glimpse of the attacking speeds of these fierce predators of the sand.

FIREWORMS

Another group of polychaetes contains the most dangerous worms of the muck environment – the fireworms. These distinctive worms have very fine bristles – hence their other common name of 'bristleworms' – that run along their bodies that are extremely painful, and difficult to remove, if they pierce a diver's skin.

Around 120 species of fireworms have so far been discovered in the world's oceans. These vary in length from a few centimetres to over 60cm. These bizarre-

looking creatures are scavengers that feed on any dead animal they come across, although some species also feed on corals. Fireworms possess no teeth or jaws – instead they have a rasp-like lower throat that can be extended like a tongue to tear flesh from the objects they feed on. Fireworms reproduce either sexually, by releasing eggs and sperm into the water column, or asexually, by an individual dividing to form two new animals.

As mentioned above, these creatures are well armed with rows of needle-like bristles. These bristles are designed purely for defence, mainly to stop fish eating them, and are engineered to irritate rather than kill. The sting is extremely irritating, with the wound swelling and itching for hours. Fireworms live in all marine environments and are generally nocturnal, so rarely seen during the day. In muck environments fireworms live in the sand and under rubble or rubbish, while some species reside on other animals such as sea urchins and sea cucumbers. The most common species seen by divers is the Golden Fireworm (*Chloeia flava*), which has pretty eye patterns across its back.

BELOW: The Golden Fireworm is a spectacular muck critter.

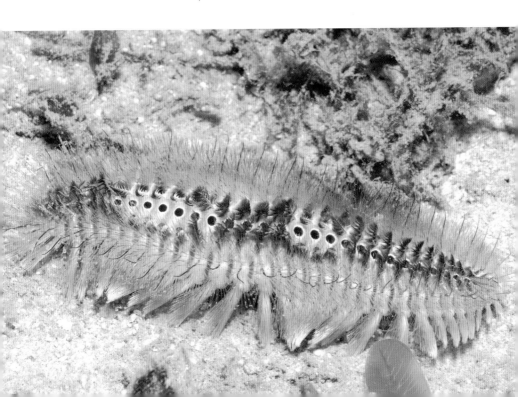

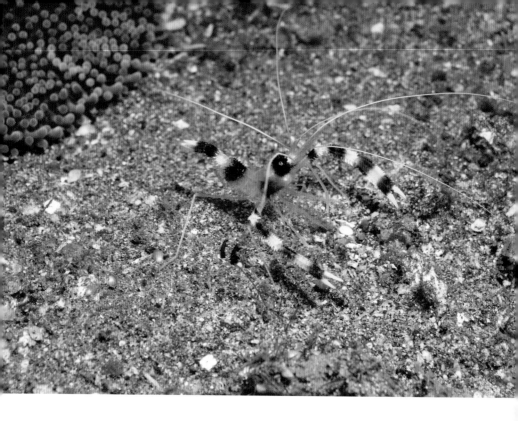

ABOVE: The Banded Boxer Shrimp is very common at muck sites.

SHRIMPS

The shrimp family is part of an incredibly diverse range of creatures known as crustaceans, which contains over 67,000 species. While they vary in size and appearance they all have a few things in common; their bodies are protected by a hard armour-like outer casing (exoskeleton) and they all have jointed legs. Shrimps are particularly common in muck environments, and the family contains many photogenic members.

BOXER SHRIMPS

The Banded Boxer Shrimp (*Stenopus hispidus*) is one of the most common shrimp species found in all marine habitats in tropical seas. These pretty shrimps, with their distinctive red and white bands, are usually found in pairs and prefer to

shelter in holes amongst coral, rocks or debris. There are actually a number of species of boxer shrimps found in tropical seas and they are all thought to provide cleaning services to fish. To attract customers, boxer shrimps sit at the entrance to their home and wave their antennae. Because they provide this invaluable service boxer shrimps are generally not preyed upon by fish, but lionfish don't always follow the rules and have been seen snacking on them.

CLEANER SHRIMPS

Many shrimps provide a cleaning service to fish, but the one with the most customers tends to be the White-banded Cleaner Shrimp (*Lysmata amboinensis*), which is also known as the Scarlet Cleaner Shrimp. These hard-working shrimps are found in tropical waters throughout the Indo-Pacific region and often set up shop in muck environments. With a characteristic white stripe down their back, they are usually found in groups and often have fish queuing up to be cleaned.

BELOW: A White-banded Cleaner Shrimp waiting for customers.

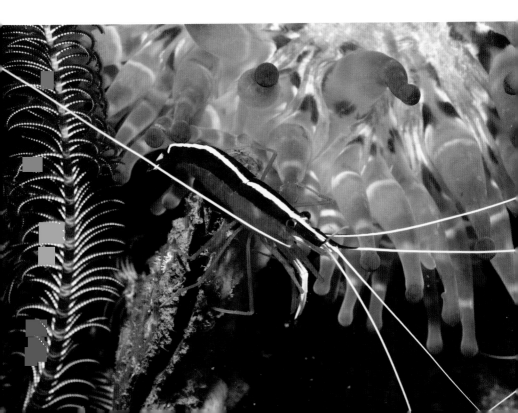

The shrimps gamely climb all over fish, and enter their mouth and gills to remove parasites, old skin and even food particles stuck between the teeth. These shrimps are often found sharing a home with moray eels, which tend to monopolise their cleaning services. Other members of the genus *Lysmata* also perform cleaning duties, but are not quite as obvious.

CORAL SHRIMPS

Found living on black corals and seagrasses, coral shrimps are extremely well camouflaged and often difficult to find without the aid of a dive guide. Around a dozen species of these bizarre elongated shrimps have so far been discovered, but many more probably exist and have been completely overlooked. The most common member of this family found in muck environments is the Sawblade Shrimp (*Tozeuma armatum*), which is also known as the Banded Gorgonian Shrimp.

BELOW: Sawblade Shrimps are keenly sought by photographers.
BOTTOM: Coral shrimps (*Tozeuma* sp.) can be found on seagrass and corals.

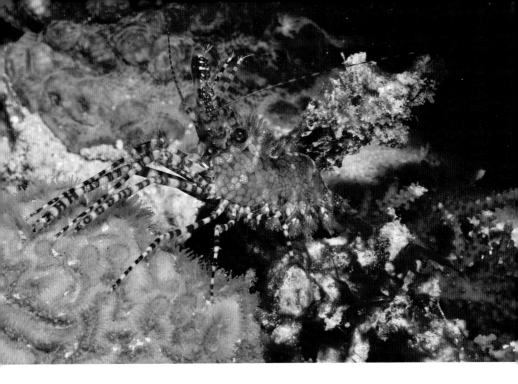

ABOVE: Marble shrimps (*Saron* sp.) are very shy and only seen at night.

The Sawblade Shrimp is found in tropical waters of the Indo-West Pacific and grows to a maximum length of 5cm. Long and thin, with an extended rostrum (nose), it has a transparent body decorated with colourful bands that usually match the pattern and colour of its host coral. These shrimps are keenly sought by underwater photographers, but it does require a bit of effort to find them. If in the area, the dive guides will often know where to find these fabulous shrimps, as they fortunately tend to occupy the same coral for months at a time.

MARBLE SHRIMPS

Marble shrimps are one of the most colourful families of shrimps and highly prized photographic subjects, but they only emerge at night and are very camera shy. Partly covered in hairy filaments, many species of marble shrimp have been discovered in the tropical waters of the Indo-Pacific region. Most only grow to around 4cm in length, but larger species can reach twice this size. Marble shrimps are more common on coral reefs, but are often found amongst rubble in muck

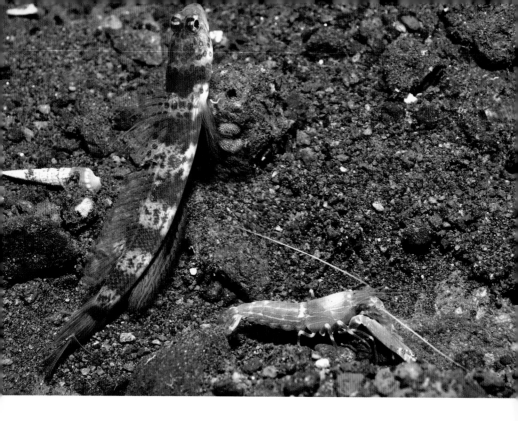

ABOVE: The Fine-striped Snapping Shrimp (*Alpheus ochrostriatus*) shares accommodation with the Double-barred Shrimpgoby (*Amblyeleotris periophthalma*).

habitats. They are also very wary of strong torchlight, so a red filter is often used by underwater photographers to get close to these very colourful critters.

SNAPPING SHRIMPS

Snapping shrimps have powerful claws that are quite audible underwater when they close with a resounding snap! Members of this family are often found sheltering on feather stars, but the most obvious ones in the muck environment are those that share a home with shrimpgobies. One of the most unusual behaviours that divers can observe while muck diving is the odd-couple arrangement of the shrimpgoby and snapping shrimp. This pair have a very unique symbiotic relationship, sharing a hole in the sand, with the shrimps providing cleaning and repair duties on the home, while the gobies keep an eye out for predators. In most

of these relationships there will be a pair of gobies and a pair of shrimps, but single couples are also observed.

There are many species of shrimpgobies and snapping shrimps that share this strange relationship, and they are very common at muck sites in the Indo-Pacific region. Photographing these snapping shrimps in action is difficult at times. While the shrimps can be preoccupied shovelling sand out of the home, the ever-watchful gobies are more nervous, and with a simple flick of their tail the shrimps will disappear into the safety of the home.

ROCK SHRIMPS

Rock shrimps are often mistaken for the more common commensal shrimps, and they are very closely related, with many rock shrimps found living in commensal relationships with sea anemones. The main difference between these families is

BELOW: The Pretty Snapping Shrimp (*Alpheus bellulus*) lives with the Diagonal Shrimpgoby (*Amblyeleotris diagonalis*).

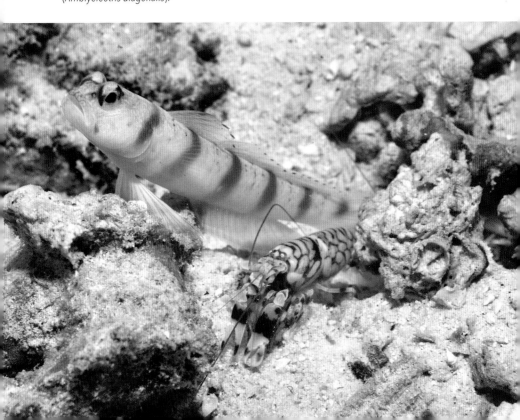

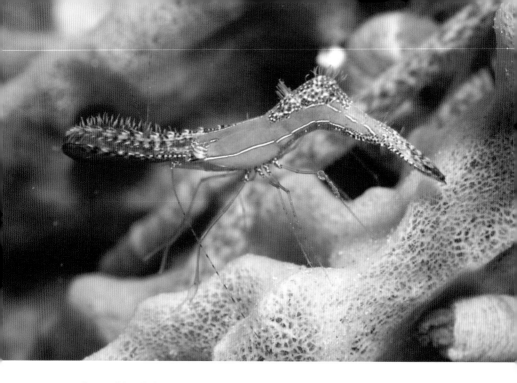

ABOVE: The Donald Duck Shrimp is hard to find, but a wonderful muck critter.

that rock shrimps are more common in temperate waters and they also tend to have a much longer rostrum. Many rock shrimps also have transparent bodies and members of this family are known to clean fish and moray eels.

Numerous rock shrimp species are found at muck diving sites in tropical and temperate seas, but they are easily overlooked, especially as the ones with transparent bodies are difficult to see. The easiest ones to find are the ones that clean fish, as they set up a cleaning station on a rocky patch. One member of this family that is worth looking out for is the very pretty Donald Duck Shrimp (*Leander plumosus*). This beautifully patterned shrimp is also commonly called the Long-nose Shrimp, as it has an extremely long rostrum. Only discovered in 1994, this species grows to 3cm long, but is often very difficult to find due to its habit of sheltering under rocks and debris during the day.

The most common member of this family found in the temperate waters of southern Australia is the Rock-pool Shrimp (*Palaemon serenus*), which can reach a length of 6cm. This species is common under jetties, and unlike many other

shrimps it doesn't shy away from divers and will sometimes even climb onto the camera of a diver attempting to take a photograph.

COMMENSAL SHRIMPS

This is a large family of shrimps, with close to 1,000 species. They are always found living in commensal relationships with other species. Commensal shrimps are found on sea anemones, soft corals, sea pens, feather stars, sea cucumbers, sea stars, basket stars, sea urchins, sea whips and even nudibranchs. These pretty little shrimps are rarely more than 2cm long and very common in muck environments.

BELOW: The Tosa Commensal Shrimp (*Periclemenes tosaensis*) is common on corals and anemones.

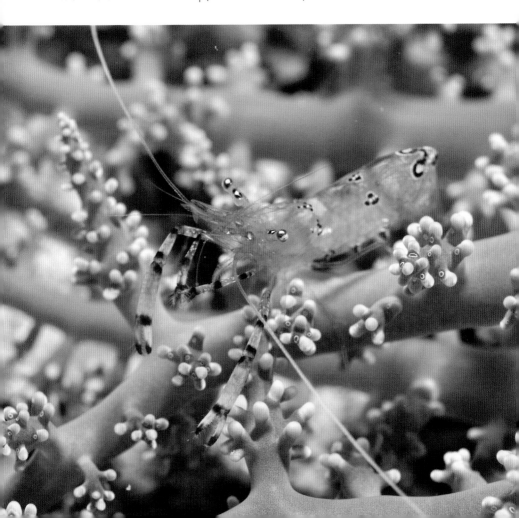

COLEMAN'S SHRIMP

One of the most stunning commensal shrimps found in muck environments is the Coleman's Shrimp (*Periclimenes colemani*). First discovered by renowned marine naturalist, the late Neville Coleman OAM, these tiny red-and-white shrimps live almost exclusively on Variable Fire Urchins (*Asthenosoma varium*). Growing to a length of 2cm, these attractive crustaceans are always found in pairs, with a larger female and her smaller male partner. The shrimps clear a patch on the urchin, by pruning off the spines, and live their entire life on this tiny cleared area. The urchin gets no benefit from this association, but the shrimps create a secure home which is safe from predators. Coleman's Shrimps feed on algae and plankton that washes into their fortress home.

BELOW: A beautiful pair of Coleman's Shrimps.

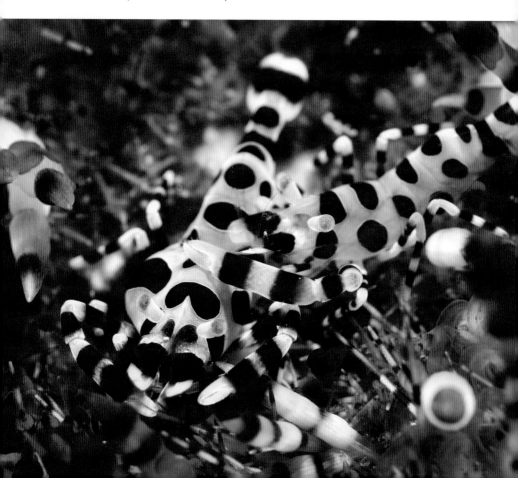

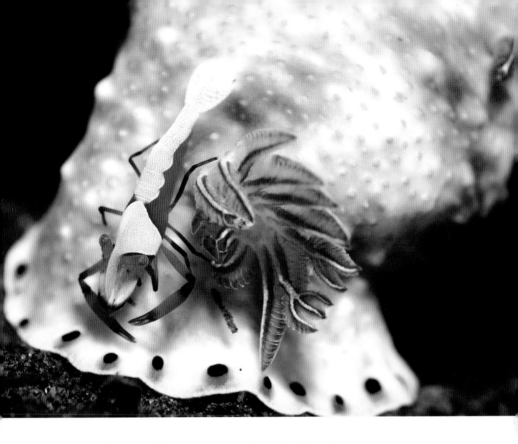

ABOVE: Look for Imperial Shrimps on sea cucumbers and nudibranchs.

IMPERIAL SHRIMP

Another wonderful commensal shrimp is the colourful Imperial Shrimp (*Periclimenes imperator*), which also goes by the name of Emperor Shrimp. This very photogenic species is often found in pairs, usually on sea cucumbers and nudibranchs. Growing to a length of 3cm, they can sometimes be almost as large as the nudibranch they are riding. Found in tropical waters of the Indo-Pacific region, Imperial Shrimps have a lovely colour pattern of reddish-orange with white bands across the back. Similar to other commensal shrimps they feed on algae and plankton, but they will also consume the faecal matter of their host. A good guide is often required to find Imperial Shrimps, as they often hide on the underside of sea cucumbers. The most photogenic ones are found on nudibranchs, with the colour of both species combining to make for stunning images.

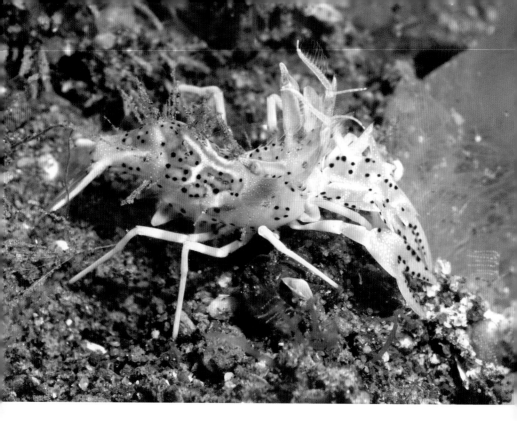

ABOVE: Tiger Shrimps are rare at most muck sites.

BUMBLEBEE SHRIMPS

This small family of shrimps contains some very small members that are usually difficult to find without the assistance of a good guide. Bumblebee shrimps are a group of tiny colourful shrimps that generally live under rocks and coral rubble. The best-known member of this family is the Striped Bumblebee Shrimp (*Gnathophyllum americanum*), which has a distinctive black-and-yellow striped pattern similar to a bumblebee. These tiny shrimps grow to 2.5cm in length and are often found on echinoderms such as sea cucumbers. The most highly prized member of this shrimp family is the wonderful Tiger Shrimp (*Phyllognathia ceratophthalmus*). Only reaching a length of 2cm, Tiger Shrimps have a carapace covered in jagged spines. Bumblebee shrimps are not only difficult to find, but also very difficult to photograph, as they are tiny and don't like the light, so will quickly hide once uncovered.

HARLEQUIN SHRIMP

The most beautiful and photogenic of all the shrimps is without doubt the incredible Harlequin Shrimp (*Hymenocera picta*). Found in the tropical seas of the Indo-Pacific region, these lovely shrimps grow to 5cm in length and are always found in a male and female pair.

Harlequin shrimps are beautifully patterned, white with a covering of brownish-purple blotches with blue margins. These distinctive shrimps can never be confused with any other species as they also have wide flat claws and flag-like antennae. They reside in both reef and muck environments, and tend to make a home under dead coral or rocks, so are easily missed if you don't know where to look.

These beautiful shrimps feed exclusively on sea stars, and will even consume Crown-of-thorns if given the chance, although they prefer smaller sea stars which they can drag or carry into their home to be consumed at their leisure. Sea

BELOW: Harlequin Shrimps are cherished by all muck divers.

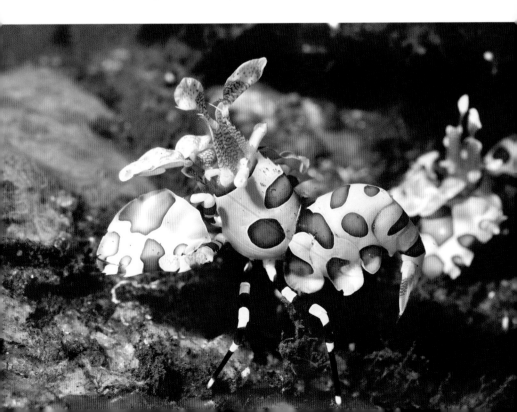

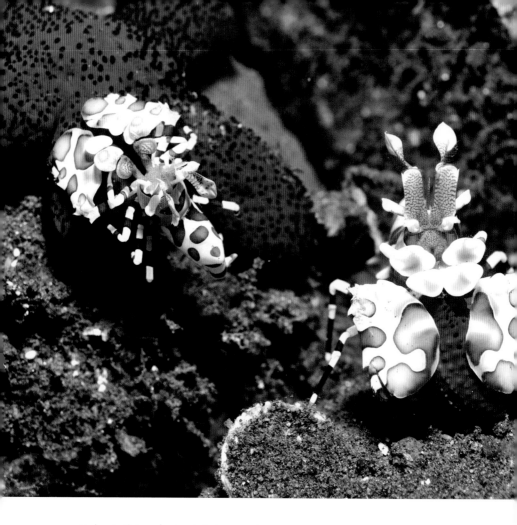

ABOVE: Harlequin Shrimps feed exclusively on sea stars.

stars often escape their clutches, with missing limbs, and a good indication that Harlequin Shrimps are in an area is if sea stars with missing legs are evident.

Harlequin Shrimps are muck diving stars, and if in the area every dive guide will know where they are living. The guides cherish these lovely little shrimps so much that they will often give them a sea star to feed on, so they don't have to venture from their home and are easier to find.

PRAWNS

Prawns look similar to a shrimp, and their names seem to be interchangeable in some cultures, but there are a few differences between these two creatures. Prawns are generally larger than shrimps, and many species are captured or bred for human consumption. Prawns have claws on their first three pairs of legs, while shrimps only have claws on the first two pairs. Prawns also have larger legs, and a more segmented body, with overlapping plates. They also have quite prominent eyes that are set on stalks. Prawns are also nocturnal, and spend the daylight hours hidden under the sand.

Many prawn species are seen in the muck environment, and some grow quite large, to over 30cm in length. The Tiger Prawn (*Penaeus monodon*) is a species that is sometimes found at muck sites throughout the Indo-Pacific region. These large prawns make for interesting photographic subjects, but don't expect them to sit still for too long, as when highlighted by a torch they either bury themselves in the sand or swim off with a snap of the tail. Smaller prawn species are far more photogenic, as they are more colourful and often not as shy.

BELOW: Tiger Prawns emerge at night, but are not seen at many muck sites.

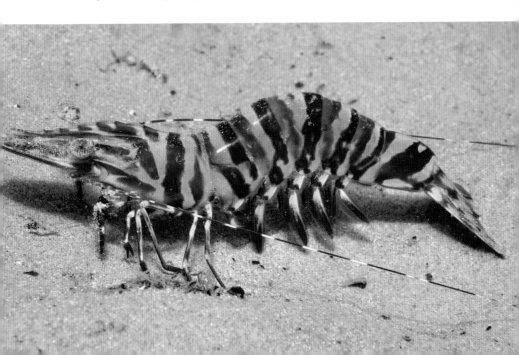

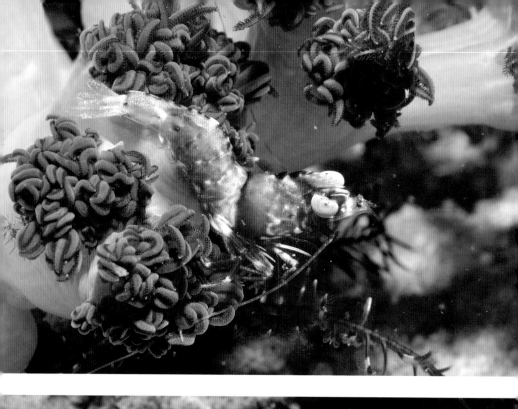

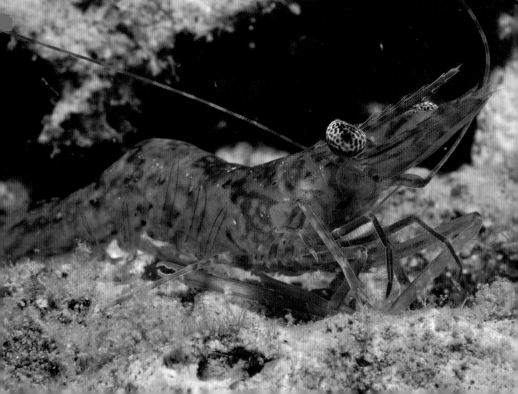

MANTIS SHRIMPS

They may have shrimp in the name, but mantis shrimps are a very different type of crustacean, and well represented in muck environments. Around 400 species of mantis shrimp have been described, with most found in the warm tropical waters of the Indo-Pacific region. These elongated shrimps have many features that set them apart from other crustaceans. Mantis shrimps have exceptional eyesight. Human eyes have three colour receptors, while mantis shrimps have 16 different colour receptors. Mantis shrimps also have some basic intelligence, they have a good memory and can learn simple tasks. They are long-lived, with individuals of some species living for 20 years, and also have complex social behaviour with each other. Mantis shrimps are split into two groups based on their type of claws – the smashers and spearers.

SMASHERS

Divers encounter many crustaceans while muck diving, but the only species with personality is the amazing Peacock Mantis Shrimp (*Odontodactylus scyllarus*). This species is the best-known member of the smashing mantis shrimp family, so named because their claws are club-like and can smash the shells of their prey.

The Peacock Mantis Shrimp is a common inhabitant of coral reefs and muck environments throughout the Indo-Pacific region. Growing to a length of 18cm, this species is easy to identify with its bright green body colour, red highlights around its legs, claws and armour and by its pink eyes. These curious crustaceans live in burrows, with several exits, and will often sit at the entrance in a praying mantis-like pose and watch the world go by. Peacock Mantis Shrimps are active by day and night, and will either ambush or hunt down prey. They feed on gastropods, crustaceans and bivalves, and smash their shells with the fastest recorded punch of any animal – 340 pounds of force per strike, which is enough force to break the glass of a fish tank!

OPPOSITE ABOVE: The pretty Humpback Prawn (*Metapenaeopsis lamellata*) is only seen once the sun sets.

OPPOSITE BELOW: Identifying prawn species is no easy task, as many species look similar.

Peacock Mantis Shrimps are a common species in muck environments and usually easy to find, but sometimes difficult to approach and photograph. They each seem to have their own personality, some shy, some very curious and some even aggressive. Photographers always enjoy interacting with Peacock Mantis Shrimps, but the big prize is to find a female carrying a clutch of eggs. Many other smashing mantis shrimp species are found in muck environments, but none are as commonly seen as this lovely species.

SPEARERS

A large circular hole in the seabed is usually the first evidence most divers see of one of the most unusual crustaceans, the spearing mantis shrimp. This family of shrimps have spear-like claws arrayed with sharp prongs, which they use to great effect to capture small fish and other shrimps.

Similar to their close cousins the smashing mantis shrimps, spearing mantis shrimps have great eyesight and watching their eyes move about independently of each other is always an unusual experience. Spearing mantis shrimps make circular tunnel-like homes in the sand and silt, and often sit at the entrance, waiting to ambush prey that gets too close. Their bodies are decorated with elaborate camouflage colours and divers often swim right past large spearing mantis shrimps without seeing them.

Many spearing mantis shrimp species are found in muck environments, but divers are most likely to see the biggest, the Zebra Mantis Shrimp (*Lysiosquillina maculata*). Found throughout the Indo-Pacific region, this massive shrimp grows to 40cm in length and can live in a hole 10cm in diameter. A guide is always handy to help find Zebra Mantis Shrimps, but if you do find an empty hole, tap near the entrance a few times and you might be surprised when a giant mantis shrimp rises to the entrance to investigate the noise.

OPPOSITE ABOVE: The most charismatic crustacean would have to be the Peacock Mantis Shrimp.
OPPOSITE BELOW: A large Zebra Mantis Shrimp peers from its home.

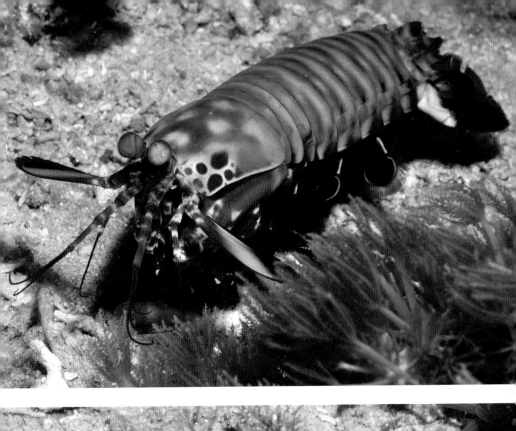

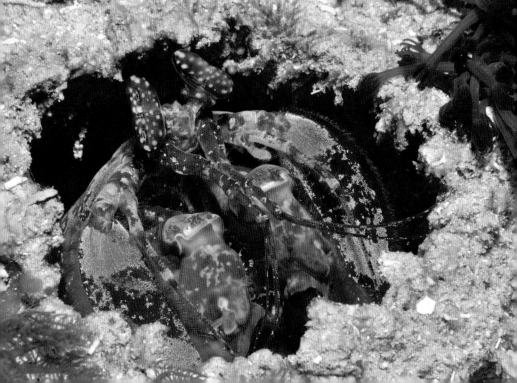

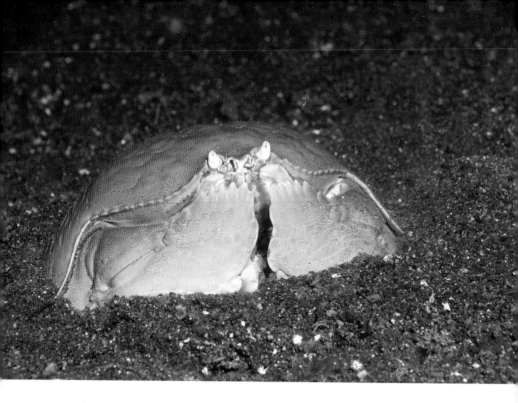

ABOVE: The Giant Box Crab (*Calappa calappa*) emerges from the sand at night.

TRUE CRABS

The crab family is quite extensive with over 7,000 members, however a number of other families of crustacean also carry the name crab, like porcelain crabs and hermit crabs, but they are not true crabs. True crabs have four pairs of walking legs, a hard exoskeleton and one pair of claws. They are a very diverse group of creatures, with species found living in water, on land or both. True crabs are omnivores and will feed on just about anything they can get their claws on.

BOX CRABS

Box crabs are kind of box-shaped, with a large box-like carapace. Around 43 species of box crab have been described, and most of these are found in muck environments as they like to bury themselves in the sand during daylight hours. They are also known as the 'shame-faced crab', because their claws fold up neatly

under their carapace hiding their face, like they are ashamed. These distinctive crabs are often found on night dives, and are hard to miss as larger species can be 15cm wide.

ROUND CRABS

Round crabs generally spend the day hiding in the coral or under rocks, and most species are not generally associated with muck diving. But one member of the family ventures into muck environments and is highly prized by underwater photographers, the beautiful Boxer Crab (*Lybia tessellata)*. These tiny crabs, rarely bigger than 1.5cm, are found throughout the tropical Indo-West Pacific, but are always difficult to find. Boxer Crabs have a striking colour pattern, but what makes them unique is what they stick on their claws – sea anemones. These tiny

BELOW: A tiny Boxer Crab displays its anemone gloves.

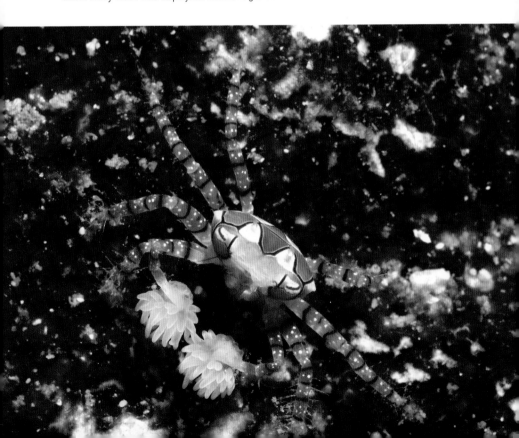

crabs attach a minute sea anemone to each claw, which makes them look a bit like boxing gloves. These are used for defence against potential predators. A good guide and a great deal of luck is required to find this bizarre critter.

ELBOW CRABS

With large claws and very prominent elbows it is easy to understand how this family of crabs achieved its unusual name. Elbow crabs generally live in the sand or under rocks, coral or rubbish during the day, emerging to scavenge for food after dark. These crabs are not common, but are seen every now and again in muck habitats. Smaller species in this family are easily overlooked, as they are usually very well camouflaged, but large elbow crabs are hard to miss with their oversized claws, and can be 20cm wide.

BELOW: A well-camouflaged elbow crab (*Daldorfia* sp.).

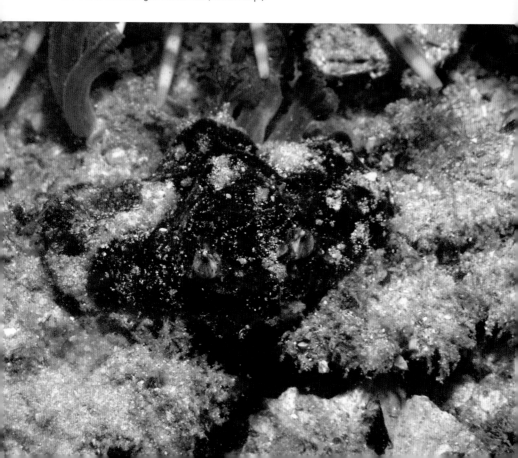

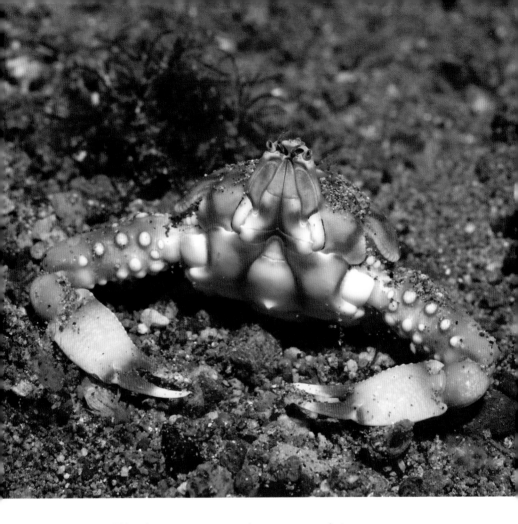

ABOVE: The pebble crab *Leucosia anatum* is rarely seen at most muck sites.

PEBBLE CRABS

Pebble crabs are small crustaceans with a very round, pebble-shaped carapace. This family of crabs contains around 70 members, which are mostly found in deeper water. Pebble crabs are usually no more than 3cm wide and like many crab species they are nocturnal, emerging from their hiding place in the sand after dark to feed. Pebble crabs have very small eyes, which are set close together on a raised section of the head. Most species also have very pretty patterns on their carapace, so are great photographic subjects.

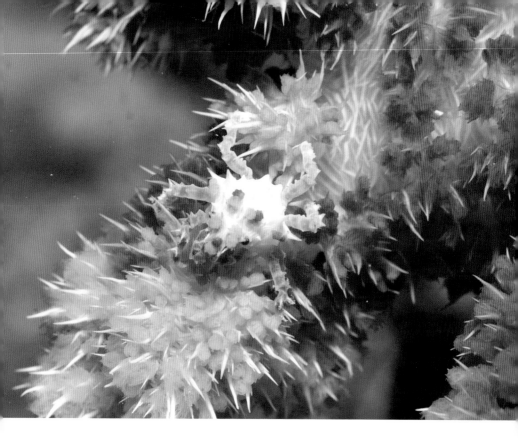

SPIDER CRABS

Spider crabs come in a wide variety of shapes and sizes, with the largest member of this family 4m wide! The species found in the muck environment are generally a lot smaller, and mostly found on corals. The Candy Crab (*Hoplophrys oatesii*) is a gorgeous small species that lives in soft corals. These well-camouflaged critters have body spines that match the texture of their host soft coral, which makes them difficult to spot.

Many other spider crab species reside on corals, including the Orangutan Crab (*Achaeus japonicus*). These delicate spider crabs are covered in orange hair that does look like the hair of an Orangutan. Found throughout the Indo-Pacific region, Orangutan Crabs are most often found on bubble coral and soft corals, which are more commonly found on coral reefs, but they also turn up in muck areas. Other spider crab species decorate their bodies with sponges and corals as a form of camouflage.

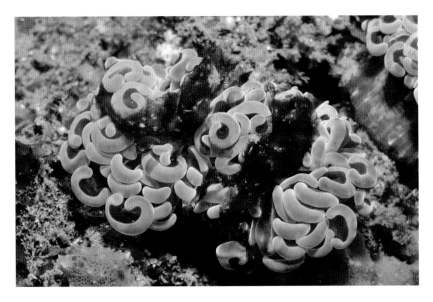

OPPOSITE: Soft corals are the best place to find lovely Candy Crabs.

ABOVE: A pair of hairy Orangutan Crabs.

BELOW: The Sponge Decorator Crab (*Hyastenus elatus*) is common at Australian muck sites.

Another spider crab species to look out for is the bizarre-looking Xeno Crab (*Xenocarcinus tuberculatus*), which is also known as the Wire Coral Crab. These tiny crabs live on black corals, gorgonians and sea whips and are rarely more than 1.5cm long. Xeno Crabs have an elongated snout and are extremely well camouflaged, with their colouration matching that of their host coral. Xeno Crab is another species prized by underwater photographers, so most dive guides know the best locations to find these strange little crustaceans.

SWIMMING CRABS

There are many species of swimming crab found in muck environments and they can be identified by the paddles on the ends of their rear legs. These are used for swimming, with many crabs in this family being very quick through the water.

BELOW: A Blue Swimmer Crab defends its meal.

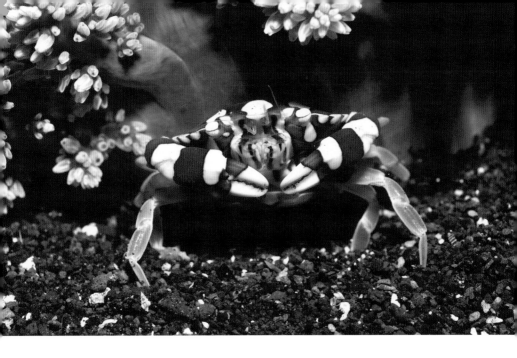

ABOVE: Harlequin Crabs are often found sitting at the base of anemones.

Larger members of this family are captured for human consumption, including the Blue Swimmer Crab (*Portunus pelagicus*), which is common throughout the Indo-Pacific region. A very photogenic member of this family is the Harlequin Crab (*Lissocarcinus laevis*), which is usually found hiding at the base of tube anemones. These beautifully coloured crabs, with their striking brown-and-white pattern, are rarely more than 4cm long.

CARRYING CRABS

Another crab species that is often seen while muck diving at night is the Carrying Crab (*Dorippe frascone*). Found throughout the tropical Indo-Pacific region, the Carrying Crab is very easy to identify as it will be carrying an object on its back. They use their rear legs to hold the item, which may be a leaf, stick, upside-down sea jelly, sea cucumber or sea urchin. These unusual crabs use the item they are carrying as a form of protection, but will also bury themselves in the sand if threatened. The Carrying Crab is a common species at many muck diving locations.

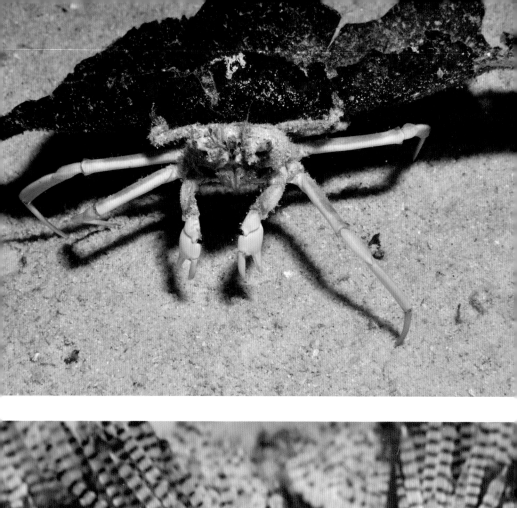

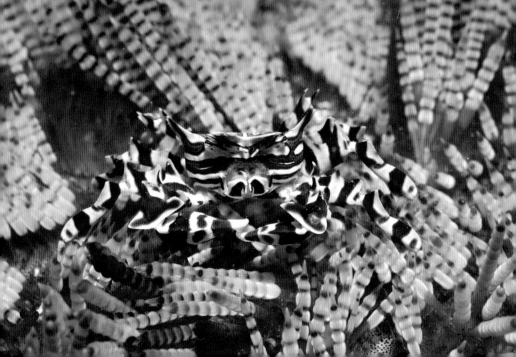

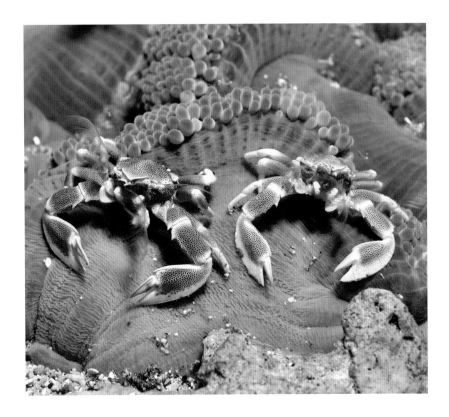

ZEBRA CRABS

This small family of crabs only contains three species, but the best known is the lovely Zebra Crab (*Zebrida adamsii*), which is found on sea urchins in tropical waters of the Indo-Pacific region. These beautifully coloured crabs, with their striking zebra-like stripes, only grow to 2cm wide. Usually found in pairs, Zebra Crabs have hooks on their back legs to anchor them to the spines of the sea urchin. A good guide is required to find these pretty crabs, as many sea urchins usually have to be lifted to find where they are hiding.

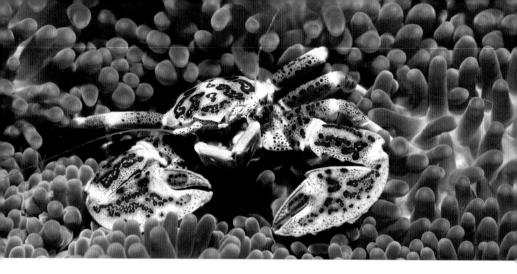

ABOVE: A Red-spotted Porcelain Crab in its sea anemone home.

PORCELAIN CRABS

Porcelain crabs are pretty little crustaceans, and although they look like a crab, they are not a true crab. Porcelain crabs are more closely related to squat lobsters, and only have three pairs of walking legs instead of four pairs like a true crab. Around 277 species of porcelain crab have been described, and they can be found in all marine habitats around the globe. These small crabs feed on plankton and capture these tiny food particles on modified jaw legs that are covered in fine brushes. Most species generally live under rocks and are rarely seen, but a few are commensal and encountered by divers.

Porcelain crabs are often found in muck environments. Small species live on sea pens and soft corals, but you may need a magnifying glass to see them, as they are usually less than a 1cm long. The most common porcelain crabs that divers see are the slightly larger species that live in sea anemones. The Red-spotted Porcelain Crab (*Neopetrolisthes ohshimai*) and Spotted Porcelain Crab (*Neopetrolisthes maculatus*) reside in anemones throughout the Indo-Pacific region. They look superficially similar, but the former is decorated with large red spots and the later has a covering of fine red dots. These pretty crabs reach a maximum length of 3cm and are often seen amongst the sea anemone tentacles waving their feather-like jaw legs to capture food.

HERMIT CRABS

Over 1,100 hermit crab species have been described, with this family of crustaceans common in all marine habitats and even on land. Hermit crabs differ from true crabs in having a soft spirally curved abdomen. To protect this soft underbelly, most hermit crabs use old shells as a home, but a few species also live in burrows (old worm holes) in hard corals.

Living in a mobile home means that hermit crabs regularly have to upgrade their shelter as they grow. Finding new shells can often be a challenge, and hermit crabs are known to fight over prized shells and will even pull other crabs out of their home.

Numerous hermit crab species are found in muck environments, but the most interesting would have to be the Anemone Hermit Crab (*Dardanus pedunculatus*), which likes to attach sea anemones to its shell to give it extra protection from predators. Although often seen during the day, hermit crabs are far more active at night.

BELOW: The Anemone Hermit Crab is a common muck critter.

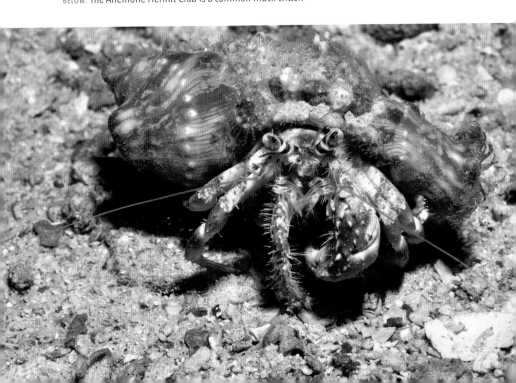

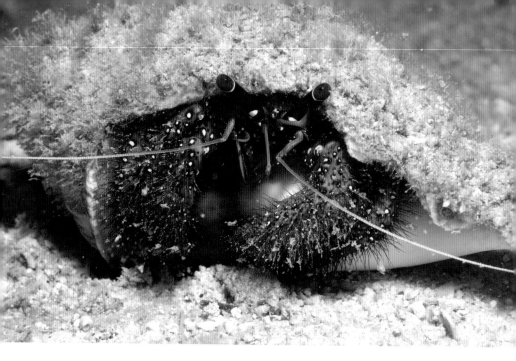

ABOVE: The White-spotted Hermit Crab (*Dardanus megistos*) is one of the largest members of the family.

BELOW: A Feather Star Squat Lobster defends its home.

OPPOSITE: The Hairy Squat Lobster is a marvellous little muck critter.

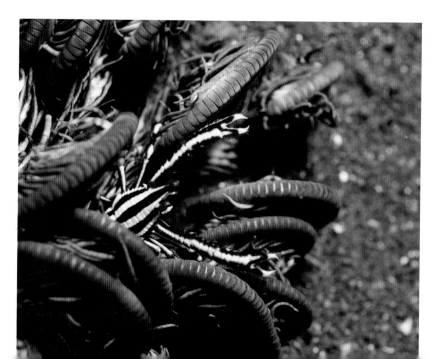

SQUAT LOBSTERS

Another pretty crustacean found while muck diving are tiny squat lobsters. Over 900 species are found in this family, and while they do look like a miniature lobster, with their oversized claws, they are more closely related to porcelain crabs. In muck environments squat lobsters are generally found living on corals, sponges and feather stars.

The Feather Star Squat Lobster (*Allogalathea elegans*) is only found living in feather stars in the Indo-Pacific region. Growing to 2cm in length, these well-camouflaged critters come in a range of colours and are great photographic subjects if they are sitting in the right position, which is not often the case when hidden amongst the arms of a feather star. A good guide will know where to find Feather Star Squat Lobsters and should be able to show you one without destroying the delicate feather star.

Barrel sponges are common at many muck sites in the Indo-Pacific region, and they provide shelter for many species, including Hairy Squat Lobsters (*Lauriea siagiani*). Pink with purple stripes, these colourful critters are covered in numerous sharp spines. Hairy Squat Lobsters are not difficult to find, but being only 1.4cm long they are tiny and often a challenge to photograph.

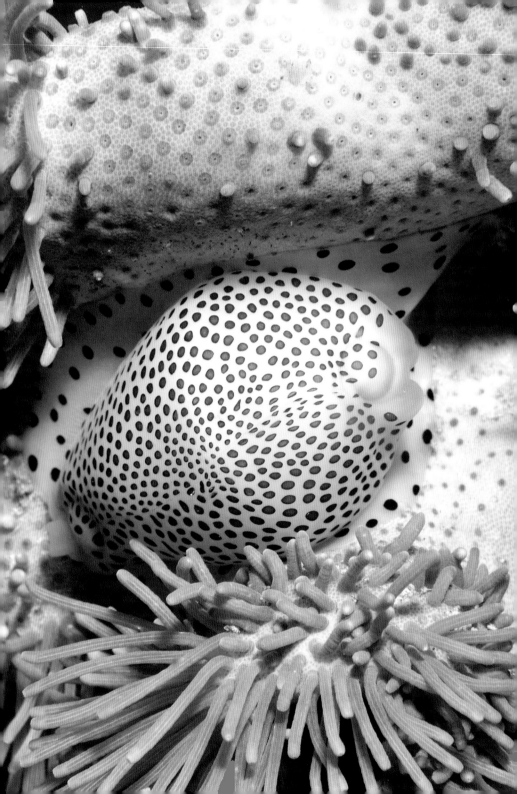

MOLLUSCS

There are nearly 100,000 species of mollusc. However, this group of animals is extremely varied as it includes the nudibranchs, sea hares, nautilus, octopus, squid, cuttlefish, chitons, gastropods and bivalves – creatures that really look nothing like each other. Members of this diverse group of invertebrates share universal traits, including a head with a mouth and sensory organs, a muscular foot and a mantle containing the stomach, excretory and reproductive organs.

Critters from the mollusc family are the star attraction at many muck diving sites, with divers going to the ends of the earth to see species of nudibranch, octopus, cuttlefish and squid. However, many beautiful shells are found in muck environments that are fascinating to observe and also very photogenic.

Shells are split into two classes – the gastropods, which commonly have a single shell, and the bivalves, which have two shells that open and close around a hinge. Of these two groups the gastropods are by far the more prolific and generally much more attractive. There are many different families of gastropods – cowries, cones, murex, helmets, volutes, strombs, winkles and whelks to name but a few. There isn't room in this book to look at all the family groups, so we will focus on just a few that muck divers will encounter and enjoy.

COWRIES

Cowries are without doubt the most beautiful of all the shells, as they have a mantle that extends over their shell that protects it from algae growth and keeps it very shiny. These lovely shells are so precious that they were used as currency in many cultures in the past. The cowry family contains over 250 species that are found in a wide variety of marine habitats, including many wonderful species seen while muck diving.

Larger species like the Egg Cowry (*Ovula ovum*), Tiger Cowry (*Cypraea tigris*) and Toe-nail Cowry (*Calpurnus verrucosus*) are commonly found on corals during the day. But other species like the Eyed Cowry (*Cypraea argus*), Tapering Cowry

OPPOSITE: Beautiful Toe-nail Cowries are best found on soft corals.

ABOVE: The Tiger Cowry is a common muck species.

(*Cypraea teres*) and Map Cowry (*Cypraea lynx*) only emerge at night. All of these species are egg-shaped cowries.

Some of the most exquisite cowries are the smaller species that live on the corals found in muck environments. Soft corals are often home to the tiny Dondan's Egg Cowry (*Serratovolva dondani*) and Whitworth's Egg Cowry (*Pseudosimnia whitworthi*) that have a similar mantle pattern to their host and are often less than 1.3cm long. Gorgonians, black corals and sea whips play host to wide variety of well-camouflaged spindle cowries. One very striking species that is well worth looking for is the Tiger Egg Cowry (*Primovula tigris*). This species is found on gorgonians and has bold black stripes on a yellow base, but only grow to 1.2cm in length. Port Stephens, a great muck diving site in Australia, is a great location to see several species of spindle cowry. One of the most commonly seen at this site is the spectacular Rosy Spindle Cowry (*Phenacovolva rosea*). Many smaller cowry species are difficult to find without the assistance of a good guide.

ABOVE: The wonderful Rosy Spindle Cowry is often found at Port Stephens, Australia.

BELOW: The Compressed Spindle Cowry (*Phenacovolva coarctata*) is a well-camouflaged species that lives on sea whips.

CONE SHELLS

Cone shells are another pretty group of shells that are often found in muck environments, but care should always be taken around this family of molluscs as they are quite venomous. Around 800 species of cone shell have been identified and all shoot venomous darts to stun their prey. During the day cone shells hide in the sand, but after dark they emerge to hunt prey such as small fish, marine worms and other molluscs. Many cone shell species have venom that is non-fatal to humans, but others are deadly, and over a dozen deaths have been attributed to these small shells. The best advice is to never touch any cone-shaped shell.

Some of the prettier cone shells that can be found in muck environments are the Geography Cone (*Conus geographus*), Music Cone (*Conus musicus*), Nusatella Cone (*Conus nusatella*), Princely Cone (*Conus aulicus*) and Textile Cone (*Conus textile*). All these species are found in the Indo-Pacific region and are very photogenic.

BELOW: The Textile Cone is a beautiful but deadly mollusc.

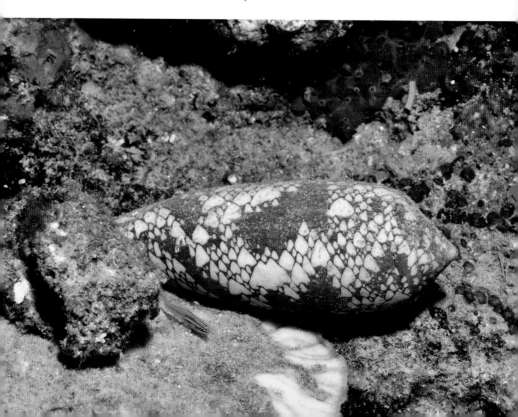

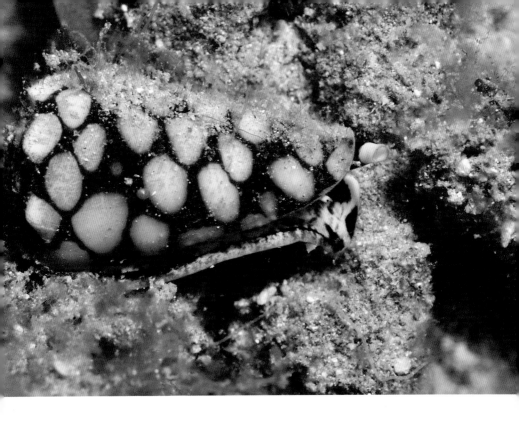

ABOVE: The Marble Cone (*Conus marmoreus*) is often found amongst rubble.

BELOW: A Monk Cone (*Conus monachus*) searching for prey.

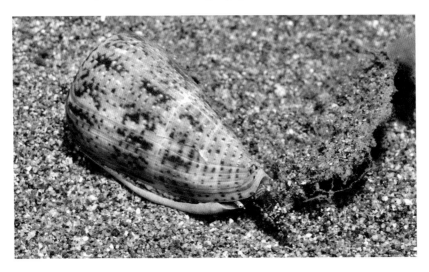

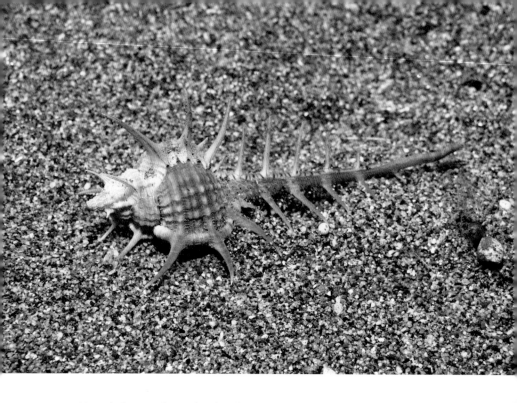

ABOVE: Murex shells are rarely seen, but the Caltrop Murex turns up at muck sites occasionally.

MUREX SHELLS

The most spectacular shells found in muck environments are from the murex family. Around 50 species of murex shells have been described, and they all typically have an elongated shell decorated with bumps and spines. This family of shells was once collected by the ancient Phoenicians to make a purple dye, used exclusively to colour the clothes of royalty and high priests for religious ceremonies. Murex shells are only found in the Indo-Pacific region, and they generally feed on other molluscs.

Night is the best time to find murex shells, as during daylight hours they hide in the sand. The most prized species is the Venus Comb Murex (*Murex pecten*). This incredible shell is decorated with rows of long spines and reaches a length of 10cm, but is unfortunately rarely seen. Divers are more likely to see the almost-as-beautiful Caltrop Murex (*Murex tribulus*), which grows to a similar size but has less spines.

NUDIBRANCHS

All divers love nudibranchs, and with their incredible array of shapes and colours it is easy to understand why. These colourful little sea slugs are members of the mollusc group, and sit in the same class as the shells (gastropods), but in a subclass known as the opisthobranchs. This subclass actually contains eight orders of sea slugs without shells or with very small shells, with the nudibranchs falling into the order Nudibranchia.

Around 2,300 species of nudibranch have been described, and while they vary greatly in shape, size and colour, they all have a few similar features. Nudibranchs are soft-bodied creatures with no shell, a pair of rhinophores to detect odours, oral tentacles for touch, taste and smell and many have external gills on their back. They are hermaphrodites, and have their sex organs located in their neck, and

BELOW: Many wonderful and undescribed nudibranchs are found while muck diving, such as this *Janolus* sp.

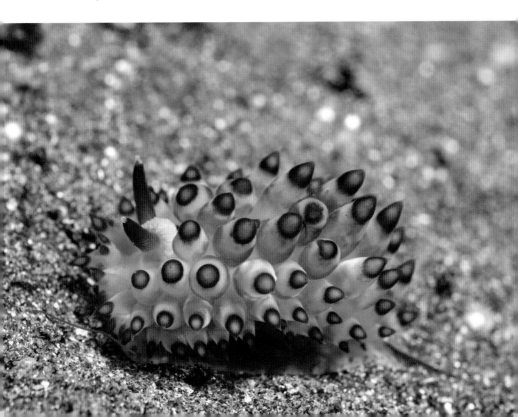

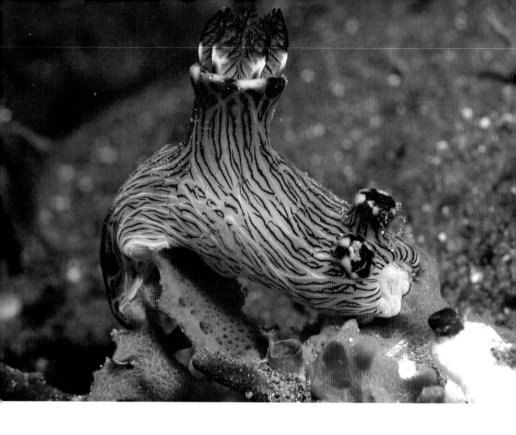

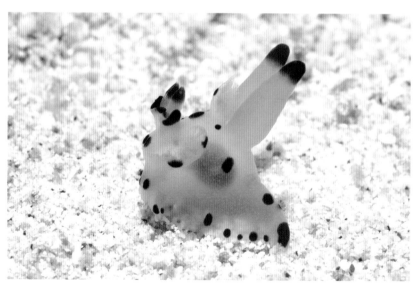

when a pair meet and mate, they exchange sperm. They each then lay a ribbon of eggs. Nudibranchs feed on a variety of food sources, depending on the species, and consume algae, seagrass, sponges, hydroids, soft corals, sea fans, anemones, bryozoans, ascidians and some even eat other nudibranchs.

These colourful little sea slugs are found in all marine habitats around the world and are very well represented in muck environments. Most species are active by day, but a surprising number emerge after dark in muck habitats and can be seen moving across the sand. Nudibranchs vary in size from 4mm to 40cm. As many species are extremely colourful they are not difficult to find, but a sharp-eyed guide will be required to find the well-camouflaged or tiny species. Illustrated is just a handful of the wonderful nudibranch species that can be found while muck diving.

Nudibranchs come in a range of amazing shapes, sizes and colours. Special species to look out for while muck diving include the Red-lined Jorunna (*Jorunna rubescens*) OPPOSITE TOP, the Lembeh Thecacera (*Thecacera* sp.) OPPOSITE BOTTOM and the Stellifer Bornella (*Bornella stellifer*) BELOW.

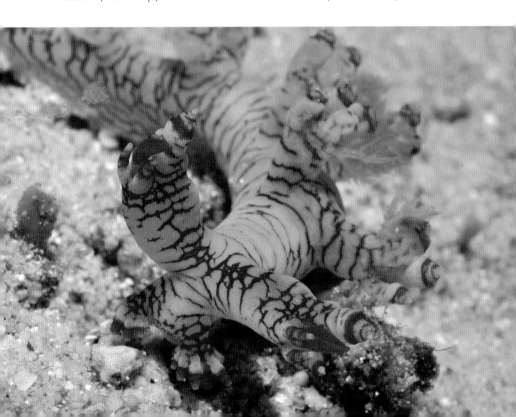

OTHER OPISTHOBRANCHS

Other members of the opisthobranch subclass that can be seen while muck diving include sea hares, bubble shells, sap-sucking slugs and side-gilled slugs. At a glance all these creatures look like nudibranchs, but there are a few ways to tell them apart.

With two long rhinophores that look like rabbit's ears it is easy to understand how the sea hares got their common name. Sea hares also have well-developed oral tentacles and wing-like body flaps that are called the parapodia. They also have a small internal shell, and release a purple ink when harassed. Some sea hare species can grow quite large, over 40cm long, but the smaller members of the family are generally the most colourful. In muck environments sea hares are generally seen close to their preferred food of algae and seagrass.

You would think that bubble shells are probably the easiest member of this group to identify, as most have a small shell on their back. However, this shell varies greatly in size, in some species it is large enough for the animal to retract into, but in others it is hardly visible. Bubble shells lack rhinophores, and instead have a wide headshield. Most are carnivores, feeding on worms and other molluscs, but others feed on sponges or algae.

Sap-suckers are very small slender sea slugs that mainly eat algae. They are generally thin-bodied, with rhinophores and ribbon-like parapodia flaps on their back. Many species of sap-suckers are green in colour and easily missed, but a few colourful members of the family are seen in muck habitats.

Side-gilled slugs are often found on night dives at muck sites and most divers would think they are just another nudibranch. This family has rhinophores like a nudibranch, but also has a small internal shell and the gills are located on the side of the body. There are some very pretty side-gilled slugs and most are round in shape when view from above, but they have been burdened with a very unappealing name.

TOP ROW: Sap suckers, Ornate Elysia (*Elysia ornata*) and Ocellate Plakobranchus (*Plakobranchus ocellatus*).
SECOND ROW: Bubble Shells, Rose Petal Bubble (*Hydatina physis*) and Green Oxynoe (*Oxynoe viridis*).
THIRD ROW: Geographic Sea Hare (*Syphonota geographica*) and Kuroda's Sea Hare (*Aplysis kurodai*).
BOTTOM ROW: Side-gilled slugs, Moon-face Euselenops (*Euselenops luniceps*) and Forskal's Pleurobranchus (*Pleurobranchus forskalii*).

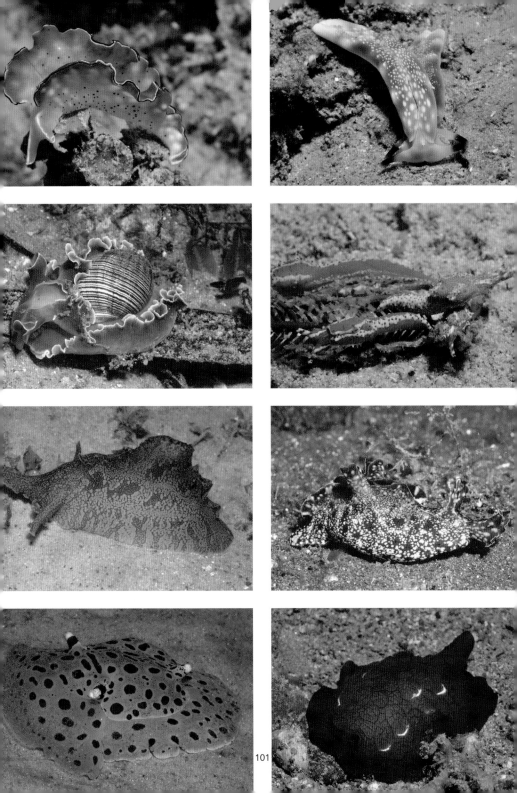

OCTOPUS

The octopus family is quite large and varied, with over 300 species so far described. These wonderful molluscs belong in the class Cephalopoda (along with the squid and cuttlefish) and the order Octopoda, and characteristically have eight arms, two eyes and a hard beak. Always a delight to encounter underwater, octopus are considered to be the most intelligent of all the invertebrates.

Like other cephalopods, octopus have chromatophores in their skin that enable them to change colour to blend in with their background, but octopus can also change the texture of their skin for incredible camouflage. Generally nocturnal, octopus move about by walking with their arms, but can also swim by expelling water in a form of jet propulsion.

Octopus are found in all marine environments around the globe, and are very well-represented in muck habitats in both tropical and temperate waters. These amazing creatures shelter in different habitats depending on the species – some live in the sand, others hide in holes in the reef, while smaller species hide in shells or debris. Many amazing species of octopus are found in the muck diving hot-spots of South-East Asia, like the Algae Octopus (*Abdopus aculeatus*), Hairy Octopus (*Octopus* sp.), Long-arm Octopus (*Abdopus* sp.), Mototi Octopus (*Octopus mototi*), Reef Octopus (*Octopus cyanea*) and Starry Night Octopus (*Octopus luteus*). Following is information about a few of the special octopus species that can be seen in muck environments.

BLUE-RINGED OCTOPUS

Among the most deadly creatures a diver will encounter are the tiny blue-ringed octopus, four species of which have been described to date, with several more awaiting classification. All species in this family have a highly toxic venom, and bites have resulted in several deaths. Fortunately they are not aggressive and will only bite if harassed; and they do give a warning, with their bright blue rings flashed when threatened.

OPPOSITE ABOVE: The Mototi Octopus is rarely seen and thought to be venomous.
OPPOSITE BELOW: Greater Blue-ringed Octopus are best observed at night.

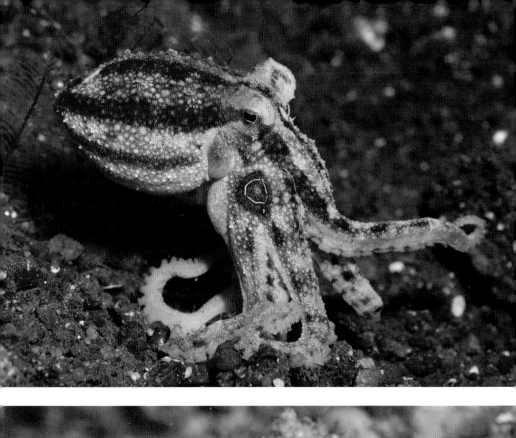
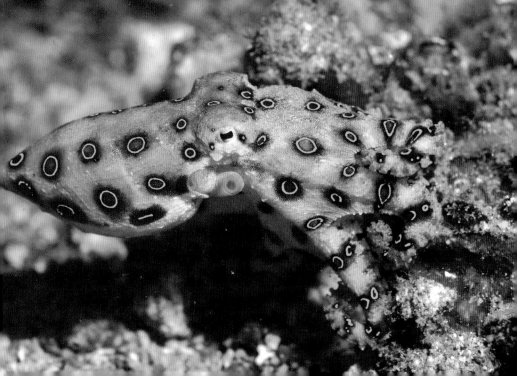

The most common species of this family that muck divers exploring the waters of South-East Asia will encounter is the Greater Blue-ringed Octopus (*Hapalochlaena lunulata*). This species is no bigger than any of the others in the family – it is rarely more than 10cm in length – but gets its name because of the larger size of its blue rings. Found on both coral reefs and mucky bottoms in tropical waters throughout the Indo-West Pacific, this species is nocturnal and spends the daylight hours hidden in a burrow, under rocks, shells or even a hole in the sand. Divers mostly encounter the Greater Blue-ringed Octopus at night, when it emerges to hunt for crustaceans, small fish and bivalve shells.

The Southern Blue-ringed Octopus (*Hapalochlaena maculosa*) is only found in the cool temperate waters of southern Australia, off Victoria, South Australia and Tasmania. A drab pale brown colour with darker bands, the small blue rings on this species are often difficult to see unless the creature gets angry. This nocturnal species can reach a length of 15cm, and is often found in very shallow water,

BELOW: The Blue-lined Octopus is only found off the east coast of Australia.

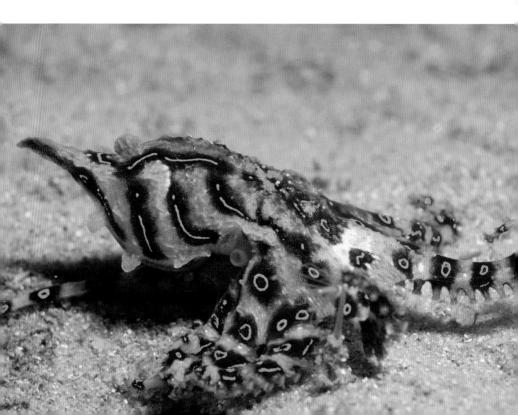

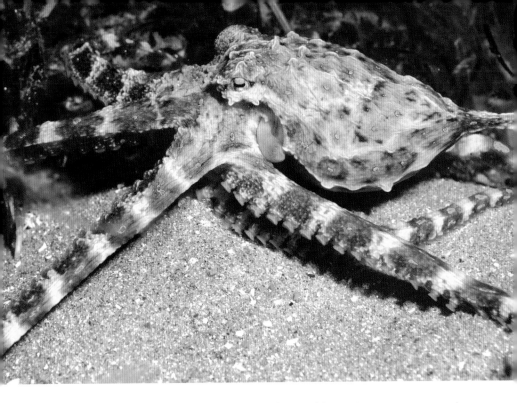

even in rock pools. While more common on rocky reefs, the Southern Blue-ringed Octopus is often found on the sand amongst the detritus under jetties in Melbourne's Port Phillip Bay – a great muck diving destination in southern Australia.

The Blue-lined Octopus (*Hapalochlaena fasciata*) is another species which is endemic to Australia, being found off the east coast in New South Wales and into southern Queensland. Light brown in colour with dark bands surrounding striking blue lines, this tiny octopus lives in shallow water on rocky reefs and seagrass beds. Blue-lined Octopus can reach a length of 10cm, and like its closely related cousins is mostly active at night. Divers regularly encounter this species at muck sites off Sydney and Port Stephens. Divers should always take care when picking up old shells or any debris, as Blue-lined Octopus often make a home in places like this and might not be very happy with you disturbing them.

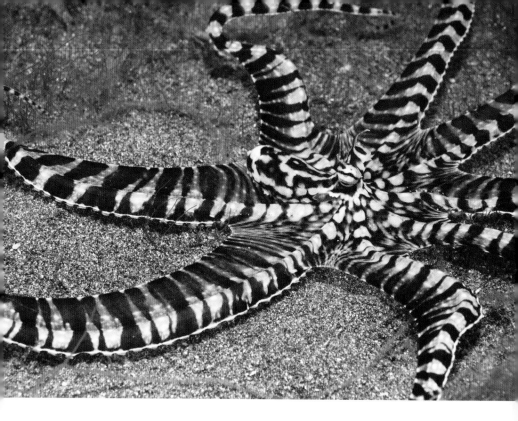

ABOVE: The highly prized Mimic Octopus is only observed at muck sites.

MIMIC OCTOPUS

One of the stars of muck diving is without question the incredible Mimic Octopus (*Thaumoctopus mimicus*). Named for its ability to mimic the shape of dangerous animals, the Mimic Octopus was first discovered in 1998 by divers exploring the wonderful muck diving sites at Lembeh. Since then this species has also been found in other parts of the Indo-West Pacific.

Often confused with the rarer Wonderpus, which has a similar body shape, size and colouration, the following will assist you in telling the two species apart. Mimic Octopus have a distinctive white edge along the underside of their arms, and they can also make their white banding pattern disappear. Mimic Octopus also tend to be larger and more muscular, and are commonly observed out in the open during daylight hours.

The Mimic Octopus lives exclusively on muck bottoms, residing in sandy

burrows. It hunts by day and night, stalking across the sand in a search for fish and crustaceans. The most remarkable thing about the Mimic Octopus is its ability to mimic other marine life. By changing its shape it can make itself look like a sea snake, lionfish, flounder, stingray or even a sea jelly. They do this for defence, and it is believed that Mimic Octopus can imitate 15 species of dangerous or venomous animals, all to avoid becoming a meal themselves.

WONDERPUS

One of the critters that all divers wish to encounter while muck diving is the incredible Wonderpus (*Wunderpus photogenicus*). First seen by divers in the 1980s, this remarkable octopus wasn't described by science until 2006.

Found throughout the tropical Indo-West Pacific, the Wonderpus is a long-armed octopus that lives only in soft-sediment environments. This species has small eyes set on elongated stalks, which it uses to observe its surroundings from

BELOW: The weird and wonderful Wonderpus.

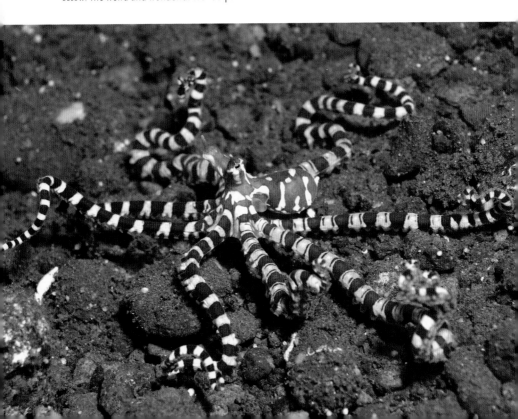

a sandy burrow while keeping the rest of its body hidden. A pair of elongated eye-stalks is often the first thing (sometimes the only thing) that divers will see of this cryptic octopus. Reddish to yellowish-brown in colour, the Wonderpus has a pattern of distinctive white bars and spots across its body, which are unique to each individual and can be used for photo-identification. Wonderpus are quite small, with an arm length of 25cm, but they can make themselves appear much larger by fanning out their arms.

During the day Wonderpus are rarely seen as they shelter in a burrow in the soft silt, only emerging at dusk and dawn to hunt for fish and crustaceans during the twilight hours. It is possible that this species is venomous, but further research is required.

Wonderpus are not as commonly seen as their close cousin the Mimic Octopus, mainly because they only emerge from their burrows for a limited amount of time each day. A sharp-eyed guide is usually essential to find these amazing creatures. They do tend to use the same burrow for up to three weeks, so if the guides have recently seen one there is a good chance it will still be in the area.

BELOW: A good dive guide is essential to find critters like the Wonderpus.

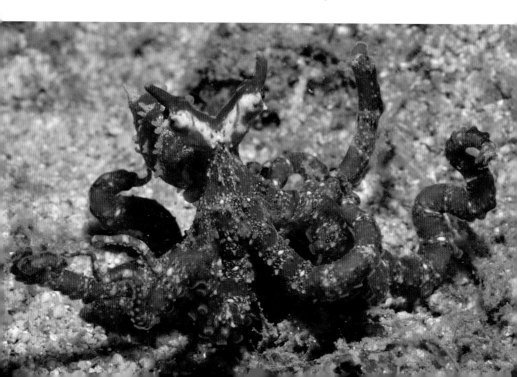

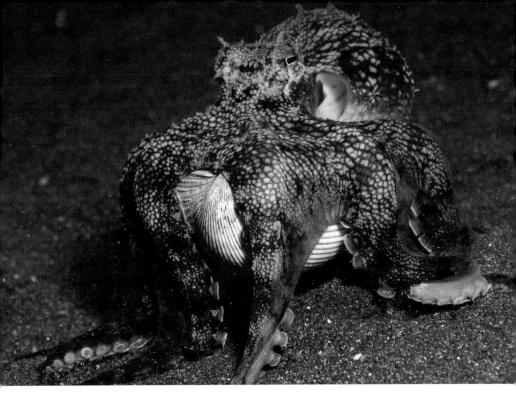

ABOVE: Coconut Octopus often carry their home with them.

COCONUT OCTOPUS

The Coconut Octopus (*Octopus marginatus*) is a fascinating creature found in the tropical Indo-Pacific region, and is one of the only octopus species known to use tools. They generally hide in the sand, but are also known to use shells, coconuts, tins or bottles to shelter in. This species has been documented collecting two half coconut husks or empty bi-valve shells and fitting them together for protection. And if a Coconut Octopus finds a good home it will often carry it around, walking across the bottom on its legs while holding its shelter around itself for protection. The Coconut Octopus has an arm span of 50cm, and is best observed at night.

TEMPERATE OCTOPUS

A number of endemic octopus species are found in the cooler temperate waters of southern Australia, especially off Melbourne, with one of the most photogenic being the Southern White-spot Octopus (*Octopus bunurong*). Residing in the

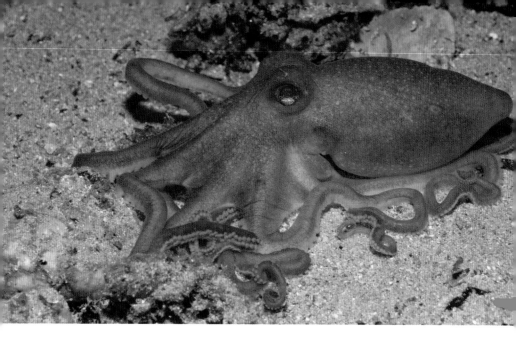

ABOVE: The Southern White-spot Octopus is endemic to southern Australia.

OPPOSITE ABOVE: One of the strangest critters found in southern Australia is the Southern Sand Octopus.

OPPOSITE MIDDLE: The Sydney Octopus is a common species at Sydney muck sites.

OPPOSITE BELOW: The Hammer Octopus is another endemic Australian octopus species.

sand, this unusual species emerges at night and is usually a bright orange colour. Other species that hide in the sand by day are the Southern Keeled Octopus (*Octopus berrima*) and the Southern Sand Octopus (*Octopus kaurna*). At least four other octopus species are seen on night dives in Melbourne's Port Phillip Bay, making this a critter haven. Many endemic octopus species are also seen at muck sites in New South Wales. The most common species is the Sydney Octopus (*Octopus terricus*). This species can grow quite large, with an arm span of up to 2m, and is mostly observed sheltering in a hole in the sand with a collection of shells and rocks piled around it. A much rarer octopus species also seen in this area is the Hammer Octopus (*Octopus australis*). This species lives in the sand at muck sites at Port Stephens and Sydney, and emerges after sunset to hunt for prey. The Hammer Octopus is generally a pale sandy colour, which makes it well camouflaged in its preferred habitat, and has an arm length of 40cm.

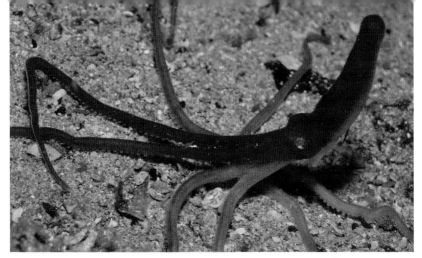

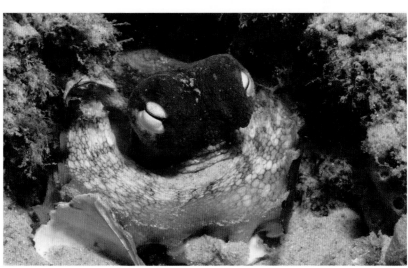

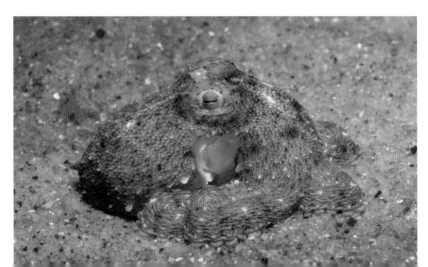

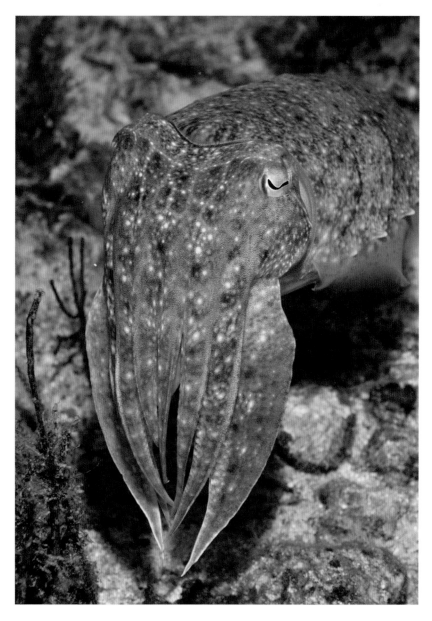

ABOVE: The Broadclub Cuttlefish is the largest cuttlefish in Asia.

OPPOSITE LEFT: The tiny Stumpy-spined Cuttlefish is so small it is often called the Pygmy Cuttlefish.

OPPOSITE RIGHT: The Reaper Cuttlefish is endemic to Australia.

CUTTLEFISH

Known as the 'chameleons of the sea', because of their incredible ability to change colour instantly, cuttlefish belong to an order of molluscs known as the Sepiida. While superficially looking like a squid, with eight arms, two tentacles and an extended mantle, cuttlefish differ in having an internal bone, known as a cuttlebone. These wonderful creatures vary in length from 2cm to 50cm, and are found in most marine environments around the world, except for the Americas.

Cuttlefish are carnivores and feed on shrimps, crabs, molluscs and fish. They are ambush predators, and use their ability to change colour to blend into the background as they sneak up on prey. Once close to prey, their two long feeder tentacles shoot out and grab the unsuspecting victim. They have quite good eyesight that helps them identify potential prey.

Like all cephalopods, cuttlefish have complex mating rituals, with the male flashing colours to attract a mate. Males also display warning colours to rival males and will sometimes fight to establish dominance. When mating the male and female lock together in an embrace of arms, which allows the male to insert a package of sperm via a modified arm. The female then lays a clutch of eggs under a ledge or amongst the coral. Most cuttlefish only live for a year and die soon after mating.

A good variety of cuttlefish species are found in the Indo-Pacific region, including many that venture into muck environments. One of the smallest species seen in this area is the Stumpy-spined Cuttlefish (*Sepia bandensis*), which only grows to 5cm in length. This species is mostly seen at night and tends to walk across the bottom using its arms and mantle. One of the more common species divers will encounter is the Needle Cuttlefish (*Sepia aculeata*), which reaches a length of 23cm and often settles in the sand. The Papuan Cuttlefish (*Sepia papuensis*) is another small species, reaching 11cm in length, and is found in tropical Australia, Papua New Guinea and eastern Indonesia.

Two small cuttlefish common in muck environments on the east coast of Australia are the Reaper Cuttlefish (*Sepia mestus*) and Mourning Cuttlefish (*Sepia plangon*). Both these species reach 15cm in length, with the former always a reddish-pink colour and the latter tending to be more creamy-brown. Both these species are great photo subjects and commonly observed during the day. The largest cuttlefish species is also found in Australia, the Giant Cuttlefish

BELOW: A group of male Mourning Cuttlefish fight over a smaller female.

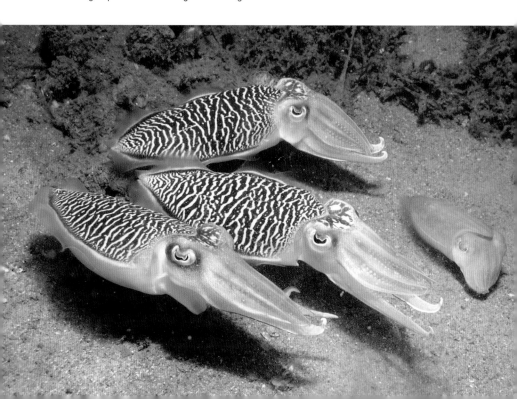

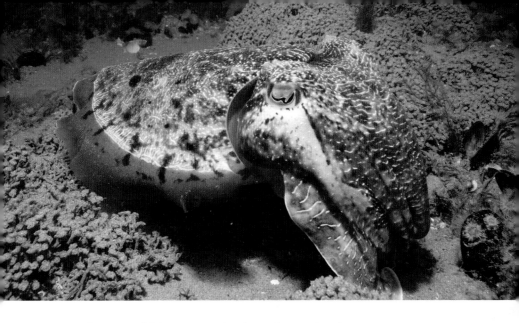

ABOVE: The Giant Cuttlefish is sometimes found at muck sites in Australia.

(*Sepia apama*). With a mantle 50cm long and arms just as long, these huge creatures are much too big for a macro lens. Found only in the temperate waters of southern Australia, the Giant Cuttlefish is more common on reefs, but does venture into bays and estuaries. Only slightly smaller is the Broadclub Cuttlefish (*Sepia latimanus*), which grows to 40cm in length and is common in tropical waters of the Indo-Pacific region.

FLAMBOYANT CUTTLEFISH

While all cuttlefish are fun to watch and photograph, the most prized in muck environments is the spectacular Flamboyant Cuttlefish (*Metasepia pfefferi*). This stunning critter only grows to 8cm in length and can never be confused with any other cuttlefish species. The Flamboyant Cuttlefish is usually a drab brown in colour, but when threatened or excited it displays a rainbow of colours – white, yellow, brown and pink. These colours hardly make it blend in with the background, but then this species is not concerned with sticking out from the crowd as it is poisonous, and the bright colours help to advertise this fact.

This species is found on muck environments of the Indo-West Pacific region, and is generally observed during the day slowly walking across the bottom using

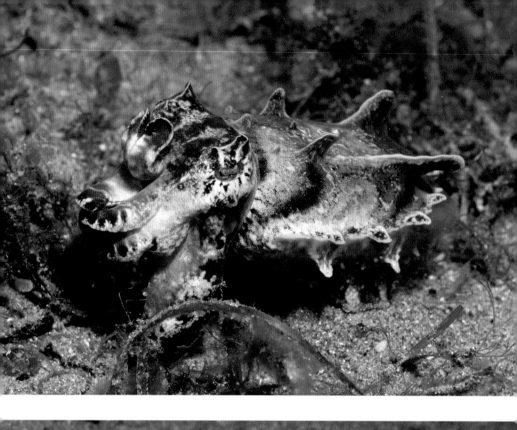
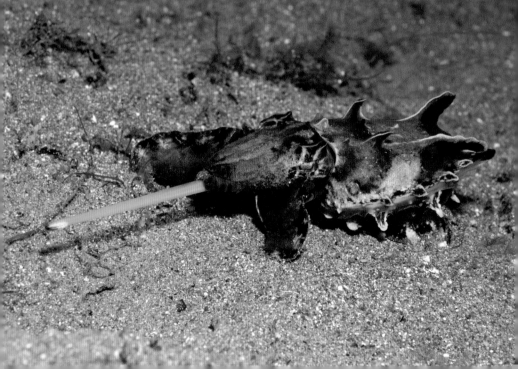

OPPOSITE ABOVE: The spectacular Flamboyant Cuttlefish is a muck diving superstar.
OPPOSITE BELOW: A Flamboyant Cuttlefish shoots out its feeding tentacles to capture prey.
BELOW: One of the most amazing critters from southern Australia is the Striped Pyjama Squid.

its arms and mantle. Flamboyant Cuttlefish are highly skilled hunters, using slow movements to stalk prey. When close to the prey they launch two feeder tentacles like a sling-shot. At Lembeh this species breeds between January and July, and the female lays tiny round eggs under rocks or in discarded coconut shells.

Flamboyant Cuttlefish are usually solitary, but occasionally a pair will be seen together. This is one of those critters that you can never guarantee seeing, as they seem to come and go from popular muck diving sites. A good guide will know if one has been seen in the area, and will be invaluable in locating this spectacular cuttlefish.

BOTTLETAIL SQUID

The cuttlefish family also contains a few members that are very small and look more like squid, and have ended up with squid in their names. The bottletail squid family contains eight species that hide under a layer of sand during the day and emerge at night to hunt prey, but they rarely move off the bottom.

The Southern Bottletail Squid (*Sepiadarium austrinum*) is only found in the

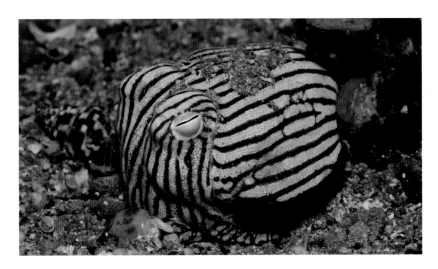

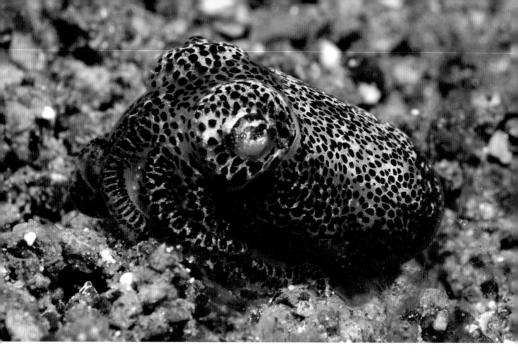

ABOVE: Emerging at night, Berry's Bobtail Squid are easily missed without a guide.

BELOW: Night time is the only time divers see the Southern Dumpling Squid.

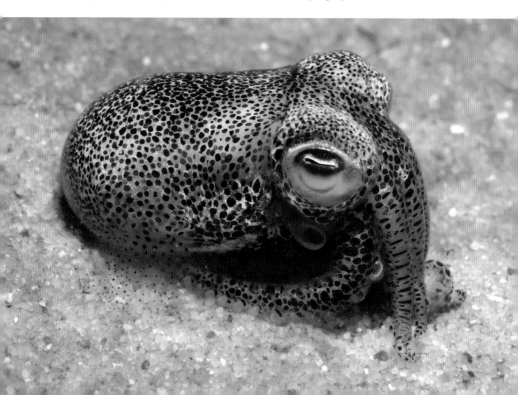

waters of southern Australia and is often encountered around seagrass beds and sandy bottoms. This tiny animal grows to 4cm long and is easily overlooked. It has a gland that manufactures slime, which makes it less appealing to predators. A rarely seen relative found in warm waters is the Tropical Bottletail Squid (*Sepiadariidae kochi*). This tiny critter, usually only 4cm long, turns up at muck sites from time to time.

The most photogenic of all the bottletail squids is only found in the cooler waters of southern Australia – the exquisite Striped Pyjama Squid (*Sepioloidea lineolata*). With its bold black stripes over a white base colour, this species is easily identifiable despite only reaching a length of 7cm. These small critters shelter under a layer of sand during the day, with only their eyes showing, to watch for prey. The Striped Pyjama Squid is thought to be venomous.

BOBTAIL SQUID

The bobtail squid look very similar to the bottletail squid. They also hide in the sand during the day, but swim in the water column after dark to capture prey. Around 50 species of bobtail squid have been described and they all have a light organ with luminescent bacteria that they can use to minimise their silhouette while in midwater, to make them less obvious to predators.

The Berry's Bobtail Squid (*Euprymna berryi*) only reaches 5cm in length, so is easily overlooked in the sand and rubble in tropical muck sites. The closely related Southern Dumpling Squid (*Euprymna tasmanica*) is only a little bigger, at 7cm long, and is only found on night dives in southern Australia.

PYGMY SQUID

Another cuttlefish family with a misleading name, the pygmy squid are the smallest members of the cephalopod family. The Southern Pygmy Squid (*Idiosepius notoides*) is found in southern Australia and only grows to 2cm long. This tiny critter is generally found in seagrass beds on night dives. The Tropical Pygmy Squid (*Idiosepius pygmaeus*) isn't much bigger, 3cm long, and is sometimes found at muck diving locations with seagrass or black coral trees in the tropical Indo-Pacific region. Both these species have a glue-gland on the mantle that allows them to attach to seagrass or corals.

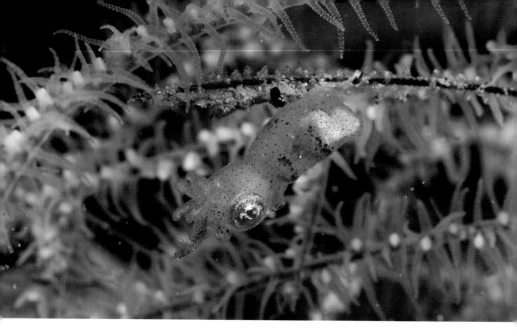

ABOVE: Tropical Pygmy Squid are tiny and very hard to find.

OPPOSITE ABOVE: Bigfin Reef Squid feed at night and are often attracted to divers' lights.

OPPOSITE BELOW: Endemic to southern Australia, the Southern Calamari Squid is best seen at night.

SQUID

A number of squid species are found in muck environments, but they are not as common or as conspicuous as their more captivating cousins, the octopus and cuttlefish. Squid are another member of the cephalopod family and belong to the order Teuthida, with around 300 species having been described.

Squid have eight arms and two longer tentacles, and most species live a pelagic life, living entirely in the water column. The largest squid that divers will encounter in muck environments in the Indo-Pacific region is the Bigfin Reef Squid (*Sepioteuthis lessoniana*). This squid grows to 40cm in length and feeds on crustaceans and fish. During the day it is difficult to get close to and will depart in a cloud of ink, but after dark they become more active and will often approach divers' torches. A similar-sized species found in the waters of southern Australia is the Southern Calamari Squid (*Sepioteuthis australis*), which is often encountered in bays and estuaries.

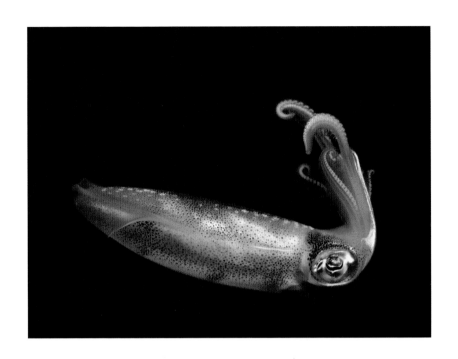

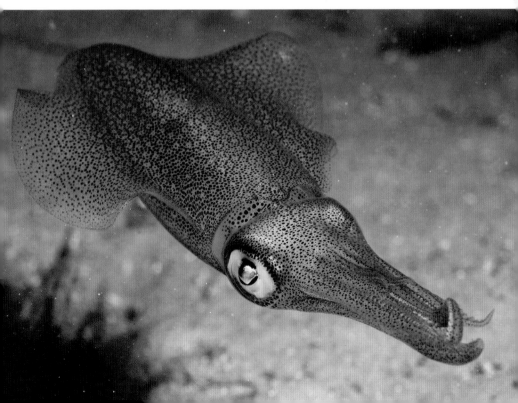

ECHINODERMS

The echinoderm group contains a wide variety of animals split into five classes – the sea stars, brittle stars, feather stars, sea urchins and sea cucumbers. This group contains over 7,000 species that share a common feature of being pentamerous, meaning that they have either five arms, five parts or five sides. While a sea urchin looks nothing like a sea cucumber or a sea star, this group shares a couple of common traits, with a radial symmetry in their body design and tentacle-like tube feet. They also possess no heart, brain or eyes, and most have no apparent front or back.

Echinoderms might not be the most exciting or unusual species that divers will find in muck environments, but they are well worth looking for, as many more desirable critters often live in commensal relationships with these animals or use them as a hiding place.

BELOW: A common species at muck sites in southern Australia is the Eleven-armed Sea Star (*Coscinasterias muricata*).

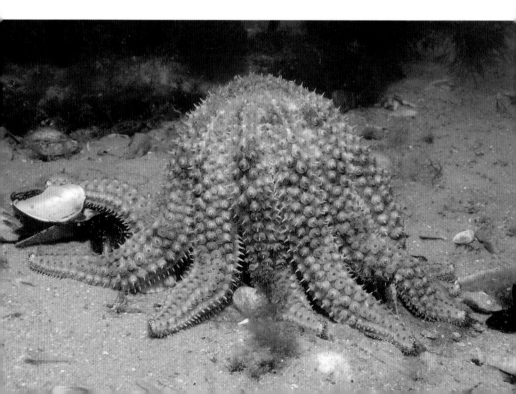

ABOVE: Rhinoceros Sea Stars (*Protoreaster nodosus*) litter the bottom at some muck sites.

SEA STARS

Sea stars (or starfish) as a rule generally have five arms, but there are many species that possess more than five, like the Crown-of-thorns (*Acanthaster planci*), which has up to 18 arms. Belonging to the class Asteroidea, around 1,500 sea star species have been described and they occupy all marine habitats around the globe.

Sea stars come in a wide variety of shapes and sizes, some have smooth arms, others are covered in spines, while some are decorated with nodules. They live on reefs, rocks and sand, and feed on molluscs, fish, crustaceans, worms, corals, seaweeds and algae depending on the species. With a mouth on the underside of their body, sea stars feed in a rather peculiar way. They extrude their stomach over their food, which slowly dissolves the item with powerful enzymes, before absorbing the food into the stomach.

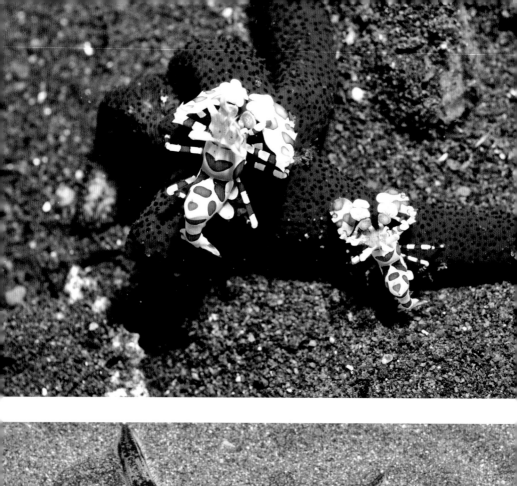

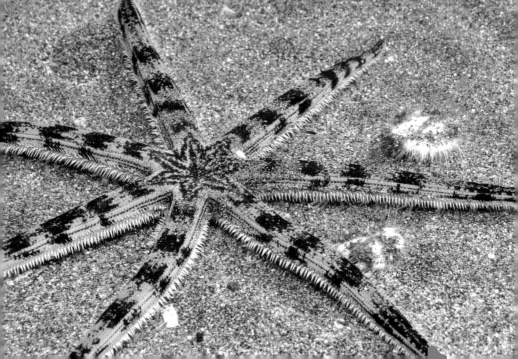

OPPOSITE TOP: Sea stars of all shapes and sizes are preyed upon by Harlequin Shrimps.

OPPOSITE BELOW: A Speckled Star (*Luidia maculate*) after a meal of Fine-spined Heart Urchins (*Maretia planulata*).

BELOW: Comb Stars (*Astropecten polyacanthus*) emerge at night at muck sites.

Sea stars reproduce by releasing eggs and sperm in a synchronised spawning, but they can also reproduce asexually, with a lost arm regrowing an entire new body. Sea stars with missing arms are a good sign that Harlequin Shrimps (*Hymenocera picta*) are in the area, as they feed exclusively on sea stars.

A number of sea star species are observed while muck diving, most are commonly observed by day, but a number of sand star species only emerge from the sand after dark. Blennies, marine worms, commensal shrimps and commensal crabs are occasionally observed on sea stars, but one species that always seems to host commensal species is the large Pin Cushion Star (*Culcita novaeguineae*). This football-sized sea star is common throughout the Indo-Pacific region and always seems to have a few Sea Star Shrimps (*Periclimenes soror*) living on its underbelly.

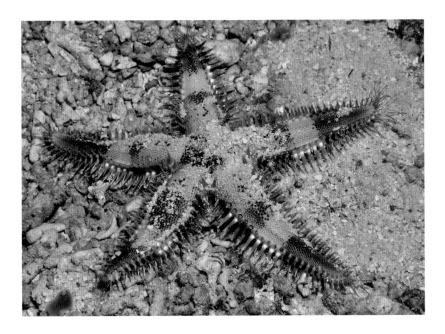

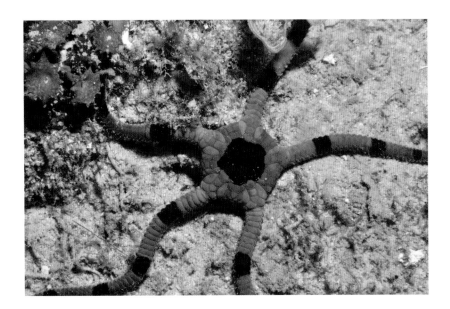

BRITTLE STARS

Brittle stars belong to a class of echinoderms known as Ophiuroidea, with this group also containing the serpent stars and basket stars. These species all have long slender arms, five generally, that tend to be very brittle and easily broken. Over 2,000 species are found in this class, and the great majority are nocturnal and rarely seen during the day.

Most brittle star species hide under rocks, coral or under other echinoderms during the day. Divers will generally only see brittle stars after dark, and usually only fleetingly, as they scamper to return to their hiding spot when highlighted by a torch. There are some very pretty brittle stars that make for great photographic subjects, but they can be a challenge to frame as they wriggle away from your camera. Most brittle stars are also quite small, with a disk only one or two centimetres wide, but with spindly arms that can be 10cm long.

The largest members of the family are the basket stars, with some species

OPPOSITE: Basket stars emerge at night to feed at muck sites.

ABOVE: Brittle stars are easily missed at most muck sites as they are nocturnal and don't like bright lights.

having arms over one metre wide. These incredible creatures hide under coral and rocks, rolled into a ball of lacy arms. But after dark they emerge and perch on a high outcrop, unrolling their arms to capture passing plankton. While commensal species are rarely found on brittle stars, they do hide on basket stars, but with sticky arms it can be very difficult to get close enough to look for commensal shrimps and crabs sheltering on these weird creatures.

FEATHER STARS

Feather stars, or crinoids, belong to the class Crinoidea and are easily distinguished from other echinoderms by their feather-like arms. These plant-like creatures may look like they are attached to the reef by roots, but this anchor, known as a cirri, can move to allow the feather star to walk. Feather stars can also swim, undulating their arms to propel themselves through the water.

Around 600 feather star species have been documented and they all feed

BELOW: Feather stars provide a home to many critters, including Crinoid Clingfish.

ABOVE: With a shortage of hiding spots, feather stars attract small fish and many other critters looking for shelter.

on plankton, using their arms to catch passing food particles. Once an item of food has been captured the arm rolls up to deliver it to the mouth, which is located on the top side in the centre of the arms. Feather stars come in a broad range of colours, some being quite bland while others are very colourful. They usually perch where they can capture passing food, but some species prefer to hide amongst the coral.

While some feather stars are quite attractive, it is the critters that shelter in their protective arms that makes them most interesting in the muck environment. Ghost pipefish and shrimpfish often hover between their arms, but many other small fish species like gobies, clingfish and cardinalfish can often be found on feather stars. Also found hiding on feather stars are squat lobsters, crabs and marine worms, but the prettiest is the Feather Star Shrimp (*Periclimenes cornutus*). These

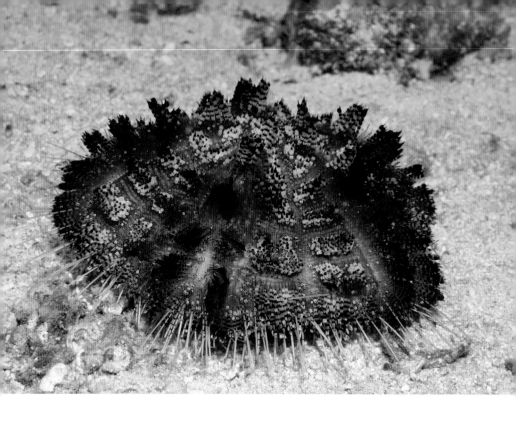

ABOVE: Always have a close look at Variable Fire Urchins as they play host to some great critters.

tiny shrimp are rarely more than 1.5cm long, but come in a range of wonderful colours that match their host feather star.

SEA URCHINS

Although covered in spines that can cause excruciating pain, sea urchins are fascinating creatures of the muck environment that are always worth a close inspection. Sea urchins belong to the class Echinoidea, and around 950 species have so far been described. They all have a hard body case, which looks like a shell once the animal has died, and are armed with spines that can be sharp, blunt, long, thin or very short. These spines are used for defence and in some species motion, as most are fitted in a ball-and-socket connection that gives a wide range of motion.

Sea urchins feed on sponges, seagrasses and algae and are found on reefs and

sandy habitats. A number of species also live under the sand, such as the heart urchins and sand dollars, and are more commonly seen by night. While being jabbed by any sea urchin spine will cause a fair amount of pain, several species are also venomous, such as the Flower Sea Urchin (*Toxopneustes pileolus*), so always watch where you place your hands, and wearing gloves is always advisable.

A surprising number of critters seek shelter in the protective spines of sea urchins, especially in muck environments. Ornate Ghostpipefish (*Solenostomus paradoxus*) and Striped Clingfish (*Diademichthys lineatus*) are often seen dancing between the spines, but at times whole schools of tiny cardinalfish can be found swarming on a sea urchin. Brittle stars, commensal shrimps, squat lobsters and tiny crabs also turn up on different species of sea urchin. However, one of the most colourful of all the sea urchins, the Variable Fire Urchin (*Asthenosoma varium*), is

BELOW: The Radiant Urchin (*Astropyga radiate*) is a very attractive sea urchin and common at many muck sites.

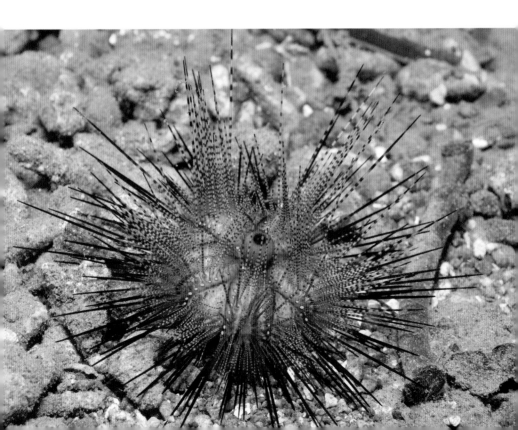

highly prized in muck habitats as this species is home to the spectacular Zebra Crab (*Zebrida adamsii*) and Coleman's Shrimp (*Periclimenes colemani*).

SEA CUCUMBERS

Some look like a cucumber, others like a burnt sausage, and some look like a giant worm – there is no denying that sea cucumbers come in wide variety of forms. Belonging to the class Holothuroidea, sea cucumbers are the strangest of all the echinoderms, and usually the most overlooked. This family contains over 1,700 species and all have a tube-like shape and a body of soft tissue supported by an underlining calcified structure.

Very slow-moving creatures, sea cucumbers travel across the seabed on tubed feet. Several of these feet are modified around the mouth into branch-like arms and are used to gather food. Sea cucumbers feed on sand, shovelling it into their mouth to remove food particles, typically plankton and bacteria, before ejecting it from their anus as clean sand.

Generally found on sandy bottoms, most sea cucumbers are quite bland, but a few of the colourful members of the family are very photogenic. Numerous sea cucumber species are observed while muck diving in the Indo-Pacific region and should never be ignored. Living on the exterior, often on the underbelly, of these creatures are marine worms, crabs and commensal shrimps, including the lovely Imperial Shrimp (*Periclimenes imperator*).

However, a more bizarre creature has taken up residence in a rather strange location on some species of sea cucumbers. Pearlfish (*Encheliophis* sp.) are small eel-like fish that have been found living in clams, oysters and sea cucumbers. In sea cucumbers they live inside the animal, and enter and exit the poor host via the anus. Generally only one pearlfish lives in a sea cucumber's anus, but 15 were once found crowded in one unfortunate host.

OPPOSITE ABOVE: Robust Sea Cucumbers (*Colochirus robustus*) are often found in large groups. OPPOSITE BELOW: One of the prettiest of all the sea cucumbers is the Red-lined Sea Cucumber (*Thelenota rubralineata*).

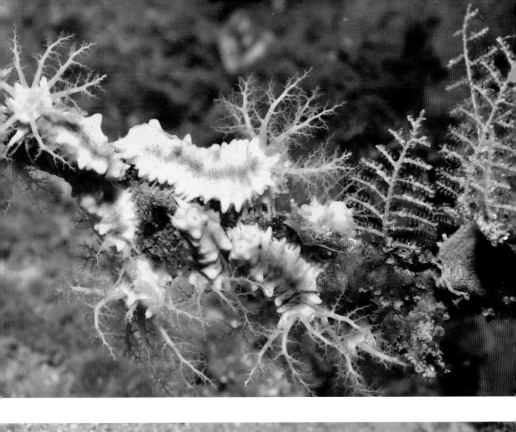

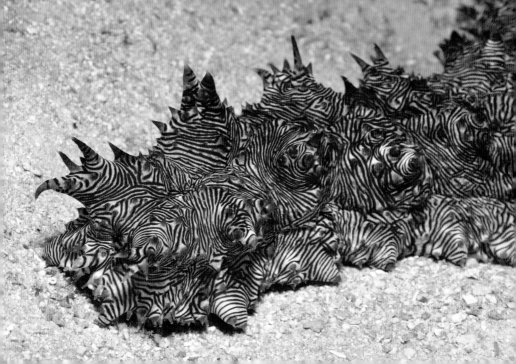

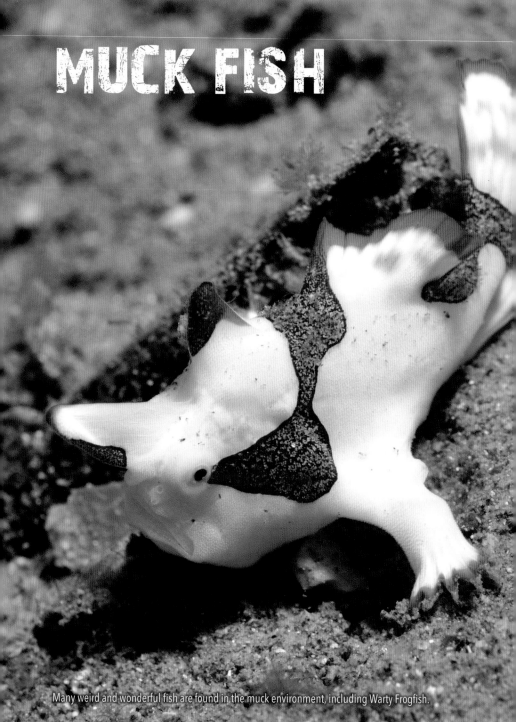

MUCK FISH

Many weird and wonderful fish are found in the muck environment, including Warty Frogfish.

A wide range of fish species are found in muck environments, including many typical reef species like the butterflyfish, angelfish, wrasse, damselfish and surgeonfish. You will not find any of those reef fish depicted here, as this book is far more interested in the weird, wonderful and bizarre fish that are either only found in muck or more likely to be found in muck.

Fish found in muck habitats of the Indo-Pacific region are fascinating creatures, and come in a wide variety of shapes and sizes. Many have adapted their behaviour to survive in this habitat of sand and silt. Some live in the sand, some are so well camouflaged that they look like sand or debris, while others are brightly coloured to warn other creatures that they are either venomous or poisonous. One thing is for sure, if it has eyes, even if it looks like a half-chewed chicken bone, it is more than likely a bizarre muck fish.

MORAY EELS

Moray eels are common on coral reefs throughout the Indo-Pacific region, and quite a good range of species are also observed in muck environments. This group of fish contains over 200 species that vary in size from 11cm to 4m in length. Some moray eels are ambush predators, but most are active hunters and stalk the reef at night looking to prey on octopus, cuttlefish, squid and fish. By day they rest tucked up in a lair, with only their head exposed to keep an eye on their territory.

A very pretty moray species found in muck environments is the Clouded Moray (*Echidna nebulosa*). Also commonly known as the Starry Moray or Snowflake Moray, this species has lovely black and white bands covered in yellow dots and grows to a length of 70cm. The Honeycomb Moray (*Gymnothorax favagineus*), also known as the Tessellate Moray, grows a lot bigger, up to 2m in length, and is white in colour with a honeycomb pattern of black spots. The Barred-fin Moray

BELOW: Clouded Moray.

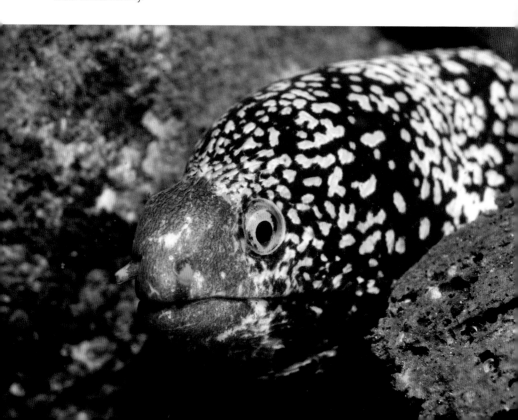

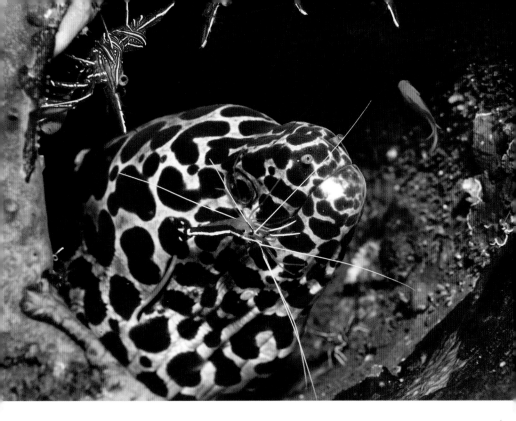

ABOVE: Honeycomb Moray getting cleaned.

(*Gymnothorax zonipectis*), or Bartail Moray, is another species that is often seen at muck diving sites. It grows to 50cm in length and has a distinctive white bar on its face.

One of the most common moray eels a muck diver will encounter is the White-eyed Moray (*Siderea thyrsoidea*). This very social moray is often found in pairs or even groups, and is usually a grey or yellowish colour with white eyes. A shier species that is also found in muck environments is the Fimbriate Moray (*Gymnothorax fimbriatus*). Yellow in colour with a pattern of random dark spots, this moray grows to 80cm in length and is quite shy, even at night.

A small number of moray eels also live in sandy burrows, including the Whitemargin Moray (*Gymnothorax albimarginatus*) which attains a length of 1m. Like all moray species it secretes a protective mucous on its skin, but in this species the mucous helps to bond grains of sand together to form a stable burrow.

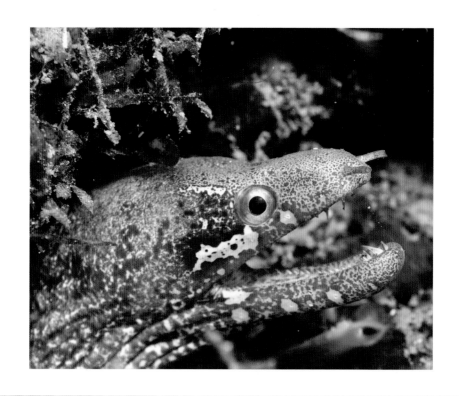

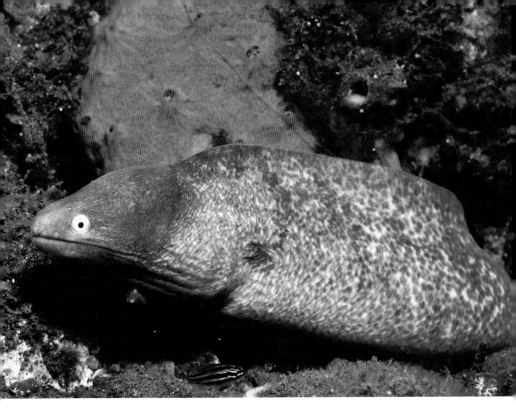

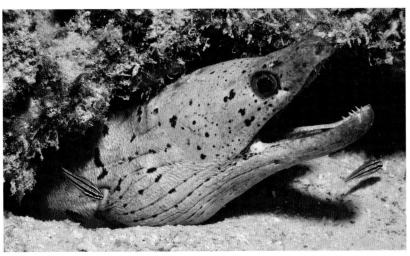

OPPOSITE ABOVE: Barred-fin Moray.

OPPOSITE BELOW: Whitemargin Moray.

ABOVE: White-eyed Moray.

BELOW: Fimbriated Moray.

RIBBON EEL

The most spectacular moray found in muck environments is without doubt the beautiful Ribbon Eel (*Rhinomuraena quaesita*). This thin-bodied eel is very distinctive with its large flared nostrils, chin whiskers and lovely colouration. Ribbon eels grow to 1.2m in length and change colour, and sometimes sex, as they grow. Not a lot is known about their biology and behaviour, but the juveniles are black with yellow fins, and as they get older the males become blue with yellow fins and the females all yellow.

Ribbon eels live in holes in the sand or rock, and usually have several entrances to their lair. During the day they will often hang half out of their hole, waving their head and body about and snapping at passing fish. Most quickly disappear into their home if a diver, especially one with a camera, gets too close. But some don't seem to mind the attention and will allow you to get very close to study them.

BELOW: The always eye-catching Ribbon Eel.

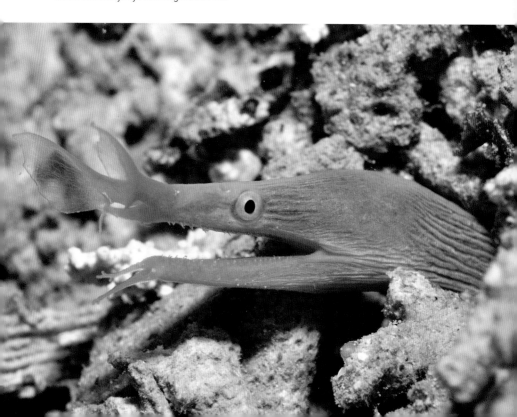

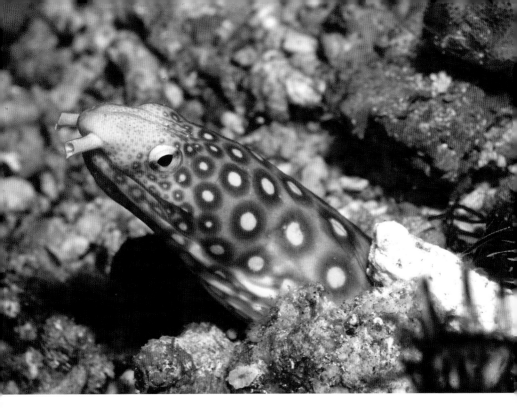

SNAKE EELS

Often mistaken for sea snakes when they swim across the seabed, snake eels are a family of fish that live exclusively in muck environments. These unusual worm-like eels burrow in the sand and silt, and around 320 species have so far been identified. Snake eels vary in size from 10cm to 3m in length, and many species lack fins so their body can slide easily through the sand, just like a large worm. Many species of snake eels have a banded or spotted colouration, and it is believed that this is to mimic sea snakes and deter potential predators.

Snake eels spend the day in the sand, with just their head exposed at the surface, but the species that mimic sea snakes often emerge during the day to look for prey. The rest emerge at night to hunt crustaceans and small fish. Snake eels are one of those species that have become more popular with the growth of muck

ABOVE: The Many-eyed Snake Eel is quite rare.

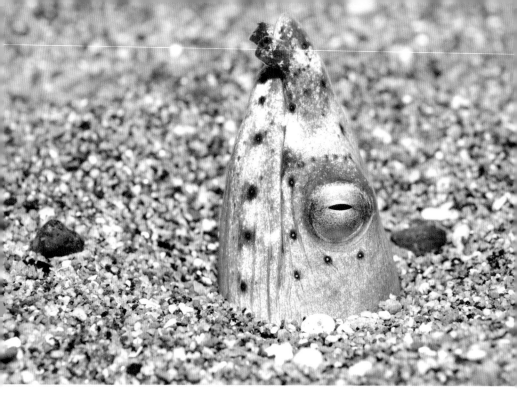

ABOVE: The Longfin Snake Eel is common at many muck sites.

diving, but many species are still rarely seen and a good guide is always helpful to spot the more camouflaged members of this bizarre family of eels.

The Banded Snake Eel (*Myrichthys colubrinus*), also known as the Harlequin Snake Eel, is the most common snake eel that divers encounter, and the species most likely to be seen swimming about. Found throughout the Indo-Pacific region, it grows to 1m in length and is easily identified by its black and white striped body pattern. Another common species is the Longfin Snake Eel (*Pisodonophis cancrivorous*), also known as the Burrowing Snake Eel, which is generally observed with its head sticking vertically out of the sand. This species grows to 75cm in length and is yellowish-brown in colour with small dark spots. They are occasionally seen with a commensal shrimp sitting on their snout.

One of prettiest snake eels, relatively speaking, is the Napoleon Snake Eel (*Ophichthus bonaparti*), or Purplebanded Snake Eel, which is very photogenic with a distinctive speckled pattern on its head. Also very pretty, but far less common, is

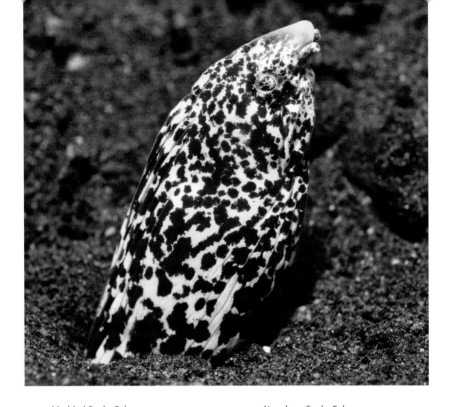

ABOVE: Marbled Snake Eel. BELOW: Napoleon Snake Eel.

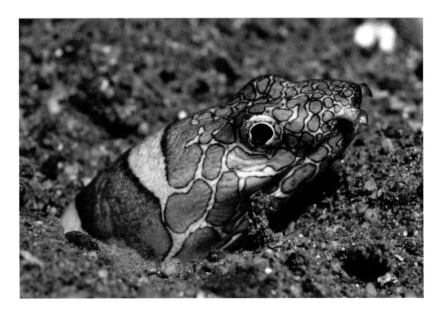

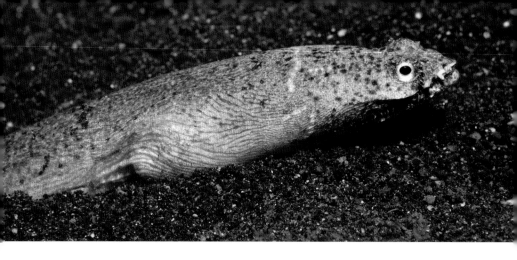

ABOVE: The Crocodile Snake Eel is a spectacular member of the family.

the Many-eyed Snake Eel (*Ophichthus polyophthalmus*), which grows to 65cm in length and is covered in bright yellow spots. The Marbled Snake Eel (*Callechelys marmorata*) is another common species of the Indo-Pacific region, reaching up to 87cm in length and with tiny eyes that sit right at the end of the snout.

Two of the more spectacular members of this family are the Stargazer Snake Eel (*Brachysomophis cirrocheilos*) and the closely related Crocodile Snake Eel (*Branchysomophis crocodilinus*). These two evil-looking eels are star attractions at muck diving sites, when they can be found. The Stargazer Snake Eel is one of the larger members of the family, growing to 1.2m in length, and appears to mimic stargazers in their colouration and the positioning of their eyes. With a mouth full of very sharp teeth, this species must be a scary sight to its potential prey. Growing to a length of 1m, the Crocodile Snake Eel looks just as frightening and also has rows of sharp teeth. This species can be one of the more colourful members of the family, with red, yellow, white or orange colouration. They are also very well camouflaged, with their rough skin and mottled colouration helping them blend in to their sandy environment.

A number of snake eel species are also found in the temperate waters of Australia, with the Serpent Eel (*Ophisurus serpens*) the most common species a diver will encounter. This long slender eel grows to 2.5m in length and, being a sandy colour, is often overlooked due to its excellent camouflage. This species is sometimes seen at muck sites off Sydney and Port Stephens.

CONGER EELS

Conger eels are more commonly associated with temperate waters, where they are more frequently encountered by divers than moray eels. However, conger eel species are found around the world and are even seen in muck habitats. The conger eel family contains over 100 members, and some species can grow to over 3m in length. Conger eels generally have a large head, a large mouth and large gill slits and prey on fish. In muck environments conger eels are often confused with snake eels, as they also live in the sand with only their head exposed.

The most common conger eel seen at muck sites throughout the Indo-Pacific region is the Big-eye Conger (*Ariosoma anagoides*), or Sea Conger. This eel reaches a length of 50cm and is easily identifiable by its very large eyes. It is hardly a common species, and is quick to disappear into the sand when spotted by a diver. A few other conger eel species are seen at muck sites, but some of these are undescribed and others are hard to identify when only their head is visible.

BELOW: The Big-eye Conger Eel is a rare muck critter.

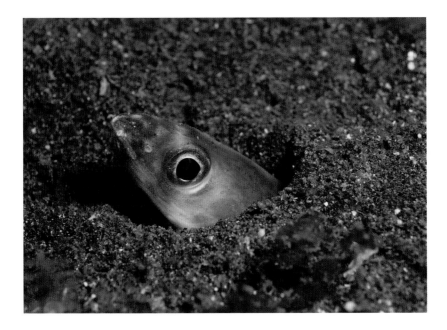

GARDEN EELS

Members of the conger eel family, garden eels live in large colonies in sandy habitats. These slender rope-like eels can be seen in their hundreds, and sometimes thousands, at some muck sites, swaying back and forth like a strange garden of plants. Around 35 species of garden eel have been described, and are usually only found in areas with a good cross-current, which brings them their food of zooplankton.

Garden eels are amazing to watch, but are very difficult to photograph, as many frustrated underwater photographers can testify. These sneaky eels lure you to take their photo as they boldly dance hanging out of their burrow. But as soon as you move close to them they slowly retract. And just when you are within camera range they completely disappear. It doesn't matter how slowly you creep up on them, you can rarely get close to most garden eel species without a long lens or a powerful zoom lens.

One of the most common garden eel species found while muck diving is the Spotted Garden Eel (*Heteroconger hassi*). This species reaches a length of 40cm, and is often seen with three-quarters of its body protruding from the sand. It is found throughout the Indo-Pacific region, and sometimes in water as shallow as 6m. This species is easily identified by its pretty black-and-white pattern and by the two black spots on each side of its body, just behind the head.

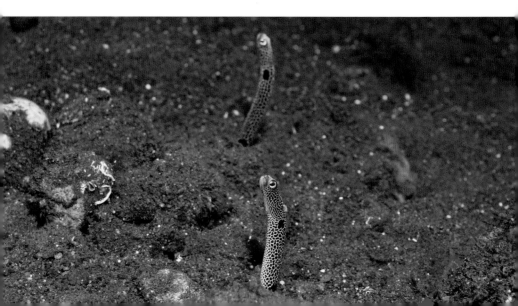

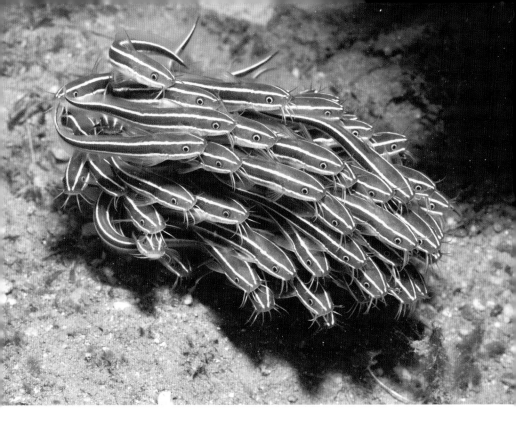

OPPOSITE: Spotted Garden Eels are common at many muck sites.

ABOVE: Striped Catfish are always found in schools.

CATFISH

The catfish are a very large family, with over 2,000 species. However, most catfish species live in freshwater and only a handful of species are seen in marine environments. Marine catfish are generally known as eeltail catfish, as they have an eel-like tail. These fish are also identified by barbels around the mouth, which look like cat's whiskers, and by their venomous fin spines. Divers should always take care around catfish as a jab from one of their spines can be very painful, or possibly cause death.

There is only one species of catfish that is commonly seen at tropical muck sites and it is not easily forgotten, the Striped Catfish (*Plotosus lineatus*). These black-and-white striped catfish are always found in schools that swarm across the

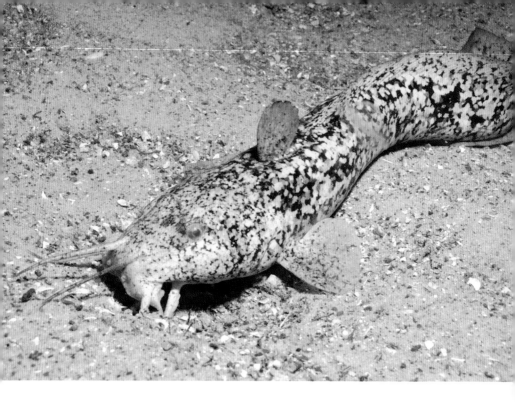

ABOVE: The Estuary Catfish is found at some Australian muck sites.

sand feeding. They grow to 35cm in length and are fascinating to watch as they move across the bottom like a rolling ball. At estuary muck sites in Australia there is another large catfish that divers have the chance of encountering, the Estuary Catfish (*Cnidoglanis macrocephalus*), which is also known as the Estuary Cobbler. This blotchy yellow-and-black catfish grows to 90cm in length and likes to shelter under ledges during the day.

LIZARDFISH

The lizardfish are not the most exciting group of fish to observe while muck diving, as they generally sit motionless on the bottom. However, if you ever see one of these fish attack and swallow another fish then you will treat them with a new-found respect. The lizardfish family contains around 35 species, and all have

a lizard-like head with a mouth full of sharp teeth. These elongated fish are found on reefs and in muck environments, and are mostly observed in pairs perched on a rock or partially buried in the sand. They are ambush predators and will attack any fish that is big enough to swallow, and sometimes a few that are little too big.

A number of lizardfish species are common at muck sites throughout the Indo-Pacific region. These fish are never hard to find, but seeing them attack other fish is generally a matter of being in the right spot at the right time. The Tailspot Lizardfish (*Synodus jaculum*) grows to 20cm in length and often buries itself in the sand. Also commonly seen half-buried in the sand is the Grey-streak Lizardfish (*Synodus dermatogenys*), which is also known as the Banded Lizardfish. This species has a grey line along its body and reaches 22cm in length. The Variegated Lizardfish (*Synodus variegatus*) is mostly seen sitting on coral or rocks. This species grows to 22cm in length and has an attractive red mottled pattern.

BELOW: The Variegated Lizardfish is a common species.

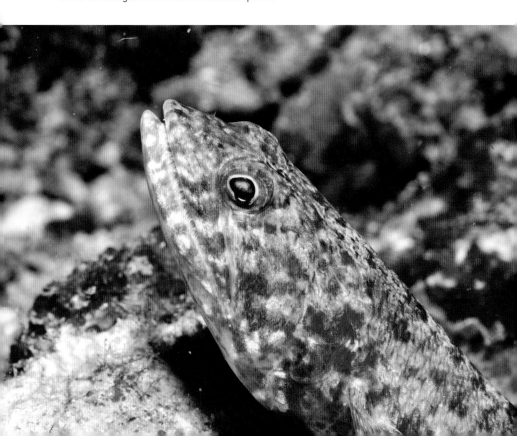

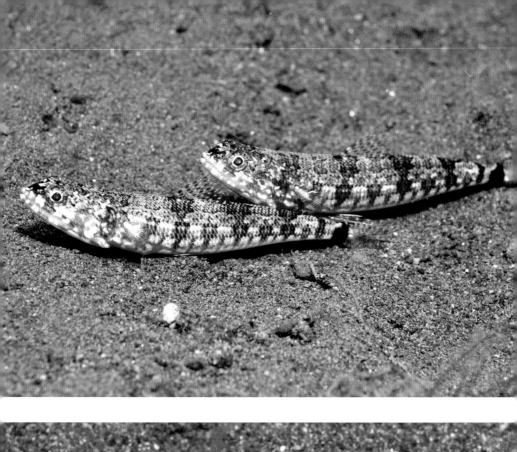

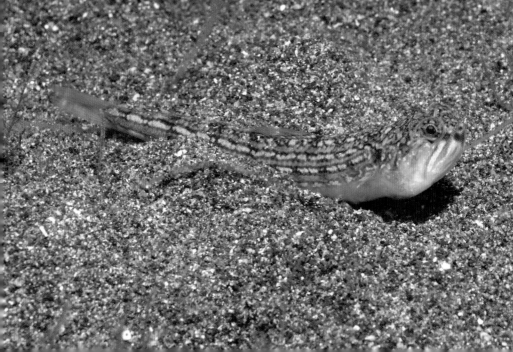

Another species sometimes seen at muck sites with fine powdery sand is the Painted Lizardfish (*Trachinocephalus myops*). Also known as the Painted Grinner, this fish grows to 40cm in length and often sits half-buried in the sand while awaiting prey, and will disappear into the sand if threatened.

TOADFISH

With wide mouths and flat heads it is easy to understand how the toadfish obtained their name. This family contains 80 species that are found in both reef and muck habitats around the world. Toadfish are quite a distinctive group of fish, but also difficult to find as they spend most of the day hidden in caves or under ledges. Ambush predators, toadfish use their camouflaged shape and colouration to capture fish, marine worms, crustaceans and molluscs.

Toadfish have one of the best parental care records of any fish. During the

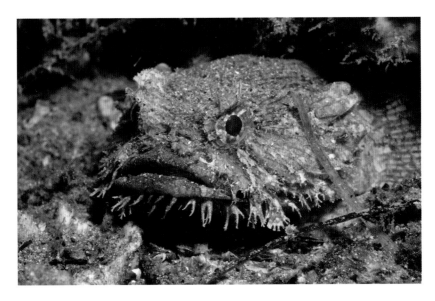

OPPOSITE ABOVE: Tail-spot Lizardfish are often found in pairs.

OPPOSITE BELOW: The Painted Lizardfish is generally found buried in the sand.

ABOVE: The strange Eastern Toadfish is endemic to Australia.

breeding season the male will establish a nest and then 'sing' to attract females by expanding and contracting his swim bladder. The best singers usually get the most girls, with multiple females depositing eggs in the male's nest for him to fertilise. The male then guards his batch of eggs until they hatch, never leaving to feed. He also stands guard over his young until they are big enough to fend for themselves.

Toadfish are one of those families that are not always seen in tropical muck diving sites. The most common species seen in the Indo-West Pacific appears to be Hutchin's Toadfish (*Halophryne hutchinsi*), which grows to a length of 14cm. Toadfish are actually more commonly seen in cooler waters and several species are found in muck sites in Australia. The Eastern Toadfish (*Batrachomoeus dubius*) is quite a large species, reaching 30cm in length, and often seen at Port Stephens and Sydney.

BELOW: Hutchin's Toadfish is a very rare muck critter.

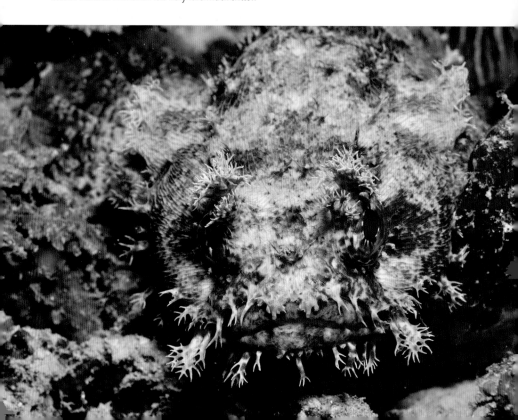

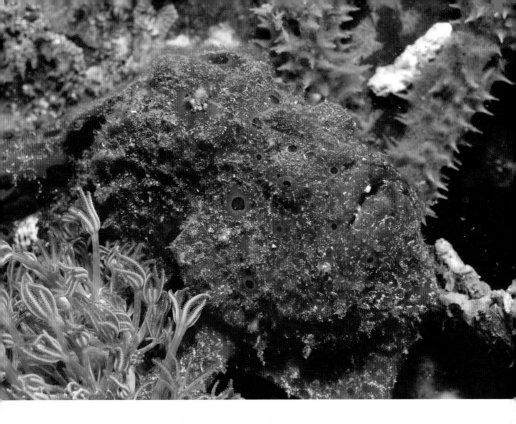

ABOVE: Painted Frogfish can be found in a range of colours.

FROGFISH

One of the main attractions of muck diving is the opportunity to encounter wonderful frogfish. Member of the anglerfish family, frogfish are among the most colourful and captivating critters a diver will ever see underwater. Ambush predators, almost all species of frogfish have fleshy lures attached to the end of a rod that protrudes from the head. The lure varies depending on the species – some look like worms, some like little squid and others like tiny fish. Around 50 species of frogfish have been described so far, with the greatest variety found in the Indo-Pacific region.

These charismatic fish are masters of camouflage, with colouration, body shape and even fleshy filaments hanging from their bodies to help them blend into the background. These sneaky critters can even change colour to assist

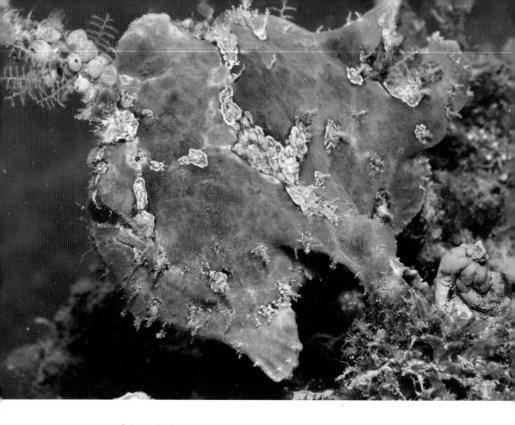

ABOVE: Giant Frogfish may be large, but they are also well-camouflaged.

their camouflage, and many resemble corals, sponges, algae and even ascidians. Although they can swim, reluctantly at times, most frogfish remain stationary for hours at a time, waiting for prey to come within striking range. And if they do move to get closer to prey, they walk using their pectoral fins, which are shaped like hands. Frogfish feed on fish, crustaceans and other frogfish at times, and have been known to bite off more than they can chew, attacking fish that are far bigger than they are. They capture prey by sucking the victim into their mouth and the attack can be so quick (around six milliseconds) that other fish don't even realise that one of their friends has disappeared from the school.

Frogfish reproduction strategies vary greatly; some species simply release eggs and sperm into the water column, while others lay eggs on a solid surface. Some species guard their eggs and a few even carry the eggs with them, with the female depositing the eggs on the side of the male's body. Young frogfish have to fend for

themselves as soon as they hatch, and some species have developed colourations that mimic toxic nudibranchs and flatworms, so that they don't end up as a tasty treat for another frogfish.

Frogfish are found both on reefs and in muck habitats, and one species, the Sargassum Anglerfish (*Histrio histrio*), even lives on rafts of floating seaweed. The following frogfish species are just a sample of these wonderful critters that divers can encounter while muck diving.

TROPICAL FROGFISH

The largest frogfish found in muck environments is the magnificent Giant Frogfish (*Antennarius commerson*), which grows to 30cm in length and likes to rest on sponges, and can be almost any colour you can imagine. Another colourful species is the Painted Anglerfish (*Antennarius pictus*), which reaches a length of 16cm. This species is very common and often has large spots decorating its body.

BELOW: Like all frogfish, Hairy Frogfish walk across the bottom on their fins.

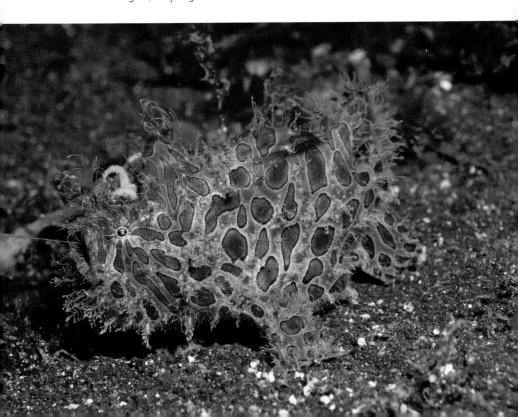

One of the most prized frogfish in muck environments is the Hairy Frogfish (*Antennarius striatus*), which is also known as the Striped Frogfish or Striate Frogfish. This species varies greatly in appearance, with some covered in long filaments that resemble hair, while others have only short spiky filaments or none at all. They usually have a tiger-like skin pattern, grow to 20cm in length and can often be found sitting on the seabed flicking their worm-like lure. The Shaggy Frogfish (*Antennarius hispidus*) is easily confused with the Hairy Frogfish, as it can have a striped skin pattern and filaments, but this species is much rarer and can be identified by its tubeworm-like lure. It grows to 20cm in length.

One of the best camouflaged frogfish that muck divers will see is the Spotfin Frogfish (*Antennatus nummifer*), which is rarely more than 10cm long and has a distinctive large spot towards the rear of its body, under the dorsal fin. The Spotfin

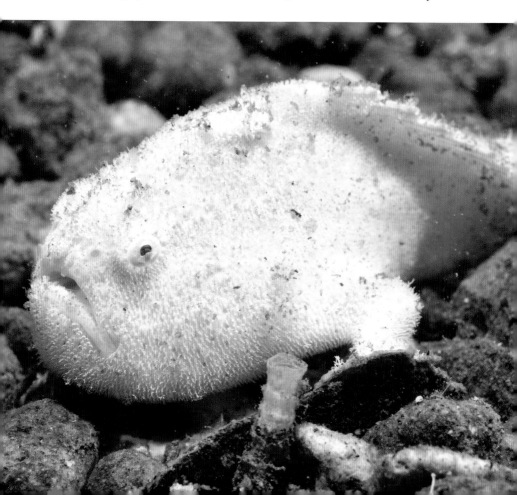

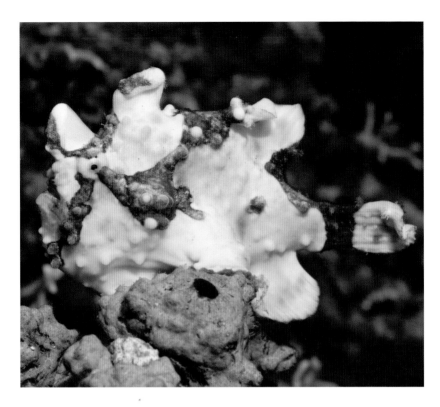

OPPOSITE: The Shaggy Frogfish is not a common species.
ABOVE: The Warty Frogfish is the most colourful member of the family.

is one of those species that is easily overlooked, and often requires the services of an eagle-eyed guide to locate it. One species that often stands out from the background with its garish colours is the Warty Frogfish (*Antennarius maculatus*), also known as the Clown Frogfish, which grows to 10cm in length and is often decorated with algae-like growths. It can be found sitting on sand or amongst corals, and has a lure shaped like a small fish.

TEMPERATE FROGFISH

One of the best collections of frogfish is found in the cooler waters of southern Australia. Around a dozen endemic species are found in this region, including a few species that are yet to be described. The Tasselled Frogfish (*Rhycherus*

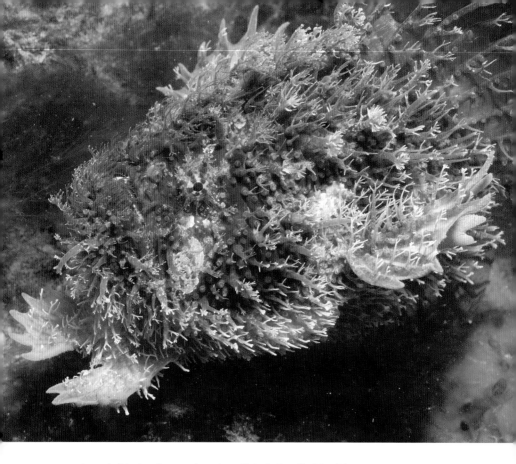

ABOVE: A wonderful critter from southern Australia is the Tasselled Frogfish.

OPPOSITE: Rare and endemic, the Spotted Handfish is only found off Tasmania.

filamentosus) is one of the most spectacular fish found in this region and also one of best-camouflaged members of its family. Weedy filaments grow all over the body of this species, and these closely match the surrounding corals, making the fish very difficult to see unless it moves. It grows to 23cm in length and is often found on the piers in Melbourne's Port Phillip Bay. Other weird frogfish to look out for in southern Australia are the Smooth Frogfish (*Phyllophryne scortea*), Prickly Frogfish (*Echinophryne crassispina*), and Reynold's Frogfish (*Echinophryne reynoldsi*).

HANDFISH

One very unusual family of muck fish that are only found in the cool waters of southern Australia are the handfish. Closely related to the frogfish, these rare fish also have a head lure, which they don't appear to use for fishing, and walk across the bottom on hand-like pectoral fins. But these pretty fish have more prominent fins, including a crest-like dorsal fin, and fan out all their fins when excited or threatened. Fourteen species of handfish have been described, and all are extremely rare, with a number of species close to extinction.

Handfish are not commonly seen by divers at any muck sites, but if exploring muck sites around Hobart in Tasmania, divers have a chance of seeing the spectacular Spotted Handfish (*Brachionichthys hirsutus*). This bizarre fish grows to a length of 12cm and is a creamy colour with brownish spots. Like all handfish they feed on small crustaceans and worms. Spotted Handfish spawn in September and October, with the female laying an egg mass of 80 to 250 eggs. She then guards the eggs until they hatch around eight weeks later. This species is listed as endangered, with numbers declining due to pollution, loss of habitat and invasive species eating their eggs and food.

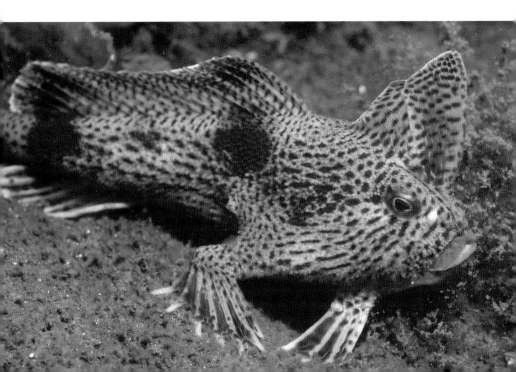

CLINGFISH

With a sucking disc that allows them to attach to objects, clingfish are a very unusual group of small fish. Around 100 species of clingfish are known, and while more common in reef habitats, a number of species are found while muck diving. These tiny fish can be found clinging to seagrass, kelp and corals, and a number of species also live commensal lifestyles, hiding in the arms of feather stars and the spines of sea urchins. The sucking disk on clingfish is found under the head and is created by modified pelvic fins. These cute fish have no scales, are quite colourful and have a smooth soft skin.

Two species of clingfish can be found residing in feather stars in the Indo-Pacific region, the Crinoid Clingfish (*Discotrema crinophila*) and the Two-stripe Feather Star Clingfish (*Discotrema lineata*). Both species are around 3cm long, and both have a striped body pattern, but they can be easily identified by their behaviour and body shape. The Crinoid Clingfish has a flattened body and spends

BELOW: Crinoid Clingfish are only found in feather stars.

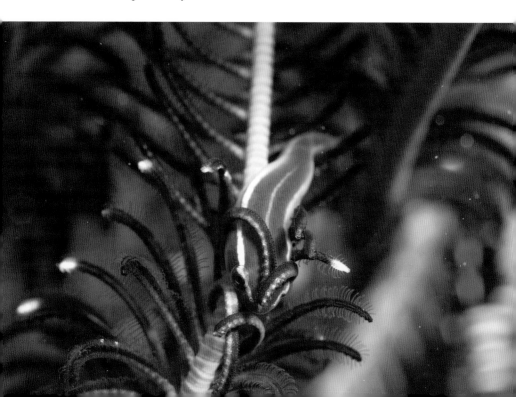

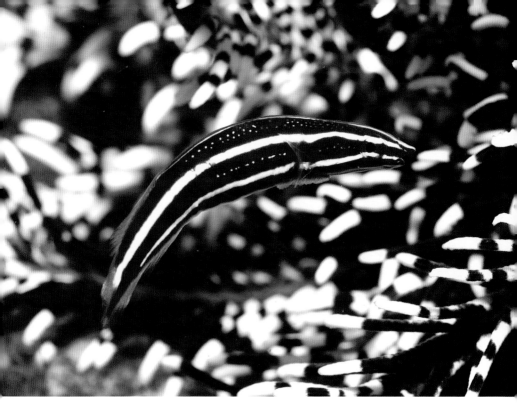

ABOVE: Two-stripe Feather Star Clingfish also hide in feather stars.

most of its time clinging to the arms or body of the feather star. The Two-stripe Feather Star Clingfish has a more rounded body and is more likely to be seen swimming amongst the arms of its host.

Another clingfish species seen in muck environments is the Longsnout Clingfish (*Diademichthys lineatus*), which is also known as the Striped Clingfish or the Urchin Clingfish. This species reaches a length of 5cm and is mostly observed darting between the spines of sea urchins. With an elongated snout and lovely reddish-brown colour it is quite photogenic.

Numerous clingfish species are also found in the cooler temperate waters off Australia, with the Eastern Cleaner Clingfish (*Cochleoceps orientalis*) a common species at muck sites off Sydney and Port Stephens. This pretty little fish reaches a length of 3cm and has a colourful pattern of bands and spots. They are generally observed clinging to kelp, sponges or rocks, but have also been observed cleaning

ABOVE: The Eastern Cleaner Clingfish can be found attached to almost anything.

BELOW: The Tasmanian Clingfish is endemic to Australia.

OPPOSITE: The strange Common Pineapplefish is not common at all.

other fish species. Another temperate species, generally only seen at night, is the Tasmanian Clingfish (*Aspasmogaster tasmaniensis*), which grows quite large, up to 8cm long, and comes in a variety of colours, but always has a darker banded pattern.

PINEAPPLEFISH

There are not many fish as strange as the pineapplefish. This small family contains only four species found in the Indo-Pacific region, and they do look remarkably like a pineapple. These bizarre yellow-and-black critters have a hard exoskeleton made of armour-like scales, and if that wasn't strange enough they also possess bioluminescent organs below the eyes, almost like headlights, that they use for feeding on shrimp at night. Pineapplefish are nocturnal and spend the day sheltering under ledges, often in small groups.

Divers rarely see pineapplefish at most muck sites, but the Common Pineapplefish (*Cleidopus gloriamaris*) makes a regular appearance in Australian waters. This species is often found under ledges at Port Stephens and Sydney. It is the largest member of the family and grows to 25cm in length. They seem to have favoured homes, which is good news for divers wishing to see and photograph them, with one group recorded under the same ledge at Port Stephens for seven years. These bizarre fish are very slow swimmers, and if you spend a little time observing them, you may even hear them croaking like a frog.

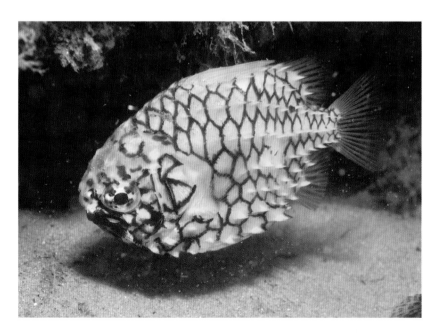

SHRIMPFISH

Bobbing around the bottom with their head down and tail up, shrimpfish, which are sometimes known as razorfish, are one of the strangest fish a diver will encounter in muck environments. They are very thin and shaped like a cut-throat razor, and always seen in schools that vary in number from less than a dozen to several hundred. These bizarre fish swim in a vertical position, and are regularly seen sheltering in corals, sea whips, seagrasses, feather stars and sea urchins. They feed on tiny shrimp and zooplankton. Four species are found in the Indo-Pacific region, but only two are commonly seen in muck habitats and are very similar.

The Rigid Shrimpfish (*Centriscus scutatus*), also known as the Grooved Shrimpfish, and the Coral Shrimpfish (*Aeoliscus strigatus*), also known as the Jointed Shrimpfish, are quite difficult to tell apart. Both grow to 15cm in length, and both are found in schools, but the former appears to be far more common in muck environments. Shrimpfish are not difficult to find, but they are difficult to photograph, with a lot of patience required to get good images of these bizarre fish.

BELOW: Rigid Shrimpfish are almost always found in schools.

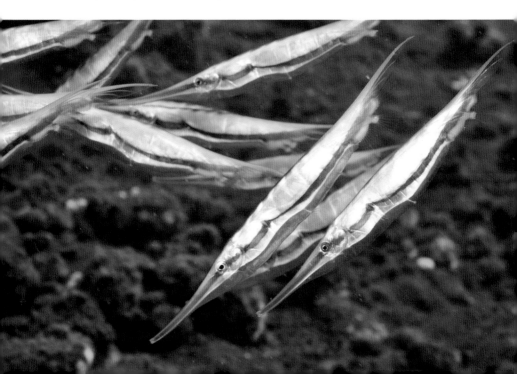

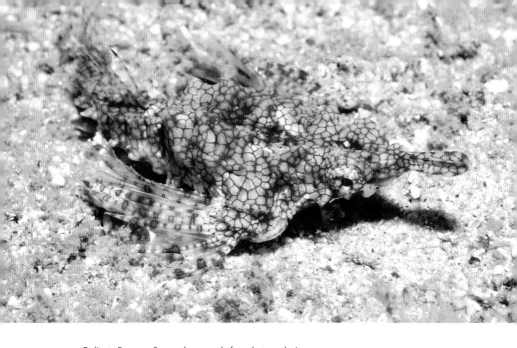

ABOVE: Delicate Pegasus Seamoths are only found at muck sites.

SEAMOTHS

If a fish and moth ever had their genes spliced together by some mad scientist the result couldn't look any weirder than the very strange seamoths. This small family of fish – only five species are known – is only found in the Indo-Pacific region. Seamoths have a rigid body-casing, a tube like snout, and modified pectoral fins that look like wings, which they use to walk across the seabed. They feed on worms and other small invertebrate species that can be sucked into their elongated snout.

The most common species of seamoth that divers will encounter while muck diving is the Pegasus Seamoth (*Eurypegasus draconis*), which is also known as the Little Dragonfish. These delightful little fish are usually found in pairs and reach a maximum length of 8cm. They are always fun to watch as they slowly walk across the bottom, stopping now and then to dig their snout into the sand to locate food. When mating, the male and female perform a slow dance around each other, before swimming towards the surface to release their eggs and sperm. A rarer species that turns up occasionally at muck sites is the Slender Seamoth (*Pegasus volitans*).

165

GHOSTPIPEFISH

The lovely ghostpipefish are among the most delicate and dainty critters found in muck environments. This small family contains only six recognised species, and a few undescribed species, and is only found in the Indo-Pacific region. Similar to their close relatives the seahorses and pipefish, ghostpipefish have a hard body-casing, a tube like snout and small fins. But they have a different breeding strategy to their relatives, with the female holding on to her clutch of eggs by cupping them in her pelvic fins until they hatch. Ghostpipefish feed on small shrimps, which are sucked into the mouth with a vacuum action.

Two species of ghost pipefish are common at muck diving sites, the Ornate Ghostpipefish (*Solenostomus paradoxus*) and the Robust Ghostpipefish (*Solenostomus cyanopterus*). Both these species are easy to find, once you know what to look for, but are also seasonal at muck sites. Where they disappear to at other times of the year is a mystery.

The Ornate Ghostpipefish comes in a range of colours and has hair-like filaments all over its body that assist in camouflage. It grows to 10cm in length and is usually found in pairs, but sometimes occurs in groups of up to a dozen. Ornate Ghostpipefish are often observed hiding in feather stars and black coral trees.

The Robust Ghostpipefish is more plain and often has a colouration that makes it look like a rotting leaf. This species grows to 15cm in length. Divers usually observe them close to the bottom pretending to be a drifting leaf, and they are mostly found in pairs.

Rarer ghostpipefish which turn up at muck sites from time to time include the Roughsnout Ghostpipefish (*Solenostomus paegnius*), Halimeda Ghostpipefish (*Solenostomus halimeda*) and Velvet Ghostpipefish (*Solenostomus* sp.).

OPPOSITE TOP: Robust Ghostpipefish.
OPPOSITE MIDDLE: Ornate Ghostpipefish.
OPPOSITE BOTTOM: Roughsnout Ghostpipefish.

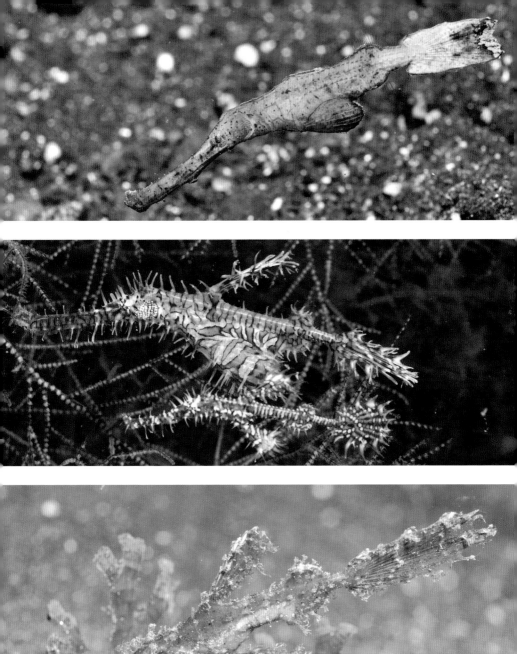

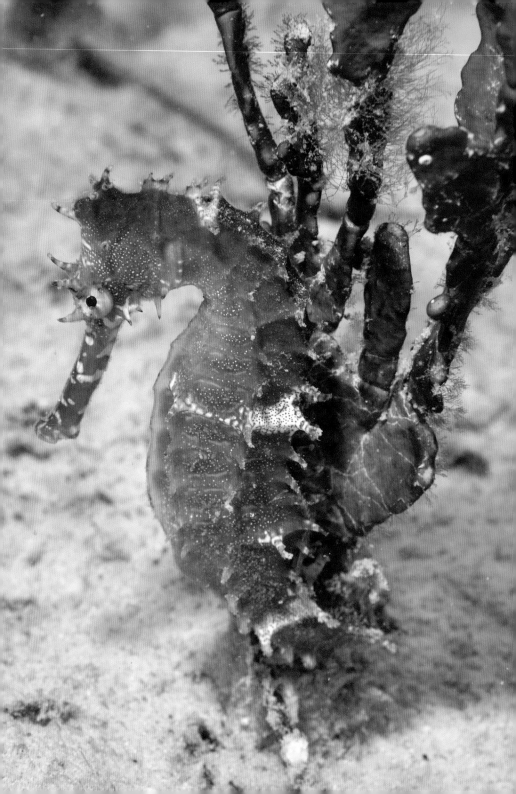

SEAHORSES

The wonderful seahorses are among the most enigmatic creatures of the muck realm. They are members of the large Syngnathidae family, which also contains the pipefish, pipehorses and seadragons. Seahorses are found in tropical and temperate seas around the globe. All members of this family have armoured body-plates, a long tube-like snout and small fins, with the seahorses also possessing a prehensile tail that allows them to grip on to any base. More than 50 species of seahorses have been described, and these vary in size from the tiny pygmy seahorses, which are only 1cm high, to larger species that are 35cm high.

Seahorses are found on both reef and muck environments and feed on mysid shrimps and other small crustaceans. They have a very unique reproduction strategy, with the male being the one to get pregnant. After an elaborate courtship ritual, which can last for days, the male and female join together to mate. The female then deposits her eggs into a special brooding pouch on the male's stomach. The male then retains the eggs in his pouch until they hatch, with his stomach getting quite extended, as if he was pregnant. It can take two to four weeks for the eggs to hatch, depending on the species, and once they are ready to emerge the male ejects them from the pouch with muscular contractions. The young seahorses then have to fend for themselves.

Most seahorses are very well camouflaged, with colouration that matches their preferred habitat. They can be found anchored to sponges, sea whips, seagrasses, soft corals, hard corals, gorgonians, algae, rocks, junk, branches, ropes and even feather stars.

TROPICAL SEAHORSES

The most common seahorse divers will encounter while muck diving in the tropics is the pretty Thorny Seahorse (*Hippocampus histrix*), which is very distinctive with a covering of short spines, and is often found in seagrass beds. The Thorny Seahorse grows to 17cm in height, and is usually a greenish-yellow colour that helps it

OPPOSITE: The most common seahorse divers will find while muck diving in Asia is the pretty Thorny Seahorse.

blend in with the seagrass. With a name like Common Seahorse (*Hippocampus kuda*) you would expect this species to be very common, and it is in some places and not in others. This species is also known as the Spotted Seahorse, as it usually has a covering of small spots, and can grow to 28cm high. The Tiger-tail Seahorse (*Hippocampus comes*) is found on reef and muck environments, and is often a brilliant yellow colour. The young of this species look very different from the adults, as they are covered in weed-like growths.

TEMPERATE SEAHORSES

Australia has the largest variety of seahorse species, and many of these are seen in muck habitats. White's Seahorse (*Hippocampus whitei*) is found on the east coast and is regularly encountered by divers at Port Stephens and Sydney. Another species found at these muck sites, and in Melbourne, is the Bigbelly Seahorse (*Hippocampus abdominalis*). This is the largest seahorse species in the world and can reach a height of 35cm. Another lovely member of the family seen off Melbourne is the Shorthead Seahorse (*Hippocampus breviceps*), which has long filaments growing from its body and reaches a height of 10cm.

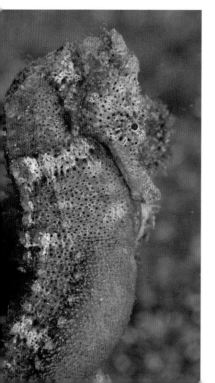
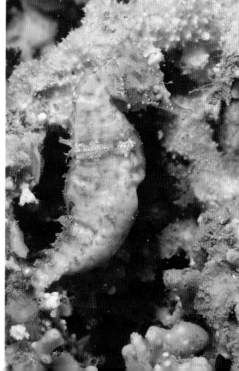

OPPOSITE LEFT: Common Seahorse.

OPPOSITE RIGHT: White's Seahorse.

RIGHT: Shorthead Seahorse.

BELOW: Bigbelly Seahorse.

BOTTOM: Tiger-tail Seahorse.

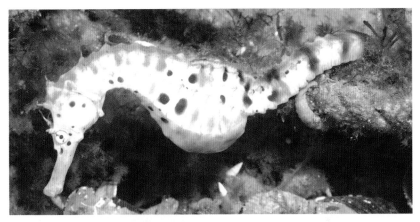

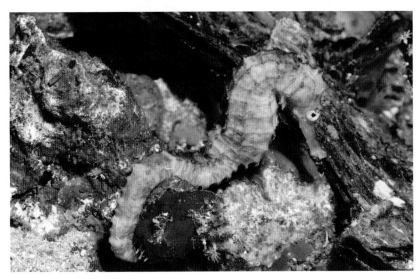

PYGMY SEAHORSES

Before 1997 only one species of pygmy seahorse was thought to exist, but with the advent of muck diving, and with keen-eyed divers looking for unusual critters, another seven species of these tiny seahorses have been discovered. Pygmy seahorses are true seahorses, just miniature versions of their better-known cousins. They are all small and extremely well camouflaged, with colouration and body decoration that matches their preferred habitat. These tiny creatures are found on both reef and muck, and are so small that a good guide is usually required to locate them.

The first pygmy seahorse discovered is still the most common, the Bargibant's Pygmy Seahorse (*Hippocampus bargibanti*), which is generally less than 2cm high and is found on only one species of sea fan – it has nodules on its body that match those of the fan. Denise's Pygmy Seahorse (*Hippocampus denise*) is found on a few species of gorgonian and grows to a height of 1.5cm. Although quite plain in appearance, this species' colouration and thin body perfectly match the structure of its host gorgonian. Another species that you may be lucky enough to see in muck environments is Pontoh's Pygmy Seahorse (*Hippocampus pontohi*), which grows up to 1.7cm tall, although some are no bigger than a grain of rice – they are generally a whitish colour and usually lives on algae or hydroids.

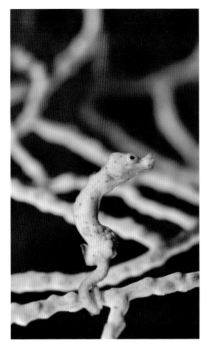

ABOVE LEFT: Denise's Pygmy Seahorse. ABOVE RIGHT: Pontoh's Pygmy Seahorse.

OPPOSITE: Bargibant's Pygmy Seahorse.

PIPEHORSES

The pipehorses are a strange mix between a seahorse and a pipefish, with most members of this family decorated with body filaments that help to camouflage them in their habitat. Pipehorses are more closely related to the seahorses, possessing a prehensile tail, but they lack a neck and angled head like the seahorses and their elongated body shape is more like a pipefish. Over a dozen species of pipehorses are known, and a few grow to 50cm in length, but most species are small and commonly referred to as pygmy pipehorses.

The most common member of the pipehorse family seen at muck sites in the Indo-Pacific region is the Shortpouch Pygmy Pipehorse (*Acentronura breviperula*). This well-camouflaged fish grows to 6cm in length and is typically found clinging to seagrasses. A good guide will be required to point out this species as it is

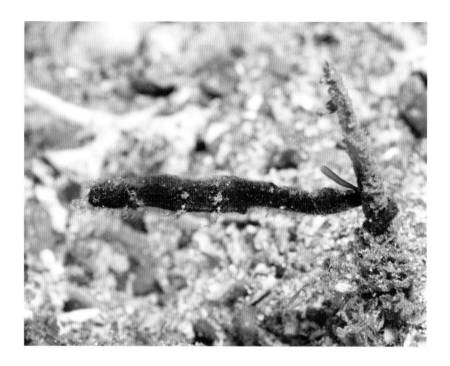

ABOVE: The Shortpouch Pygmy Pipehorse is a difficult species to find.

OPPOSITE ABOVE: The Sydney Pygmy Pipehorse is only known from a few dive sites in Australia.

OPPOSITE BELOW: Several undescribed pygmy pipehorses are seen at muck sites.

always difficult to locate. A number of other tropical pygmy pipehorses are also occasionally seen, and a few new species have been found in recent years that are still undescribed.

The cool waters of southern Australia also play host to a variety of pygmy pipehorses. Occasionally seen in southern Australian waters is the Southern Pygmy Pipehorse (*Idiotropiscis australe*), which looks like it is covered in algae and grows to a length of 6cm. A more common member of this family is found off Sydney and is known as the Sydney Pygmy Pipehorse (*Idiotropiscis lumnitzeri*). Discovered by an observant Sydney diver in 1997, this lovely little fish also grows to 6cm in length.

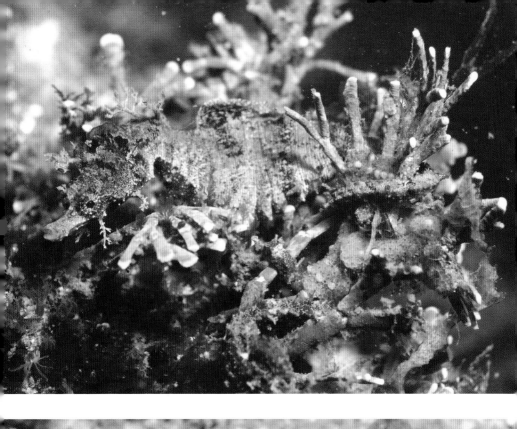

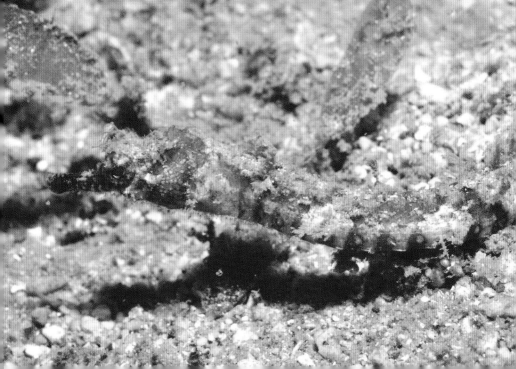

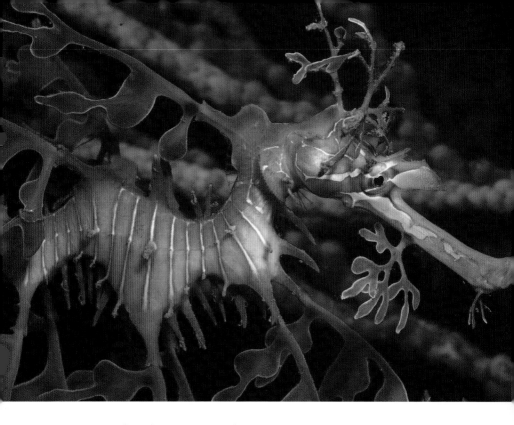

ABOVE: The beautiful Leafy Seadragon is only found in southern Australia.

SEADRAGONS

In the waters of southern Australia live two bizarrely beautiful creatures found nowhere else on earth – the majestic Weedy Seadragon and Leafy Seadragon. These two wonderful fish are closely related to the seahorses, and their head and body look very similar to their close cousins. But seadragons differ in lacking a prehensile tail and they are also covered in elaborate weed-like growths that help to camouflage them around seagrass, seaweed and kelp. Seadragons share a similar reproductive strategy to seahorses, with the male retaining the eggs, however they don't have a pouch and instead stick the eggs to their tail until they hatch.

The species more commonly seen by divers is the Weedy Seadragon (*Phyllopteryx taeniolatus*), which is found in all the southern states of Australia, from southern Western Australia to central New South Wales. This species grows to 45cm in

length and is often encountered at muck sites with kelp and seagrass. The Weedy Seadragon has only a few fleshy appendages, but these and its colouration can make it difficult to locate. The colours of these fish vary from state to state, but all have a base which is red, pink and purple, and are covered in yellow dots. The most colourful individuals are seen off New South Wales and Tasmania.

The Leafy Seadragon (*Phycodurus eques*) is one of the most highly prized photo subjects in the marine world, with divers from around the planet travelling to the cool waters of southern Australia to encounter these wonderful fish. They reach a length of 35cm, and covered in elaborate weed-like growths they blend in perfectly with their environment. Their camouflage is so effective that small fish often hide amongst the growths thinking they are hiding in seaweed. This incredible fish is only found off Victoria, South Australia and southern Western Australia. Leafies are typically a yellowish-green colour with pretty white face patterns and slim white bars along the body.

BELOW: The Weedy Seadragon is found at some muck sites off Sydney.

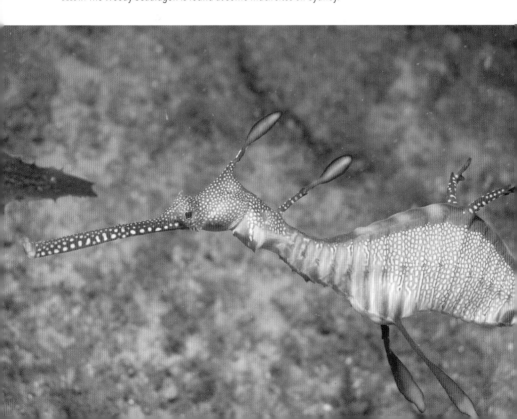

Both seadragon species are slow swimmers, and generally found in the one location for extended periods. They feed on tiny mysid shrimps, which are sucked up with a vacuum-like action by their elongated snouts. Seadragons are generally solitary creatures, only coming together to breed. Although seen at many muck sites in southern Australia that have seagrass and kelp, a guide is always a big help when trying to locate your first seadragon, as their camouflage is so good that many divers simply swim straight past these amazing creatures.

PIPEFISH

Looking more like a stick that a fish, pipefish are a common critter in muck habitats. Pipefish are really elongated seahorses, with a dorsal fin and small caudal fin. Around 200 species of pipefish have been described, and they all have a similar reproduction strategy to the seahorses, with the male carrying the eggs in a brooding pouch. Found on both reef and muck habitats, pipefish are very slow swimmers, and many just snake across the bottom. Being immobile for most of the time, many pipefish species are well camouflaged, to avoid being eaten by predators such as frogfish.

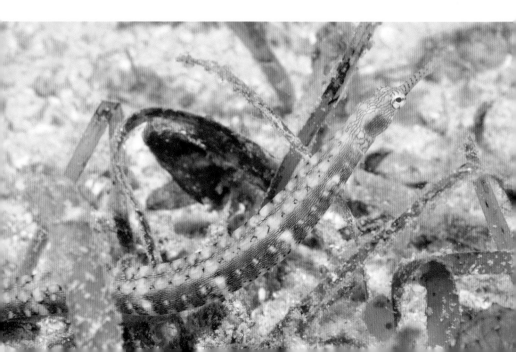

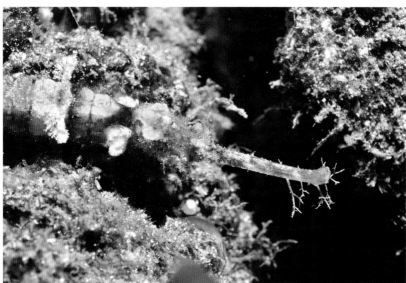

OPPOSITE: The Messmate Pipefish is generally found in seagrass.

TOP: The Banded Pipefish resides in caves and ledges.

ABOVE: The Whiskered Pipefish is a well-camouflaged species.

TROPICAL PIPEFISH

One of the most common pipefish seen while muck diving is the Longsnout Pipefish (*Trachyrhamphus longirostris*), also known as the Straightstick Pipefish, which grows to a length of 40cm and occurs in a variety of colours. Equally long is the Bentstick Pipefish (*Trachyrhamphus bicoarctatus*), which is easily confused with the Longsnout, but has more of a bend at the neck. Another species to look out for is the Mud Pipefish (*Halicampus grayi*), which is very well camouflaged and grows to a length of 15cm.

A number of small pipefish species are often observed around seagrasses, with the Messmate Pipefish (*Corythoichthys intestinalis*) the most common. It grows to 16cm in length and has a pattern of fine lines covering its body. One of the prettiest species found in muck habitats is the Whiskered Pipefish (*Halicampus macrorhynchus*). This species has exceptional camouflage with whiskers on its snout and what looks like small wings along its body. It grows to a length of 18cm and can be very colourful or quite plain.

A far more active pipefish found in muck environments is the Banded Pipefish (*Dunckerocampus dactyliophorus*). This distinctive species with its red and white bands is usually found under ledges, and always in pairs. It grows to a length of 20cm and is difficult to photograph as it darts around constantly.

TEMPERATE PIPEFISH

Australia once again has more than its fair share of pipefish species, which are seen at muck sites around the country. The Tiger Pipefish (*Filicampus tigris*) reaches a length of 35cm and is common at most muck sites in Australia. It has a lovely pattern of bands, blotches and lines, and is easy to observe and photograph as it sits still on the bottom. A number of species with very short snouts are also found in Australia, including the Ringback Pipefish (*Stipecampus cristatus*), which grows to 25cm in length and is often found around Melbourne.

OPPOSITE ABOVE: The Bentstick Pipefish is a common muck critter.
OPPOSITE MIDDLE: The Tiger Pipefish is found at muck sites in Australia.
OPPOSITE BELOW: The Ringback Pipefish is endemic to southern Australia.

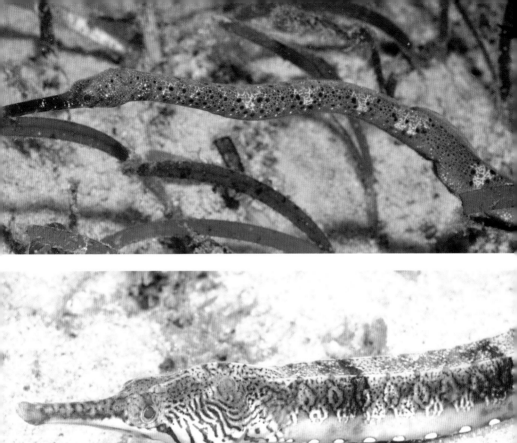
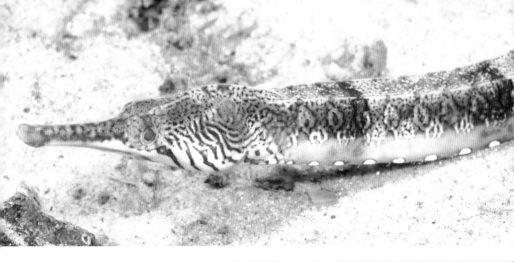

SCORPIONFISH

Scorpionfish are very well represented in muck environments, and many members of this large family are prized photographic subjects. All scorpionfish have venomous spines, however the toxicity varies greatly between the species. But in general you don't want to be jabbed by any member of the scorpionfish family. Most are ambush predators and well camouflaged, and divers often swim right past them without realising what they are missing. This large family includes too many species to document in this book, but the ones included are the most interesting ones that divers will encounter while muck diving.

BELOW: The Reef Stonefish is colourful but deadly.

ABOVE: The Horrid Stonefish likes to bury in the sand, so always watch where you place your hands.

STONEFISH

One muck critter that you don't want to stumble upon accidently is a stonefish. The deadliest members of the scorpionfish family, stonefish have been responsible for numerous deaths and divers should always take care around them. This family contains five species that are extremely well camouflaged to look like stones or lumps of algae. Two species are common on reef and muck sites throughout the Indo-Pacific region – the Reef Stonefish (*Synanceia verrucosa*) and the Horrid Stonefish (*Synanceia horrid*), which is also known as the Estuarine Stonefish. Both these fish can grow quite large, around 40cm long, however with their camouflage and habit of burying themselves in the sand they are easily missed without the aid of a guide. Stonefish are not the most attractive critters a diver will see, but the Reef Stonefish wins in terms of looks as it is much more colourful, occurring in shades of pink, yellow or orange.

LIONFISH

Beautiful but deadly, lionfish are beautiful to look at with their feather-like fins and lovely colours, but they are ferocious predators and highly venomous. Native to the Indo-Pacific region, 18 species of lionfish have been described and they are found in both reef and muck environments. These pretty fish feed mostly at night by fanning out their pectoral fins to round up small fish, shrimps and crabs. The Common Lionfish (*Pterois volitans*) is such an efficient killing machine that it has devastated reefs in the Caribbean since being introduced there in the 1990s by some misguided aquarium owners. This species is the largest member of the family and grows to 35cm in length.

More appealing members of the family, that muck divers should keep an eye out for, are the Dwarf Lionfish (*Dendrochirus brachypterus*) and the Bluefin Lionfish (*Parapterois heterura*). The Dwarf Lionfish varies greatly in colouration, grows to 15cm in length and spends the day tucked up on sponges or rocks, or amongst bottom debris. The Blue-fin Lionfish is less common and smaller,

BELOW: The Dwarf Lionfish is a common muck critter.

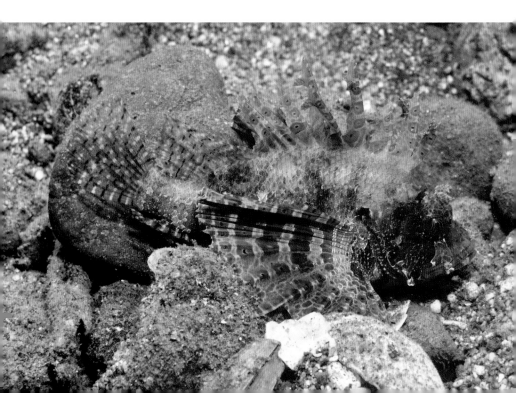

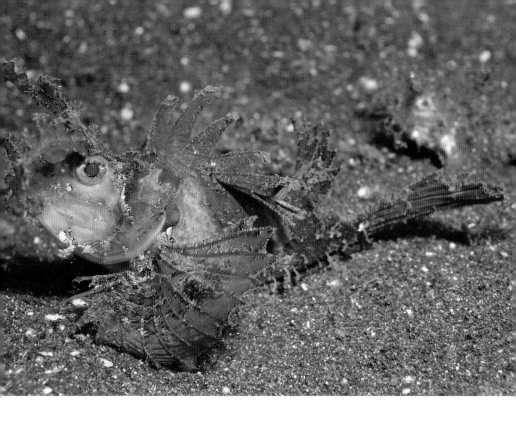

ABOVE: Ambon Scorpionfish is a prized muck species.

only reaching 11cm in length. It is happy to sit on the sand and is often found in pairs. With lovely vivid blue patterns on its pectoral fins it is one of the most outstanding members of the lionfish family.

AMBON SCORPIONFISH

The Ambon Scorpionfish (*Pteroidichthys amboinensis*) is quite a small fish, only reaching 12cm in length, but with its prominent weedy appendages it is one of the more spectacular members of the scorpionfish family. This species generally only occurs in muck habitats, and is found throughout the Indo-West Pacific region. Highly prized by underwater photographers, the Ambon Scorpionfish varies greatly in colour, with yellow, cream, brown, red and pink morphs recorded. This bizarre scorpionfish is not common at any muck site, and seems to come and go from locations, so seeing one is often a matter of good luck.

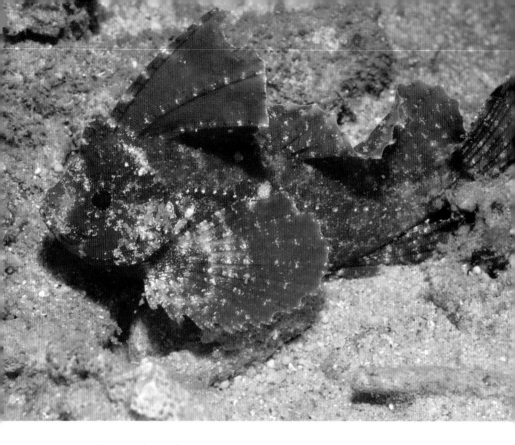

ABOVE: Cockatoo Waspfish are found at muck sites throughout Asia.

COCKATOO WASPFISH

Named for is large crest-like dorsal fin, the Cockatoo Waspfish (*Ablabys taenianotus*) is found throughout the Indo-West Pacific region. This well-camouflaged species grows to a length of 15cm and is usually a uniform brownish colour, although individuals often have a paler snout. These fish have evolved to resemble a dead leaf, and they use this camouflage to their advantage in order to ambush their preferred prey of shrimps, crabs, small fish and worms. They even act the part of a dead leaf, rocking and drifting across the seafloor just like a leaf would. The Cockatoo Waspfish is common at many muck sites. They are more active by night, and spend the day hidden amongst debris, so are often difficult to spot without the help of a good guide.

DEMON GHOUL

With a face that only a mother could love, the Demon Ghoul (*Inimicus didactylus*) is definitely one of the most unattractive and scary muck critters a diver will encounter. A member of the genus *Inimicus*, which contains nine other equally ugly fish, the Demon Ghoul is found throughout the Indo-West Pacific region. Depending on the location this fish has been given a variety of common names, none of which are very flattering, including Longsnout Stingerfish, Demon Stinger, Devil Stinger and Spiny Devilfish to name a few.

The Demon Ghoul is common in muck habitats and during the day can be found half-buried in the sand or amongst debris. This species is usually dull brown, grey, red or yellow in colour, but they have very colourful pectoral and caudal fins that they open and display when threatened. It grows to a length of 26cm and is far more active at night, when it can be seen walking across the seabed on four modified fins that act as legs. Although well camouflaged, it is an easy species to find in most muck habitats.

BELOW: The Demon Ghoul is a common muck critter.

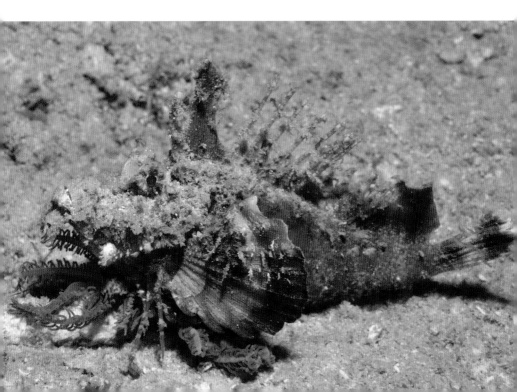

GOBLINFISH

One of the weirdest members of the scorpionfish family would have to be the bizarre Goblinfish (*Glyptauchen panduratus*). Only found off southern Australia, it grows to a length of 20cm and is one very strange-looking fish. For a start it has a squashed head and what looks like a neck. It also has a blood-red ring around its eye, and venomous dorsal spines. The Goblinfish also has feather-like pectoral fins, and when threatened it can fan out these fins and flatten its body, which actually makes it look a bit like a chicken without a beak.

Goblinfish are only occasionally seen at Australian muck sites. These unusual fish are nocturnal, and spend the day squashed up beside similar-coloured rocks. They can be very difficult to find, but divers have seen them off Melbourne occasionally.

BELOW: The strange Goblinfish is only found in southern Australia.

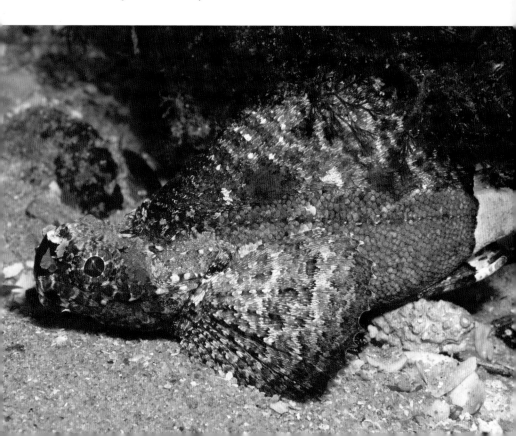

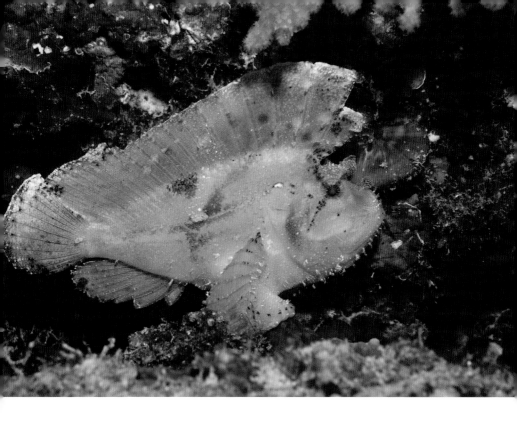

ABOVE: Leaf Scorpionfish are one of the prettiest members of the scorpionfish family.

LEAF SCORPIONFISH

The delicate Leaf Scorpionfish (*Taenianotus triacanthus*), or Paperfish, is one of the most beautiful members of the scorpionfish family and a wonderful photographic subject. Found throughout the Indo-Pacific region, it grows to a length of 10cm and comes in a dazzling array of colours – white, cream, pink, red, brown, yellow, green, and sometimes a mix of colours. These amazing little fish also moult every two weeks, so regularly change their colour palette.

The Leaf Scorpionfish has a very flat body and high dorsal fin that make it look like a dead leaf, similar to the Cockatoo Waspfish. These lovely little fish are ambush predators, and sneak up on prey by pretending to be a dead leaf, slowly rocking from side to side. They are often observed around shrimps and small fish, just waiting for a victim to come close to their mouth so that they can

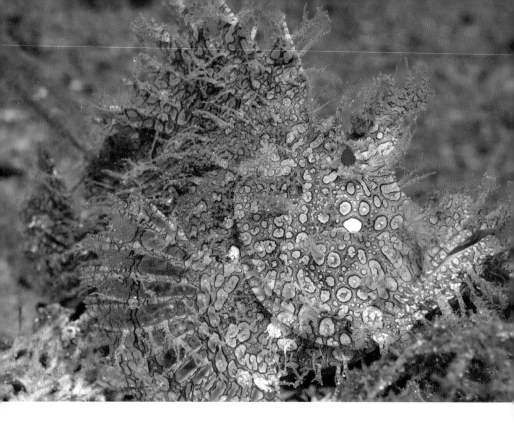

ABOVE: The Weedy Scorpionfish is rarely seen at most muck sites.

be sucked in and consumed. To enhance their camouflage they also have fleshy appendages sprouting from their head, and sometimes blotchy patterns that make them look more like a rotting leaf. Found in both reef and muck environments, Leaf Scorpionfish are often found in pairs, so if you find one have a close look around for its partner.

WEEDY SCORPIONFISH

A member of the famed genus *Rhinopias*, the Weedy Scorpionfish (*Rhinopias frondosa*) is found throughout the tropical Indo-West Pacific region and is one of the most highly prized muck critters that underwater photographers dream of finding. This bizarre-looking fish comes in two forms, a pretty but plain morph and very spectacular weedy morph, and until recently they were thought to be two different species.

The Weedy Scorpionfish reaches a length of 23cm and is found both on coral reefs and in muck environments. The plain variety (once called the 'Paddle-flap Scorpionfish') is more regularly seen in muck habitats. Considering that it is an ambush predator, the plain variety often stands out from its background due to its bold colouration of red, pink, white, yellow, grey and even purple, whereas the weedy morphs are far better camouflaged. These colourful fish often walk on their fins, and feed on shrimps, crabs and small fish.

Even at the top muck diving sites like Lembeh and Anilao, encounters with Weedy Scorpionfish can never be guaranteed, but if one is in the area all the dive guides will know about it. Ambon appears to be one of the best places to see this species, with both forms encountered on a regular basis, and recently a video of this species mating was captured in this area.

BELOW: The Mossback Velvetfish is only found at Australian muck sites.

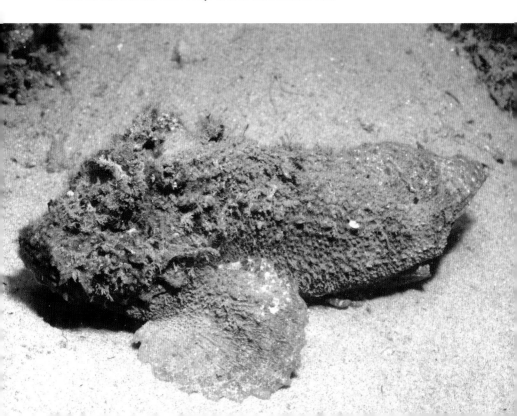

OPPOSITE ABOVE: The Phantom Velvetfish is a rare muck critter.

OPPOSITE BELOW: The Southern Velvetfish is found at muck sites in Southern Australia.

VELVETFISH

The velvetfish are another group of very unusual critters that divers will encounter when muck diving. Over 40 species have so far been described, and the family got its name because a very confused person thought their skin was like velvet. These fish are another part of the scorpionfish family, but not all species have venomous spines.

Velvetfish have a very long dorsal fin that travels the length of the body. They are also well camouflaged, with a colouration and body texture that matches their background. Velvetfish are found in both tropical and temperate waters, and these are just some of the more typical species.

A tropical species that turns up at muck sites in the Indo-Pacific region is the Phantom Velvetfish (*Paraploactis kagoshimensis*). Usually a greyish-brown colour, yellow versions of this fish are seen occasionally that are far more photogenic. The species reaches a length of 12cm and is not common. The very similar-looking Mossback Velvetfish (*Paraploactis trachyderma*) grows to 11cm in length and is endemic to Australia. It is often seen by divers at muck sites at Port Stephens and Sydney.

In the waters of southern Australia divers will find a number of velvetfish species, with the most common being the Southern Velvetfish (*Aploactisoma milesii*). This well-camouflaged fish reaches a length of 23cm and divers will find them sitting amongst debris at muck sites at Port Stephens, Sydney and Melbourne.

GURNARDS

The gurnards are a weird group of fish that walk across the seafloor and have large wing-like fins. This family contains over 200 species that are found in oceans around the world. Gurnards are bottom-dwelling fish that have an armour-plated body, large eyes and six spiny legs (modified pelvic fins) that they use to probe

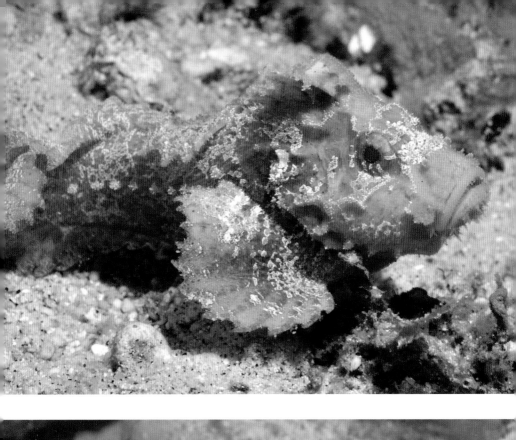

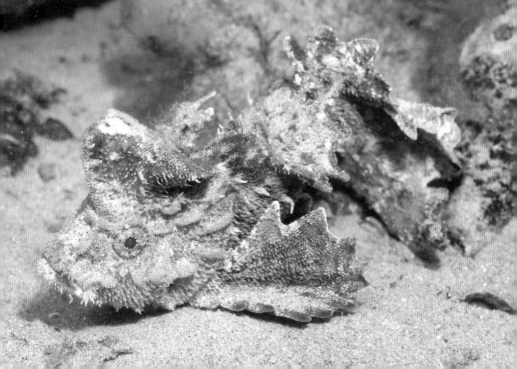

the sand for food and also to walk with. These strange fish also have oversized pectoral fins that can be opened up like a pair of wings. These wings are generally folded away, and only opened when swimming or when threatened, as they make the fish look bigger to potential predators. Members of this unusual family of fish also have a drumming muscle that beats against the swim bladder to make a drumming sound. While gurnards live in muck environments, they are not regularly seen in tropical waters, and divers have more chance of encountering one in cooler temperate waters.

The waters of southern Australia are home to a number of gurnard species. The most colourful member of the family would have to be the beautiful Eastern Spiny Gurnard (*Lepidotrigla pleuracanthica*), which grows to about 20cm in length. This spectacular fish is encountered at muck sites at Port Stephens and Sydney, and is a fabulous photographic subject when it fans its bright blue wings. The more common Spiny Gurnard (*Lepidotrigla papilio*) is very similar in size and appearance, but instead possesses pale blue wings. This species is more common in southern Australia, and regularly encountered at muck sites around Melbourne.

BELOW: The Eastern Spiny Gurnard is another great critter only found in Australia.

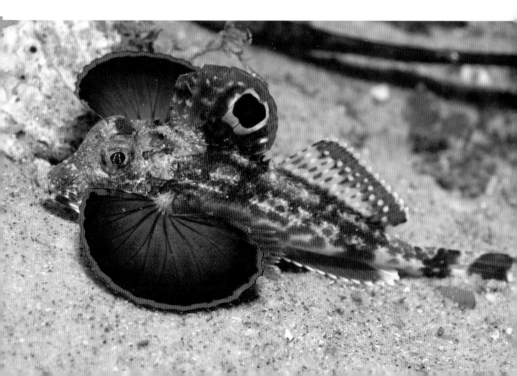

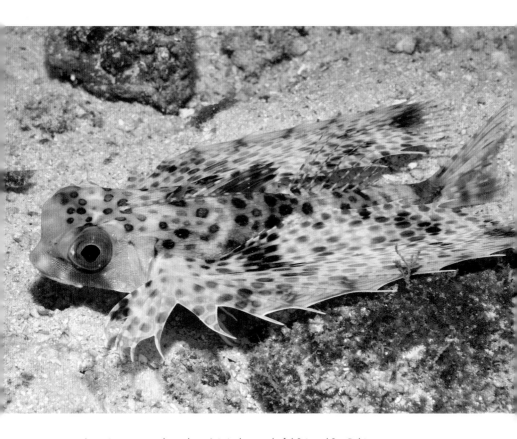

ABOVE: A species common throughout Asia is the wonderful Oriental Sea Robin.

ORIENTAL SEA ROBIN

The sea robins look similar to gurnards, and often the names are confused, but they are a small family of fish closely related to the gurnards. They have the same features as the gurnards, but possess much larger wings. The most famous member of the family, and a species regularly encountered in muck environments of the Indo-Pacific region, is the Oriental Sea Robin (*Dactyloptena orientalis*), which also goes by the name of Purple Flying Gurnard. This colourful fish grows up to 40cm in length, and has beautiful wings that fan out in a spectacular display. These wings are used to make the fish look much larger and warn off predators. The Oriental Sea Robin is often seen at the top muck diving sites, but can be difficult to photograph with a macro lens as those wings are impressively large.

ABOVE: The Red Indian Fish is a bizarre critter only found in Australia.

RED INDIAN FISH

Some very unusual and unique fish are found in the temperate waters of Australia, including the bizarre Red Indian Fish (*Pataecus fronto*). Growing to a length of 35cm, it is a member of the very small prowfish family, a group of fish only found in Australia which have a dorsal fin that extends the length of their body. This unusual species is found on rocky reefs and muck sites, and likes to camouflage itself among similarly coloured sponges. These colourful fish don't seem to swim much, and move across the bottom by rocking from side to side, pretending to be a piece of broken sponge. Red Indian Fish are ambush predators and feed mostly on small shrimps. One of the most bizarre facts about the prowfish is that they don't have scales, instead having a leather-like skin which they regularly moult to remove algal growth which accumulates due to their sediment-dwelling lifestyle. Sydney is one of the best places to see this amazing fish, but an experienced local guide may be required in order to point one out as their camouflage is so good that they really do look like a sponge.

CROCODILEFISH

The flathead family contains around 60 species found throughout the Indo-Pacific region. Numerous members of this family are found in muck habitats, and they spend most of the day hiding under a layer of sand, but the most impressive species is the Crocodilefish (*Cymbacephalus beauforti*). Growing to a length of 50cm this is not a small critter, but with a camouflaged skin-pattern it is easily overlooked. Crocodilefish, like all flathead species, lack a swimbladder, so spend most of the day resting on the bottom. They don't need to swim much as they are ambush predators that feed on fish, crustaceans and molluscs. Crocodilefish are found on reefs and in muck environments, and are generally easy to find without the aid of a guide.

BELOW: Crocodilefish are one of the largest fish species found at muck sites.

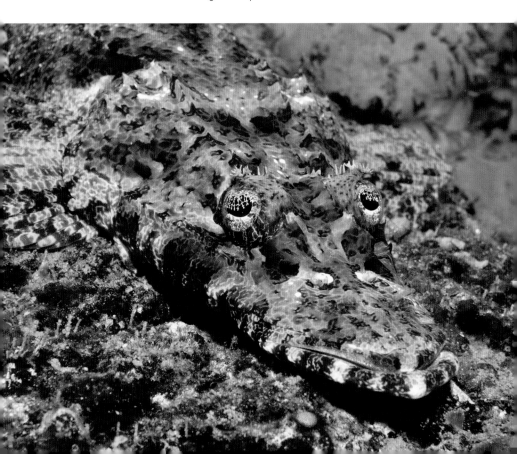

CARDINALFISH

Among the most common fish found on reefs throughout the Indo-Pacific region are the humble cardinalfish. Over 250 species of these small fish have been described, and most are far from interesting to look at or photograph. However, they do have one interesting behaviour that makes them stand out from the crowd – oral brooding. After a pair of cardinalfish spawn, by releasing sperm and eggs, the male sucks up the fertilised eggs into his mouth and keeps them there until they hatch. It takes up to 30 days for the eggs to hatch and the young to emerge. It is possible to see males with a mouthful of eggs – you just have to look for ones with a bulging jaw, and every now and then they open their mouth to flush the eggs with clean water.

Most species of cardinalfish are ignored by divers as they are a little bland, but a few colourful members of the family are found in muck habitats. The Pyjama

BELOW: Pyjama Cardinalfish are commonly seen in branching hard corals.

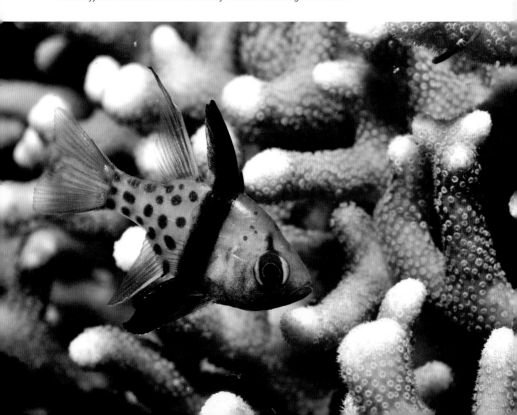

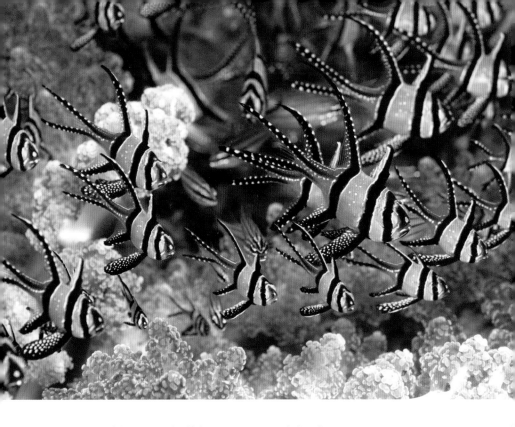

ABOVE: Beautiful Banggi Cardinalfish are common at Lembeh, Indonesia.

Cardinalfish (*Sphaeramia nematoptera*) is often seen at muck sites in Papua New Guinea and Indonesia, and grows to a length of 8cm. Like most cardinalfish it likes to gather in schools and hover around branching corals. With its polka-dotted body and bright red eye, this is one species that is hard to miss.

The most spectacular member of the family would have to be the Banggai Cardinalfish (*Pterapogon kauderni*). Once only found around the Banggai Islands in Indonesia, this beautiful fish has been spread to other parts of Indonesia by aquarium collectors. Its long fins and vivid black-and-white colouration make it highly photogenic. This species grows to 8cm in length, and is found in groups of up to 500. The Banggai Cardinalfish likes to hover above corals, sea anemones and even sea urchins. Lembeh is one of the few places where this species can be observed.

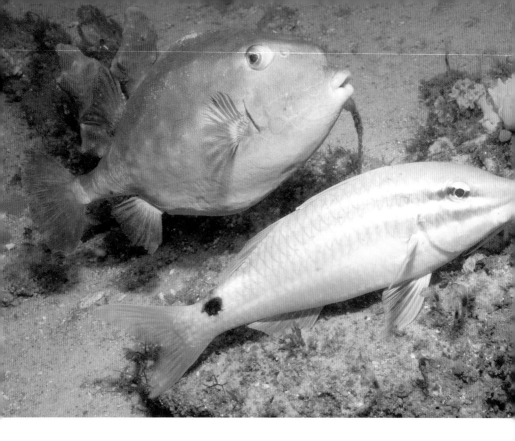

GOATFISH

You will not have to search the muck for goatfish as they will find you, especially if you kick up a bit of sand. This colourful family contains more than 80 members, and all typically have a pair of barbels on their chin. These barbels contain chemosensory organs which the fish use to locate prey buried in the sand, and this can include crustaceans, worms and molluscs. Feeding goatfish are often shadowed by an army of freeloaders hoping to snatch any tasty morsel exposed. Goatfish also have the ability to change colour quickly, and some species are thought to mimic other fish with their colouration. Goatfish are common at muck sites and can be observed singly, in pairs, or in schools that can vary greatly in number.

Numerous goatfish species are seen while muck diving, and most grow to around 30cm in length, except for the Dot-and-dash Goatfish (*Parupeneus barberinus*) which can reach a length of 50cm. Some of the more common species

include the Blacksaddle Goatfish (*Parupeneus spilurus*), Bartail goatfish (*Upeneus tragula*), Banded Goatfish (*Parupeneus multifasciatus*) and Yellowspot Goatfish (*Parupeneus indicus*). A number of endemic goatfish species are also found at muck sites in Australia, with one of the prettiest being the Bluestriped Goatfish (*Upeneichthys lineatus*). One thing to watch out for when a school of goatfish approaches is that they are messy feeders, and can stir up a silty bottom and make photography a nightmare.

OPPOSITE: A Blacksaddle Goatfish feeding alongside an Eastern Smooth Boxfish (*Anoplocapros inermis*).

BELOW: Bartail Goatfsh are commonly seen while muck diving.

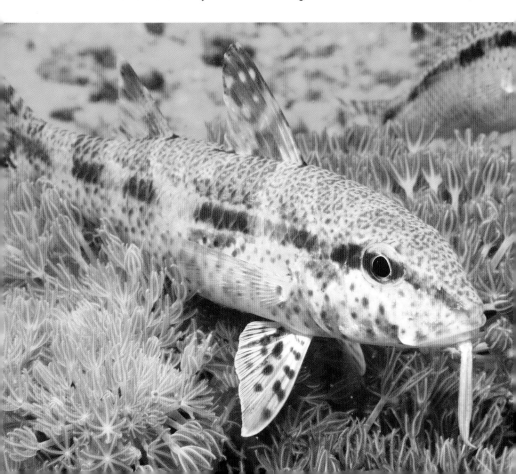

ANEMONEFISH

Often mistakenly called clownfish, anemonefish are a type of damselfish which live in a symbiotic relationship with sea anemones. Only found in the Indo-Pacific region, around 30 species of anemonefish have been described.

The relationship between the anemonefish and the sea anemone is still not fully understood. Both species benefit from the relationship, with the fish getting protection for themselves and their eggs, plus the odd meal. In return the anemonefish protect their host sea anemone from predators such as turtles, and also keep them free of parasites. Anemonefish have a coating of mucous on their scales that deters the tentacles from stinging. How they develop this mucous is not known.

The sex lives of anemonefish are more complex than a television soap opera. A large female rules the roost with her male partner, while all the smaller fish sharing their sea anemone are small males. However, if the female dies, her male partner changes sex to take charge and the next largest male steps up to take his place.

Anemonefish often share their sea anemone home with commensal shrimps, porcelain crabs and many smaller fish, such as cardinalfish and juvenile Domino Damsels (*Dascyllus trimaculatus*), which are also known as Threespot Humbugs. Anemonefish are far more common on coral reefs, but several species inhabit the sea anemones that prefer a muck environment.

The most common anemonefish seen while muck diving is the Panda Anemonefish (*Amphiprion polymnus*). Also known as the Saddleback Anemonefish, this species varies greatly in colour across its range, but typically has several large white saddle patterns. These fish can get quite aggressive with divers as they protect their host, and it can be quite amusing to see a 2m-long diver driven off by a 12cm-long fish!

Other species that are often found in muck environments include Clark's Anemonefish (*Amphiprion clarkii*), Orangefin Anemonefish (*Amphiprion chrysopterus*), Skunk Anemonefish (*Amphiprion akallopisos*), Western Clown Anemonefish (*Amphiprion ocellaris*) and Spinecheek Anemonefish (*Premnas biaculeatus*).

A number of anemonefish species are found at muck sites, including the popular Western Clown Anemonefish (TOP) and the Spinecheek Anemonefish (BOTTOM).

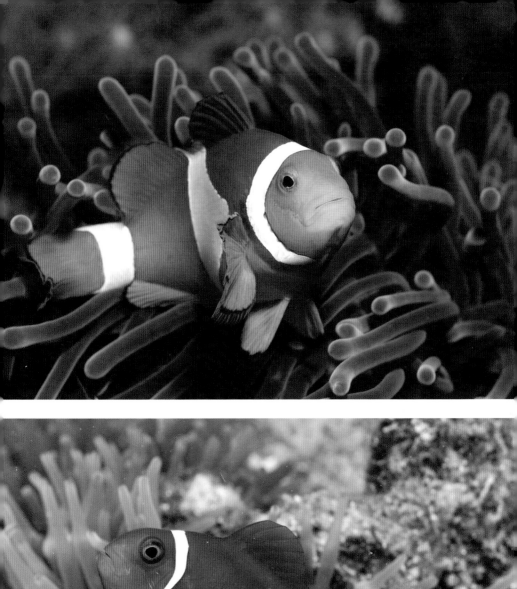
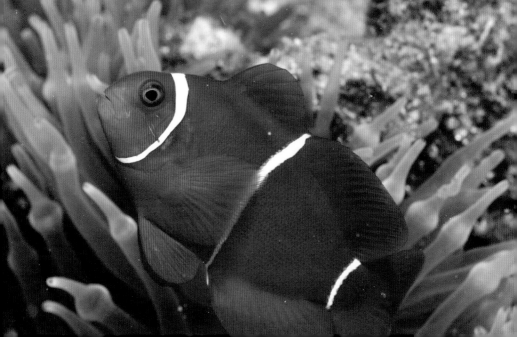

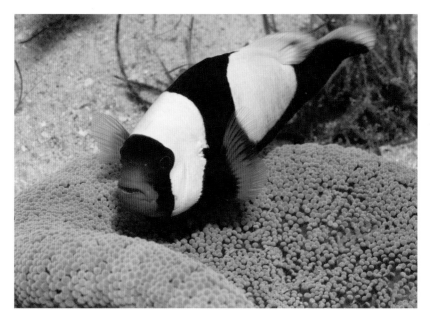

ABOVE: Panda Anemonefish are common at muck sites.

BELOW: Blotched Hawkfish often follow divers at muck sites, hoping you will kick up a tasty morsel.

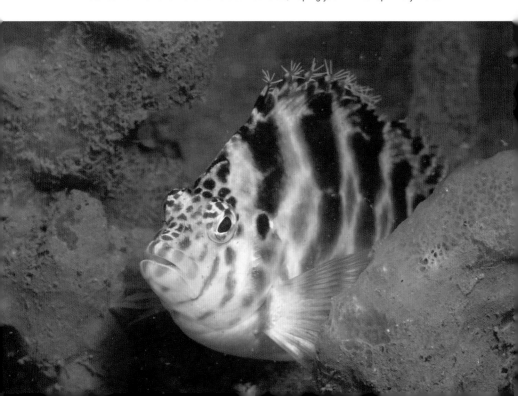

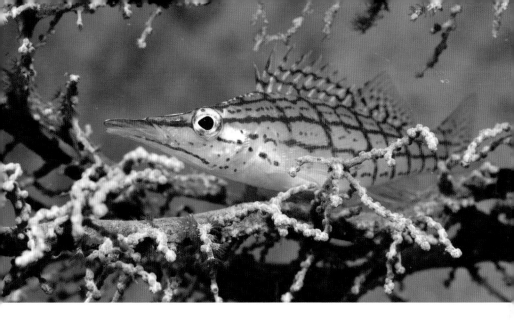

ABOVE: The most spectacular member of the hawkfish family is the pretty Longnose Hawkfish.

HAWKFISH

Ever feel like you are being watched as you explore the underwater world? Chances are that you are, and often it will be by a very watchful hawkfish. Around 35 species are known in this family, and they are typically small tropical fish, less than 10cm long, which spend most of their time perched on a rock or coral outcrop observing their surroundings. Hawkfish feed on small fish and invertebrates, and are common in both reef and muck environments.

A number of hawkfish species are observed while muck diving, with the Blotched Hawkfish (*Cirrhitichthys aprinus*) the most conspicuous. It grows to 12cm in length and is easily identified by is reddish blotchy pattern and the tassels on the tips of its dorsal fin. Blotched Hawkfish are often seen in pairs and are generally easy to approach for photographs.

The most impressive member of this family is the Longnose Hawkfish (*Oxycirrhites typus*). These pretty fish live in gorgonians and black coral trees and reach a maximum length of 10cm. Longnose Hawkfish have a lovely red-and-white checked pattern and an elongated snout for feeding. They feed on small crustaceans, but dive guides have also seen them consuming pygmy seahorses.

RAZORFISH

The wrasses are one of the most colourful families of fish, and also one of the largest with over 600 species. Although more common on reefs, many species are also encountered in muck environments, with one of the most interesting groups being the razorfish. Around 20 species of razorfish have been identified, and they all have a very flat body, which they use to great effect when threatened, by diving into the sand. Razorfish are commonly seen in muck environments throughout the Indo-Pacific region, as they never venture too far away from their sandy hideout.

The Whiteblotch Razorfish (*Iniistius aneitensis*) grows to a length of 24cm and is identified by the large white patch on the side of its body. This pretty fish is more common on muck sites with fine silty sand, although it is never easy to approach for photographs, because as soon as you get within camera range they tend to dive straight into the sand. Another pale-coloured species with faint bands is the Fine-scaled Razorfish (*Cymolutes torquatus*), which reaches a length of 20cm.

The Peacock Razorfish (*Iniistius pavo*), or Blue Razorfish, is one of the larger

BELOW: The juvenile Peacock Razorfish is a challenging photographic subject.

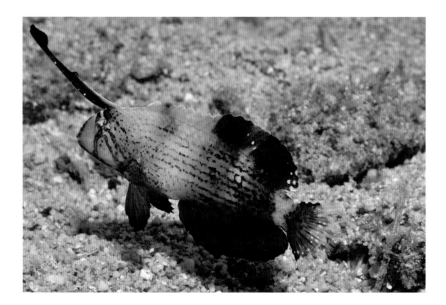

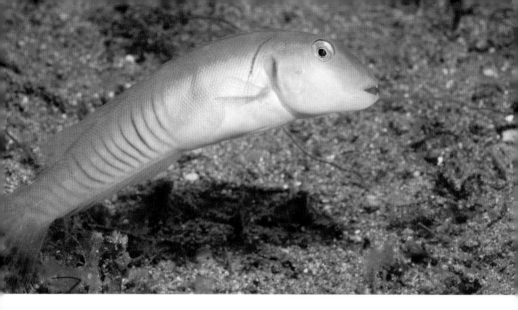

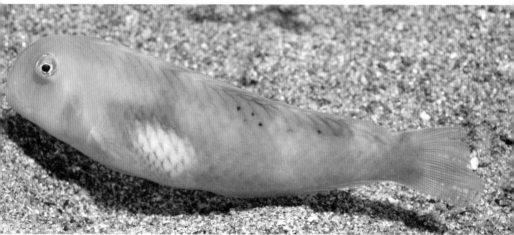

A number of razorfish species are seen at muck sites, including the Fine-scaled Razorfish (TOP) and the Whiteblotch Razorfish (BOTTOM).

members of the family, growing to a length of 36cm. The adults of this species are a rather plain bluish colour with a darker patch beneath the eye, but the young are much more spectacular with brown and white bands and a large banner-like fin above the head. This prominent fin unfortunately disappears with age, so the young are definitely more appealing to photographers.

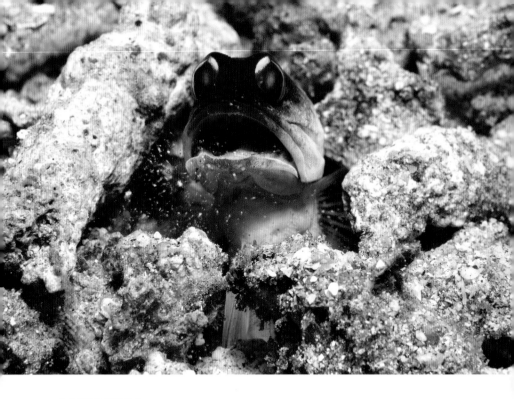

JAWFISH

With big eyes and a wide mouth, jawfish are one of the cutest fish divers will encounter while muck diving. The jawfish family contains around 80 species and all are found in muck environments as they live in burrows in the sand. These lovely fish are commonly seen with only their head bobbing up and down at the entrance of their burrow. But if busy maintaining their home they can be observed disappearing into the darkness and emerging with a mouthful of sand, which is spat out with much gusto. Jawfish feed on plankton which they catch near their burrow, and they will dart out of their burrow to quickly grab a tasty morsel when the opportunity presents itself.

Jawfish, like the cardinalfish, are oral brooders and can often be seen smiling with a mouthful of eggs. They are very entertaining to watch as they feed and maintain their home, and they are also very territorial, with fights often breaking out between neighbours. Many of the common jawfish species seen at muck sites throughout the Indo-Pacific region are undescribed.

The Yellow-barred Jawfish (*Opistognathus* sp.) grows to a length of 12cm and has distinctive yellow bands across its body, which are only seen if it emerges from its burrow. However, it can also be identified by the yellow markings on its eyes. This species is one of the more common jawfish seen in Indonesia and Timor-Leste.

The Variegated Jawfish (*Opistognathus solorensis*) is another common species and grows to 11cm in length. With a lovely marbled colouration, this species makes for great pictures, if you can get close enough. It is found at many muck sites in Indonesia and the Philippines.

OPPOSITE: A Yellow-barred Jawfish maintaining its home.

BELOW: The pretty Variegated Jawfish is often a shy species.

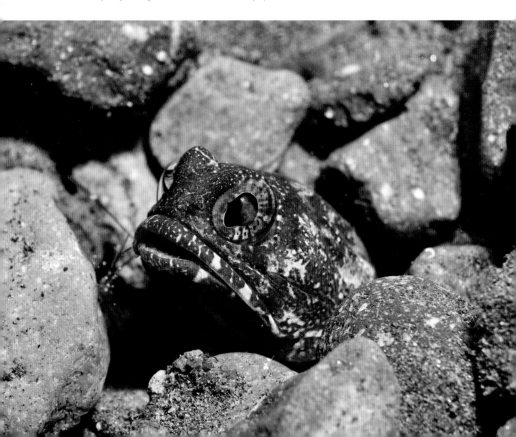

STARGAZERS

With some of the crankiest faces on the planet, stargazers are among the weirdest critters in the world of muck. Around 50 species of these unusual fish have been described, and all have eyes on the top of the head and a downturned mouth that makes them look perpetually cranky. Stargazers are found in shallow and deep water in oceans around the world and prefer a sandy habitat as they spend most of their time buried in the sand with only their eyes and mouth visible. They are ambush predators, and explode out of the sand to snatch passing fish and invertebrates, while some species attract prey by wriggling a worm-shaped lure in their mouth.

Stargazers are venomous, with two spines located at the back of the head, just above the pectoral fins. In addition, a few species can generate electric shocks from modified muscles in the body. Stargazers are often difficult to find during the day without the help of a good guide, but they do move around at night so are more frequently seen after dark.

One of the most common members of this family seen at muck sites in the Indo-Pacific region is the Whitemargin Stargazer (*Uranoscopus sulphureus*). This species reaches a length of 45cm and is generally identified by the pattern of

BELOW: The Common Stargazer is an Australian species.

OPPOSITE: The two most common stargazers seen at Asian muck sites are the Reticulated Stargazer (ABOVE) and the Whitemargin Stargazer (BELOW).

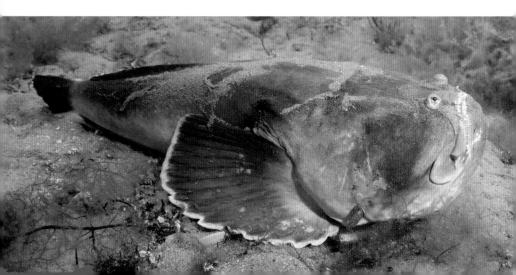

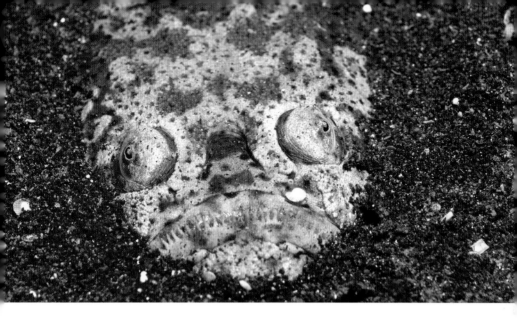

black spots on its face. Like all species of stargazers it has cirri around the edge of its mouth to stop sand falling in. A number of other stargazer species are seen in tropical waters, but identification is always a challenge, and it appears there are a few undescribed species in this region. One of these species is the Reticulated Stargazer (*Uranoscopus* sp.), which appears to reach a length of 30cm and is covered in dark spots and blotches. This species is often seen at Lembeh at night.

Several stargazers are also found in the cooler waters of southern Australia, with the most common species at muck sites being the appropriately named Common Stargazer (*Kathetostoma laeve*). These unusual fish can grow quite large, up to 75cm, and are a dusty brown colour.

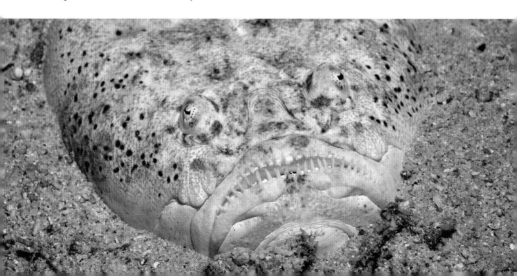

ABOVE: The attractive Elegant Sand Diver is shy and wary of divers.

SAND DIVERS

With a habit of diving into the sand as soon as a diver gets close, sand divers are a very difficult family of fish to observe and photograph. This small family contains about ten members that are only found in the Indo-Pacific region. Sand divers have long elongated bodies and spend much of their time buried in the sand, only emerging to feed on zooplankton. These pretty fish are usually found in small groups, with a male and his harem of females. The male is easily distinguished in the group as he has long filaments at the start of the dorsal fin.

One of the more common sand divers is the Elegant Sand Diver (*Trichonotus elegans*), or Long-rayed Sand Diver. This attractive species grows to 18cm in length and has a bright spotted pattern along its body that seems to vary in colour depending on the area.

GRUBFISH

Grubfish are among the most curious fish found at muck sites. This family contains around 60 bottom-dwelling species that feed on a range of small invertebrates and fish. Grubfish live and feed on sandy bottoms and are quite active during the day. They spend a great deal of time sitting on the seabed with their head held high and their large eyes scanning their surroundings for food or danger. They are often very curious of divers and have been known to follow humans around, possibly hoping that a diver will disturb some potential prey.

A number of grubfish species are seen at muck sites throughout the Indo-Pacific region. Some are seen singly, but many species are always seen in pairs. Some of the typical species encountered include the Blackbanded Grubfish (*Parapercis tetracantha*), Lyretail Grubfish (*Parapercis schauinslandi*), Sharpnose Grubfish (*Parapercis cylindrica*) and Latticed Grubfish (*Parapercis clathrata*), which is also known as Spothead Grubfish. All these species have attractive patterns on their bodies and grow to between 15cm and 20cm long.

BELOW: The Lyretail Grubfish is a common muck fish.

BLENNIES

The blennies are a large family of fish, containing over 800 species that are typically small with big eyes and a large mouth. These fish also have elongated bodies, some are even eel-like, and generally have a dorsal fin that runs the length of their body. This family of fish also lack scales, their bodies instead protected by a slimy skin.

The blennies feed on a wide variety of food items depending on the species. Some consume plankton or zooplankton, others nibble on algae, some take small invertebrates and a few also feed on other fish, taking nips of flesh. Blennies are found in all oceans, but are more common in tropical waters. Most are bottom-dwellers, and spend much of their time hiding amongst the corals or sitting in a burrow with only their head exposed. Only a handful of blennies are seen while muck diving, as most prefer reef habitats.

One of the largest blennies lives in muck environments, the bizarre Hairtail

BELOW: The Shorthead Sabretooth Blenny is often found living in old bottles.

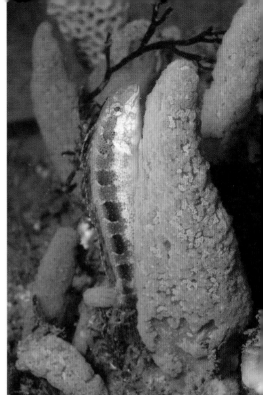

ABOVE LEFT: The Hairtail Blenny is a rare muck critter.

ABOVE RIGHT: The Brown Sabretooth Blenny is found at some Australian muck sites.

Blenny (*Xiphasia setifer*). Living in burrows in the sand, when first seen divers often think they are looking at a weird garden eel, as the Hairtail Blenny is very eel-like and grows to 50cm long. This species is rarely seen, but it is one that you will never forget.

A more common species is the Shorthead Sabretooth Blenny (*Petroscirtes breviceps*), a yellow, black and white striped blenny which grows to 12cm in length and has very large sabre-like fangs that carry venom. In muck environments they are often found living in old bottles, shells and tins. This species is one of several fang blennies that mimic other species, this one mimics the Stripedblenny (*Meiacanthus grammistes*), which is also known as the Linespot Fangblenny. The very similar-looking Brown Sabretooth Blenny (*Petroscirtes lupus*) grows to 13cm in length and is common at Australian muck sites.

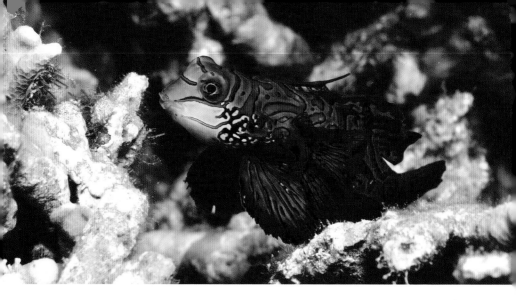

ABOVE: One of the most spectacular fish seen at muck sites is the Splendid Mandarinfish.

DRAGONETS

The dragonets are among the prettiest fish found while muck diving. Closely related to the blennies, dragonets are small, colourful and often very cryptic. This family of fish is only found in the waters of the Indo-Pacific region and contains around 140 species. Dragonets lack scales and instead have a tough slimy skin, which is designed to deter other fish from eating them as it has a strong odour, leading to their other appealing name of stinkfish.

Dragonets are found on reefs and in muck habitats, with a number of species burying themselves in the sand. They are rarely observed swimming, preferring to walk, skip or wriggle across the bottom on their pectoral fins and tail. But they do swim when mating, with the male and female rising into midwater in a synchronized dance to release their sperm and eggs.

The best-known member of the dragonet family is the Splendid Mandarinfish (*Synchiropus splendidus*) – a beautiful fish with psychedelic colouration, which only grows to 6cm in length but is highly sought-after by photographers. Splendid Mandarinfish spend the day hidden amongst coral and rocks, in both reef and muck environments, but every day at dusk they slowly emerge in a mating frenzy. There are a number of closely related species that are almost as colourful,

including the Picture Mandarinfish (*Synchiropus picturatus*), which is also known as the Spotted Mandarinfish.

A number of small dragonet species are often encountered foraging in the sand at muck sites. Many are well-camouflaged, including the Longtail Dragonet (*Callionymus neptunius*), but others are more colourful and really stand out, such as the Morrison's Dragonet (*Synchiropus morrisoni*) and Moyer's Dragonet (*Synchiropus moyeri*). However, there is one member of the family that can't be missed, the wonderful Finger Dragonet (*Dactylopus dactylopus*). This is one of the largest dragonets, reaching a length of 30cm. It has fingers, modified pelvic fins, which it uses to walk across the bottom while searching for food. This magnificent fish has a flag-like dorsal fin that it flicks in a memorable display. The Finger Dragonet is commonly seen at muck sites throughout the Indo-Pacific region.

A great variety of lovely dragonets are seen while muck diving including (CLOCKWISE FROM TOP LEFT) Morrison's Dragonet, Moyer's Dragonet, Longtail Dragonet and Finger Dragonet.

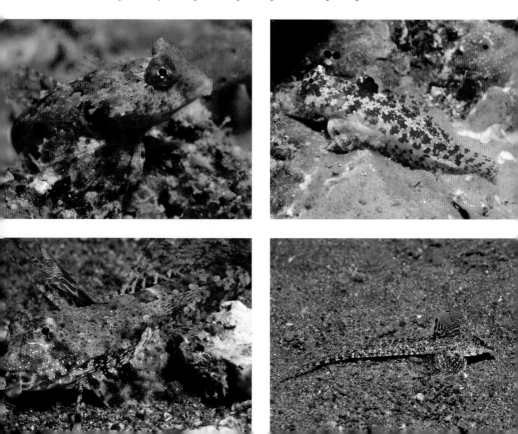

GOBIES

The gobies are one of the largest fish families, and are extremely well represented in muck habitats. The goby family contains over 2,000 species, and most are quite small, rarely more than 5cm long. All gobies have fused pelvic fins that can be used like a suction cup to grip on to rocks or coral, but not all species use these modified fins. These small bottom-dwelling fish usually live in a male and female pair, and many species live in sandy burrows. Other species cling to corals or hide between rocks.

One of the most eye-catching gobies found in muck environments is the pretty Twin-spot Goby (*Signigobius biocellatus*), which is also known as the Crab-eye Goby. It grows to 10cm in length and has lovely markings, including two large spots, which are thought to mimic a crab when threatened, by fanning its fins and rocking from side-to-side. Another attractive species to watch out for is the

BELOW: A pair of Twin-spot Gobies. OPPOSITE: Half-banded Gobies are common at many muck sites.

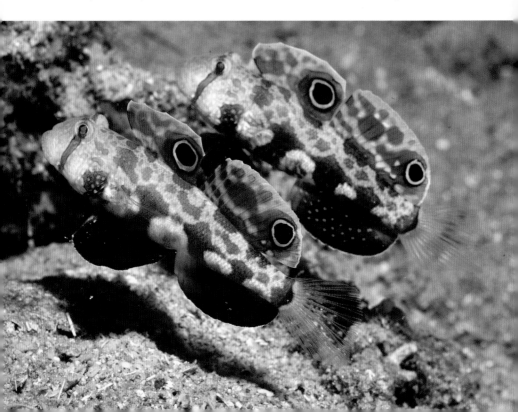

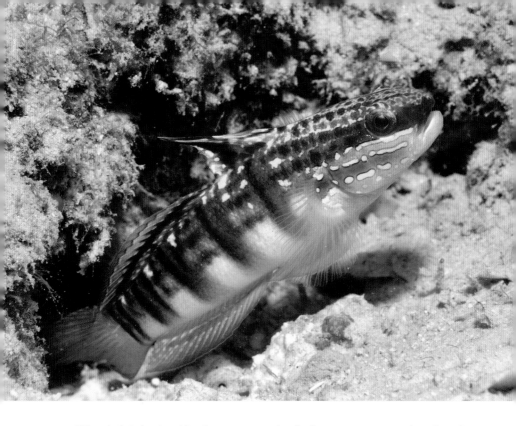

Half-banded Goby (*Amblygobius semicinctus*), which grows to 15cm in length and never ventures too far from its burrow.

The largest gobies seen at muck sites belong to a group known as sleeper gobies or glider gobies. These handsome fish have vivid markings and a metallic sheen, and some of the larger species are up to 20cm long. They are often observed scooping up mouthfuls of sand, but are quick to dart into their burrow when a diver gets too close. Typical species divers will see include the Orangelined Sleepergoby (*Valenciennea puellaris*), Immaculate Sleepergoby (*Valenciennea immaculata*) and Blacklined Sleepergoby (*Valenciennea helsdingenii*).

A number of very pretty coral gobies can also be found hiding amongst corals and rocks. These are generally very small, less than 5cm long, and a nightmare to see and photograph. Far easier to find are the Softcoral Ghostgoby (*Pleurosicya boldinghi*), Many-host Ghostgoby (*Pleurosicya mossambica*) and Loki Whipgoby (*Bryaninops loki*). These species are all small, generally less than 3cm long, but clinging to soft corals, gorgonians and sea whips they are very photogenic.

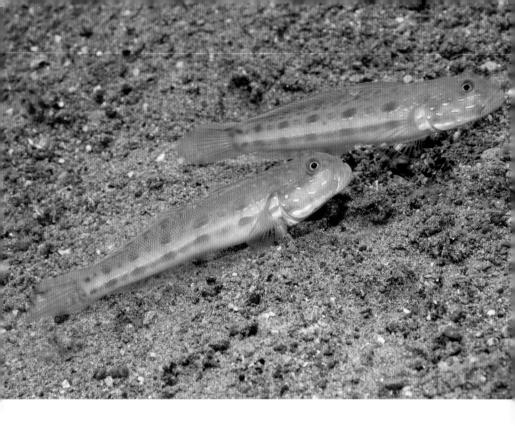

Numerous sleepergobies are seen at muck sites, including the Orangelined Sleepergoby (TOP) and Blacklined Sleepergoby (BOTTOM).

Many small gobies hide on corals, including the Loki Whipgoby (TOP) and Softcoral Ghostgoby (BOTTOM).

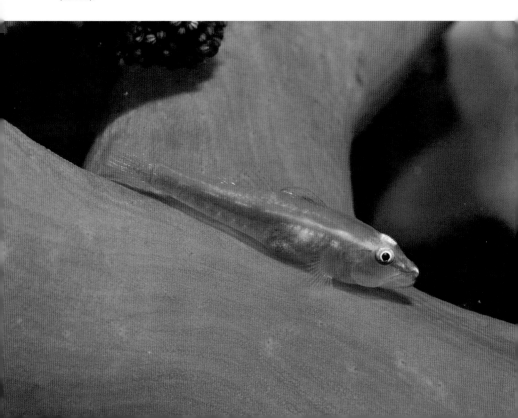

SHRIMPGOBIES

The best-known gobies in muck environments are the shrimpgobies, and at some dive sites you can find a dozen different species. Shrimpgobies live in a symbiotic relationship with snapping shrimps, with the gobies watching for danger and the shrimps maintaining the burrow. There are so many shrimpgobies that look similar, and numerous undescribed species, that identifying individual species can be hard work.

Some of the more common shrimpgoby species seen in the Indo-Pacific region are the Yellow Shrimpgoby (*Cryptocentrus cinctus*), Spotted Shrimpgoby (*Amblyeleotris guttata*), Giant Shrimpgoby (*Amblyeleotris fontanesii*) and Red-margin Shrimpgoby (*Amblyeleotris gymnocephala*). One of the more striking members of the family to keep an eye out for is the Black-ray Shrimpgoby (*Stonogobiops nematodes)*, which has a bold black-and-white body pattern and a yellow head.

Shrimpgobies are found in large numbers at muck sites throughout Asia. Common species include (CLOCKWISE FROM TOP LEFT) the Giant Shrimpgoby, Diagonal Shrimpgoby (*Amblyeleotris diagonalis*), Black-ray Shrimpgoby and Double-barred Shrimpgoby (*Amblyeleotris periophthalma*).

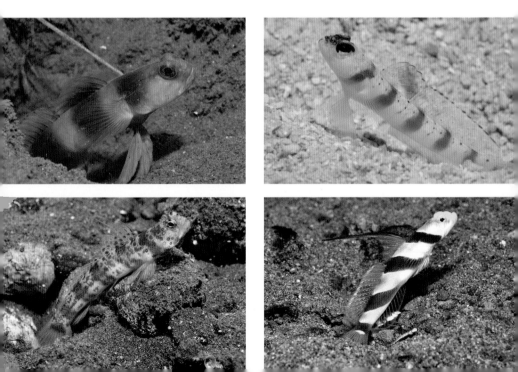

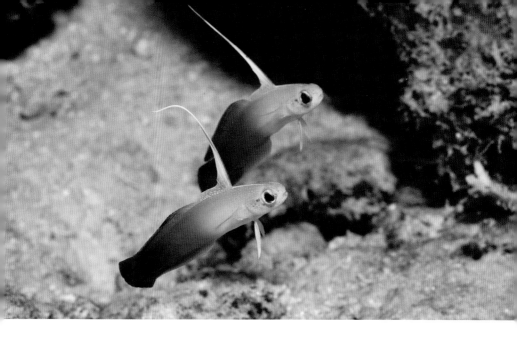

ABOVE: Fire Dartfish are always seen in pairs.

DARTFISH

Dartfish are closely related to gobies, and look very similar in having elongated bodies and large eyes, but they also have prominent dorsal and anal fins, and are usually very colourful. Around 40 species of dartfish have been identified, and they all like to shelter in burrows. These handsome fish are often observed hovering above the bottom while feeding on zooplankton, but quickly dart into their burrow if threatened. They are also very cheeky, and known to steal the burrows of other fish.

Numerous dartfish are observed in muck habitats, with the Fire Dartfish (*Nemateleotris magnifica*) and Elegant Dartfish (*Nemateleotris decora*) the most beautiful. These colourful fish both grow to 8cm in length and look very similar, but the latter has a purple tail and the former has an orange tail. Nearly always seen in pairs, these fish are fabulous photographic subjects.

Much larger dartfish species, with a typical metallic sheen on their skin, are also seen in muck environments. These include the Robust Ribbon Dartfish (*Oxymetopon compressus*), which grows to 24cm in length. The strangest dartfish

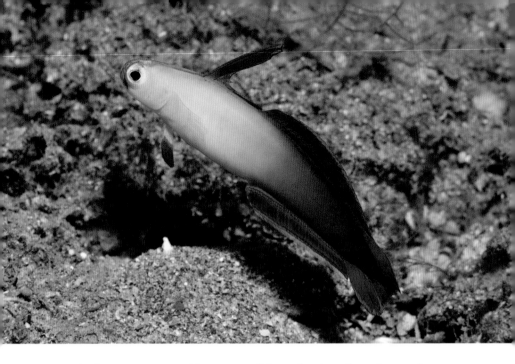

are also known as wormgobies or wormfish, as they have long elongated worm-like bodies. Most wormgobies are small and easily overlooked, and are rarely more than 12cm long.

ABOVE: The Elegant Dartfish is a wonderful subject for photographs.
BELOW: The Robust Ribbon Dartfish is a rarely seen species.
BOTTOM: The bizarre wormgoby is hard to find at most muck sites.

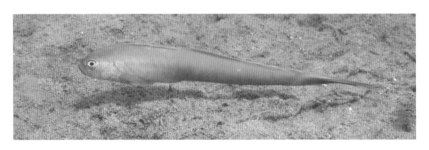

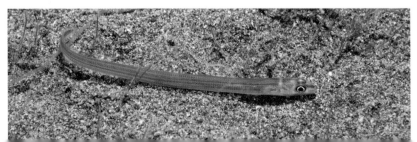

FLOUNDERS

The flounders are a group of superbly camouflaged flat-bodied fish, which are often encountered while muck diving. This family is particularly well represented in the Indo-Pacific region, with over 90 species recorded in the area. Flounders, like the closely related soles, start life with eyes on either side of their body, but once they settle on the bottom one eye migrates to join the other on one side of the body. In flounders both eyes end up on the left side of the body, while in soles they are on the right side. Flounders are most often found either buried in the sand or slowly gliding above it. Some species are active by day, others by night, but they all have sandy coloured skin that helps with camouflage.

Many divers just ignore flounders while looking for more exotic critters, but they are an interesting group of fish if you spend a little time observing them. The Panther Flounder (*Bothus pantherinus*), also known as the Leopard Flounder, and the Peacock Flounder (*Bothus mancus*), also known as the Flowery Flounder, are two of the more common species, and easily confused as they both have a spotted pattern and the males of both species have long filaments on their pectoral fins.

BELOW: Panther Flounders are easily overlooked when muck diving.

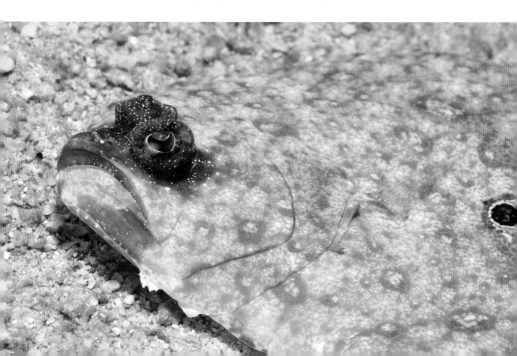

The former grows to 30cm in length and often has a dark patch on the head, while the latter grows to 45cm in length and has a bolder pattern of ocelli.

One species that is hard to miss is the Cockatoo Flounder (*Samaris cristatus*), which reaches a length of 22cm and have a fabulous array of long white filaments projecting from the dorsal fin. Another species to watch out for is the Angler Flounder (*Asterorhombus fijiensis*), which has a modified dorsal fin that acts like a lure. This species grows to 30cm in length and has been recorded feeding on Mimic Octopus, Coconut Octopus and Wonderpus.

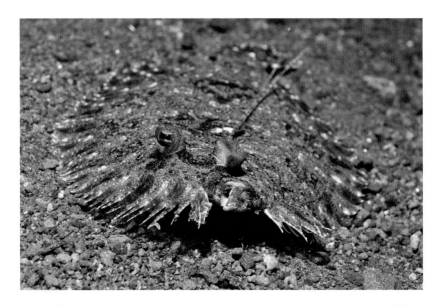

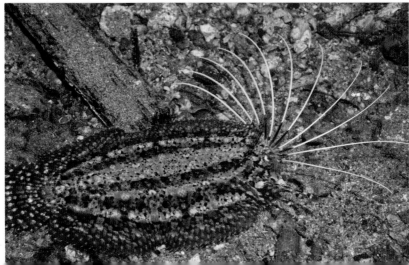

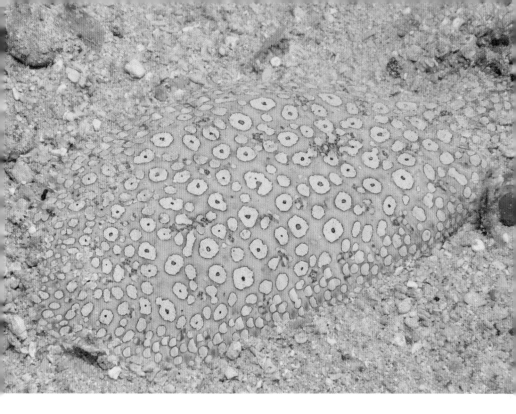

SOLES

The soles are very similar-looking fish to the flounders, but are easily identified as they have their eyes on the right side of the body. This family contains over 100 species, and the ones seen at muck sites are generally much smaller than the flounders. Many sole species have toxins in their skins, which are used to stop predators eating them, while a number of smaller species are thought to mimic flatworms to avoid being targeted by predators.

The Peacock Sole (*Pardachirus pavoninus*) is one of the more common species seen at muck sites. This medium-sized sole grows to 25cm in length and has a lovely spotted pattern. Another species to keep an eye out for is the Carpet Sole

OPPOSITE: The Peacock Flounder (TOP) is a colourful member of this family, but the most spectacular flounder found at muck sites is the Cockatoo Flounder (BOTTOM).

ABOVE: Peacock Soles are easily missed as they blend into the sand.

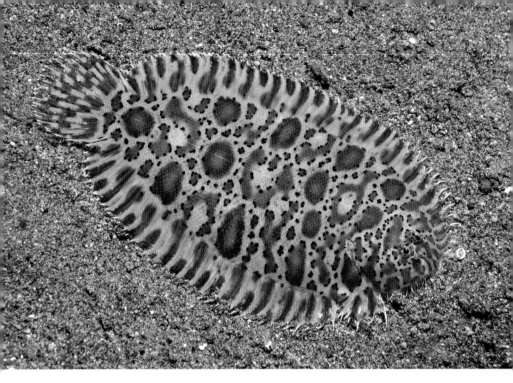

Two small soles often only seen at night are the Carpet Sole (TOP) and the Black-tip Sole (BOTTOM).

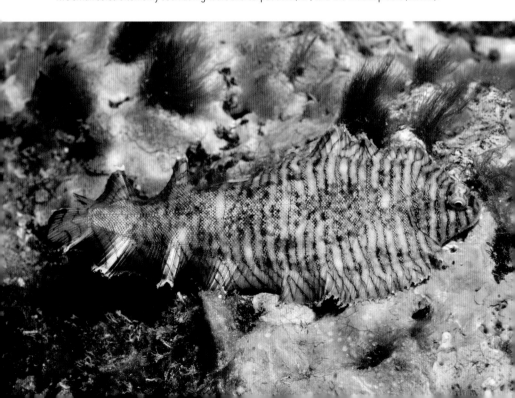

(*Liachirus melanospilus*), which has brown spots and blotches and is rarely more than 15cm in length. A species that is only seen at night is the Black-tip Sole (*Soleichthys heterorhinos*), which is also known as the Tiger Sole. This small sole, only reaching 11cm in length, has an attractive banded pattern, and is just as likely to be seen swimming over coral or sand.

FILEFISH

The filefish are an interesting group of fish with sandpaper-like skin instead of scales. Around 100 species are known, with half of the family occurring in Australian waters where they are commonly known as leatherjackets. The filefish vary greatly in shape and size – some have a round body, some are diamond-shaped, others are oval, and some are long and elongated. But they all have one thing in common, a sharp spine in front of the dorsal fin that is used for defence.

BELOW: The Strapweed Filefish is often found in pairs.

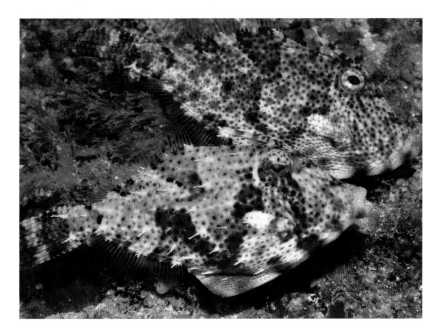

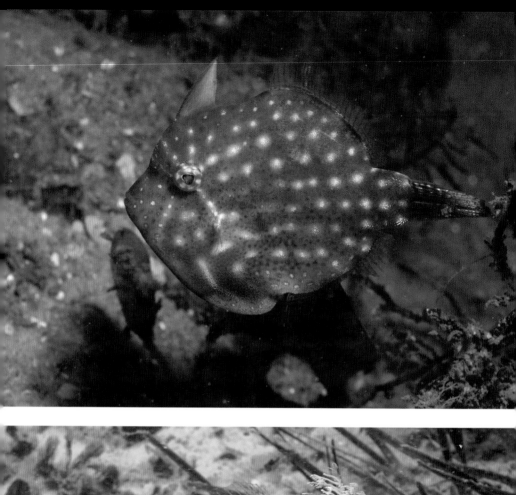

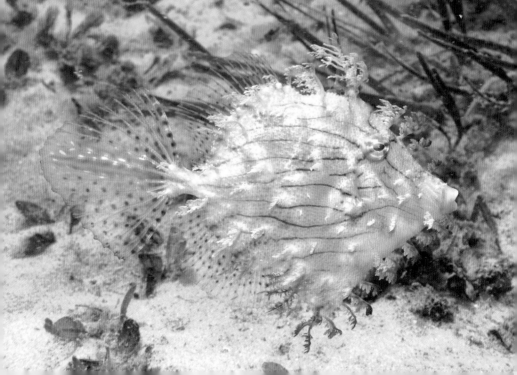

Filefish are found on reefs and in muck environments, and are quite common in areas of seagrass, as many species eat algae and seagrass. Other species eat corals, including gorgonians, hydroids and tunicates. Filefish are active during the day, and at night smaller species are often found biting onto seagrass to stay in one place while they nap.

Numerous small to medium-sized filefish are encountered in muck environments. The Strapweed Filefish (*Pseudomonacanthus macrurus*) is a common species that grows to 18cm in length and is very attractive, with a lovely spotted pattern and filaments decorating its skin. The Diamond Filefish (*Rudarius excelsus*) and Minute Filefish (*Rudarius minutus*) are tiny species that only grow to 3cm in length. Another tiny but colourful species is the Pygmy Filefish (*Brachaluteres jacksonianus*), which is only found in the temperate waters of Australia and grows to 9cm in length. A much larger member of the family is the Fanbelly Filefish (*Monacanthus chinensis*), which grows to 40cm in length and has a pretty marbled pattern and prominent fan-like fin on its belly. This species is found in both tropical and subtropical waters of the Indo-Pacific region.

The most spectacular member of the filefish family found in muck environments is the Tasselled Filefish (*Chaetodermis penicilligerus*). This bizarre-looking fish is covered in dermal appendages that help to camouflage it in its preferred habitat of seagrass. It grows up to 30cm long and is a prized subject for photographers. Unfortunately this species is only occasionally seen at popular muck diving sites. More commonly observed is the pretty Rhinoceros Filefish (*Pseudalutarius nasicornis*), which is seen in small groups at some popular muck sites. It grows to 18cm in length and has distinctive brown stripes.

OPPOSITE ABOVE: The Pygmy Filefish is only found in Australian waters.

OPPOSITE BELOW: A rarely seen muck fish is the Tasselled Filefish.

ABOVE: A tiny member of the filefish family is the Minute Filefish.

BOXFISH

With lips perpetually posed for kissing, boxfish are a delight to observe and photograph. This family contains around 23 species and includes the cowfish and trunkfish. All boxfish have a box-like shape, with their bodies encased in a firm ridged carapace. This hard casing protects them from predators, but also makes them slow swimmers. To help ensure that they don't get eaten their bodies are also covered in a toxic mucous.

Boxfish are found in reef and muck environments and feed on small invertebrates. The young fish are brightly coloured in most species, such as the Yellow Boxfish (*Ostracion cubicus*), which is bright yellow when young and then matures into either a blue adult male or dull yellow adult female. This species grows to 45cm in length, with the dice-sized young always fun to photograph. Another species seen at muck sites is the Solor Boxfish (*Ostracion solorensis*), which is also known as the Striped Boxfish. This species is much smaller, only growing to 11cm, but has lovely colour patterns. The Rhino Boxfish (*Ostracion rhinorhynchus*) is often found while muck diving. This brown spotted species grows to 50cm in length, but smaller species are more commonly observed.

BELOW: Juvenile Yellow Boxfish are a great photographic subject.
OPPOSITE: Two boxfish often found at muck sites are the Solor Boxfish (TOP) and the Rhino Boxfish (BOTTOM).

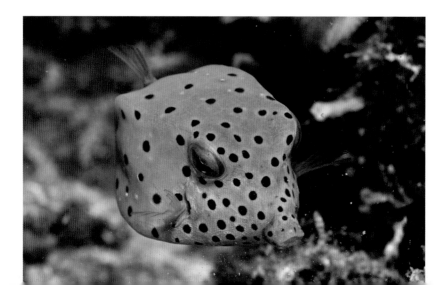

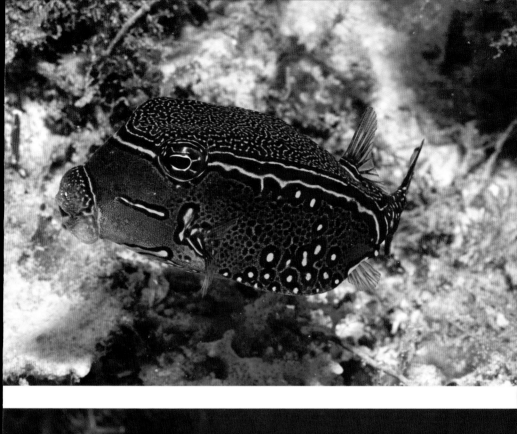

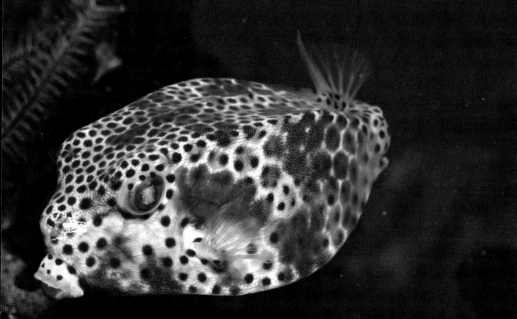

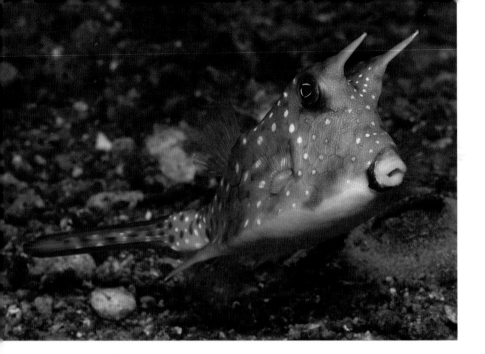

COWFISH

Cowfish are commonly seen in muck habitats, as they search the sand for food by blowing on it. All members of this family have horns on their head and body. The largest member of the family is the Longhorn Cowfish (*Lactoria cornuta*) which grows to 50cm in length. With pretty white spots, a long tail and horns that would do any bull proud, this is a very distinctive species. Its smaller cousin, the Thornback Cowfish (*Lactoria fornasini*), has much smaller horns, but a lovely colouration with radiant blue markings. The Thornback is common at muck sites with seagrass, and grows to 20cm in length. Another member of the family that turns up now and again at muck sites is the Humpback Turretfish (*Tetrosomus gibbosus*). Also called the Camel Cowfish, this species grows to 30cm in length and appears to be more common in depths below 20m.

Two of the most colourful members of the cowfish family are only found in the cooler waters of southern Australia. Shaw's Cowfish (*Aracana aurita*) grows to 25cm in length and has an amazing psychedelic colouration. The females are orange with white wavy patterns, while the males have blue and yellow lines and spots. Even more colourful is the Ornate Cowfish (*Aracana ornata*), which grows to 15cm in length. Both these species are seen around sandy seagrass beds.

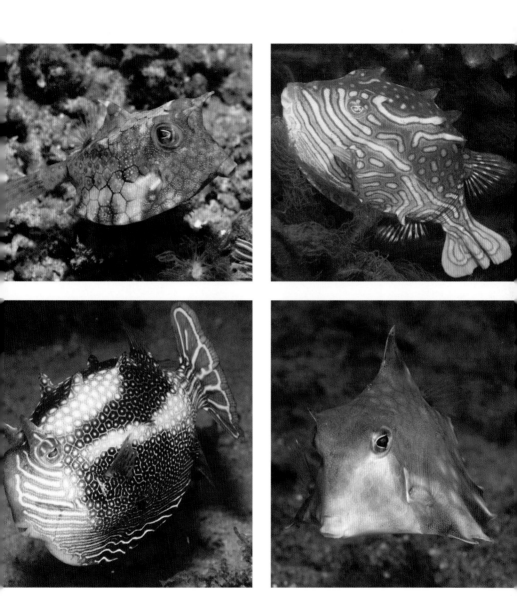

A collection of cowfish: OPPOSITE Longhorn Cowfish, TOP LEFT Thornback Cowfish, TOP RIGHT Shaw's Cowfish, BOTTOM LEFT Ornate Cowfish, BOTTOM RIGHT Humpback Turretfish.

PUFFERFISH

Having poisonous organs or skin, pufferfish are content to wonder around at any time of the day knowing that few animals will attempt to eat them. This large family contains over 120 species. Pufferfish are reported to be the second most poisonous vertebrate species in the world (the first being a species of frog) and should never be eaten. However, the flesh of some species is consumed in Japan, after being prepared by highly trained chefs.

Poison is not the only defence that pufferfish use, as they also have a rough prickly skin and can swallow water to inflate their stomach to appear much bigger to potential predators. Pufferfish feed on crustaceans and molluscs, and have four fused teeth designed to crush the shells of their prey. Numerous pufferfish species are found in muck environments, including many of the common large reef species, but the smaller, more colourful species – which are also known as tobies – are the most attractive.

BELOW: The Saddled Puffer is a common muck fish.

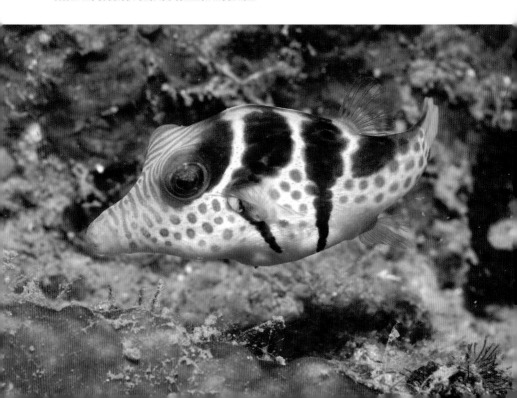

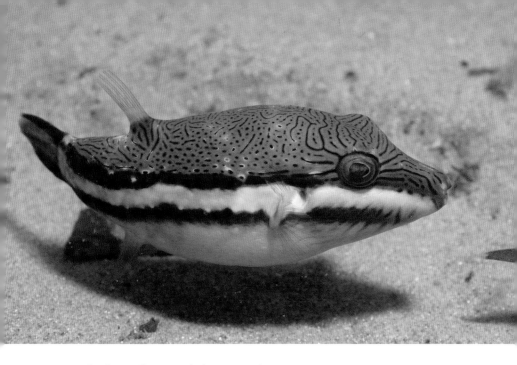

ABOVE: The Clown Puffer is a rare find at some muck sites.

The Saddled Puffer (*Canthigaster valentini*), or Blacksaddle Toby, grows to 10cm in length and has a pretty black banded pattern. The Crowned Puffer (*Canthigaster coronata*) is a similar size and colouration, but is even more lovely, with vivid yellow spots and highlights. There is even a species of filefish that has imitated the colouration of these two pufferfish so that predators will also think it is poisonous – the Mimic Filefish (*Paraluteres prionurus*).

Another small and pretty pufferfish found around muck habitats is the Compressed Puffer (*Canthigaster compressa*), which is usually seen in pairs and grows to 12cm in length. One of the most beautiful of all the small pufferfish is the Clown Puffer (*Canthigaster callisterna*), which appears to be quite rare and reaches a length of 20cm. Bennett's Puffer (*Canthigaster bennetti*), also known as the Blackspot Toby, is another colourful member of the family that prefers muck habitats. This species has handsome blue spots and stripes, but is easily missed as it only grows to 9cm in length. Often found sitting on the sand at muck sites, the Yellow-eye Puffer (*Arothron immaculatus*) is plain in colour but has a very cute face and grows to 30cm in length.

SHARKS

Sharks are generally not associated with muck diving, and at most muck sites you will never see one, but a number of shark species do venture into this environment. In the tropical waters of South-East Asia only two shark species are frequently seen at muck sites, the Coral Catshark (*Atelomycterus marmoratus*) and the Grey Bamboo Shark (*Chiloscyllium griseum*). Both these sharks shelter under ledges during the day, but emerge at night to feed, when divers are more likely to see them. The former has a lovely grey-and-white spotted pattern and reaches a length of 70cm, while the latter can grow to over 1m in length, and is usually a greyish-brown colour with faint bands.

Divers are more likely to encounter sharks while diving muck sites in Australia. At Port Stephens Ornate Wobbegongs (*Orectolobus ornatus*) are quite common. These sharks have lovely skin patterns and are also known as carpet sharks. They grow to 1m in length and are often observed resting on the bottom during the day,

waiting for fish to swim within striking distance. Other shark species seen at muck dives at Port Stephens and Sydney include the Blind Shark (*Brachaelurus waddi*) and Port Jackson Shark (*Heterodontus portusjacksoni*). Port Jackson Sharks are also seen at Melbourne muck sites, and so is the Australian Angelshark (*Squatina australis*) – a flat-bodied shark that grows to a length of 1.5m and spends most of its life buried under a layer of sand. It is an ambush predator that explodes from the sand to snatch fish, octopus and crustaceans that get too close to its mouth.

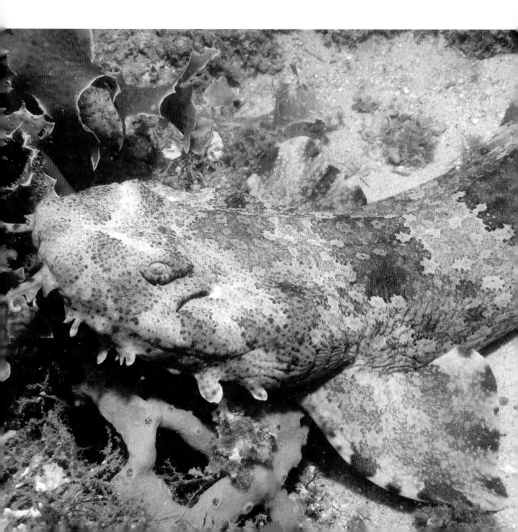

RAYS

A number of ray species are commonly found at muck sites, as rays feed, rest and hide in sandy habitats. While larger ray species turn up at muck sites from time to time, the most common species divers will see in the Indo-Pacific region is the Bluespotted Maskray (*Dasyatis kuhlii*) and the Bluespotted Fantail Ray (*Taeniura lymma*). Both these species have prominent blue spots and are around the same size, 50cm wide, but they can be identified from their shape, with the maskray having a diamond shape, and the fantail ray an oval shape. These two rays are both members of the stingray family and quite active during the day, so are often seen by divers.

At muck sites in Australia divers are likely to encounter a wide variety of ray species. Stingarees are smaller cousins to the stingrays, with this family well represented in Australian waters. At almost every muck site in Australia divers will see at least one, but sometimes several species of these small rays, most of which

BELOW: Divers often find Bluespotted Maskrays when muck diving.

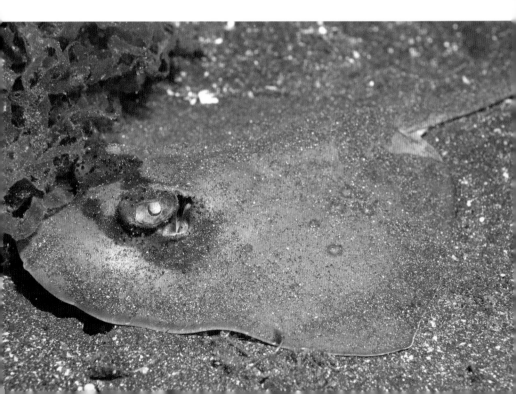

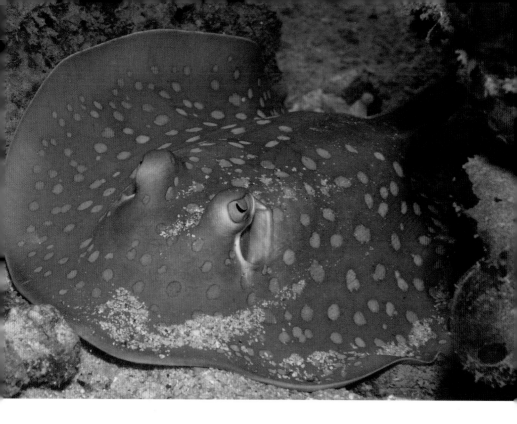

ABOVE: Bluespotted Fantail Rays like to hide under ledges at muck sites.

are little more than 30cm wide. Some of the species seen include the Common Stingaree (*Trygonoptera testacea*), Kapala Stingaree (*Urolophus kapalensis*), Banded Stingaree (*Urolophus cruciatus*), Spotted Stingaree (*Urolophus gigas*) and Sparsely-spotted Stingaree (*Urolophus paucimaculatus*). In Australia divers always have to be careful where they settle on the sand as the Coffin Ray (*Hypnos monopterygium*) may be in hiding. These chubby little rays have electric organs and can give divers a nasty shock. Other ray species that divers are likely to encounter at muck sites in southern Australia are the Eastern Shovelnose Ray (*Aptychotrema rostrata*), Southern Fiddler Ray (*Trygonorrhina fasciata*) and if lucky a Thornback Skate (*Dentiraja lemprieri*).

MUCK REPTILES

The Yellow-lipped Sea Krait is the most common sea snake seen at muck sites in Asia.

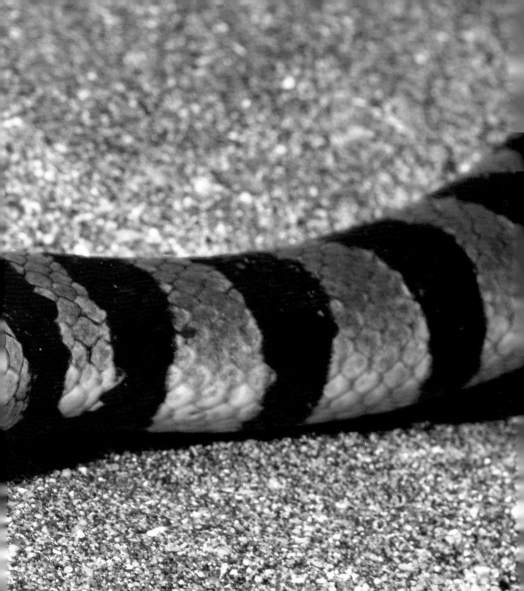

A number of marine reptiles are found in muck environments. Turtles often feed in muck habitats, especially around areas with seagrass, but far more common are the sea snakes.

SEA SNAKES

Limited in their distribution to the Indo-Pacific region, over 70 species of sea snakes have so far been identified. These serpents of the deep evolved from terrestrial snakes around 135 million years ago and are split into five family groups.

The Laticaudids, or sea kraits, are the only group that regularly return to land and the only group that lay eggs - on land naturally. The Acrochordids, or file snakes, are found in fresh water and estuaries, so are sometimes seen at muck sites. The Natricids, or salt marsh snakes, are found only in salt marshes. The Homalopsids, or mangrove snakes, are found mostly in mangroves. But the largest family of sea snakes are the Hydrophiids, or true sea snakes. This group is represented by around 60 species that are highly venomous, have fixed front fangs and spend their whole lives in the sea.

Although looking superficially like terrestrial snakes, sea snakes have developed a few special adaptations to survive in the marine environment. Marine sea snakes have a flattened paddle-shaped tail to assist with swimming. They also have one very long cylinder-shaped lung that extends for almost the entire length of the body, which allows them to remain under water for up to two hours. They can also

absorb oxygen through their skin while underwater. Sea snakes also have unique nostril valves that prevent water entering the lung. Living in a salty environment, sea snakes expel excess salt via a gland under their tongue.

The most common sea snake seen at muck sites in the Indo-Pacific region is the Yellow-lipped Sea Krait (*Laticauda colubrina*). Also known as the Banded Sea Krait, this species grows up to 1.6m in length and is regularly observed during the day searching every nook and cranny for a meal of fish. Like all sea snakes they are non-aggressive and easily avoided if you have a fear of snakes.

The strangest sea snake found at muck sites is the Little File Snake (*Acrochordus granulatus*). This species has rough sandpaper-like skin, is non-venomous, and grows to a length of 1m. It also has a banded pattern, but the bands can be quite faint in some animals. The Little File Snake has a habit of burrowing itself in the sand, and while the male hunts for small fish, the larger and fatter females are ambush predators. This strange sea snake is just another bizarre critter that can be found while muck diving.

BELOW: The Little File Snake is mainly seen at night while muck diving.

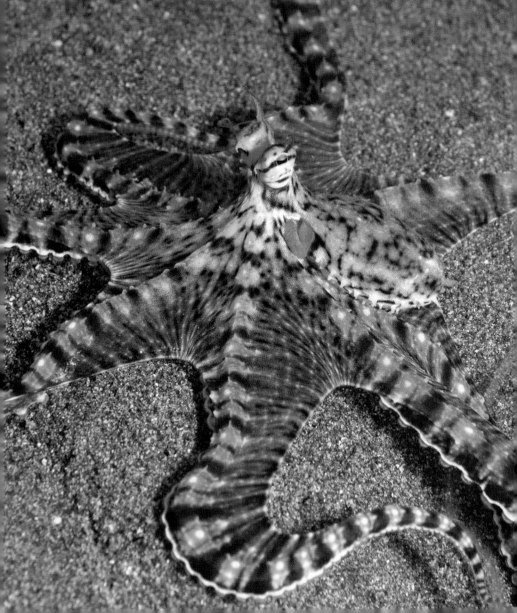

MUCK DIVING
DESTINATIONS

Over the last 20 years muck diving has become increasingly popular with the diving public. Divers now book holidays to exotic destinations in South-East Asia just to see weird and wonderful critters. While Lembeh, Anilao and Bali remain the premier muck diving locations, the choice of muck diving destinations grows each year, as new sites are discovered and new areas for diving are opened up.

In the following pages is a guide to the top muck diving destinations in the Indo-Pacific region. In each section information is provided about the best sites, what the terrain is like, common critters, the best time to visit and the typical conditions a diver can expect. To further assist the reader each destination has been rated as either mega muck or major muck. Minor muck sites are also mentioned in the introduction to each country.

Mega muck sites are destinations with many muck sites and a wonderful collection of critters – locations that you would travel to just to experience the muck diving for a week or more. Major muck sites have numerous muck sites, and a great variety of critters, but are generally destinations where the muck is enjoyed alongside the local reefs or shipwrecks. Minor muck sites still have great critters, but with only a handful of muck sites they play second fiddle to the other dive sites in the area, and you wouldn't travel to these areas just to experience the muck. A number of countries in the Indo-Pacific area with only a small selection of minor muck sites have been excluded, such as Thailand, Cambodia, Vietnam, Brunei, Yap, Palau, Japan, Vanuatu, Fiji and the Solomon Islands.

One thing to remember about muck diving is that nothing is ever guaranteed, as many dive guides will remind you. The critters move about, they also hide from predators and some seasonally disappear. It may take you a dozen trips to muck destinations to see a Flamboyant Cuttlefish (it did me), but the good news is that you will see some fantastic critters along the way. Just have a great time and always be prepared for the unexpected when muck diving.

OPPOSITE: An elusive muck species is the wonderful Mimic Octopus.

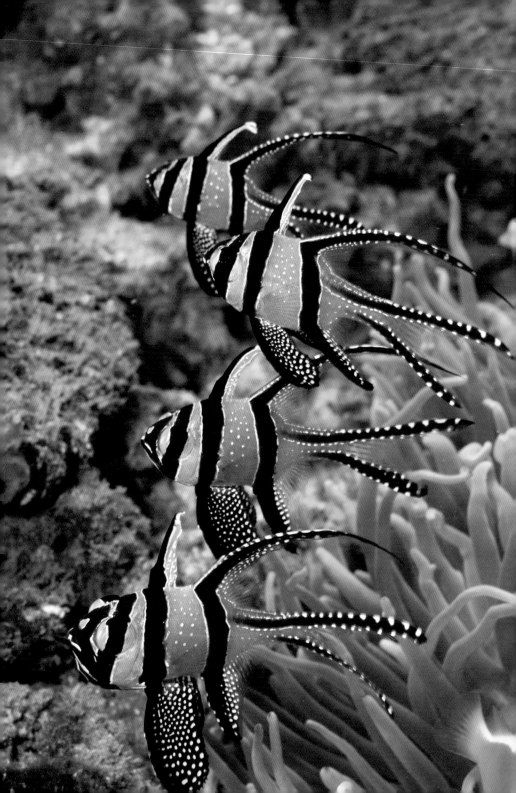

INDONESIA

With over 17,000 islands spread each side of the equator, and located in the heart of the Coral Triangle, Indonesia is blessed with some of the finest diving in the world. Divers are spoilt for choice in this island nation, with an endless collection of reefs, shipwrecks and muck. Indonesia's premier muck site is the legendary Lembeh, but the country has so many great muck diving destinations that it would take many years, and many visits, to explore them all.

Besides the wonderful destinations detailed in the following pages, divers will also find many minor muck sites at locations across Indonesia. Manado, in north Sulawesi, has been a popular reef diving destination for decades. Located only a two-hour drive from Lembeh, the muck diving at Manado has always been overshadowed by its close proximity to the world's premier muck diving destination. However, many wonderful muck critters can be found on the dark sand adjacent to the mainland at sites like Odyssea Point, Wori Bay Point, Posi Posi, Popo, Lumba Lumba and Critter Circus. Komodo is well-known for its spectacular reefs, pinnacles and prolific fish life, but it also has some lovely muck diving at Wae Nilu, Torpedo Alley, Pantai Merah and Pantai Padar. Derawan, located off Kalimantan, has a very interesting mix of dive sites, including a lake full of stingless sea jellies, but it also has some wonderful muck diving at Samama and Pulau Panjang. The Gili Islands, off Lombok, is more famous as a destination for backpackers, but divers will find some great critters at a muck site called Hann's Reef. Alor is a remote location that few divers get to, but it has wonderful reefs and some great muck diving at sites like Dive Logs, Crab City, Afterlife and Bay Watch. In the Maluku area divers exploring the Banda Islands can enjoy muck diving at Mandarin City and Pulau Keraka. While at nearby Halmahera, a great range of critters can be seen at Gemaf Jetty, Airport Critters and Old Weda. At the moment Raja Ampat is famous for its rich reefs, but in the future it could become just as well-known as a muck diving destination, with a great range of critters seen at sites like Happy Endings, Aljui Bay and Algai Patch.

OPPOSITE: Banggai Cardinalfish were once only found at the Banggi Island, but have been spread to other destinations around Indonesia by aquarium collectors.

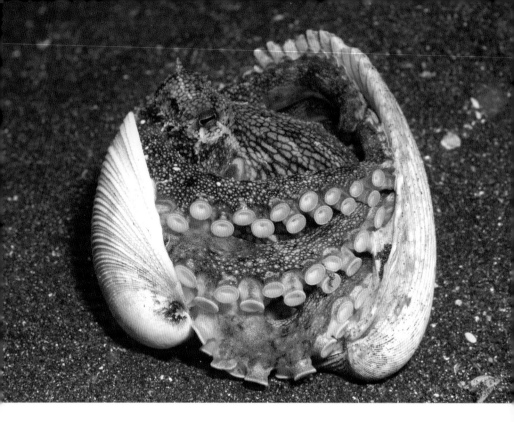

ABOVE: Coconut Octopus are often seen at Lembeh enclosed in a shell mobile home.

Almost anywhere you dive in Indonesia you will discover many fascinating and fabulous muck sites.

LEMBEH (Mega Muck)

The Lembeh Strait is a picturesque body of water located at the north-eastern tip of the island of Sulawesi. The calm waters of the strait are only one to two kilometres wide, and flushed with tidal flows from the Celebes Sea to the north and the Molucca Sea to the south. The shore on both sides of the strait is a mix of rocky headlands and black sandy beaches – a legacy of several nearby volcanos. It is a combination of these factors, and being geographically at the heart of the Coral Triangle, that has made Lembeh the perfect habitat for critters and the best muck diving destination on the planet.

Located a two-hour drive from Manado, the capital of North Sulawesi,

Lembeh was first explored by divers in the early 1990s. What these pioneers found was an incredible variety of muck sites and a smorgasbord of exotic critters. The first dive resort was soon established in the area, and word quickly spread about this fabulous new dive destination with strange critters that divers had rarely seen before. At first divers only visited Lembeh as a side trip to the already famous Manado, but with the growth of muck diving, and the establishment of more dive resorts in the area, Lembeh quickly became a destination in its own right. Today many divers bypass Manado and head straight to Lembeh to explore the world's premier muck diving location.

Dozens of wonderful muck diving sites are found at Lembeh, on both sides of the strait, and one of the best things about the diving in the area is the variety of muck and critters. At Lembeh divers can explore pure muck, with black sandy bottoms that are only broken by the odd rock, coral, sponge or piece of rubbish. At other muck sites the bottom is made up of pebbles, rocks, coral rubble, patchy

BELOW: The black sand at Lembeh is a good place to find Hairy Frogfish.

reef, grey sand, white sand and at some sites a surprising amount of coral. Many of the best muck sites have a combination of bottom terrains, and each type of habitat has its own special muck critters.

On the mainland side of the Lembeh Strait, **Aw Shucks** is the most northerly of the muck sites. Pretty coral gardens are found in the shallows, but the sand and rubble slope is where the best critters can be found in depths to 25m. Commonly seen at Aw Shucks are Finger Dragonets, Ribbon Eels, nudibranchs, lionfish, sea moths and the odd Flamboyant Cuttlefish.

Nearby **Hairball** is a true muck site – a black sand slope in depths to 30m. This site covers such a wide area that it is split into three sections. Exploring Hairball divers are likely to see Hairy Frogfish, Cockatoo Waspfish, ghostpipefish, Demon Ghouls, snake eels, garden eels, Flamboyant and Stumpy-spined Cuttlefish, pipefish, Oriental Sea Robins and several species of octopus. In the shallows are seagrass and rocky outcrops covered in reef fish. Around the seagrass divers will see

BELOW: The Longsnout Clingfish is always found hiding in sea urchins.

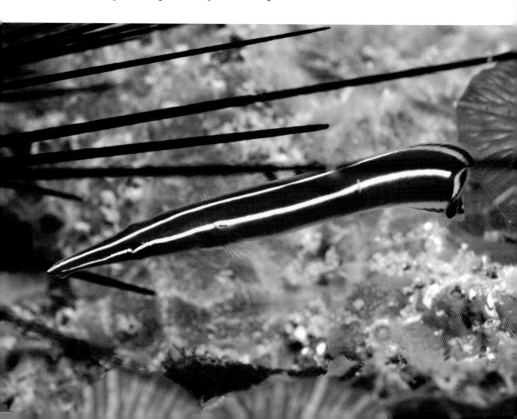

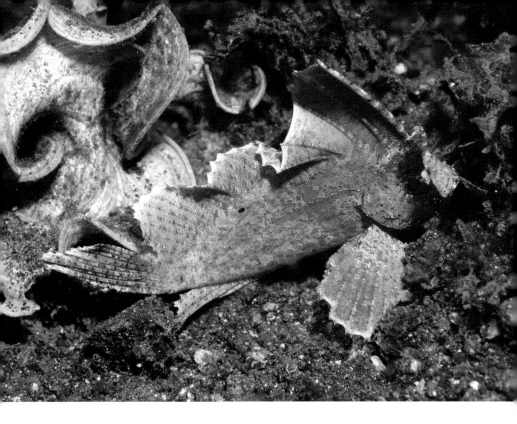

ABOVE: Cockatoo Waspfish can change their colour to aid with camouflage.

filefish, cuttlefish, Orangutan Crabs, pygmy pipehorses, seahorses and flounders. **Teluk Kembahu** (or TK) is a similar site with black sand and is also split into three sections. Both these sites are excellent for night dives, and divers will see Coconut Octopus, Long-arm Octopus, moray eels, squid, soles and numerous crustaceans.

Retak Larry, named after legendary Lembeh dive guide Larry Smith, is another excellent muck site with sloping black sand. Special critters seen at this site include Mimic Octopus, Wonderpus, Hairy Frogfish, dragonets, moray eels and snake eels. **Slow Poke** is a similar site nearby with black sand and many species of nudibranchs, including the occasional one with an Imperial Shrimp hitchhiker. Also look out for stonefish, snake eels, shrimpgobies, Common Seahorses and numerous sand divers.

Magic Crack and **Nudi Retreat** are two sites with pretty coral gardens

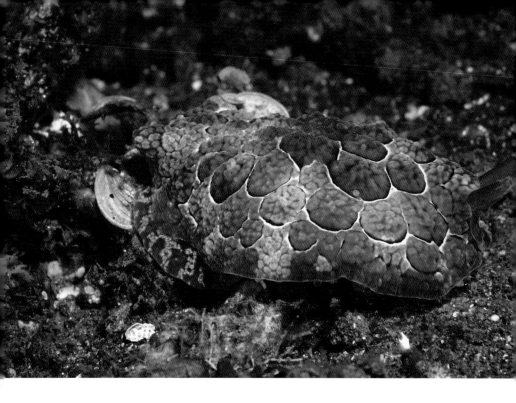

ABOVE: Forskal's Pleurobranchus is a side-gilled slug that is seen at night at Lembeh.

and sand slopes that can be explored to 25m. At either site divers are likely to find cuttlefish, Leaf Scorpionfish, sea moths, pipefish and a good collection of nudibranchs. Nudi Retreat is famous for its wonderful nudibranchs, but this dive site is also a good location to see Pontoh's and Bargibant's Pygmy Seahorses.

Makawide is the name of a village and a popular muck site. This extensive dive site has coral gardens in the shallows and a mix of sand and rubble slopes to explore. Numerous anemones dot the sandy bottom and are occupied by Panda Anemonefish, commensal shrimps, porcelain crabs and beautiful Banggai Cardinalfish. Fire Urchins are also common here, and some are home to Zebra Crabs and Coleman's Shrimps. Other critters to keep an eye out for include Cockatoo Waspfish, Demon Ghouls, moray eels, snake eels, garden eels, mantis shrimps, ghostpipefish and Mimic Octopus.

In the next bay south is **Jahir**, another wonderful black sand slope loaded with critters. Exploring the sand to 20m expect to see Painted Frogfish, Demon

Ghouls, nudibranchs, dragonets, cuttlefish and Bluespotted Maskrays. Jahir is one of those muck sites that is often better at night, with a different variety of critters on show. Snake eels, including Crocodile Snake Eels, are easier to spot at night, but also look out for stargazers, fireworms, box crabs, hermit crabs, decorator crabs, bobtail squid, Bigfin Reef Squid, prawns, Coconut Octopus and Long-arm Octopus. **Air Pang** is a similar site nearby, and a good location to see Hairy Frogfish, Sawblade Shrimps, shrimpfish and cuttlefish. It is also one of the best sites to see bizarre Bobbit Worms at night.

Nudi Falls is one of the most interesting and varied of all the dive sites at Lembeh. With the dive boat tying up to a rocky wall under overhanging trees, divers can explore the wall to 15m, then a sandy rubble slope and finally an extensive garden of lovely soft corals. You can get beyond 30m at this site and you will want to go deep to explore the soft coral gardens as this is where Weedy Scorpionfish often shelter. Also seen in this area are Painted Frogfish, ghostpipefish and Candy Crabs. On the sandy rubble slope are Finger Dragonets, garden eels, flounders, mantis shrimps and the odd Flamboyant Cuttlefish. Finally, the rock wall is a great location to see nudibranchs, pipefish, shrimpfish, moray eels, anemonefish, lionfish and Banggai Cardinalfish.

Off the **Police Pier** divers can explore a sandy rubble slope that is covered in soft corals, sponges and anemones. Nudibranchs, Painted Frogfish, Ribbon Eels, lionfish, Cockatoo Waspfish, mantis shrimps and Harlequin Crabs are some of the typical species seen.

Lots of rubbish litters the waters of the Lembeh Strait, with **Bianca** the biggest rubbish pile of all. Located in the harbour, under numerous fishing boats, this sandy rubble slope might be very unsightly and disturbing at times, but is still home to some amazing critters. Cockatoo Flounders, Painted and Warty Frogfish, blennies, Cockatoo Waspfish, moray eels, mantis shrimps, pipefish, lionfish, cuttlefish and Banggai Cardinalfish are all common. But the coral rubble is worth a close look as dozens of Splendid Mandarinfish feed here in daylight hours and are completely oblivious to divers. Nearby **Tandurusa** is another sandy rubble slope where divers will see ghostpipefish, nudibranchs, gobies, hairy shrimps and frogfish. There are a few muck sites south of here, but they are rarely dived.

Located in the middle of the Lembeh Strait are the Sarena Islands. Lovely

coral gardens are found right around these islands, but beyond are sandy rubble slopes with critters. At **Sarena Pata** divers will find Ribbon Eels, Sawblade Shrimps, ghostpipefish, snake eels, pygmy pipehorses, frogfish, boxfish, cowfish and nudibranchs amongst the coral rubble. Similar sites, with similar critters, are **Sarena Barat** and **Sarena Besar**. But the best muck site at these islands is **Critter Hunt**. The rubble slope at Critter Hunt at first looks barren, but a good guide will find Tiger Shrimps, Hairy Shrimps, Sawblade Shrimps, blue-ringed octopus and many other critters.

The Lembeh Island side of the strait also hosts numerous muck sites. The northern end of the island has lovely coral reefs, with the first muck site found at **Batu Merah**. At this site divers can explore pretty coral gardens or drift down a sandy slope to 28m. The sandy slope is dotted with numerous bommies and also the remains of a fishing boat. Common critters include moray eels, pipefish, gobies, nudibranchs, cuttlefish, dragonets and the odd Boxer Crab.

Rojos is a true muck site, with wonderful black sand sloping to 25m and beyond. Snake eels, garden eels, Coconut Octopus, Cockatoo Waspfish, nudibranchs, sand divers and cuttlefish are some of the common species. But Rojos is the sort of muck site where anything can turn up, so watch out for Mimic Octopus, Wonderpus, Flamboyant Cuttlefish and Hairy Frogfish.

Divers can explore a mix of coral and sand at **Batu Sandar**, with pygmy seahorses common at this site. Nearby **Aer Bajo** is another black sand site and one of the premier muck dives at Lembeh. This dive site covers such a huge area that it is usually split into three zones. Cruising this sandy slope divers will see Ambon Scorpionfish, Cockatoo Waspfish, Demon Ghouls, frogfish, cuttlefish, Coconut Octopus, flounders, pipefish, Flamboyant Cuttlefish and many other great critters.

One of Lembeh's best mixed muck sites is **Tanjung Kubur**. This site has hard corals in the shallows, a coral rubble slope and then a sandy slope, with different critters found in each area. On the sand are dragonets, gobies, flounders and mantis shrimps. The coral rubble zone is often the most rewarding with seahorses, pipefish, Banggai Cardinalfish, nudibranchs, frogfish and blue-ringed octopus. The coral gardens are also worth exploring at the end of the dive as Halimeda Ghostpipefish and Pontoh's Pygmy Seahorses are found here.

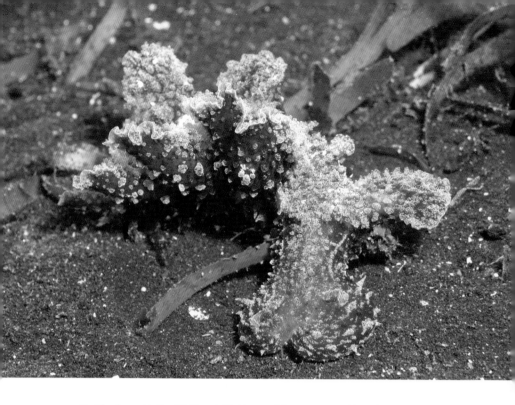

ABOVE: The Wonderous Melibe (*Melibe minifica*) is one of the strangest nudibranchs seen at Lembeh.

Pantai Parigi is one of the only muck sites at Lembeh with white sand. Exploring this sandy slope, divers are likely to see Ambon Scorpionfish, pipefish, nudibranchs, mantis shrimps and blue-ringed octopus. **Pintu Colada** is a similar site nearby with a white sandy slope and coral gardens in the shallows. At **Pante Abo** the black sand returns. Exploring this slope, divers will see ghostpipefish, frogfish, gobies, Cockatoo Waspfish and a good variety of nudibranchs. At night numerous squid and octopus species take over this site. **Pintu Kota Kecil** is another muck site with sloping black sand and rubble. Divers will encounter Ribbon Eels, cuttlefish, dragonets, moray eels, lionfish and Banggai Cardinalfish at this site.

Tanjung Kusu-Kusu is a site with coral gardens and coral rubble. While frogfish, octopus, nudibranchs, pipefish and cuttlefish are common, the site is popular for a dusk dive to watch the mating activities of Splendid Mandarinfish. South of this site are a few other muck sites that are rarely visited.

North
Sulawesi

Aw Shucks
Hairball
Teluk Kembahu
Retak Larry
Slow Poke
Magic Crack
Nudi Retreat
Makawide
Jahir
Air Pang
Nudi Falls
Police Pier
Bianca
Tandurusa
Critter Hunt

Batu
Merah
Rojos
Batu Sandar
Aer Bajo
Tanjung Kubar
Pantai Parigi
Sarena Barat
Pintu Colada
Pante Abo
Pintu Kota Kecil
Tanjung Kusu-Kusu
Sarena Pata
Sarena Besar

Palau Lembeh

There are so many muck sites in the Lembeh Strait that you would have to stay for at least two weeks to experience them all. But even then you are unlikely to visit them all, as you will find yourself returning time and time again to favourite sites to see fabulous critters.

LEMBEH DIVE DATA

HOW TO GET THERE – Manado has the closest airport to Lembeh, with regular flights from Singapore, Jakarta and Bali. Lembeh is located approximately two hours' drive from the airport. Ask your dive resort to organise a pick-up from the airport.

BEST TIME TO VISIT – Year-round, but different critters are often seen at different times of the year.

VISIBILITY – Typically 10–15m, but varies with the tide at some muck sites.

DIVING CONDITIONS – Currents affect a few dive sites, but most only have gentle water movements.

WATER TEMPERATURE – 25–29°C.

BALI (Mega Muck)

The beautiful island of Bali is a paradise for holidaymakers, with great beaches, wonderful resorts, spectacular scenery, good value shopping, a fascinating culture and the warm friendly Balinese people. At times it can appear to be overrun with tourists, but once beyond the tourist strips the island still has many quiet areas where you can get away from it all. One area where you may find it hard to escape from other tourists is underwater, as the reefs and muck sites around Bali are brilliant, but also very popular.

Diving in Bali is mainly done on the eastern and northern coasts, as these are sheltered from the prevailing winds and swell. A number of dive resorts are based at popular dive sites like Tulamben and Padangbai, but the good thing about Bali is that the island is so small that you can dive any part of it on day trips. Dive safaris are popular, allowing you to do a road trip and explore the best of the island over a number of days. One of the most popular safaris is a muck diving adventure, with Bali having a huge supply of wonderful muck sites.

At the western tip of Bali, near the town of Gilimanuk, is a spectacular muck dive known as **Secret Bay**. This site is located in a sheltered bay with black sand, seagrass and a fair bit of rubbish, all found in depths from 3m to 12m. Secret Bay is best dived on the high tide, for the clearest water, and the water can be cool, down to 20°C at times, but rarely more than 25°C. But it is the perfect habitat for some amazing critters.

Exploring Secret Bay divers will find frogfish, Cockatoo Waspfish, cuttlefish, octopus, shrimps, crabs, nudibranchs, seahorses, snake eels, stargazers, flounders, soles, gobies, dragonets, pipefish and many other wonderful species. This is the best spot in Bali to see Ambon Scorpionfish, Bluefin Lionfish and Bobbit Worms, but just about anything can turn up at this brilliant muck site.

Bayu's Place is a less well-known muck site at the western end of Bali, but it is worth a look if you are in the area. The terrain is a mixture of sand and rubble, with the odd coral outcrop, but it is a good location to see ghostpipefish, Pyjama Cardinalfish, dragonets, gobies, nudibranchs, octopus, Demon Ghouls and several species of shrimp. Splendid Mandarinfish are found in the coral at Bayu's Place, even during the day.

A number of artificial reefs are found off the coast of Bali, with the **Pemuteran**

Biorock one of the more unusual sites. Located at the western end of the island, these electrified metal structures are located on a sandy bottom and used to promote coral growth. The structures may be interesting, but the critters found on the sand generally get all the attention. Commonly seen are frogfish, gobies, moray eels, dragonets, Leaf Scorpionfish, stingrays and even seamoths.

In the last few years the area around Seririt has grown in popularity as one of the most interesting muck diving destinations in Bali. Near the town are two wonderful muck sites, **Puri Jati** and **Kalang Anyar**, which are home to some amazing critters. Both sites have dark sand slopes with little coral, but plenty of seagrass, algae and rubbish for critter accommodation. Divers will find an endless collection of impressive muck species, including seahorses, frogfish, snake eels, pipefish, shrimpfish, seamoths, ghostpipefish, Cockatoo Waspfish, Demon Ghouls, lionfish, Oriental Sea Robins, cowfish, filefish, boxfish and cuttlefish. Both sites are a haven for octopus, so look out for Coconut Octopus, Greater Blue-ringed Octopus, Mimic Octopus and even Wonderpus.

BELOW: The Mototi Octopus is occasionally seen at Bali muck sites.

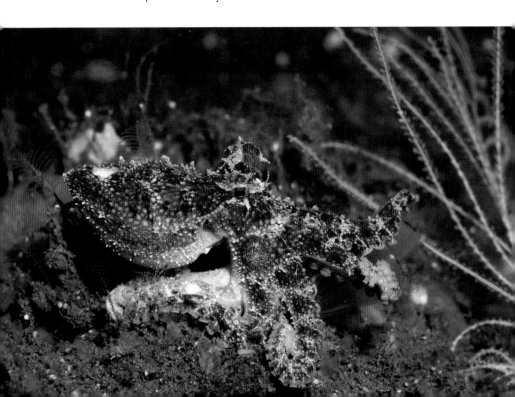

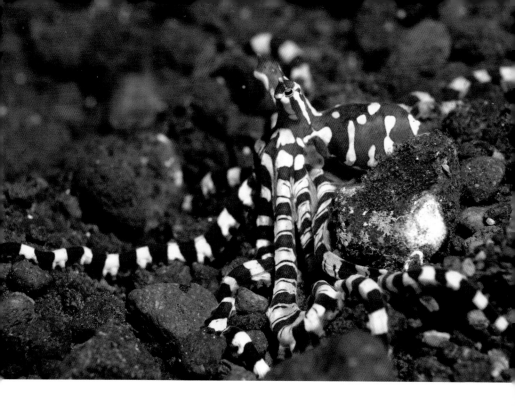

ABOVE: Bali is home to a good range of octopus species, include the amazing Wonderpus.

The Tulamben area has always been the most popular dive destination in Bali, with the USAT *Liberty* shipwreck a major drawcard, but there are also some wonderful muck sites. West of the town is the seldom-dived **Tianyar**. The black sand at this site slopes into the depths, but also has many undulations formed by the strong currents that sweep the area. Dives are timed to avoid the currents, so you can marvel at frogfish, snake eels, seahorses, gobies and maybe a Mimic Octopus.

Tulamben's main dive sites, the **Liberty Wreck** and the adjacent **Coral Gardens**, also have some excellent muck. The USAT *Liberty* rests on a sandy/rocky slope in depths from 6m to 27m, and is a good location to find pygmy seahorses, ghostpipefish, Leaf Scorpionfish, mantis shrimps and many other critters. The Coral Gardens has a mix of coral and sand, and also has a good selection of critters, with Ribbon Eels, nudibranchs, pipefish, scorpionfish, Harlequin Shrimps and ghostpipefish all common.

Robust Ghostpipefish come in a range of colours at Bali muck sites.

East of Tulamben is the most famous muck site in Bali, the legendary **Seraya Secrets**. This site covers a wide area, and is often called Seraya Slope, but anywhere you dive at this site you will have an incredible time. The black sand slopes into 30m plus. Some outcrops of coral dot the bottom, but there are also rocks, rubbish and the odd log that provide a home for critters. Divers will find ghostpipefish, pipefish, shrimpfish, scorpionfish, dragonets, gobies, flounders, cuttlefish, filefish, snake eels, garden eels, Harlequin Shrimps, Zebra Crabs, Hairy Squat Lobsters, Coleman's Shrimps and a vast collection of commensal shrimps and nudibranchs. Rarer species such as Mimic Octopus, Tiger Shrimps and seamoths are seen here from time to time. A special feature of Seraya Secrets is the baby frogfish. A good guide will be required to point out the smaller ones, which may be only 1cm long! A similar site nearby is **Petitisan**, which is a great spot to see octopus, and divers have found Wonderpus and Mototi Octopus at the site.

Ghost Bay is located near the town of Amed and is good spot to see ghostpipefish. The sloping sand at this site is also a habitat for seahorses, frogfish, pipefish and stonefish.

Padangbai is located on the east coast of Bali and is best known as the port for boats travelling to Lombok. However, this sheltered bay and the surrounding coastline is dotted with some lovely muck sites and some great critters. At **Blue Lagoon** divers can explore sand, rubble, seagrass and coral outcrops in depths from 3m to 30m. Common species include frogfish, stargazers, seamoths, dragonets, nudibranchs, Leaf Scorpionfish and the occasional Ambon and Weedy Scorpionfish. **Jepun** is a similar site, but with a small wreck and other manmade additions to explore. A dive here will expose divers to numerous sea anemones, nudibranchs, boxfish, Cockatoo Waspfish, cuttlefish, spider crabs, cowfish, Ribbon Eels and Harlequin Shrimps.

Two other nearby muck sites, **Tanjung Bungsil** and **Bias Tugel**, also feature a mix of sloping sand and coral, and are very productive. These sites are home to Ribbon Eels, gobies, Giant Frogfish, moray eels and numerous pygmy seahorses. One of the best muck sites in the area is **The Jetty**. The sandy bottom here is 18m

BELOW: A rare sight at Jepun, a jawfish completely out of its hole.

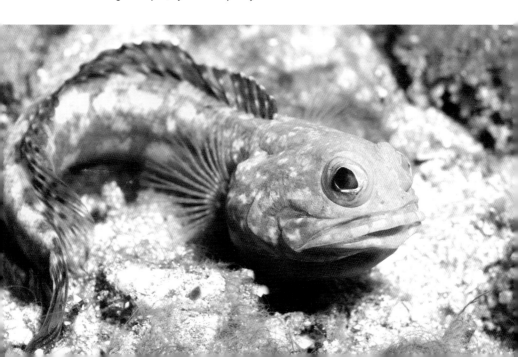

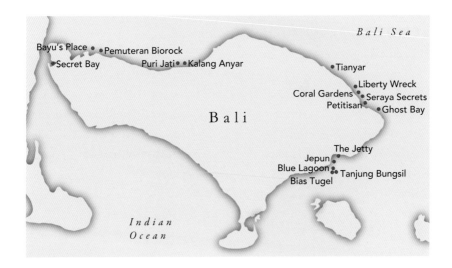

Map labels:
Bali Sea

Bayu's Place • • Pemuteran Biorock
• Secret Bay Puri Jati • • Kalang Anyar • Tianyar

 Coral Gardens • • Liberty Wreck
 • • Seraya Secrets
 Petitisan • • Ghost Bay

Bali

 The Jetty
 Jepun •
Blue Lagoon •• Tanjung Bungsil
Bias Tugel

Indian
Ocean

deep and a great location to see snake eels, frogfish, pipefish, Cockatoo Waspfish, flounders and even the occasional Flamboyant Cuttlefish. Unfortunately this jetty is also popular with fishers, so watch out for lines, hooks and fishing nets!

Bali is blessed with an abundance of muck sites that rival better-known muck destinations such as Lembeh and Anilao.

BALI DIVE DATA

HOW TO GET THERE – Bali is serviced by numerous airlines and is a popular stopover point for exploring other areas of Indonesia.

BEST TIME TO VISIT – Year-round, but many consider April to November to be the best months for diving.

VISIBILITY – Typically 10–20m, but varies with the tide at some muck sites.

DIVING CONDITIONS – Currents vary greatly around Bali. Most muck sites are exposed to gentle currents, but others experience quite strong currents.

WATER TEMPERATURE – Generally 26–29°C, but can be much cooler at some muck sites.

SEKOTONG, LOMBOK (Major Muck)

Located off the south-west corner of Lombok is a collection of scattered islands that are known as the Secret Gili's. While the famous Gili Islands, off the northern end of Lombok, are over-run by divers and backpackers, these lovely islands off the town of Sekotong have managed to slip under the radar. This is very surprising as the diving around these islands is superb. The main reason that this area is less popular is because there has been little development, with no night clubs, bars or restaurants, and just a handful of resorts. But if you want to experience some wonderful reefs and amazing muck diving without the crowds, then Sekotong could be the place for you.

Wills Beach is the premier muck site in the area, and many rate it as good as the best sites at Lembeh. It takes a few dives to explore this site properly, as it covers a wide area and there is so much to see. Wills Beach is a sandy sloping site, with seagrass in the shallows and lots of soft corals in deeper water. You will find great critters at any depths, and on a typical dive your guide will lead you on a zigzag trail up and down the slope in depths to 20m.

Common critters at Wills Beach include cuttlefish, snake eels, jawfish, filefish, seamoths, boxfish, flatworms, pufferfish, soles, mantis shrimps, Demon Ghouls, shrimpfish, frogfish, ghostpipefish, commensal shrimps, spider crabs, shrimpfish, gobies and blennies. There are also plenty of sea anemones and sea pens that are home to shrimps, porcelain crabs and anemonefish. This site also has an abundance of shrimpgobies, with around a dozen species on show, and an impressive number of nudibranchs, including large Spanish Dancers.

Wills Beach is the kind of muck site where just about anything can turn up. Other muck species recorded here include Wonderpus, Coconut Octopus, Long-arm Octopus, Mimic Octopus, Greater Blue-ringed Octopus, Sawblade Shrimps and Ambon Scorpionfish. If that wasn't enough to whet your appetite the odd Dugong has been encountered here, feeding on the seagrass beds.

Another wonderful muck site in the area is **Odyssea 3**, a steep rubble bank with patches of seaweed and corals. In depths from 6m to 20m divers are likely to see mantis shrimps, cuttlefish, upside-down jellyfish, snake eels, pipefish, commensal shrimps, shrimpgobies, Demon Ghouls, Hairy Shrimps, lionfish and many unusual nudibranchs. A similar rubble site is **Nudie Slope**, and it is

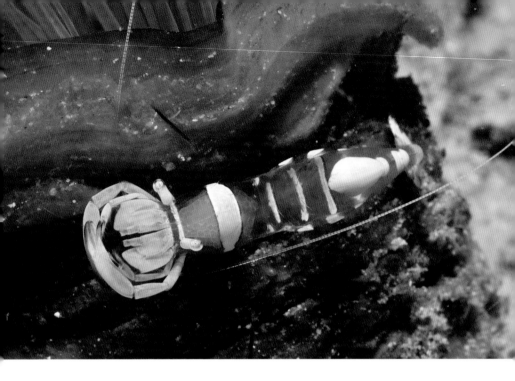

ABOVE: The Magnificent Anemone Shrimp *(Ancylomenes magnificus)* is often found on tube anemones.

a great place to find many weird and wonderful nudibranchs. Other critters to look out for include Harlequin Shrimps, ghostpipefish and octopus. **Gili Gelong** is another muck site with sand and rubble where divers will see Ribbon Eels, cuttlefish, gobies, mantis shrimps, pipefish and many other species.

Kura Kura can be almost as good as Wills Beach and has a variety of muck terrains, including sloping sand, coral rubble, seaweeds, rocks and patchy coral. Nudibranchs, cuttlefish, pipefish, shrimps, crabs and juvenile fish are all common, but this site is especially good for scorpionfish. With luck your guide will be able to find Demon Ghouls, Cockatoo Waspfish, Phantom Velvetfish and maybe a spectacular Ambon Scorpionfish.

Some of the reef dives at Sekotong are a combination of coral, sand and coral rubble, so are home to a wide variety of muck critters. The best of these is **Rangit Barat**, with the sandy plain beyond the reef a great place to find mantis shrimps, nudibranchs, Ribbon Eels, Demon Ghouls, pipefish and Painted Frogfish. All

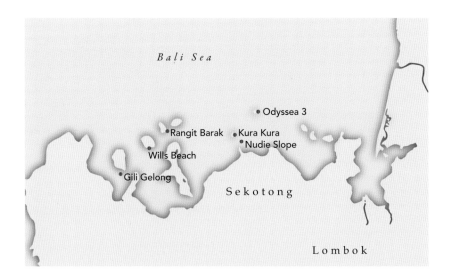

the reefs off Sekotong are brilliant for macro photography, with Harlequin Shrimps, pygmy seahorses, squat lobsters, Xeno Crabs and a diverse collection of nudibranchs to be seen. Hopefully this wonderful destination will remain an undeveloped gem.

SEKOTONG DIVE DATA

HOW TO GET THERE – There are several ways to get to Sekotong, including daily boats from Bali, but flying is far easier. Garuda Airlines operates daily flights to Lombok from Bali, Jakarta and several other cities in Indonesia. Silk Air also offers direct flights from Singapore, and Asia Air has direct flights from Kuala Lumpur. From the airport it is a 90-minute drive to Sekotong. Arrange a pick-up with your dive resort.

BEST TIME TO VISIT – Year-round, but some of the best critters can be seen in the wet season (November to March).

VISIBILITY – Typically 10–15m, but can be less in the wet season.

DIVING CONDITIONS – Currents are generally mild or non-existent on the muck sites, but can be strong on the coral reefs.

WATER TEMPERATURE – 26–29°C.

MAUMERE, FLORES (Major Muck)

Flores was once one of the most popular dive destinations in Indonesia. In the 1980s it was one of the places to dive in South-East Asia with lovely coral reefs and a wealth of marine life. However, in 1992 a devastating earthquake and tsunami hit Flores, killing thousands of people and destroying the dive tourism industry. But in reality the tsunami had little impact on Flores' dive sites and today the island has become one of Indonesia's forgotten treasures.

The diving in Flores is centred around Maumere, a small town near the north-eastern end of the island. Divers have the choice of exploring this area from a dive resort or via a liveaboard – either way you will get to see some lovely reefs and a variety of magic muck sites.

The numerous bays around Maumere offer endless muck diving opportunities, with black sand common at these sites – a legacy of the 17 volcanos scattered across Flores. One of the most popular muck sites is **Old Ankermi Muck**, a sandy

BELOW: Lovely Sexy Shrimps (*Thor amboinensis*) are found in anemones and corals.

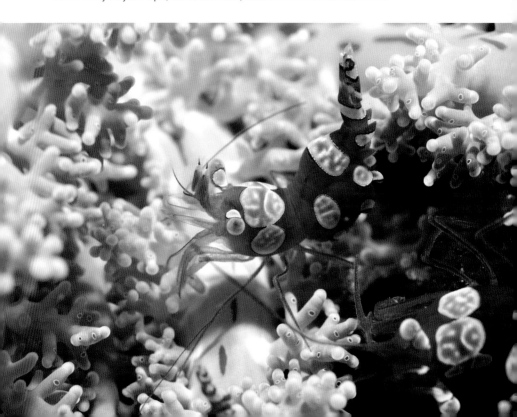

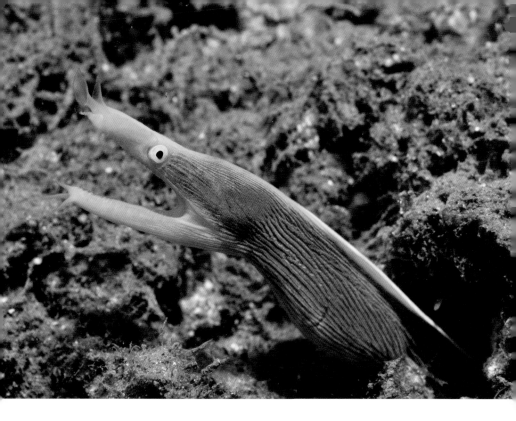

ABOVE: A good population of Ribbon Eels is found off Maumere.

slope with seagrass and coral outcrops. In depths to 18m divers will commonly see mantis shrimps, pipefish, lionfish, nudibranchs, numerous sea anemones with resident anemonefish and countless shrimpgobies. Sea cucumbers are common and a surprising number play host to pretty Imperial Shrimps. This site is also a good place to see seahorses, frogfish, Ambon Scorpionfish and many other brilliant muck critters.

One of the most unusual muck dives at Maumere is actually a wreck dive, known as the **Wairterang Wreck.** This 50m-long ship, thought to be a tank landing craft, was sunk during World War II and lies in 13m to 32m of water. The wreck is very open and fun to explore, and is home to a surprising variety of reef and pelagic fish. This wreck is also a habitat for numerous critters, with pipefish, nudibranchs, lionfish and shrimps all common. After exploring the wreck divers can venture into the shallows to explore the muck and coral outcrops. Found here

are moray eels, Demon Ghouls, nudibranchs, soles, garden eels and Ribbon Eels.

At **Wair Blerer** there is a shallow reef surrounded by black sand in depths to 16m. This is a good spot to see Ribbon Eels, octopus, moray eels, dragonets, lionfish, nudibranchs, shrimpfish, Twin-spot Gobies and the occasional stargazer. More black sand is found at **Zubinarius**, with this site a good location to see frogfish, seahorses, pipefish, octopus and nudibranchs.

Maumere Harbour is another excellent muck site, if you can avoid the boats. Divers have seen seahorses, frogfish, dragonets, moray eels and other great critters here. If you can get permission, a dive at **Pertamina Jetty** can be unforgettable. The pylons at this jetty are covered in lovely corals and the sandy bottom is home to scorpionfish, dragonets, flounders, mantis shrimps, stonefish and frogfish.

Another brilliant muck site is the **Sea World Club House Reef**. The clean black sand at this site is a haven for critters in depths from 2m to 6m. In the shallows are hundreds of Radiant Sea Urchins and hiding amongst them are Ornate Ghostpipefish, Dwarf Lionfish, hermit crabs, swimming crabs, shrimps and the occasional Shaggy Frogfish. Exploring the black sand divers will also find

BELOW: Juvenile triggerfish are often seen at muck sites, this one is a juvenile Yellowmargin Triggerfish (*Pseudobalistes flavimarginatus*).

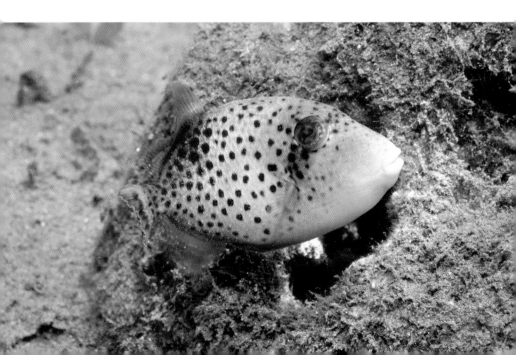

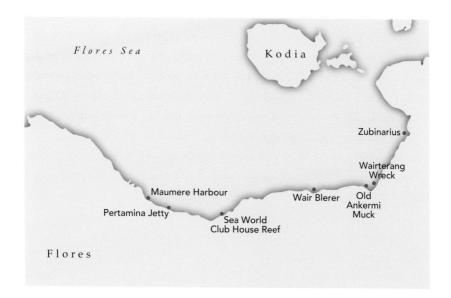

garden eels, gobies, shrimpfish, sand divers, box crabs, sea pens and snake eels. An interesting feature of this site is that it plays host to thousands of small heart urchins, which totally cover the bottom in places. They look pretty boring at first, but when you see a large sea star hunting them, the action is amazing to watch, and they move a lot faster than you would expect.

One of the best things about diving in Flores is the complete lack of divers (at the moment), but this can't last forever as the rest of the diving world is sure to discover this forgotten treasure.

MAUMERE DIVE DATA

HOW TO GET THERE – Daily flights from Bali to Maumere are available with several airlines.
BEST TIME TO VISIT – Any time of year.
VISIBILITY – Typically 8–12m at the muck sites.
DIVING CONDITIONS – Currents are rare at the muck sites.
WATER TEMPERATURE – 26–30°C.

AMBON (Mega Muck)

Ambon is located in the Maluku group of islands in eastern Indonesia, which are better known as the famed Spice Islands. These lovely islands are the source of many rich spices found nowhere else, including pepper, cloves, nutmeg and cinnamon, and as such have always been one of the most important areas of the country. For centuries these spices have attracted ships from across Asia, seeking to buy these unique and valuable products. The spices are also what first drew Europeans to Indonesia, but the Dutch, Portuguese and British were more interested in seizing the islands to control the spice trade. Today these spices are still a drawcard for some tourists, but Ambon's major attraction is its wonderful muck diving.

Surrounding Ambon are lovely coral reefs, but most divers travel to this island to experience some of the best muck diving in the world in the sheltered Amboyna Bay. Wedged between the two main islands of Leihitu and Leitimur, this bay is full of fabulous muck sites overflowing with exotic critters, which will keep any underwater photographer busy for weeks.

BELOW: Ambon is one of the best locations to see the incredible Weedy Scorpionfish.

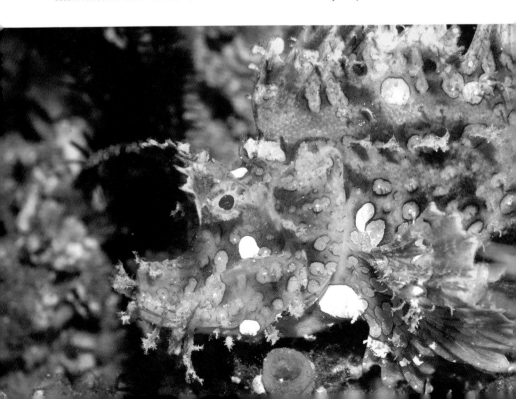

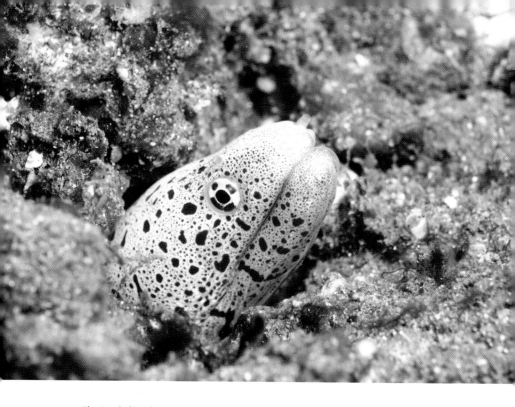

ABOVE: The Banded Mud Moray (*Gymnothorax chlamydatus*) is a muck species rarely seen.

One of the first muck diving sites to gain fame in the 1990s is a site off Ambon called **The Twilight Zone**. This amazing site covers a wide area, and is split into three separate dive sites, Laha1, Laha2 and Laha3, which are named after the nearby village of Laha. The main site is **Laha1**, where a jetty – known as 'the aviation jetty' as fuel is offloaded here for the airport – provides shelter for a vast array of marine life. Under this jetty is sand, junk and a wonderful collection of critters in depths from 3m to 12m. Just about any muck critter you could wish for can be found at this site, including ghostpipefish, frogfish, Leaf Scorpionfish, Ambon Scorpionfish, mantis shrimps, moray eels, lionfish, Demon Ghouls, seahorses, snake eels, octopus, cuttlefish, nudibranchs, flatworms, pipefish, Splendid Mandarinfish, stonefish, Harlequin Shrimps, Mimic Octopus, Weedy Scorpionfish and many other species. Schools of batfish and thick clouds of silversides also dwell under the jetty, making this site spectacular not only for macro photography, but also for wide-angle work.

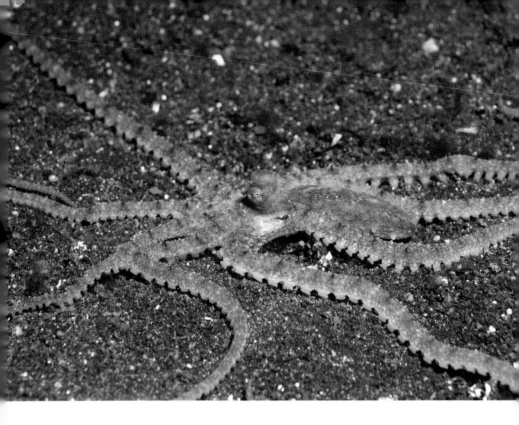

ABOVE: The Longarm Octopus lives in the sand and is best seen at night.

Laha 2 is located nearby and divers can explore this sandy rubble slope in depths to 30m or more. Sponges and small corals are found here and provide shelter for frogfish, ghostpipefish, nudibranchs, shrimps and crabs. On the sand are shrimpgobies, jawfish and sometimes Flamboyant Cuttlefish. Weedy Scorpionfish are often found in this area. Another jetty is found at **Laha 3**, but most diving is done on the sandy slope where divers will see Ribbon Eels, mantis shrimps and many other critters.

North of Laha are a number of muck sites that are not regularly dived, but one wonderful site is **Mimic Point**. This sandy slope is a great place to see Mimic Octopus and Wonderpus, but divers will also see numerous nudibranchs, cuttlefish and cowfish. South of Laha is the brilliant **Rhino City**. At this site divers can explore a sandy slope or seagrass beds. Named after the Weedy Scorpionfish that are regularly found in the area, this site is also a great location to see

dragonets, nudibranchs, jawfish, Orangutan Crabs, ghostpipefish, seamoths and seahorses. Numerous sea anemones dot the bottom here and are home to Panda Anemonefish, commensal shrimps and porcelain crabs.

Another good spot to see Weedy Scorpionfish is **Kampung Baru**. This sloping site has scattered coral and rocks, and is populated by moray eels, shrimpgobies, frogfish, ghostpipefish, shrimpfish and cuttlefish. **Middle Point** has a good mix of sand, rubble and coral in depths to 20m. Fire urchins are common here, and a close look may reveal Zebra Crabs and Coleman's Shrimps living between the urchin spines. Halimeda Ghostpipefish, Leaf Scorpionfish and frogfish are also found at this site.

The **Air Manis Jetty** is a good spot to see a range of interesting critters. Divers will find nudibranchs, gobies, hawkfish, pipefish, moray eels, scorpionfish and cuttlefish amongst the sand and rubbish. Pygmy seahorses are also found on the gorgonians at this site, and if you are lucky a Tiger Shrimp could be in residence.

BELOW: A very cute fish seen at muck sites is the Longhorn Cowfish.

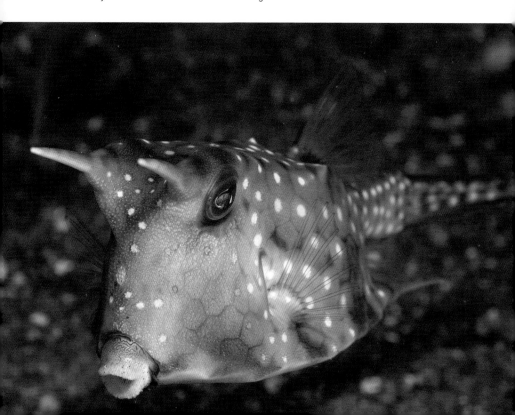

Another wonderful jetty dive can be experienced at the **Airport Jetty**. This long jetty has colourful pylons that swarm with small fish, but on the sand divers will see lionfish, moray eels, mantis shrimps, nudibranchs, gobies, octopus, hermit crabs and maybe a Weedy Scorpionfish.

On the other side of Amboyna Bay are more delightful muck sites to explore. The sandy slope at **Tirta Point** is interrupted occasionally by patches of coral. Exploring this site divers will see gobies, shrimpfish, frogfish, jawfish and a good collection of nudibranchs and crustaceans. At **Devion Point** many of the same species can be seen, but also look out for Leaf Scorpionfish.

Kaca Lengkung also has a mix of sand and coral patches. Critters found here include Ribbon Eels, Leaf Scorpionfish, Demon Ghouls, cuttlefish, nudibranchs and dragonets. Another fascinating jetty dive is found at **Dark Blue Jetty**. The

BELOW: Named after the island, the Ambon Scorpionfish is often seen at the local muck sites.

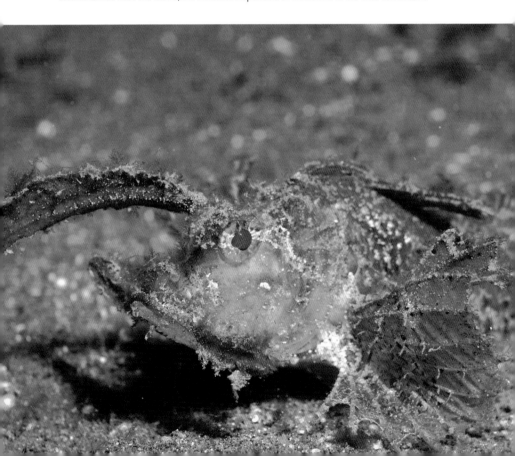

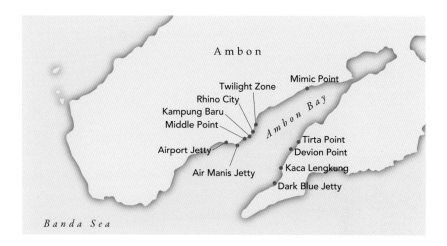

sandy bottom under this jetty is a good location to see frogfish, mantis shrimps, pufferfish, boxfish, stonefish and maybe a Boxer Crab.

Ambon is a wonderful muck diving destination, and if you are very lucky you may even see one of the rarest muck critters of all, the incredible Psychedelic Frogfish (*Histiophryne psychedelica*). Since it was first discovered off Ambon in 2008, less than a dozen of these amazing fish have been seen in the area. A very special treat, at a very special muck destination.

AMBON DIVE DATA

HOW TO GET THERE – Ambon may be in a remote area, but it is well serviced with domestic flights, generally via Makassar, from Bali, Jakarta, Sorong and Manado. The area is also regularly visited by liveaboard vessels.
BEST TIME TO VISIT – Anytime, but the dry season, April to October, generally has better visibility.
VISIBILITY – Typically 10–15m at the muck sites.
DIVING CONDITIONS – Currents are common, but are generally mild.
WATER TEMPERATURE – 25–30°C.

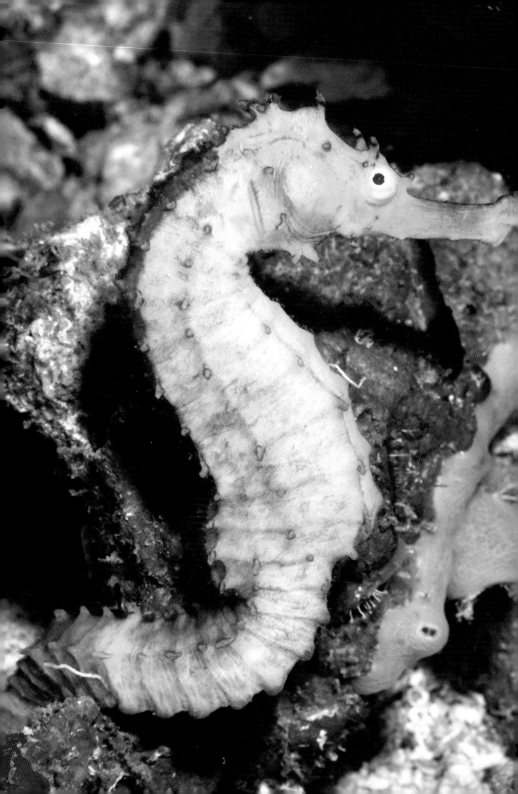

PHILIPPINES

The Philippines, a nation of more than 7,000 islands, offers the diver unrivalled underwater adventures that few countries can match. This is a nation where you observe thresher sharks rising from the depths to be cleaned on a sea mount at dawn and in the afternoon swim with a dozen Whale Sharks. It is a nation with beautiful coral reefs that pulsate with colourful reef fish and a location where divers can explore a fleet of Japanese ships sunk during World War II. But the Philippines, with its numerous volcanos and calm sheltered waters, is also a great muck diving destination, and home to many bizarre and wonderful critters.

The two premier muck diving destinations in the Philippines are Anilao and Dumaguete, although almost every destination in this diver-friendly country has one or two good muck sites. Minor muck destinations include Moalboal, where divers will find a great collection of critters at Moalboal Bay. Famous for its thresher sharks, Malapascua also has wonderful reefs and wrecks, plus a few productive muck sites at North Point, Bantigi and Ka Osting. Cabilao, off Bohol, is another destination where divers can explore a few minor muck sites when not enjoying the reef diving, the main sites being Lighthouse and Sandingan Slope. At nearby Alona Beach divers will also find many interesting muck critters at Kalipayan. The diving possibilities in the Philippines are endless.

ANILAO (Mega Muck)

At one time Anilao was a destination only visited by divers in the know. It may have many colourful coral reefs, but with a rocky coastline and no pretty sandy beaches for tourists to relax on, most divers ventured to other more picturesque locations in the Philippines.

Located 125km south of Manila, Anilao has always been popular with divers from the capital looking for a weekend escape to explore rich coral reefs. But with the growth of muck diving people started to explore beyond Anilao's reefs and discovered the area is blessed with many sandy bays, the perfect habitat for critters. Today Anilao is rated second only to Lembeh as a muck and macro

OPPOSITE: The Tiger-tail Seahorse is regularly seen at muck sites in the Philippines.

diving destination, as almost any critter you could wish to see can be found at this fabulous location.

The most famous muck diving site at Anilao, and the site that put it on the map, is **Secret Bay**. The black sand at this site slopes beyond 30m, but most diving is done in depths from 3m to 20m. Starting in the shallows divers will find numerous sea urchins, sea cucumbers and sea anemones, which are home to cardinalfish, anemonefish, commensal shrimps, porcelain crabs, Zebra Crabs and Coleman's Shrimps. Going down the slope divers will see black coral trees, barrel sponges, sea pens, tube anemones and sea whips. These shelter numerous small reef fish, plus Xeno Crabs, Orangutan Crabs, Hairy Squat Lobsters, ghostpipefish, moray eels and nudibranchs.

The sandy slope at Secret Bay is also home to Thorny Seahorses, Oriental Sea Robins, dragonets, shrimpgobies, sleeper gobies, garden eels, Ribbon Eels, snake eels, flounders, cowfish, lionfish, mantis shrimps, flatworms, grubfish, stingrays

BELOW: Rare Bluefin Lionfish are sometimes found at Secret Bay and Coconut Point.

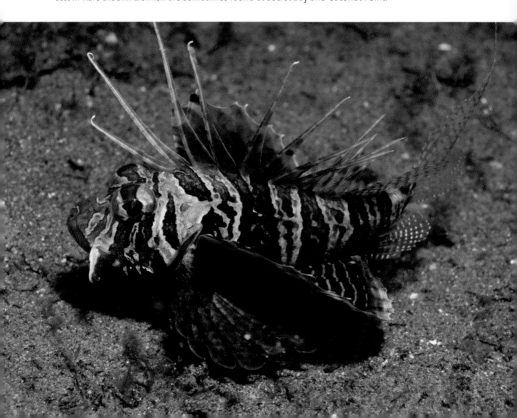

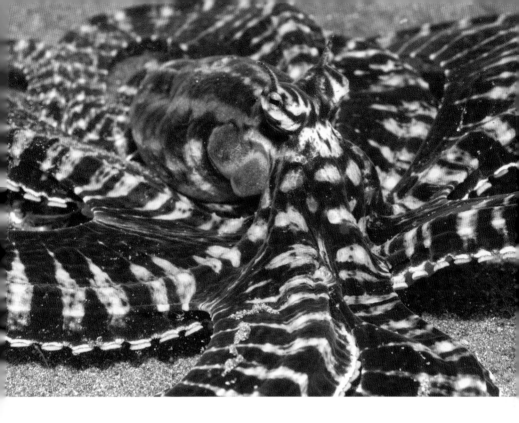

ABOVE: The silty sand at Anilao Pier is a great place to find Mimic Octopus.

and many other species. At night the crustaceans take over the site, with pebble crabs, box crabs, prawns, shrimps, swimming crabs, elbow crabs, spider crabs, hermit crabs and boxer shrimps emerging. Also commonly seen after dark are cuttlefish, soles, snake eels, octopus, Bobbit Worms, cone shells, murex shells and bobtail squid. Tiny pygmy squid can also be seen here, as can Mimic Octopus, Flamboyant Cuttlefish and Hairy Frogfish.

As good as Secret Bay is, the local guides say it is not a patch on its former self and has degraded somewhat in recent years due to too many boat anchors and possibly because of run-off from new resorts adjacent to the site. The premier muck site at Anilao now would have to be **Coconut Point**.

This site is very similar to Secret Bay with black sand sloping to 20m, but it has even more critters. This is a good spot to see Flamboyant Cuttlefish, with these spectacular cephalopods sometimes observed laying eggs under coconut shells

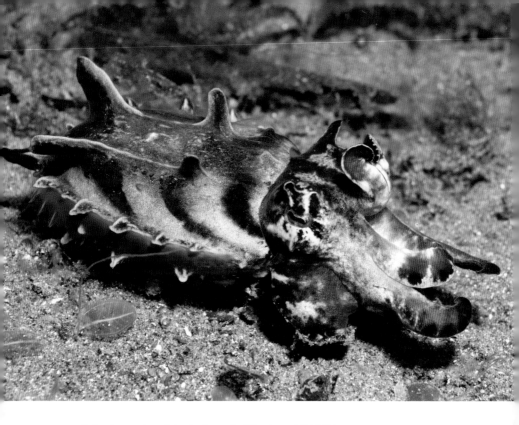

ABOVE: Anilao is a good muck destination to find Flamboyant Cuttlefish.

during the winter months. Common species include Thorny Seahorses, Imperial Shrimps, snake eels, garden eels, ghostpipefish, pipefish, cowfish, shrimpfish, razorfish, Bluefin Lionfish, Demon Ghouls, Oriental Sea Robins, commensal shrimps, flounders, sleeper gobies and numerous nudibranchs. Coconut Point is a spot where anything can turn up, including Mimic Octopus, Hairtail Blenny, Wonderpus or Sawblade Shrimp. This is a muck site you will want to dive again and again.

Another brilliant muck site is **Anilao Pier**, which is not actually a pier dive – you explore the sandy bay nearby in depths from 5m to 15m. This site generally has poor visibility, usually less than 10m, but it sure has a lot of critters. This is the best site to see Mimic Octopus, as they love the fine sand found here. This sand is also home to snake eels, grinners, sand divers, razorfish, Demon Ghouls and a surprising number of murex shells. Anilao Pier is even better after dark as

Coconut Octopus and Long-arm Octopus emerge to feed, while other octopus species are seen here include blue-ringed octopus and the bizarre Wonderpus. Also emerging from the sand at night are prawns, shrimps, crabs, molluscs, bobtail squid and even the occasional Little File Snake.

Not far from Anilao Pier is another brilliant muck site called **Basura**. The sand and rubble here can be explored in depths from 3m to 18m. Commonly seen are snake eels, frogfish, seahorses, pipefish, cuttlefish and many unusual nudibranchs. Basura is also a spot where the rare Weedy Scorpionfish turns up occasionally.

Betlehem is a site where you will see a disturbing amount of rubbish, as it is located right next to a small village. The rubbish might look unsightly, but don't let it put you off as the rubble and sand, in depths to 19m, is home to a bonanza of critters. Common at this site are mantis shrimps, nudibranchs, jawfish, dragonets, garden eels and Ribbon Eels, but if you get lucky you may also see a Coleman's Shrimp or a Weedy Scorpionfish.

BELOW: At night Bobbit Worms can be found at Anilao.

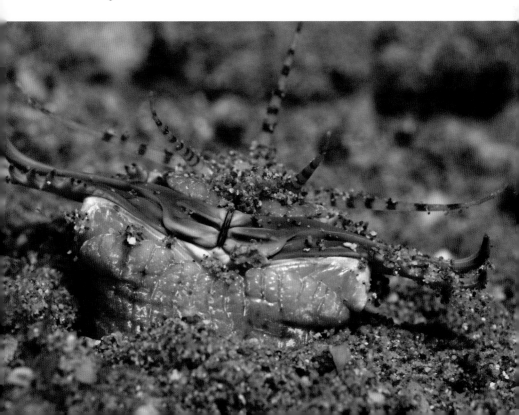

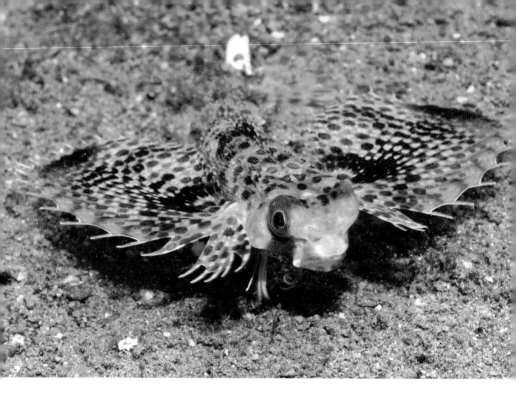

ABOVE: The Oriental Sea Robin is a common critter off Anilao.

The sloping sand and rubble at **Buceo Point** is another great muck site to see a wide assortment of critters. Nudibranchs, Ribbon Eels, mantis shrimps, pufferfish, cowfish, lionfish, pipefish and gobies are just some of the species seen. However, this muck site is even better by night as a wide variety of crustaceans and cephalopods emerge. Pebble crabs, box crabs, spider crabs, Coconut Octopus, Long-arm Octopus, bobtail squid, cuttlefish and prawns are all common. This is also a good site to see the very bizarre Bobbit Worm.

These are the main muck sites that you will want to revisit several times during your stay. However, the Anilao area has plenty more dive sites that are a mix of sand, rubble and reef – sites like **Bubble Point**, **Koala Point**, **Sun View** and **Twin Rocks**. At all these sites there are great macro critters, such as Warty Frogfish, pygmy seahorses, Leaf Scorpionfish, Boxer Crabs, Harlequin Shrimps, marble shrimps, Splendid Mandarinfish and squat lobsters.

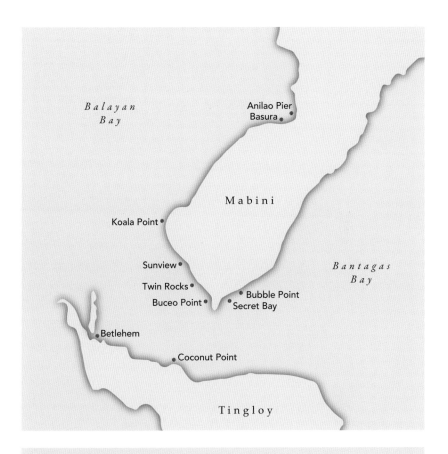

ANILAO DIVE DATA

HOW TO GET THERE – Located only 125km south of Manila, Anilao is easily reached by car, but with traffic an issue in Manila, allow three hours for the journey. Most of the dive resorts can arrange transfers.

BEST TIME TO VISIT – Year-round.

VISIBILITY – Typically 12–20m.

DIVING CONDITIONS – Currents are common in the area, but generally mild on the muck sites and strong on the coral reefs.

WATER TEMPERATURE – 25–30°C.

PUERTO GALERA (Major Muck)

Located at the northern tip of Mindoro, Puerto Galera was once a safe anchorage for Spanish galleons with its name meaning 'Port of the Galleons'. Yachts still anchor in the calm waters here, but diving is the main attraction, with macro critters on the agenda.

Divers first discovered the wonderful diving in this area in the 1970s. Being only four hours south of the capital Manila, the coral reefs of Puerto Galera quickly become popular and were protected as a marine reserve in 1973. This area has much more than coral reefs, though, being the location of some wonderful muck diving.

One of the main muck sites is located right in front of the resorts at Sabang Beach and is known as the **Sabang Wrecks**. There are half a dozen scuttled ships at this site, in depths from 16m to 22m, and while they are fun to explore the main attraction are the critters that are found on the wrecks and on the sand. Giant Frogfish are found at the Sabang Wrecks in surprising numbers – divers will generally see two or three on each dive, but don't be surprised to find more than a dozen. Other frogfish species are also common here, including Painted, Hairy and Warty frogfish.

Exploring the wrecks and sand, divers will find lionfish, grubfish, scorpionfish, mantis shrimps, moray eels, hawkfish, gobies and a huge variety of nudibranchs. Also seen at the Sabang Wrecks are pipefish, flounders, shrimpfish, snake eels, stargazers, ghostpipefish, octopus and cuttlefish.

The Boulders is a dive site with large boulders, hence the name, that are decorated with lovely soft corals, sea whips and abundant feather stars. Beyond the boulders, in depths from 25m to 30m, is a rubble and sandy bottom where sea pens, nudibranchs and shrimpgobies are common. This is the best site in the area to see Thorny Seahorses – beautiful delicate creatures that are observed clinging to the weed and coral. The depth here means that bottom times are limited, but divers will also find shrimps, crabs, cuttlefish and octopus.

One of the most unusual dive sites at Puerto Galera is called **The Hill**. This wonderful location has a bit of everything, with coral outcrops, sandy patches, seagrass and even dozens of Giant Clams. Going no deeper than 15m, divers will find Ornate Ghostpipefish, groups of shrimpfish, jawfish, hawkfish, moray eels,

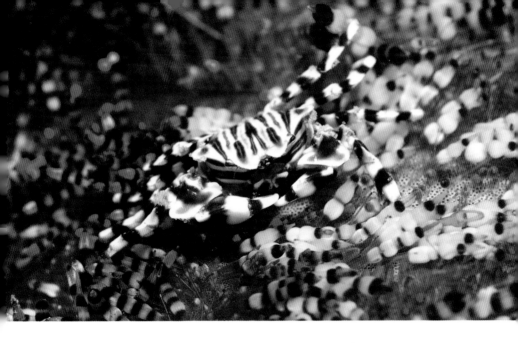

ABOVE: Always check the sea urchins near the Sabang Wrecks as you may find a Zebra Crab.

mantis shrimps, pipefish and the odd Thorny Seahorse. Snake eels are often found in this area, including the bizarre Crocodile Snake Eel. This is also the best spot at Puerto Galera to see Splendid Mandarinfish, which hide amongst the branching corals during the day only to emerge at sunset to mate.

More Giant Clams can be seen at a site simply called **Giant Clam**. The clams are found in the shallows, but most divers will ignore them to explore the sand and seagrass in depths to 20m, as this is the perfect habitat for muck critters. At Giant Clam divers will see mantis shrimps, nudibranchs, pipefish, gobies and snake eels. However, this is the type of muck site where just about anything can turn up, including Flamboyant Cuttlefish, Hairy Frogfish, Mimic Octopus and even its rarer cousin the weird Wonderpus.

Another wonderful muck site at Puerto Galera is **Shipyard**. This site often has poor visibility and, as it is located right next to a shipyard, expect to see rubbish and the remains of old ships littering the bottom. The sand and rubbish provide a great home for critters in depths to 18m. Frogfish, nudibranchs, seahorses, seamoths, ghostpipefish, Oriental Sea Robins, lionfish, Mimic Octopus and Bobbit Worms are just some of the species seen. But Shipyard can really turn it on for underwater

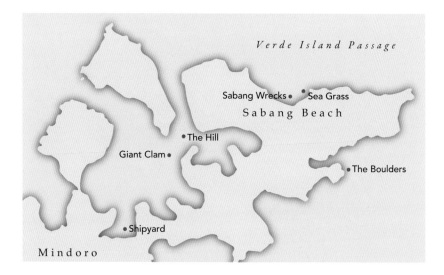

Verde Island Passage

Sabang Wrecks • • Sea Grass

S a b a n g B e a c h

• The Hill

Giant Clam •

• The Boulders

• Shipyard

M i n d o r o

photographers when an Ambon or Weedy Scorpionfish has taken up residence.

A popular spot for a long afternoon dive is **Sea Grass** in Sabang Bay. The seagrass beds here are only 3m to 8m deep, but harbour a wealth of wonderful species. Look for seamoths, dragonets, pipefish, cuttlefish and lionfish. There are also many sea anemones at this site that are home to Panda Anemonefish, commensal shrimps and porcelain crabs.

There are over 50 dive sites in the area around Puerto Galera, and every one of these seems to be overloaded with a fascinating collection of macro critters.

PUERTO GALERA DIVE DATA

HOW TO GET THERE – Puerto Galera is easily reached from Manila. Take a car or bus to Batangas, then a ferry across the channel. It should only take about four hours.

BEST TIME TO VISIT – Year-round.

VISIBILITY – Typically 12–20m at most muck sites.

DIVING CONDITIONS – Currents can be strong at some of the dive sites, but dives are usually planned to minimise the currents.

WATER TEMPERATURE – 25–30°C.

DUMAGUETE (Mega Muck)

The island of Negros, west of Cebu, is also commonly known as the Sugar Island, as sugar cane is farmed on much of its rugged terrain. This island's sweetness is not found in its sugar, though, but in the many wonderful reefs and muck sites in the waters off its southern shores.

Diving off Negros is centred around Dumaguete, or more accurately Dauin – towns located at the southern end of this elongated island. Offshore from Dauin are two wonderful islands, Apo and Siquijor, which are packed with colourful coral reefs and walls for divers to explore. But many divers never venture offshore as the coastline off Dauin has dark volcanic sand and a host of amazing muck sites.

North of Dauin is a brilliant muck site called **San Miguel**. Some split this into two sites, San Miguel North and San Miguel Tyres, but either way it is a wonderful site for critters. The sandy slope here gradually falls to 20m, but you don't have to go this deep to see frogfish, ghostpipefish, Demon Ghouls, snake eels, stargazers, gobies and nudibranchs. Seagrasses are found in the shallows and shelter pipefish and cuttlefish. Pygmy squid are sometimes seen, but as they grow to only 2cm long they are often difficult to find. An artificial reef, made of car tyres, is also fun to explore as it is now covered in soft corals and sponges, and provides a home for moray eels, lionfish, frogfish and many other species. Harlequin Shrimps have been seen here, as have their smaller relative the pretty Striped Bumblebee Shrimp.

BELOW: The Whip Coral Shrimp (*Dasycaris zanzibarica*) is a commensal shrimp often found on sea whips.

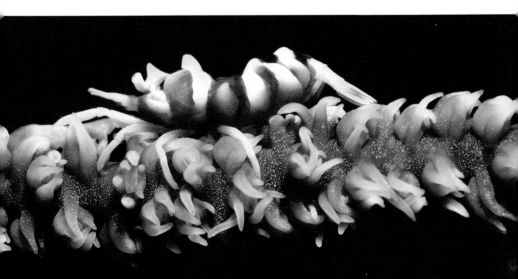

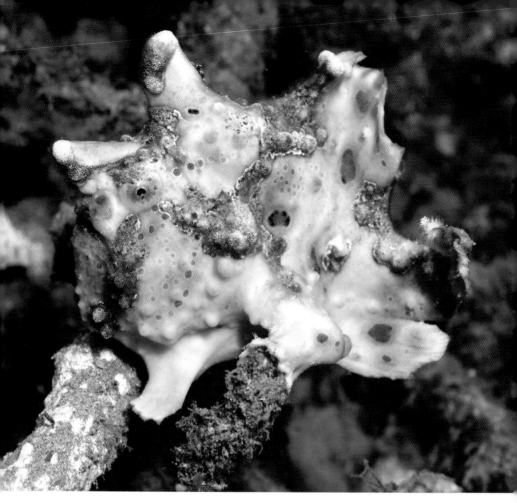

ABOVE: Warty Frogfish are a favourite with underwater photographers.

San Miguel is a site where divers have also seen Ambon Scorpionfish, Flamboyant Cuttlefish, Mimic Octopus and Hairy Frogfish. It is also a site for juvenile critters, with tiny frogfish and scorpionfish to be seen, some less than 5mm long.

The name **Sahara** would make you think you are about to explore a sandy desert, but this muck site also has coral heads and pretty sea whip gardens. A close look at the sea whips will often reveal Xeno Crabs, whip coral shrimps and whip coral gobies. Also seen at Sahara are nudibranchs, flatworms, lionfish, boxfish, ghostpipefish and moray eels. Most divers only go to 20m at this site, but some of the best critters are found a little deeper, where boat and car wrecks are located.

In depths to 30m divers will find numerous shrimps, cuttlefish, Demon Ghouls, frogfish and maybe a Flamboyant Cuttlefish.

South of Sahara is a wonderful site called **Bonnet's Corner**. This sloping sand and rubble site if often swept by strong currents, but is home to a good variety of critters, including garden eels, snake eels, Cockatoo Waspfish, pipefish and cowfish. However, its main claim to fame is it great collection of octopus and cuttlefish. At this site divers will see Mimic Octopus, Wonderpus, Coconut Octopus, Greater Blue Ringed Octopus, Flamboyant Cuttlefish and even rare Mototi Octopus. But this great gathering of cephalopods is only seen between October and December.

Artificial car-tyre reefs must have once been the flavour of the month in Dauin, as another one is found at **Ceres**. Similar to other sites in the area, this sloping sandy site has seagrass beds, rubble and tyres to explore in depths to 30m. Shrimps, nudibranchs, flounders, pipefish, cuttlefish, octopus and ghostpipefish are just some of the species seen. One critter your guide might be able to find you in the seagrass is the tiny Shortpouch Pygmy Pipehorse – an extremely well-camouflaged species that clings to the seagrass.

Cars, named after the wrecks of two car bodies, is another great muck site where you can either explore the shallows or head deep for a different collection of critters. In the shallows divers will find seamoths, seahorses, dragonets, snake eels, cuttlefish, octopus and perhaps a Cockatoo Waspfish or an Oriental Sea Robin if you are lucky. Down deeper, near the cars at 30m, divers will find ghostpipefish, lionfish, frogfish, commensal shrimps, sand divers, Demon Ghouls and maybe a Flamboyant Cuttlefish.

For a good mix of muck and reef head to **Dauin Norte**. On the sandy slope here are the typical muck critters found in the area, including nudibranchs, frogfish and ghostpipefish. But plenty of critters are also seen on the reef, including anemonefish, hawkfish, gobies, moray eels and Leaf Scorpionfish. Numerous barrel sponges also decorate the reef and are a good place to find Hairy Squat Lobsters. **Dauin Sur** is a similar site nearby, which is a good location to see garden eels and Ribbon Eels.

Another tyre reef, if you are not sick of looking at old tyres, is found at **Ginama-an**. Around the tyres look for shrimps and crabs, such as cleaner shrimps,

coral crabs, Hingebeak Shrimps and Harlequin Shrimps. Also common here are frogfish, ghostpipefish, shrimpfish and gobies. This is also a spot where Mimic Octopus and Wonderpus have been seen at times.

A different artificial reef is found at **Pyramids**, with metal pyramids situated in depths from 15m to 22m. At this site divers can also explore seagrass beds and a patchy reef. Common here are nudibranchs, Thorny Seahorses, frogfish, cowfish, lionfish and cuttlefish. Harlequin Shrimps and Donald Duck Shrimps have been found on the reef, and down deeper are black coral trees where Xeno Crabs and Sawblade Shrimps are seen.

It may be hard to believe, but another car-tyre reef is found at **Masaplod Sur**. Divers exploring this site will find a sandy valley between two reefs. In depths to 20m it is possible to find frogfish, nudibranchs, ghostpipefish, seamoths, jawfish, gobies, Oriental Sea Robins, Demon Ghouls and dragonets.

BELOW: The Algae Octopus is a rare species, but sometimes seen at Dumaguete.

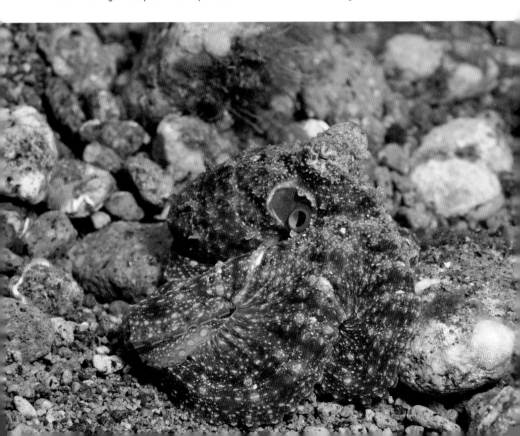

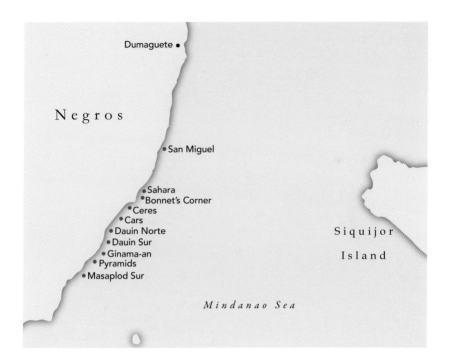

There are also a handful of muck sites on Apo and Siquijor Islands, but with so many muck sites on the mainland, when divers venture to these islands all they really want to see is pretty coral and pretty fish.

DUMAGUETE DIVE DATA

HOW TO GET THERE – Daily flights are available from Manila to Dumaguete. From there you can take a taxi or organise a pick-up to reach the dive resorts at Dauin.
BEST TIME TO VISIT – Year-round.
VISIBILITY – Typically 10–20m.
DIVING CONDITIONS – Currents, generally mild, are experienced at some dive sites.
WATER TEMPERATURE – 25–30°C.

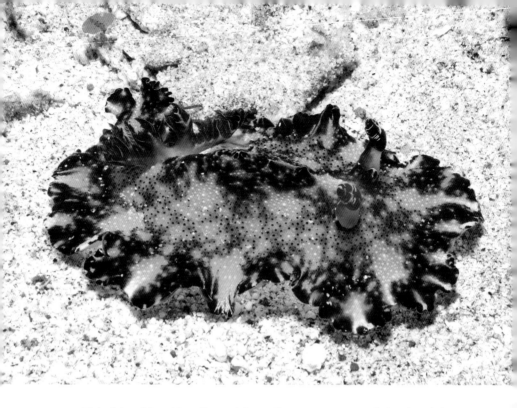

ABOVE: Night diving off Sogod Bay will reward divers will many great critters, including the Bohol Discodoris Nudibranch (*Discodoris boholiensis*).

SOGOD BAY (Major Muck)

A decade ago Sogod Bay was a destination that few divers had heard of, and even today it is one of the unknown gems of the Philippines. Located at the southern end of Leyte, Sogod Bay is blessed with lovely reefs that are regularly visited by Whale Sharks from November to May, but one of the area's best assets is its fabulous muck diving.

Several dive resorts are located on the shores of Sogod Bay, and some of the best dive sites are located right in front of them. The reef here follows a sandy slope to 15m and then drops to 40m. The corals at these sites are just beautiful, and the reef thrives with fish, turtles and invertebrate species, but the best muck critters are found on the sand and coral rubble. There are four dive sites here called **Voltaire's Rock**, **Max's Climax 1**, **Max's Climax 2** and **Bulawarte**, and all are equally good.

On a typical dive expect to find seamoths, Ornate Ghostpipefish, nudibranchs, lionfish, frogfish, pipefish and Bargibant's Pygmy Seahorses. These sites are good during the day, but they are just mind blowing at night, as this is when the best critters emerge. Shrimps, crabs, moray eels, snake eels, sea pens, molluscs, scorpionfish, huge basket stars and even Cockatoo Waspfish can be seen.

The very best night diving site in the area is a photographer's dream – the fabulous **Padre Burgos Pier**. This site can only be dived at night, as the boat traffic is just too busy during the day. Under the pier the water is only 9m deep, and the sandy bottom is a haven for critters. Make sure your batteries are fully charged and you have a fresh memory card as you will see frogfish, stargazers, cuttlefish, numerous octopus, lionfish, sea stars, brittle stars, snake eels, sea snakes, crabs, shrimps, seahorses, pipefish, shrimpfish and perhaps a pipehorse.

Another good muck site that is rarely dived is **Poloy's Anchor**. The sandy bottom here reaches a depth of 12m, giving plenty of bottom time for divers to

BELOW: The Compressed Puffer is a common muck fish.

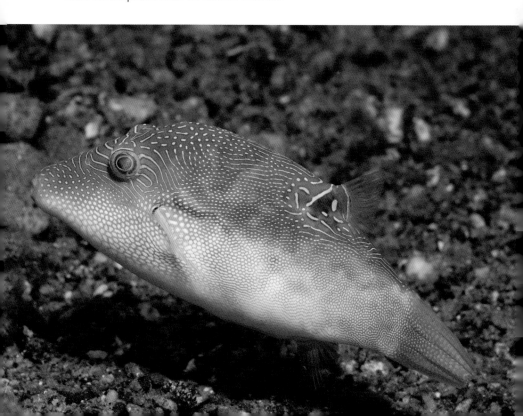

search for frogfish, seahorses, nudibranchs, hairy shrimps, blue-ringed octopus and many other critters. Numerous sea cucumbers are found at this site, and a close inspection will often reveal colourful Imperial Shrimps.

The two best muck sites in Sogod Bay rival some of the best muck at Lembeh. **Ghost Town** is a site with a silty sandy bottom that varies in depth from 5m to 18m. While at **Little Lembeh** divers can explore a black sand slope to 20m that is very similar to the best sites at Lembeh. Both these muck sites are home to a great collection of critters, with divers encountering a wide variety of nudibranchs, frogfish, scorpionfish, ghostpipefish, snake eels, mantis shrimps, seahorses, shrimps, crabs and even Flamboyant Cuttlefish and Mimic Octopus.

Many divers time a visit to Sogod Bay so they can see Whale Sharks, but this wonderful destination has brilliant muck diving that can be enjoyed at any time of year.

BELOW: Many wonderful nudibranchs are seen off Sogod Bay.

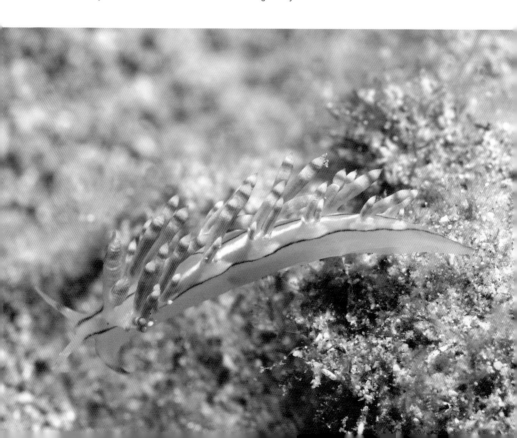

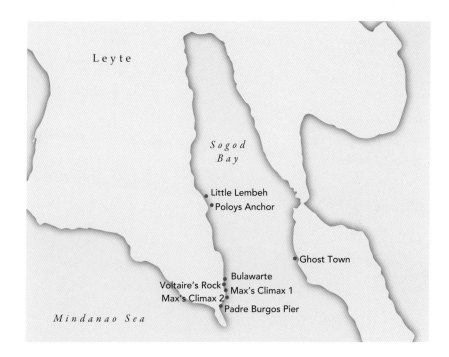

Map showing:

Leyte

Sogod Bay

- Little Lembeh
- Poloys Anchor

- Ghost Town

- Bulawarte
- Voltaire's Rock
- Max's Climax 1
- Max's Climax 2
- Padre Burgos Pier

Mindanao Sea

SOGOD BAY DIVE DATA

HOW TO GET THERE – There are a number of ways to get to Sogod Bay. From Manila you can fly to Tacloban, in the north of Leyte, and journey by car three hours to Sogod Bay. This transfer can be arranged by your dive resort. Alternatively you can fly to Cebu City and then catch a ferry across to Leyte. Three ferry services depart Cebu City for three destinations in Leyte, with the one that arrives at Maasin being the closest to Sogod Bay, although it is still a 45-minute drive away.

BEST TIME TO VISIT – Year-round.

VISIBILITY – Typically 10–20m.

DIVING CONDITIONS – Currents, generally mild, are experienced at some dive sites.

WATER TEMPERATURE – 25–30°C.

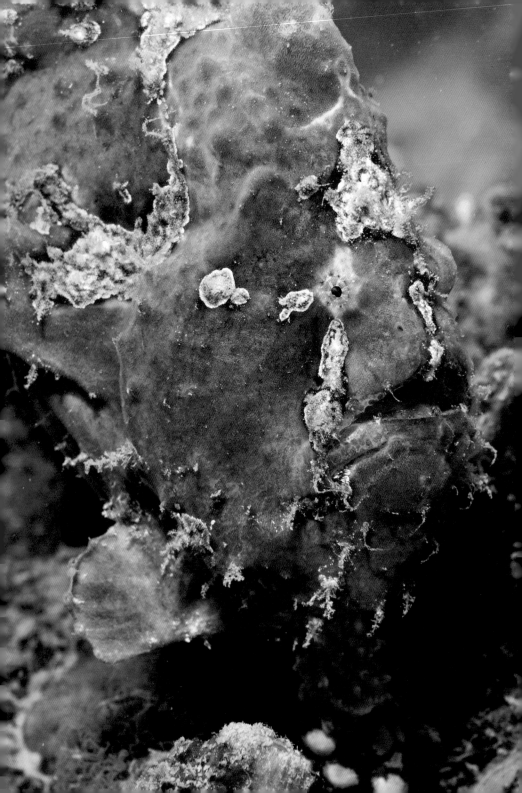

MALAYSIA

Malaysia is a great destination to visit, explore and dive. The mix of Malay, Chinese and English cultures make this country very unique in Asia, with a rich blend of customs and some fabulous food. The country also has a rich mix of dive sites located around the Malay Peninsula and also off Sabah, the Malaysian section of Borneo. While most divers come to Malaysia to explore the nation's pretty coral reefs, the country also has some brilliant muck sites that shouldn't be missed.

The most famous muck diving site in Malaysia is the wonderful Mabul and Kapalai, and while many divers think that this is the only decent muck in the country, Malaysia also has some interesting minor muck destinations, especially off the Malay Peninsula. Palau Perhentian is a wonderful dive destination with rocky reefs and numerous shipwrecks, but around these islands divers can also explore muck at Turf Club, Nudi Playground and Flea Market. Nearby Palau Redang has a few interesting muck sites at Batu China Terjun and Sandy Bottom. Some great muck critters have also been seen off Pulau Tioman at sites such as Temok Bay and Paya Beach.

Forming the western border of the Coral Triangle, Malaysia is blessed with a great variety of dive sites and an abundance of marine life.

MABUL AND KAPALAI (Major Muck)

One of the first dive destinations in Malaysia that grabbed the attention of divers around the world was Sipadan. This tiny island, off the north-east tip of Sabah, was the subject of a documentary made by the Cousteau team in 1983 that showed its amazing coral walls and abundant fish, sharks and turtles. Dive resorts soon opened up on the island and divers arrived in increasing numbers over the next 20 years. However, the fragile reef system and delicate island ecosystem soon became degraded by too much development and by the presence of too many people. In 2004 the government ordered that all resorts must be removed from Sipadan,

OPPOSITE: Mabul is a good location to see Giant Frogfish.

so they relocated to the nearby islands of Mabul and Kapalai. Both these islands have pretty coral reefs, but they also have something not found at Sipadan – great muck diving.

The first dive resorts actually opened at Mabul and Kapalai in the 1990s, but at the time divers only used the resorts as a base to dive Sipadan, believing that the local reefs were not worth looking at. But when weird and wonderful critters started to be found at dive sites around the islands, people started to take note. It wasn't long before the muck diving at Mabul and Kapalai became a major attraction, with many divers forgoing trips to Sipadan to look for exotic critters. Today divers travel to this area not only to explore Sipadan, but also to see the wonderful muck critters at Mabul and Kapalai.

Mabul is where most of the resorts are located, and also where the best muck sites are found, with one of the finest being **Paradise One**. After exploring the sheer walls at Sipadan some divers may find it a little boring drifting over powdery

BELOW: When night diving off Mabul divers have a good chance of seeing a Whitemargin Stargazer.

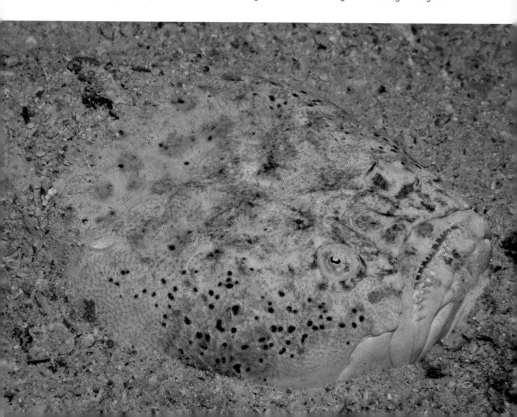

ABOVE: Painted Frogfish are found at numerous dive sites off Mabul and Kapalai.

sand, but this site is a haven for critters. In depths to 16m, divers will find both Marbled and Longfin Snake Eels quite numerous, with their heads just visible, but Banded Snake Eels are also found at this site. Also common are Dwarf Lionfish, Longhorn and Thornback Cowfish, shrimpfish, cuttlefish, flounders, pufferfish, filefish, dragonets, pipefish and numerous sea anemones that are home to Panda Anemonefish, commensal shrimps and porcelain crabs. Old tyres and other objects litter the sand and are home to rock cod, moray eels, lionfish, cardinalfish and cleaner shrimps. More critters are also found in the shallow seagrass beds and under the jetties, including Thorny Seahorses, nudibranchs, sea snakes, shrimpfish and ghostpipefish. Just about anything can turn up at Paradise One, so don't be surprised to see a Flamboyant Cuttlefish, Mimic Octopus or Weedy Scorpionfish.

Paradise One is also a great night dive with a fantastic assortment of crabs, shrimps, molluscs, cuttlefish, stargazers and octopus to be seen. It is also a popular

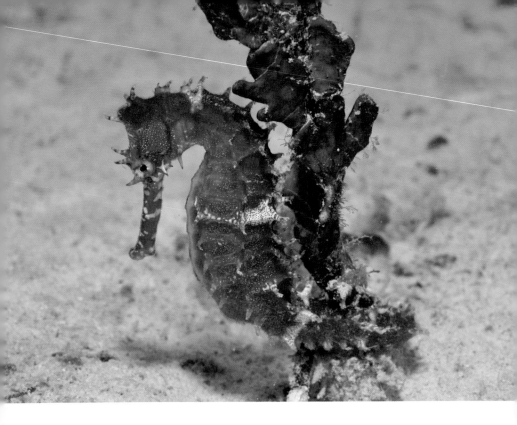

ABOVE: Thorny Seahorses are often found at Paradise One.

sunset dive as Splendid Mandarinfish live in the branching corals, and emerge to mate once it gets dark. Nearby, **Paradise Two** is also a good spot for critters, but this site is more of a coral wall dive with a little muck on the side.

The bottom at **Froggy Lair** is a mixture of sand and rubble, although a number of timber structures have been placed here as artificial reefs to attract fish life. This site varies in depth from 5m to 21m and is the perfect spot to see frogfish. A number of frogfish species turn up in the area, including Hairy, Painted, Warty and Giant Frogfish. Other species found at Froggy Lair include cuttlefish, octopus, crocodilefish, snake eels, mantis shrimps, gobies, Demon Ghouls, ghostpipefish, nudibranchs, Leaf Scorpionfish, moray eels, pipefish, flatworms, shrimps and crabs.

Another wonderful muck site at Mabul is **Crocodile Avenue**. It has sand and seaweed in depths to 15m and is named after the numerous Crocodilefish that are

resident. Exploring the sand, divers are also likely to encounter Thorny Seahorses, ghostpipefish, dragonets, snake eels, lionfish, cuttlefish and many other species. Like all the sites around Mabul, Crocodile Avenue is a wonderful night dive with stargazers, box crabs, spider crabs and squid all common.

One of the most unusual muck sites off Mabul is the **Seaventures Dive Rig**, a former oil rig accommodation platform that is now a dive resort. Below the rig the bottom is 18m deep and there is reef, rubble and sand, as well as numerous artificial reefs to explore. Schooling fish swarm under the rig, and even the odd Whale Shark has been seen here, but the rig is particularly famous for its critters. Crocodilefish are seen by the dozen, but divers will also see numerous nudibranchs, mantis shrimps, Ribbon Eels, jawfish, Leaf Scorpionfish, ghostpipefish, cuttlefish, hawkfish, gobies, flatworms, frogfish and pygmy seahorses.

Off the eastern side of Mabul there are some pretty coral walls that house countless reef fish, turtles and many invertebrate species, but at the base of these

BELOW: Many different mantis shrimp species are seen in muck environments.

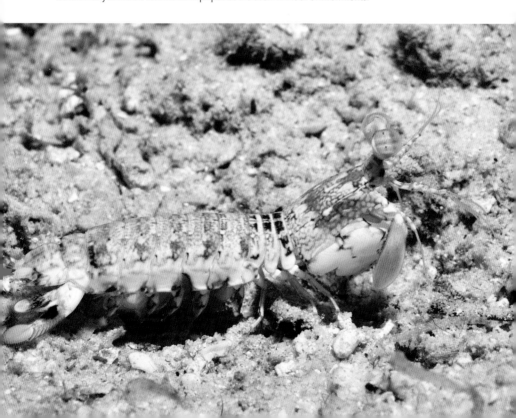

walls is rubble and sand where more muck critters can be found. The best of these sites is **Eel Garden**, were divers will find Leaf Scorpionfish, dragonets, garden eels, moray eels, stingrays, cuttlefish, octopus, mantis shrimps, shrimpgobies, Demon Ghouls and even Oriental Sea Robins.

Kapalai is little more than a sand bank, but it is surrounded by an extensive reef and has a number of good muck sites. At **Gurnard Ground** divers can either explore a reef wall or the sand and rubble looking for critters. On the sand, in depths to 20m, divers will see hundreds of jawfish with their little heads bobbing at the entrances to their burrows. Also common are shrimpgobies, mantis shrimps, garden eels, pipefish, nudibranchs, boxfish, moray eels, turtles, batfish, dragonets and Giant Frogfish. Three ships have also been scuttled at this site, which are fun to explore and home to masses of fish.

The sandy seafloor at **Mandarin Valley** has been turned into a fish's playground, with timber structures, old boats, tyres and other scrap littering the bottom. These structures are now home to numerous fish, but the sand at this site is also worth a close look as many critters live here. Commonly seen are Demon

BELOW: The fine sand at Paradise One is a good location to find Marbled Snake Eels

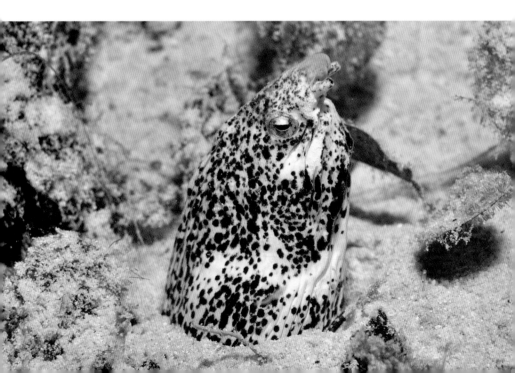

Ghouls, nudibranchs, pipefish, cuttlefish, jawfish, boxfish, lionfish and frogfish. Depths at Mandarin Valley vary from 15m to 23m, and this is another site where Splendid Mandarinfish can be seen at sunset.

Over the last decade the dive operators at Mabul and Kapalai (and also ones based on the mainland at Semporna) have been exploring new dive sites in this wonderful area. They have discovered more fabulous coral reefs, but also a few brilliant muck sites at Siamil, Denawan, Sibuan, and also Semporna – adding extra spice to one of the best muck diving destinations in the world.

MABUL AND KAPALAI DIVE DATA

HOW TO GET THERE – Access to Mabul and Kapalai is via a 40-minute boat ride from Semporna. The closest airport is at Tawau, which is less than an hour's drive from Semporna. Malaysian Airlines and Air Asia operate daily flights to Tawau from both Kuala Lumpur and Kota Kinabalu.
BEST TIME TO VISIT – Diving is available year-round.
VISIBILITY – Typically 10–15m.
DIVING CONDITIONS – Currents are usually mild at the muck sites.
WATER TEMPERATURE – 27–29°C.

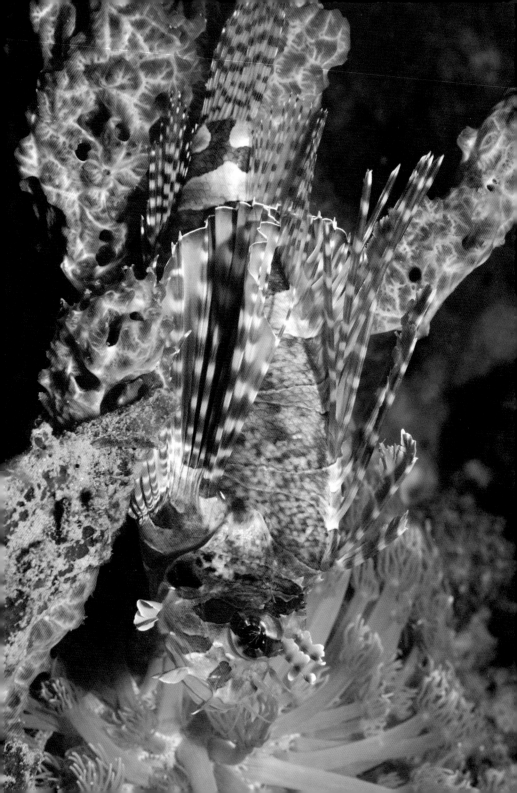

TIMOR-LESTE

Timor-Leste (or many people still know it as East Timor) only gained independence in 2002, after being ruled by the Portuguese and Indonesians for hundreds of years. This tiny country has since been struggling to find its feet, with help from the United Nations, and is slowly building its economy. The government is hoping that tourism will play a key part in the nation's future, and one sector of the tourism industry that has seen much growth is diving, as this tiny nation is blessed with wonderful coral reefs and some fabulous muck sites.

DILI (Major Muck)

Dili is the capital of Timor-Leste and unlike other cities in South-East Asia there are not many attractions to entertain visiting tourists, unless they venture underwater. The coastline east and west of Dili is dotted with dozens of brilliant dive sites that can be explored by boat or from the shore.

West of Dili is a lovely muck site called **Dan's Sandy Bottom**. The name kind of gives it away, but this site has a sandy bottom that slopes into 40m. However, you don't have to go that deep to see a great range of critters. Exploring the sand and patchy reef divers will encounter pipefish, mantis shrimps, moray eels, nudibranchs, seahorses and many other creatures.

Closer to the capital is Dili's best muck site, the always impressive **Tasi Tolu**. This site is superb, a classic muck site with sloping black sand in depths to 20m. An easy dive, you just walk off the beach and within seconds will be marvelling at some incredible critters. Commonly seen are ghostpipefish, Napoleon Snake Eels, mantis shrimps, pipefish, cuttlefish, shrimpgobies, dragonets and garden eels. Numerous sea anemones litter the bottom and are always worth a close look as they play host to commensal shrimps, porcelain crabs and cute anemonefish.

While exploring Tasi Tolu, divers will find many rocky outcrops looming out of the sand. These little oases provide shelter for frogfish, nudibranchs, flatworms, shrimps, boxfish, Dwarf Lionfish, Leaf Scorpionfish, Cockatoo Waspfish and even

OPPOSITE: Dwarf Lionfish are seen at many dive sites off Dili.

the odd Weedy Scorpionfish. Just about any muck critter can turn up at this wonderful dive site, such as Thorny Seahorses, Mimic Octopus and Flamboyant Cuttlefish. This site can be even better at night when an army of molluscs and crustaceans emerge from hiding, including bobtail squid, Coconut Octopus, spider crabs, hermit crabs and tiny shrimps.

Not far from Tasi Tolu is **Roda Reef**, where divers can explore an artificial reef in depths to 20m. The sandy seafloor at Roda Reef is dotted with concrete blocks and car tyres, which has created the perfect habitat for many critters. Commonly seen here are seahorses, pipefish, pipehorses, seamoths, frogfish, nudibranchs, moray eels and cuttlefish. This site also makes for a great night dive with squid, box crabs, spider crabs and the occasional Mimic Octopus sighted.

Piers over sand always attract a wealth of marine life and **Pertamina Pier** is no different. This fuel-loading pier sits in depths from 5m to 14m and is a haven for schooling fish. Swimming between the pylons, divers will find them covered in

BELOW: The Red-gilled Nembrotha (*Nembrotha rutilans*) is a common nudibranch off Dili.

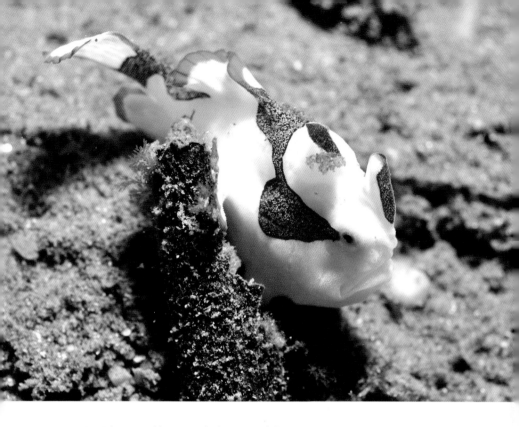

ABOVE: Tasi Tolu is a good location to find Warty Frogfish.

sponges, soft corals and beautiful gorgonians. But the sandy bottom is the place to look for critters, with frogfish, ghostpipefish, scorpionfish, nudibranchs, mantis shrimps and many other species to be seen.

K41, located 41km east of Dili along the coast road, is another wonderful muck site with black sand. This site has something for everyone. Head left and you can explore the sandy slope for critters, head right and you can investigate a pretty reef that is also loaded with great macro subjects. On the sandy slope are black coral trees and sea whips, which are home to Ornate Ghostpipefish, Xeno Crabs, Longnose Hawkfish, shrimpfish and numerous shrimps. Around the sand, divers will find shrimpgobies, jawfish, mantis shrimps and many other species.

You could spend the entire dive exploring the sand, but leave some time to visit the reef. This lovely site is decorated with beautiful sponges, soft corals, gorgonians and black corals. The standout feature, however, is the Tiger Anemones

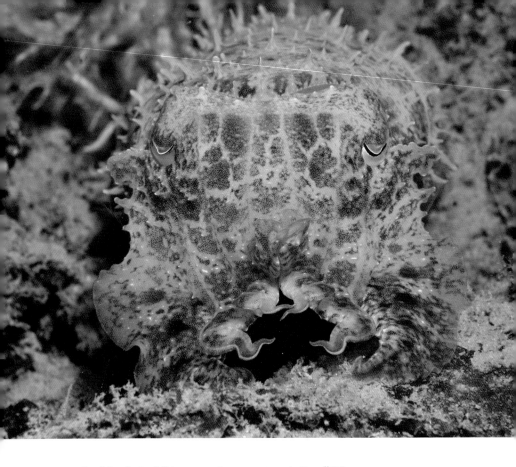

ABOVE: Small Needle Cuttlefish are sometimes seen at muck sites off Dili.

– thousands of them. Exploring the reef, divers are likely to find Leaf Scorpionfish, boxfish, numerous nudibranchs and even Whiskered Pipefish.

Next door to K41 is another wonderful muck site called **Behau Village**. The sloping sand and reef at this site drops to 40m, but the best critters are found in depths to 20m. Searching the sand, divers will find garden eels, Ribbon Eels, flounders and scorpionfish, but also have a close look at the corals and sponges as these shelter Hairy Squat Lobsters, nudibranchs and pipefish.

Another 16km along the coast road brings you to another brilliant muck site known as **K57**. This site is quite similar to K41, with muck on the left and reef on the right, but with a gentle sandy slope it is an even better muck site. Rising from the sand are numerous sea whips, sea pens, tube anemones and soft

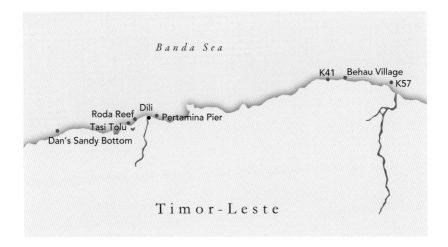

Banda Sea

K41 Behau Village
• K57

Roda Reef Dili
Tasi Tolu • Pertamina Pier
Dan's Sandy Bottom

Timor-Leste

corals. These colourful outcrops shelter small fish, with gobies, filefish, hawkfish and cardinalfish common. There are also seagrasses here, and the odd Dugong has been known to make an appearance at this site. At K57 divers will also see shrimpfish, snake eels, shrimpgobies, mantis shrimps, pipefish, cuttlefish and the occasional Oriental Sea Robin. The reef is well worth a look, especially if you are into nudibranchs as they are found here in plague proportions.

A number of the other reef dives around Dili also have a bit of muck, but not as much as the sites listed above. In years to come additional muck sites are sure to be discovered as divers explore more of this new nation.

DILI DIVE DATA

HOW TO GET THERE – A limited number of airlines operate to Dili, with Airnorth flying from Darwin, and Air Timor flying from Bali and Singapore.
BEST TIME TO VISIT – Year-round.
VISIBILITY – Typically 12–20m.
DIVING CONDITIONS – Currents can be experienced at some dive sites.
WATER TEMPERATURE – 24–29°C.

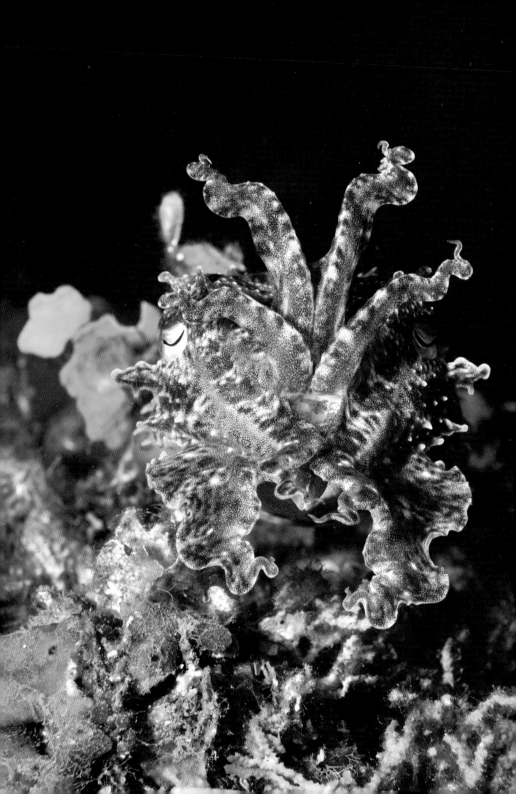

PAPUA NEW GUINEA

The first divers drawn to Papua New Guinea came to this exotic country to salvage the many shipwrecks that litter its bays and harbours – a legacy of World War II. They soon discovered that Papua New Guinea also has beautiful coral reefs and an abundance of marine life equalled by few destinations. Fortunately a few pioneer dive operators followed these salvage divers to open up the country to dive tourism in the 1980s. One of those operators was Bob Halstead, who opened the first dive shop and operated the first dive boat. He also pioneered liveaboard diving in the country and introduced divers to a new style of diving that he called 'muck diving'. Today Papua New Guinea is considered the spiritual home of muck diving, although it doesn't have as many muck sites as people think.

The main muck diving destination in Papua New Guinea is Milne Bay, although almost every part of the country where diving is enjoyed has at least one minor muck site. Many divers who head to Papua New Guinea spend as little time in the capital as possible, due to security concerns, but many brilliant dive sites are found off Port Moresby, including some wonderful muck diving at Lion Island. Tufi, located west of Milne Bay, has spectacular coral reefs and a unique coastline of fjords, where divers will find a magic muck site called the Tufi House Reef. Kavieng, located on the island of New Ireland, is a destination where divers travel to see sharks and pelagic fish, but this wonderful destination also has some muck at Bottleshop and Ral Island.

As much of Papua New Guinea is remote and many areas are only occasionally visited by liveaboard vessels, new muck sites are bound to be discovered as more of this incredible country is explored.

MILNE BAY (Major Muck)

Located at the eastern end of Papua New Guinea, Milne Bay covers a large area and encompasses many islands and sheltered inlets. Divers can explore this area by liveaboard vessel or from a dive resort, but either way you will only be exploring a small portion of this magical area. Washed by the Coral Sea and the Solomon

OPPOSITE: The Papuan Cuttlefish is common at muck sites in Milne Bay.

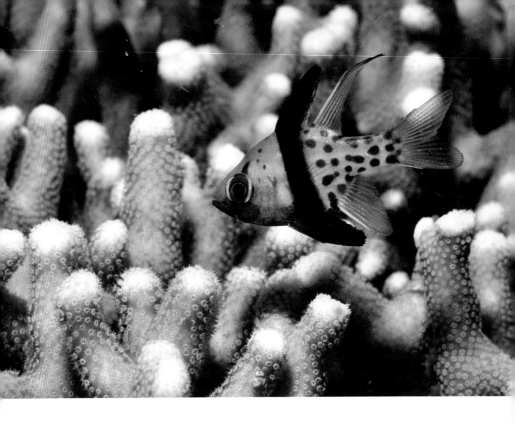

ABOVE: Muck sites with hard corals in Milne Bay are a good place to find Pyjama Cardinalfish.

Sea, Milne Bay is home to a rich variety of corals and marine life, and the area is blessed with some fabulous muck diving.

Dinah's Beach is located on the northern side of East Cape, and this is the place where muck diving began. This sloping black sand site is located near the village of Lauadi, and some use this as the name of the dive site. Although the site slopes to 50m, generally the best critters are found in depths between 3m and 15m. Take your time and you will see Ribbon Eels, octopus, moray eels, Leaf Scorpionfish, frogfish, nudibranchs, seahorses, cuttlefish, mantis shrimps, lionfish, pufferfish and shrimpgobies, and also find many cleaning stations.

Sea anemones litter the bottom and are home to several species of anemonefish and numerous commensal shrimps. While in the shallows there are coral outcrops and coral rubble that provide shelter for pipefish, Orangutan Crabs, Harlequin Shrimps and many juvenile reef fish. Special critters to watch out for at Dinah's

Beach include Cockatoo Waspfish, Coleman's Shrimps and Mimic Octopus. Naturally this site is also a brilliant night dive with crabs, shrimps, bobtail squid and numerous octopus emerging to feed. Each time you dive Dinah's Beach you will see something new.

Observation Point is a similar site and equally as good. This muck site is located on Normanby Island, part of the Eastern D'Entrecasteaux Island Group, north of Milne Bay. The steep sandy slope at Observation Point drops to 40m, but you don't have to go that deep to see Demon Ghouls, flounders, sand divers, nudibranchs, snake eels, pipefish, stargazers and much more. Some of the best critters at Observation Point are found in the shallows around the seagrass beds and the roots of mangrove trees, including seahorses, shrimpfish, ghostpipefish and filefish. Divers have also found Mimic Octopus and Flamboyant Cuttlefish at this brilliant site.

BELOW: Kune's Chromodoris (*Chromodoris kunei*) is one of the prettiest nudibranchs found in Milne Bay.

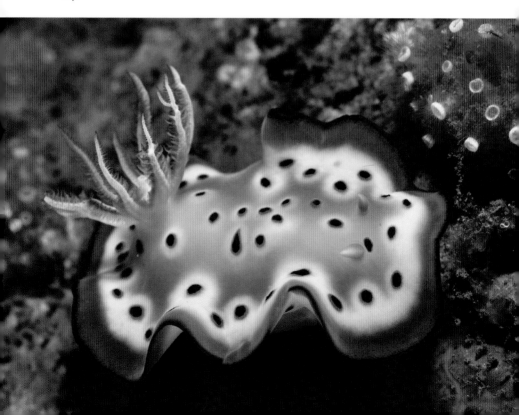

Another impressive muck site in Milne Bay is **Bunama**, which is located at the southern end of Normanby Island. This site has seagrass beds in the shallows, but from here divers can explore a sandy slope into very deep water. Around the seagrass, divers will find sea anemones, seahorses, pipefish, cuttlefish and lionfish. Other critters seen at Bunama include cowfish, frogfish, garden eels, octopus, ghostpipefish and numerous molluscs, including a wide variety of nudibranchs and even Venus Comb Murex. Dugongs have also been encountered at this site, attracted by the seagrass.

Most of the popular muck sites of Milne Bay are located in the north, but on the southern side of the bay is another lovely site called **Samarai Wharf**. This old timber wharf is swept by tidal currents, so dives are planned to avoid too much water movement, but these currents have allowed lovely corals to flourish on the pylons. Schools of baitfish linger under the wharf, often joined by batfish, and Tasselled Wobbegongs are commonly seen resting on the bottom. Plenty of rubbish has been dumped at this site over the years, and now provides shelter for octopus, mantis shrimps, gobies, crocodilefish, scorpionfish, nudibranchs, pipefish, stonefish, lionfish and the occasional toadfish. This site doesn't get as many critters as the other locations in Milne Bay, due to the strong currents, but it is always an incredible dive.

BELOW: The Red-spotted Porcelain Crab only live in sea anemones.

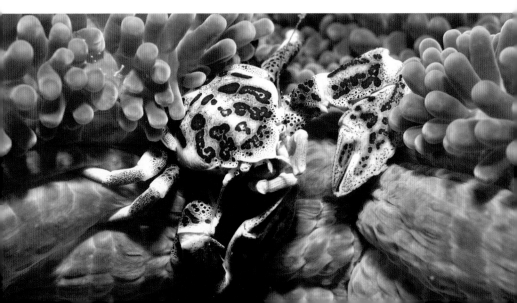

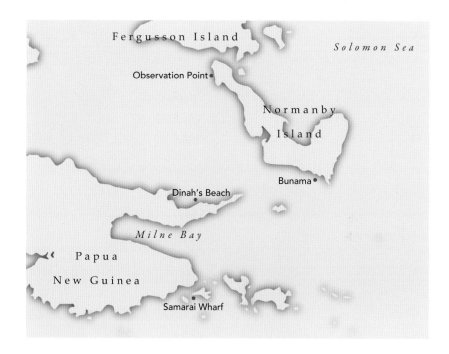

Of course there is much more to Milne Bay than just muck, with many spectacular reefs, pinnacles and shipwrecks. This area is also renowned for schooling pelagic fish, and is one of the best places in the world to see the elusive Lacy Scorpionfish, a close relative of the equally elusive Weedy Scorpionfish.

MILNE BAY DIVE DATA

HOW TO GET THERE – Most dive adventures to Milne Bay start at Alotau, which is serviced by domestic flights from Port Moresby.
BEST TIME TO VISIT – Year-round.
VISIBILITY – Typically 10–20m.
DIVING CONDITIONS – Conditions are usually calm at the muck sites and currents are either mild or non-existent.
WATER TEMPERATURE – 26–30°C.

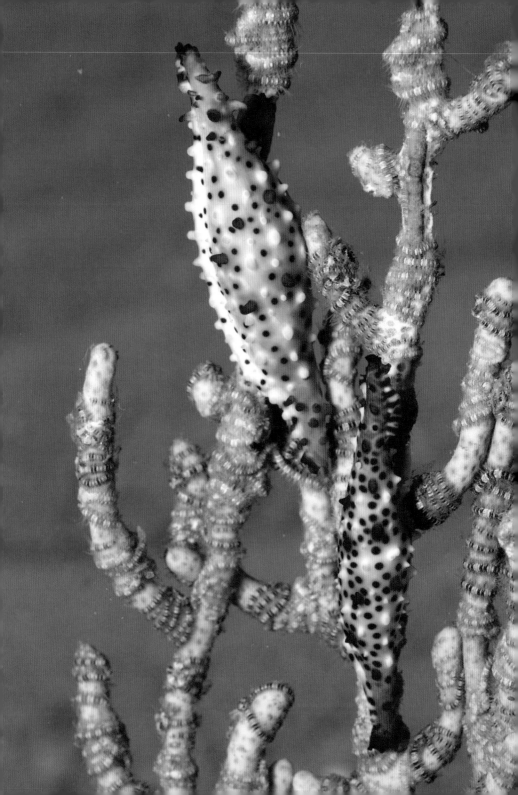

AUSTRALIA

The land 'Down Under' has fabulous diving right round its vast shoreline. In Australia's tropical north is the famous Great Barrier Reef and Ningaloo Reef, but the country's cooler temperate waters are equally impressive and support a wide array of marine life, meaning Australia is blessed with one of the most diverse marine environments in the world. One element of this is muck. Divers exploring Australia will find brilliant muck diving sites in both tropical and temperate waters that are home to amazing endemic critters seen nowhere else on the planet. While Australia does have some wonderful muck sites, there are only a handful of destinations that would be considered as major muck sites. However, scattered around the country are numerous minor muck sites that are well worth exploring. In Queensland divers should head to the south-eastern corner of the state to explore a brilliant muck site at the Gold Coast called The Seaway. New South Wales has a number of great muck diving sites that are detailed in the following pages, but divers can also investigate minor muck sites at Swansea and Jervis Bay. Off Tasmania, divers will find some interesting muck sites around Hobart, with this area home to the bizarre Spotted Handfish. South Australia has many lovely muck sites, with the many jetties of the Yorke Peninsula offering great muck diving, but divers will also find great critters at Rapid Bay and Tumby Bay. Western Australia also has some fine muck diving, especially under its many piers, while good minor muck sites are found at Esperance, Busselton, Perth, Dampier and Exmouth. Australia certainly has no shortage of amazing dive sites.

PORT STEPHENS (Major Muck)

Known locally as the 'Blue Water Wonderland', Port Stephens is a picturesque bay located on the central coast of New South Wales, 230km north of Sydney. Offshore from the bay are countless rocky islands and shipwrecks that offer incredible diving, but most divers who venture to Port Stephens spend the majority of their time exploring the bay, which has the best muck diving in Australia.

OPPOSITE: The corals at Port Stephens are home to Rosy Spindle Cowries and lots of brittle stars.

Located inside the sheltered waters of Port Stephens, near the town of Nelson Bay, are five wonderful shore diving sites called Halifax Park, Fly Point, Little Beach, Seahorse Gardens and The Pipeline. As the bay is tidal, most of these sites are only dived on either the high or low tide, unless you enjoy fast-paced drift dives. But these tidal waters bring a wealth of nutrients into the bay, creating a rich ecosystem for an incredible variety of tropical and temperate marine life.

Halifax Park is the deepest of the dive sites, with a sloping rocky and sandy bottom dropping into the channel at 30m. The rocky reef at this site is covered in sponges and corals, creating a beautiful tapestry of shapes and colours. **Fly Point** also has incredible sponge gardens in depths to 25m, but the rocky reef here has more ledges and gutters to explore. Both these sites offer a mix of reef and muck.

BELOW: Groups of male Mourning Cuttlefish are often seen in Port Stephens fighting for mating rights.

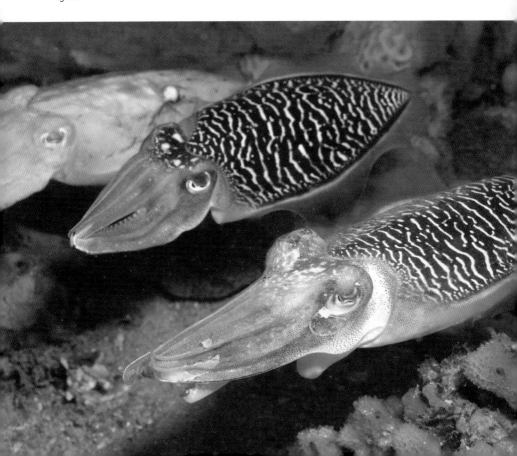

ABOVE: Numerous nudibranchs are seen at Port Stephens, including the Daphne's Chromodoris (*Chromodoris daphne*).

The Pipeline is completely different and more of a true muck site, with a sandy bottom (apart from the pipeline itself) decorated with sponges, kelp, soft corals and sea pens. Divers can reach 20m or more at The Pipeline, but most of the action is at depths between 6m and 12m. **Little Beach** is a pretty sandy bay that varies in depth from 6m to 12m and, being partly sheltered from tidal flows, can be dived between tides. Also partly sheltered from tidal flows is **Seahorse Gardens**. This sandy site has seagrass and pretty soft corals in depths from 4m to 12m where a great variety of critters can be found.

All these shore diving sites have a diverse population of reef fish that includes varieties of filefish, morwong, cardinalfish, grubfish, rock cods, gobies, flatheads,

ABOVE: Fanbelly Filefish is a common species at Port Stephens.

cowfish, boxfish, scorpionfish, goatfish, wrasse, damsels, moray eels and quite a few tropical fish like lionfish and butterflyfish. Schooling fish and pelagic fish abound, and there are plenty of sharks and rays, and even turtles to be seen.

The best feature of these dive sites are the critters, and underwater photographers rarely leave the water without a memory card full of wonderful images. Commonly found here are species of cuttlefish, octopus, decorator crabs, pineapplefish, sea hares, crayfish, flatworms, hermit crabs, boxer shrimps, spindle cowries and a huge variety of nudibranchs. Seahorses are quite common, but

seasonal, and sometimes they seem to cover the seabed, while at other times of the year only one or two may be seen. Also keep an eye out for Blue-lined Octopus, pipefish, frogfish, velvetfish, ghostpipefish, squid, dragonets, snake eels and gurnards. Some of these critters are more common at night, with all five dive sites being magical after dark.

Halifax Park and Fly Point are such special dive sites that they were declared a marine reserve in 1983, but this section of coastline at Port Stephens is so unique that the whole area should be protected.

PORT STEPHENS DIVE DATA

HOW TO GET THERE – Port Stephens is a two and half hour drive north of Sydney. If flying the nearest airport is at Williamtown, around 40km from Nelson Bay.

BEST TIME TO VISIT – Year-round.

VISIBILITY – Typically 8–12m at high tide.

DIVING CONDITIONS – Tidal, so always clearest on the high tide.

WATER TEMPERATURE – 17–24°C

SYDNEY (Major Muck)

Famed for its magnificent natural harbour, Sydney is also blessed with wonderful beaches and sheltered bays, making it the perfect location for anyone into water sports. The largest city in Australia, Sydney also has some incredible dive sites, including a number of fascinating muck sites.

Located inside Sydney Harbour are several muck sites that can be explored from the shore. **Balmoral Beach** is a sheltered cove on the northern side of Middle Head, in the suburb of Mossman. The sandy bottom off this beach is interesting to explore, but most critters are found on or near the bathing net, which is strung across the bay to protect swimmers from sharks. While the odd Bull Shark is known to lurk in Sydney Harbour, divers rarely see sharks at Balmoral Beach, apart from the harmless Port Jackson Shark.

Going no deeper than 5m, divers have plenty of time to slowly explore this netting, with White's Seahorses the most popular critter. These pretty seahorses are

BELOW: Weedy Seadragons are found at Sydney muck sites with kelp.

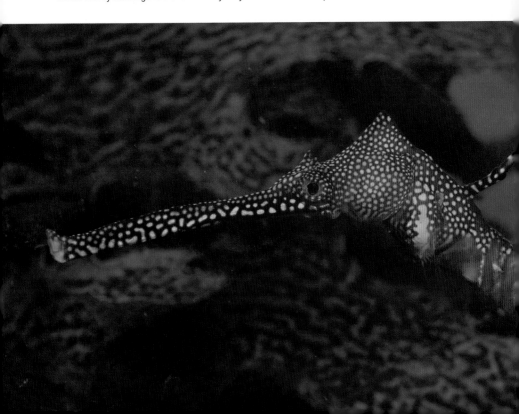

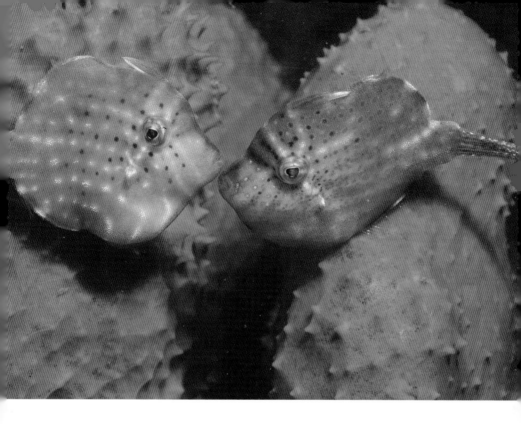

ABOVE: Cute little Pygmy Filefish are common at Sydney muck sites.

sometimes found in large numbers on the netting, but are often well camouflaged. Also common around the net are Pygmy Filefish, Fanbelly Filefish, cuttlefish, blennies, cowfish and even the occasional Blue-lined Octopus. Divers should also spend a little time exploring the sand adjacent to the net as pipefish, flounders, stingarees, flatheads and many shells can be seen.

On the other side of Middle Head is another great muck site called **Clifton Gardens**. There is also a bathing net at this site, but the main attraction is the 80m-long wharf. Depths under this wharf vary from 2m to 9m, giving the diver plenty of time to look for critters. Take a close look at the pylons as these are decorated with seaweeds and sponges that provide shelter for decorator crabs, filefish, nudibranchs, blennies and a few seahorses. On the sand under and around the wharf divers will also find octopus, cuttlefish, pipefish, stingarees, moray eels and the occasional Hairy Frogfish. Clifton Gardens is also a wonderful night dive,

ABOVE: Divers exploring Clifton Gardens will often encounter Blue-lined Octopus.

with many types of crustacean and cephalopod to be found, including Striped Pyjama Squid.

The southern side of Sydney Harbour also has some fine muck diving sites, with **Camp Cove** the best and most accessible. Located at Watson's Bay, Camp Cove is a popular site for dive training, as the terrain is a mix of sand, rock and kelp in depths from 2m to 7m. A surprising variety of reef fish and pelagic fish can be seen at Camp Cove, but this site also has no shortage of critters. Seahorses, cuttlefish, octopus, nudibranchs, tubeworms, pipefish, filefish and crabs are all common, but divers may also see Weedy Seadragons hanging around the kelp.

Car parking at all the dive sites in Sydney Harbour can be limited, especially during summer, as these sites are also popular with beach-goers.

Botany Bay, located south of Sydney Harbour, is full of muck sites. Muck critters can be found just about anywhere in this large bay, but most divers explore two wonderful dive sites on either side of the bay mouth. **Bare Island** is blessed with great diving and is accessible from the shore. This site has a mix of rocky reef, kelp beds, sponge gardens and sand, with depths varying from 6m to 25m. Commonly seen here are octopus, nudibranchs, squid, moray eels, cuttlefish, clingfish, cowfish, boxfish and dragonets. A number of special critters are found at this site, including Red Indian Fish, spiny gurnards and two local endemic species,

BELOW: Bare Island is the best place to see the endemic Sydney Pygmy Pipehorse.

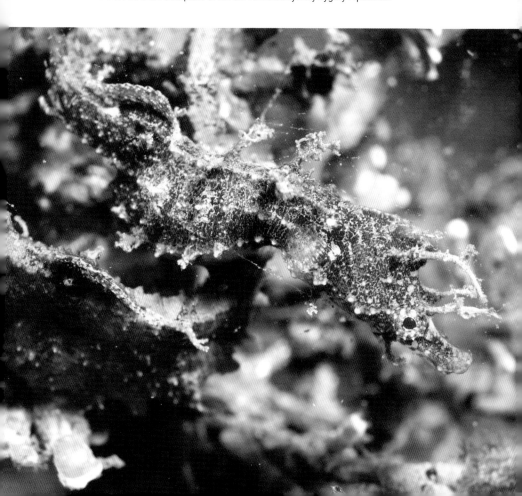

the Sydney Pygmy Pipehorse and Bare Island Frogfish (*Porophryne erythrodactylus*). Bare Island is located on the northern side of Botany Bay, but the southern side of the bay is just as popular at a site called **Kurnell**.

Like Bare Island, there are several brilliant dive sites at Kurnell that feature rocky reefs, kelp beds, sponge gardens and sand. Many of the species seen at Bare Island are also common here, but Kurnell is also a great location to see Bigbelly Seahorses and the highly prized Weedy Seadragon. Weedies are commonly found around the kelp, and are often observed feeding on tiny mysid shrimp. Care should be taken at both Bare Island and Kurnell as these sites are exposed to ocean swells and strong winds.

The best muck site off Sydney is located in the city's southern suburbs – a wonderful site called **Shiprock**. Located in a large estuary called Port Hacking, Shiprock doesn't get any beach-goers, but the car parking can still be limited as the site is very popular with divers. Access is via a set of stairs between two houses, with the entry behind a large ship-shaped rock. Once in the water, divers will find a sandy slope to 4m, then a rocky wall that drops to 14m. This wall is covered in spectacular corals, sponges and ascidians that provide food and shelter to an abundance of marine life. Commonly seen amongst the corals are moray eels, filefish, cowfish, boxfish, blennies, nudibranchs, flatworms, crabs, seahorses and sea stars. Many ledges cut into the wall and provide shelter for pineapplefish, octopus, Estuary Catfish, scorpionfish and Eastern Toadfish.

While diving Shiprock divers should also explore the sand on the top and the base of the wall as stingarees, cuttlefish, pipefish, dragonets, Coffin Rays and even the occasional Hairy Frogfish can be seen. Shiprock is a brilliant dive by day or night, but being tidal the best time to visit is on the high tide.

Around the corner from Shiprock is another lovely muck site called **Lilli Pilli Baths**. This site can be dived between tides, so makes a good second dive after Shiprock. The bathing net at this site is found in depths from 2m to 9m and is a good spot to see seahorses. Also common here are toadfish, dragonets, gobies, pipefish, hermit crabs, filefish and scorpionfish.

Sydney divers are very spoilt, as not only do they have brilliant muck sites that are easily accessible, but they also have many fascinating shipwrecks and colourful rocky reefs that can be explored by either boat or from the shore.

SYDNEY DIVE DATA

HOW TO GET THERE – Sydney Airport is the busiest airport in Australia and serviced by flights from many countries. To get around Sydney and explore its muck sites a hire car is recommended.

BEST TIME TO VISIT – Year-round.

VISIBILITY – Typically 5–8m, and generally clearest on high tide.

DIVING CONDITIONS – The sites in Sydney Harbour are calm and can be dived under most weather conditions, but Shiprock is tidal and is best dived on the high tide. The muck sites in Botany Bay are often exposed to ocean swells, so check the conditions before visiting these sites.

WATER TEMPERATURE – 16–23°C

MELBOURNE (Major Muck)

Melbourne has some of the keenest divers in Australia, and one look at its wonderful dive sites will tell you why. Each weekend sees hundreds of local divers heading out on boats to explore spectacular shipwrecks and very colourful temperate reefs. Many more divers can be found shore diving in Port Phillip Bay, exploring Melbourne's brilliant muck pier sites.

Melbourne's Port Phillip Bay is one of the most unique bays in the world. The bay contains a massive body of water that funnels through a small mouth, known as 'The Rip', which has claimed numerous ships. The huge movement of water in and out of the bay creates very strong currents and allows a rich mixture of marine life to thrive. Countless shore diving sites are located in this large bay, and most of these are muck sites, but the best critter spots would have be under the many piers that jut into the bay. The best of these piers are found on the Mornington Peninsula, about an hour and a half's drive from Melbourne city.

The closest to Melbourne city is **Mornington Pier**, which is an average day dive, but turns into 'Cephalopod City' by night. Exploring a maze of pylons, in 7m of water, divers will find Bigbelly Seahorses, shrimps, globefish, goatfish, cardinalfish, scorpionfish and dragonets. Sea stars are everywhere – a feature of Melbourne diving – especially huge Eleven-arm Sea Stars.

Mornington Pier is best known for its cephalopods. On a typical night dive expect to find several highly venomous Southern Blue-ringed Octopus strolling across the bottom looking for prey. Other species seen under this pier include Giant Cuttlefish, Southern White-spot Octopus, Southern Calamari Squid and huge Maori Octopus.

Rye Pier is about 300m long, but the best place to dive is at the end of this long jetty where the bottom is 5m deep. The clean sandy bottom around Rye Pier is often a good place to see small stingarees, huge Smooth Stingrays and angelsharks, but the best critters are found under the jetty in the forest of colourful pylons. Bigbelly Seahorses are particularly common, and so are crabs, shrimps, nudibranchs, sea stars and velvetfish. Many species of octopus, cuttlefish and squid can be seen at Rye Pier, especially after dark. A big feature here are giant spider crabs, which are seen on most dives walking across the bottom like an alien warship from *War of the Worlds*. In May and June, as the water temperature drops,

thousands of these crabs gather off Rye Pier and other spots in Port Phillip Bay to moult. It is an amazing sight, as the crabs often pile up into huge mounds and are eaten by stingrays and fur seals.

Melbourne's newest pier and best muck diving site is without a doubt **Blairgowrie Pier**. A dive under this long pier is an unforgettable experience, and while it may only be 6m deep, most divers never get to explore its full length as there is simply too much to see. The pylons are completely covered in colourful sponges, ascidians, algae and kelp, and they are home to shrimps, crabs, sea stars, tubeworms, scallops and nudibranchs.

Bigbelly Seahorses seem to be everywhere under the pier and come in a range of colours, including yellows, creams, oranges and browns, so you can pick and

BELOW: Giant Cuttlefish are often found at Melbourne's muck sites.

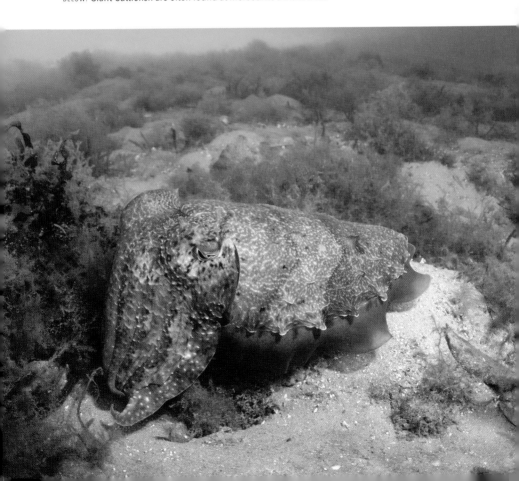

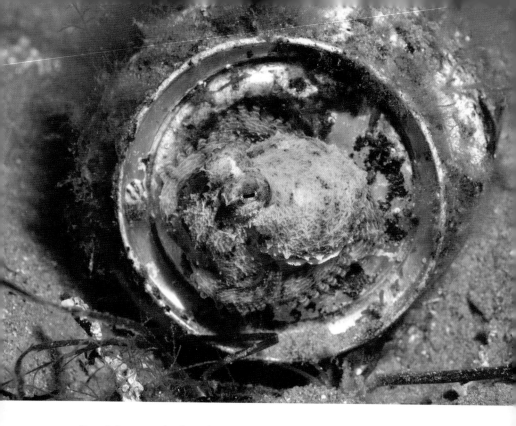

ABOVE: Discarded cans provide a home for Southern Keeled Octopus off Melbourne.

choose the most colourful ones to photograph. Other common critters include Southern Blue-ringed Octopus, pipefish, spider crabs, dragonets, gurnards, flatheads and velvetfish. A close examination of the sand may also reveal a Common Stargazer. Numerous ray species are also found under this pier, including several types of stingarees, Southern Fiddler Rays, huge Smooth Stingrays and the odd Thornback Skate.

The fish life in and around the pier is brilliant and includes filefish, wrasse, zebrafish, globefish and even pelagic fish. The favourite of many photographers is the Ornate Cowfish – not only are they colourful, but they also have the cutest face, with lips that look like they are always puckered for kissing.

One of the main attractions at Blairgowrie Pier is a rare endemic fish, the Tasselled Frogfish. This amazing species has the most elaborate camouflage of any frogfish and blends in perfectly with the sponges and algae. A number of

other frogfish species only found in southern Australian waters can also be found at Blairgowrie Pier, including the Prickly Frogfish and the very weird Smooth Frogfish.

Blairgowrie Pier is also an excellent night dive. While many people stay under the pier at night, to see the best critters, especially cephalopods, head out on the sand adjacent to the structure as you will find Southern Calamari Squid, Southern Dumpling Squid, Southern Keeled Octopus, Southern Blue-ringed Octopus and Southern Sand Octopus.

Portsea Pier is another wonderful Melbourne muck site and its main attraction is the Weedy Seadragon. A nearby kelp bed is the best place to encounter the Weedies, but they are also common under the pier. Going no deeper than 6m, divers will have a wonderful time exploring the sponge-encrusted pylons and the sand and seaweed under Portsea Pier. Common species found here include filefish, sea stars, crabs, nudibranchs, dragonets, brittle stars, cuttlefish and octopus. Other

BELOW: Blairgowrie Pier is the best location in Melbourne to see the weird Tasselled Frogfish.

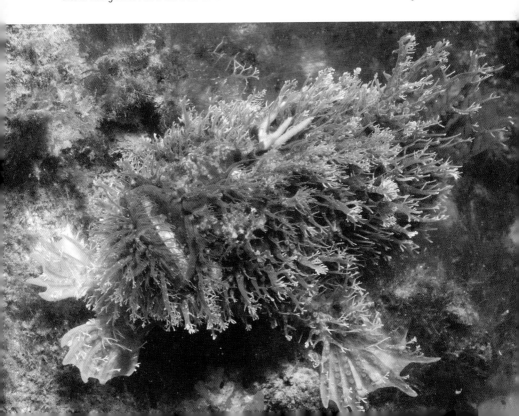

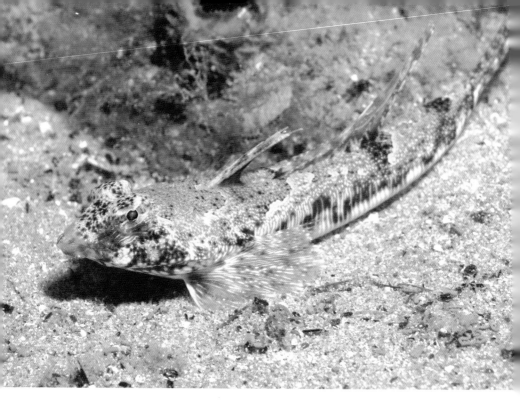

ABOVE: The Painted Stinkfish (*Eocallionymus papilio*) is a type of dragonet endemic to southern Australia.

species to look out for include frogfish, weedfish, Goblinfish, stingarees, velvetfish and gurnards. A resident Smooth Stingray, over 2m wide, also hangs around the pier and often gives divers a scare when it suddenly swims overhead while you are searching for critters.

East of Port Phillip Bay is Western Port Bay, where another great pier dive is found – **Flinders Pier**. Under this pier divers can explore the sand and seagrass to find pipefish, octopus, shrimps, hermit crabs, filefish, stingarees, nudibranchs and very cute Ornate Cowfish. This site is also a great spot to find Weedy Seadragons, velvetfish and the occasional frogfish. Divers will get plenty of bottom time at Flinders Pier, as the maximum depth is only 4m.

Melbourne's fabulous muck piers can be dived year-round, but don't let the cool water put you off as there are many special critters to be seen in these temperate waters.

MELBOURNE DIVE DATA

HOW TO GET THERE – Melbourne has two airports, but most flights arrive at Tullamarine Airport, which is to the north of the city. To explore these piers most visitors will find it best to hire a car.

BEST TIME TO VISIT – Year-round, but summer and autumn are generally the best times to dive these piers, not only because the water is warmer, but also the warmer temperatures see an influx of marine life.

VISIBILITY – Typically 8–12m.

DIVING CONDITIONS – Located in a sheltered bay, conditions are always calm.

WATER TEMPERATURE – 10–20°C

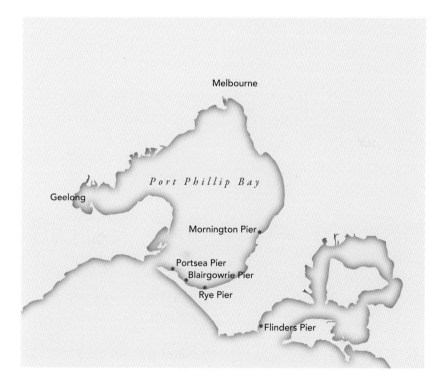

MUCK DIVE
OPERATORS

INDONESIA

Lembeh

Bastianos Lembeh Dive Resort – www.bastianoslembeh.com
 Lembeh dive resort.

Black Sand Dive Retreat – www.blacksanddive.com
 Dive resort located at Lembeh.

Cocotinos Lembeh and Odyssea Divers – www.cocotinos-manado.com
 Boutique dive resort at Lembeh.

Divers Lodge Lembeh – www.diverslodgelembeh.com
 Dive resort at Lembeh.

Eco Divers – www.eco-divers.com
 Lembeh dive resort.

Froggies Divers – www.froggieslembeh.com
 Dive resort at Lembeh.

Kasawari Lembeh Resort – www.kasawari-lembeh.com
 Dive resort located at Lembeh.

Kungkungan Bay Resort – www.kungkungan.com
 KBR were the first dive resort in Lembeh.

Lembeh Resort – www.lembehresort.com
 Dive resort located at Lembeh.

Makamaka Diver – www.makamakadiver.dabirahe.com
 Dive operation that work with Lembeh Hills Resort.

NAD Lembeh – www.nad-lembeh.com
 Lembeh dive resort.

Pulisan Jungle Beach Resort – www.pulisanresort-sulawesi.com
 Dive resort located at Pulisan.

SDQ Lembeh Dive Resort – www.sdq-dive-lembeh.com
 Dive resort located at Lembeh.

Two Fish Divers – www.twofishdivers.com
 Lembeh dive resort.

OPPOSITE: Sea pens are often occupied by tiny porcelain crabs.

Yos Dive Lembeh – www.yosdivelembeh.com
Dive resort at Lembeh.

Bali

Absolute Scuba Bali – www.absolutescubabali.com
Dive centre based in Padangbai.
Adventure Divers Bali – www.adventurediversbali.com
Dive centre based at Amed.
Adventure Scuba Diving Bali – www.adventure-scuba-diving.com
Dive shop based at Seminyak.
All 4 Diving – www.all4divingindonesia.com
Dive operation based at Sanur.
Amed Dive Center – www.ameddivecenter.com
Dive shop at Amed.
Amed Scuba – www.amedscuba-diving-bali.com
Dive centre based at Amed.
Aqua Dive Bali – www.bali-scuba-diving.com
Dive shop based at Nusa Dua.
Aquamarine Diving Bali – www.aquamarinediving.com
Organise diving across Bali.
Atlantis Bali Diving Center – www.atlantis-bali-diving.com
Dive centre based at Sanur.
Bali 2 Dive – www.bali2dive.com
Dive centre at Sanur.
Bali Aqua – www.baliaqua.com
Dive centre at Sanur.
Bali Bubbles Dive Center – www.bali-bubbles.com
Dive shop at Candidasa.
Bali Dive Tours – www.balidives.com
Dive operation based at Denpasar.
Bali Dive Trek – www.balidivetrek.com
Dive operation based at Amed.

Bali Diving – www.balidiving.com
 Dive centre based at Sanur.
Bali Diving Academy – www.scubali.com
 Dive shop based at Sanur.
Bali Hai Dive Adventures – www.balihaidiving.com
 Dive centre on Nusa Lembongan.
Bali International Diving Professionals – www.bidp-balidiving.com
 Dive shop based at Sanur.
Bali Queen Dive – www.baliqdive.com
 Dive shop based at Sanur.
Bali Scuba – www.baliscuba.com
 Dive shop at Sanur.
Bali Scuba Masters – www.baliscubamasters.com
 Dive centre at Nusa Dua.
Bali Scuba Vacations – www.baliscuba-vacations.com
 Dive centre based at Sanur.
Baliku Dive Resort – www.amedbaliresort.com
 Dive resort at Amed.
Blue Fin Bali Diving – www.bluefinbali.com
 Dive centre at Sanur.
Blue Season Bali – www.baliocean.com
 Dive shop at Sanur.
Crystal Divers – www.crystal-divers.com
 Dive shop at Sanur.
Deep Blue Dive Bali – www.diving-bali.com
 Dive resort at Tulamben.
Dive Dive Dive Bali – www.divedivedivebali.com
 Dive shop at Sanur.
Diving Bali – www.divingbali.com
 Dive operation at Sanur.
Ecodive Bali – www.ecodivebali.com
 Dive centre at Amed.

Ena Dive Center – www.enadive.co.id
 Dive centre at Sanur.
Euro Dive – www.eurodivebali.com
 Dive centre at Amed.
Geko Dive Bali – www.gekodivebali.com
 Dive centre based in Padangbai.
Joe's Gone Diving – www.joesgonediving.com
 Dive centre at Sanur.
Jukung Dive Amed Bali – www.jukungdivebali.com
 Dive resort Amed.
Liberty Dive Resort – www.libertydiveresort.com
 Dive resort at Tulamben.
North Bali Dive Center – www.balidivecenter.com
 Dive shop located at Singaraja.
Nusa Dua Dive Center Bali – www.nusaduadive.com
 Dive centre at Nusa Dua.
OK Divers Resort and Spa Bali – www.okdiversbali.com
 Dive resort at Padangbai.
Pro Dive Bali – www.prodivebali.com
 Dive shop based at Kuta.
Q Dive Bali – www.q-divebali.com
 Dive shop at Padangbai.
Scuba Dive Bali.com – www.scubadivebali.com
 Dive centre based in Sanur.
Scuba Duba Doo Dive Center – www.divecenterbali.com
 Dive shop in Kuta.
Sea Rovers Dive Center – www.searovers.net
 Dive operation based at Pemuteran.
Shangrila Scuba Divers – www.divingatbalishangrila.com
 Dive resort at Candi Dasa.
Tasik Divers Bali – www.bali.tasikdivers.com
 Organise dive holidays.

Tauch Terminal Bali – www.tauch-terminal.com
Dive resort at Tulamben.

Tulamben Wreck Divers – www.tulambenwreckdivers.com
Dive resort based in Tulamben.

Wisnu Dive Center – www.lovinadive.com
Dive centre based at Lovina Beach.

Zen Dive Resorts – www.zendivebali.com
Dive resort at Candidasa.

Sekotong

Cocotinos Sekotong and Odyssea Divers – www.cocotinos-sekotong.com
Dive resort that discovered most of the muck sites in the area.

Two Fish Divers and Dive Zone – www.twofishdivers.com
Dive operator that works with a number of local resorts.

Maumere

Ankermi Happy Dive Resort – www.ankermi-happydive.com
Dive resort offering shore and boat diving.

Budi Sun Flores Diving Resort – www.budi-sun-resort.com
Dive resort offering shore and boat diving.

MSY *Seahorse* – www.indocruises.com
Liveaboard vessel that includes Maumere muck sites in its itinerary.

Sea World Club – www.flores-seaworldclub.com
Dive resort offering shore and boat diving.

Ambon

Blue Motion – www.dive-bluemotion.com
Dive shop operating from September to June.

Blue Rose Divers – www.bluerosedivers.com
Small local dive operation.

Dive Into Ambon – www.diveintoambon.com
Dive shop based at the Maluku Resort and Spa.

Maluku Dive Resort – www.divingmaluku.com

 Dive resort at Laha.

PHILIPPINES

Anilao

Acacia Resort and Dive Center – www.acaciadive.com

 Dive resort at Anilao.

Aiyanar Beach and Dive Resort – www.aiyanar.com

 Anilao dive resort.

Anilao Beach Club – www.anilaobeachclub.com

 Dive resort located at Anilao.

Anilao Critters and Resorts – www.anilaocritter.com

 Dive operation working with a number of resorts.

Anilao Diving – www.anilaodiving.com

 Dive operation that works with a number of local resorts.

Anilao Diving Destinations and Resort – www.anilaodivingresort.com

 Dive operation based at Eagle Point Resort.

Aquaventure Reef Club – www.aquareefclub.com

 Dive resort located at Anilao.

Bambu Villa Resort – www.bambuvillaresort.com

 Dive resort at Anilao.

Bucco Anilao Beach and Dive Resort – www.buceoanilao.com

 Dive resort on the shore at Anilao.

Crystal Blue Resort – www.divecbr.com

 Dive resort at Anilao.

Halo Anilao Dive Resort – www.halodiveresort.com

 Dive resort at Anilao.

Pier Uno Resort and Dive Center – www.pierunoresort.ph

 Dive resort at Anilao.

Planet Dive Resort – www.planetdive.com.ph

 Dive resort at Anilao.

Portulano Resort – www.portulano.com

Dive resort located at Anilao.

Scuba Bro Dive Resort – www.scubabro.ph

Anilao dive resort.

Solana Resort – www.divesolana.com

Dive resort at Anilao.

Puerto Galera

AB Wonderdive B&B – www.abwonderdive.dk

Dive resort at Puerto Galera.

Action Divers – www.actiondivers.com

Puerto Galera dive resort.

Angelyn's Dive Resort – www.angelynsdiveresort.com

Dive resort located at Puerto Galera.

Asia Divers – www.asiadivers.com

Dive operation based at El Galleon Resort.

Atlantis Dive Resort – www.atlantishotel.com

Dive resort located at Puerto Galera.

Aura Beach and Dive Resort – www.auradiveresort.com.ph

Dive resort at Puerto Galera.

Badladz Adventure Resort – www.badladz.com

Dive resort Puerto Galera.

Big Apple Dive Resort – www.divebigapple.com

Dive resort at Puerto Galera.

Blue Ribbon Dive Resort – www.blueribbondivers.com

Dive resort at Puerto Galera.

Campbell's Beach Resort – www.campbellsbeachresort.com

Dive resort located at Puerto Galera.

Capt'n Gregg's – www.captngreggs.com

Dive resort located at Puerto Galera.

Cocktail Divers – www.cocktaildivers.com

Based at Garden of Eden Resort.

Coco Beach Island Resort – www.cocobeach.com
Puerto Galera dive resort.

Dive Sabang – www.divesabang.com
Located at Dream Hill Condos.

Dolphinbay Divers – www.www.dolphinbay-divers.com
Dive resort at Puerto Galera.

Frontier Scuba – www.frontierscuba.com
Dive operation working with a number of resorts.

La Laguna Beach Club and Dive Centre – www.llbc.com.ph
Dive resort located at Puerto Galera.

Marco Vincent Divers – www.mvdive.com
Dive operation working with resorts at White Beach.

Mermaid Resort and Dive Center – www.mermaidresort.com
Dive resort at Puerto Galera.

Pacific Divers – www.philippines-diving.com
Dive operation at White Beach.

Papa Fred's Steakhouse Beach Resort – www.steakhouse-sabang.com
Restaurant and dive resort at Puerto Galera.

Puerto Galera Beach Club – www.puertogalerabeachclub.com
Dive resort at Puerto Galera.

Out of the Blue Resort – www.outoftheblue.com.ph
Dive resort at Puerto Galera.

Scandi Divers Resort – www.scandidivers.com
Dive resort located at Puerto Galera.

Scuba for Change – www.scubaforchange.com
Based at the Aninuan Beach Resort.

Sea Rider Dive Center – www.seariderdivecenter.com
Dive operation working with several local resorts.

Song of Joy Dive Resort – www.sojdivers.com
Dive resort at Puerto Galera.

South Sea Divers – www.southseadivers.com
Dive resort at Puerto Galera.

Swengland Resort – www.swenglandresort.com

Dive resort at Puerto Galera.

The Manor – www.themanorpuertogalera.com/index.php

Dive resort at Puerto Galera.

Tina's Reef Divers – www.tinasreefdivers.com

Dive operation and accommodation at Puerto Galera.

Verde Divers – www.verdedivers.com

Dive operation at White Beach.

Dumaguete

Acqua Dive – www.acquadive.com

Dive resort located at Zamboanguita.

Amontillado Beach and Dive Resort – www.amontilladoresort.com

Dive resort at Dauin.

Atlantis Dive Resort – www.atlantishotel.com/dumaguete

Dive resort that also operates the liveaboard *Atlantis Azores*.

Atmosphere Resort – www.atmosphereresorts.com

Dive resort located at Dauin.

Bongo Bongo Divers – www.divebongo.com

Dive resort at Dauin.

Dive Society Dumaguete – www.divesociety.com/ds_ph/index_phil.asp

Dive operation based at El Dorado Beach Resort.

Dumaguete Divers – www.dumaguetedivers.com

Dive operation at Dauin.

Harold's Dive Center – www.haroldsdivecenter.com

Dive operation at Dumaguete.

Liquid Dumaguete – www.liquiddumaguete.com

Dive resort at Dauin.

Mike's Beach Resort – www.mikes-beachresort.com

Dive resort at Dauin.

Negros Divers – www.negrosdivers.com

Dive operation based at Thalatta Resort.

Scuba Ventures – www.dumaguetedive.com

 Dive operation based at Dumaguete.

Sea Explorers Philippines – www.sea-explorers.com/dauin/dumaguete-dive-center/

 Dive centre located at Pura Vida Beach and Dive Resort.

Tropico Scuba Diving Resort – www.tropico.ph

 Dive resort at San Jose.

Well Beach Dive Resort – www.wellbeach.com

 Dive resort at Dauin.

Sogod Bay

Padre Burgos Castle Resort – www.padreburgoscastle.com

 Dive resort at Padre Burgos.

Peter's Dive Resort – www.whaleofadive.com

 Dive resort on the shores of Sogod Bay.

Sogod Bay Scuba Resort – www.sogodbayscubaresort.com

 Dive resort located on the beach at Sogod Bay.

MALAYSIA

Mabul and Kapalai

Big John Scuba – www.bigjohnscuba.com

 Small resort and dive operation on Mabul.

Billabong Scuba – www.billabongscuba.com

 Small resort and dive operation on Mabul.

Borneo Divers – www.borneodivers.info

 Pioneered diving in this area and have a dive resort on Mabul.

Mabul Water Bungalows – www.mabulwaterbungalows.com/en/

 Dive resort based at Mabul.

MV *Celebes Explorer* – www.borneotourstravel.com/sipadan-dive/celebes-explorer-liveaboard/

 Liveaboard vessel that visits Mabul, Kapalai and Sipadan.

Scuba Junkie – www.scuba-junkie.com

Run a resort and dive operation on Mabul and at Semporna.

Seahorse Sipadan Scuba – www.seahorse-sipadanscuba.org

Have a small resort and dive operation on Mabul.

Seaventures Dive Resort – www.seaventuresdive.com

Unique former oil rig accommodation platform, now a dive resort off Mabul.

Sipadan-Kapalai Dive Resort – www.sipadan-kapalai.com

Dive resort based on Kapalai.

Sipadan Mabul Resort – www.sipadanmabulresort.com/en/

Dive resort on Mabul.

Sipadan Scuba – www.sipadanscuba.com

Dive operation based at Semporna.

Sipadan Water Village Resort – www.swvresort.com/home.cfm

Dive resort on Mabul.

Uncle Chang – www.ucsipadan.com

Backpackers lodge and dive operation based at Semporna.

TIMOR-LESTE

Dili

Aquatica Dive Resort – www.aquaticadiveresort.com

A dive resort offering both shore and boat diving.

Dive Timor Lorosae – www.divetimor.com

Dive shop offering both shore and boat dives around Timor-Leste.

PAPUA NEW GUINEA

Milne Bay

MV *Chertan* – www.chertan.com

Liveaboard vessel that explores the Milne Bay region.

MV *Golden Dawn* – www.mvgoldendawn.com

 Liveaboard charter boat that visits the Milne Bay region.

Tawali Leisure and Dive Resort – www.tawali.com

 Dive resort located in Milne Bay that also operate the liveaboard MV *Spirit of Niugini*.

AUSTRALIA

Port Stephens

Feet First Dive – www.feetfirstdive.com.au

 Dive shop based at Nelson Bay.

Lets Go Adventures – www.letsgoadventures.com.au

 Dive shop based at Nelson Bay.

Sydney

Abyss Scuba Diving – www.abyss.com.au

 Dive shop located in the Sydney suburb of Ramsgate.

Dive 2000 – www.dive2000.com.au

 Dive shop located in the Sydney suburb of Neutral Bay.

Dive Centre Manly – www.divesydney.com.au

 Dive shop located in the Sydney suburb of Manly.

Dive Centre Bondi – www.divebondi.com.au

 Dive shop located in the Sydney suburb of Bondi.

Frog Dive Scuba Centres – www.frogdive.com.au

 Dive shop located in the Sydney suburb of Willoughby.

Pro Dive – www.prodive.com.au

 Has three dive shops in Sydney – at Manly, Coogee and Cronulla.

Scuba Warehouse – www.scubawarehouse.com.au

 Dive shop located in the Sydney suburb of Parramatta.

Snorkel and Dive Safari – www.sydneydivesafari.com.au

 Has two dive shops in Sydney – at Matraville and West Ryde.

Sydney Dive Academy – www.sydneydive.com.au

Dive shop located in the Sydney suburb of Matraville.

Melbourne

Academy of Scuba – www.academyofscuba.com.au

Dive shop located in the Melbourne suburb of Camberwell.

Aquability – www.aquability.com.au

Dive shop located in the Melbourne suburb of Mordialloc.

Aquatic Adventures Scuba – www.aquaticadventures.com.au

Dive shop located in the Melbourne suburb of Rowville.

Bay Play – www.bayplay.com.au

Dive services and accommodation located in the Melbourne suburb of Portsea.

Diveline – www.diveline.com.au

Dive shop located in the Melbourne suburb of Frankston.

Dive Victoria – www.divevictoria.com.au

Has two dive shops in Melbourne – at Portsea and Queenscliffe.

Harbour Dive – www.harbourdive.com.au

Dive shop located in the Melbourne suburb of Mornington.

IDC Scuba – www.idcscuba.com.au

Dive shop located in the Melbourne suburb of Rosebud West.

Scuba Culture – www.scubaculture.com.au

Dive shop located in the Melbourne suburb of Burwood.

Scuba Life – www.scubalife.com.au

Dive shop located in the Melbourne suburb of Hallam.

The Scuba Doctor – www.scubadoctor.com.au

Dive shop located in the Melbourne suburb of Rye.

REFERENCES AND FUTHER READING

Other books by Reed New Holland include:

Australian Marine Life: The Plants and Animals of Temperate Waters
Graham Edgar ISBN 978 1 87706 948 2

Australian Tropical Marine Wildlife
Graham Edgar ISBN 978 1 92151 758 7

Coral Wonderland: The Best Dive Sites of the Great Barrier Reef
Nigel Marsh ISBN 978 1 87706 7808

Deadly Oceans
Nick and Caroline Robertson-Brown ISBN 978 1 92151 782 2

Field Guide to the Crustaceans of Australian Waters
Diana Jones and Gary Morgan ISBN 978 1 87633 482 6

Fishes of Australia's Southern Coast
Martin Gomon, Diane Bray and Rudie H. Kuiter ISBN 978 1 87706 918 5

Guide to Sea Fishes of Australia
Rudie H. Kuiter ISBN 978 1 86436 091 2

Seabirds of the World
David Tipling ISBN 978 1 92151 767 9

Tropical Marine Fishes of Australia
Rick Stuart-Smith, Graham Edgar, Andrew Green and Ian Shaw ISBN 978 1 92151 761 7

Underwater Australia: The Best Dive Sites Down Under
Nigel Marsh ISBN 978 1 92151 792 1

Wildlife Under the Waves
Jürgen Freund and Stella Chiu-Freund ISBN 978 1 92151 739 6

World's Best Wildlife Dive Sites
Nick and Caroline Robertson-Brown ISBN 978 1 92151 772 3

Ambon by Becca Saunders, Sportdiving Magazine No. 52 Oct/Nov, 1995.
Living Jewels by Bob Halstead, *Sportdiving Magazine* No. 36 Feb/Mar, 1993.
Macro & Muck Diving Magic by Bob Halstead, *Sportdiving Magazine* No. 77 Dec 1999/Jan, 2000.
Sulawesi Seas by Mike Severns, *Sportdiving Magazine* No. 55 April/May, 1996.

INDEX

Ambon scorpionfish 185

Anemonefish 202

Blennies 214

Blue-ringed octopus 102

Bobbit worm 55

Bobtail squid 119

Bottletail squid 117

Box crabs 76

Boxer shrimps 58

Boxfish 232

Brittle stars 127

Bumblebee shrimps 68

Cardinalfish 198

Carrying crabs 83

Catfish 147

Cleaner shrimps 59

Clingfish 160

Cnidarians 46

Cockatoo waspfish 186

Coconut octopus 109

Coleman's shrimp 66

Commensal shrimps 65

Cone shells 94

Conger eels 145

Corals 46

Coral shrimps 60

Cowfish 234

Cowries 91

Crocodilefish 197

Cuttlefish 113

Dartfish 223

Demon ghoul 187

Dragonets 216

Echinoderms 122

Elbow crabs 78

Feather stars 128

Filefish 229

Fireworms 56

Flamboyant cuttlefish 115

Flatworms 51

Flounders 225

Frogfish 153

Garden eels 146

Ghostpipefish 166

Goatfish 200

Gobies 218

Goblinfish 188

Grubfish 213

Gurnards 192

Handfish 159

Harlequin shrimp 69

Hawkfish 205

Hermit crabs 87

Imperial shrimp 67

Jawfish 208

Leaf scorpionfish 189

Lionfish 184

Lizardfish 148

Mantis shrimps 73

Marble shrimps 61

Marine worms 51

Mimic octopus 106

Molluscs 91
Moray eels 136
Murex shells 96
Nudibranchs 97
Octopus 102
Opisthobranchs 100
Oriental sea robin 195
Pebble crabs 79
Pineapplefish 163
Pipefish 178
Pipehorses 173
Porcelain crabs 86
Prawns 71
Pufferfish 236
Pygmy seahorses 172
Pygmy squid 119
Rays 240
Razorfish 206
Red indian fish 196
Ribbon eel 140
Rock shrimps 63
Round crabs 77
Sand divers 212
Scorpionfish 182
Sea anemones 47
Sea cucumbers 132
Seadragons 176
Seahorses 169
Sea jellies 49
Seamoths 165
Sea pens 50
Sea snakes 244

Sea stars 123
Sea urchins 130
Sharks 238
Shrimpfish 164
Shrimpgobies 222
Shrimps 58
Smashers 73
Snake eels 141
Snapping shrimps 62
Soles 227
Spearers 74
Spider crabs 80
Squat lobsters 89
Squid 120
Stargazers 210
Stonefish 183
Swimming crabs 82
Temperate frogfish 157
Temperate octopus 109
Temperate pipefish 180
Temperate seahorses 170
Toadfish 151
Tropical frogfish 155
Tropical pipefish 180
Tropical seahorses 169
True crabs 76
Tubeworms 53
Velvetfish 192
Weedy scorpionfish 190
Wonderpus 107
Zebra crabs 85

UK £15.99 US $19.99